The Art of Teaching Art

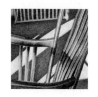

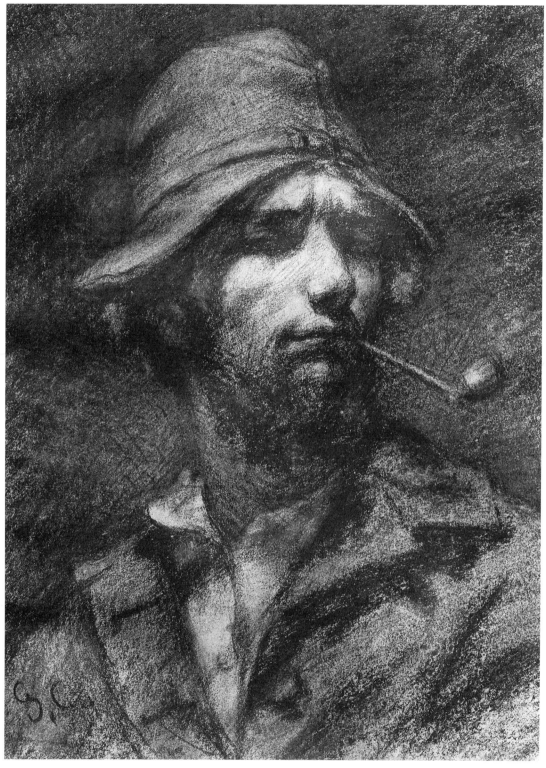

Frontispiece: Gustave Courbet. *Self-Portrait (The Man with the Pipe),* c. 1849. Black chalk on paper, 11-½ x 8-¾ inches. Wadsworth Atheneum, Hartford. Purchased through the gift of James Junius Goodwin. (1950.605)

The Art of Teaching Art

A Guide for Teaching and
Learning the Foundations
of Drawing-Based Art

*D*eborah A. *R*ockman

Kendall College of Art and Design

OXFORD
UNIVERSITY PRESS
2000

OXFORD
UNIVERSITY PRESS

Oxford New York

Athens Auckland Bangkok Bogotá Buenos Aires Calcutta
Cape Town Chennai Dar es Salaam Delhi Florence
Hong Kong Istanbul Karachi Kuala Lumpur
Madrid Melbourne Mexico City Mumbai
Nairobi Paris São Paulo Singapore
Taipei Tokyo Toronto Warsaw

and associated companies in

Berlin Ibadan

Published by Oxford University Press, Inc.
198 Madison Avenue, New York, New York 10016

Design by Charles B. Hames

Unless otherwise noted, all student drawings are the work
of Kendall College of Art and Design students.

LIBRARY OF CONGRESS CATALOGING-IN-PUBLICATION DATA
Rockman, Deborah A., 1954–
 The art of teaching art : a guide for teaching and learning
 the foundations of drawing-based art /
 Deborah A. Rockman
 p. cm.
 Includes bibliographical references.
 ISBN 0-19-513079-0 (cloth : alk. paper)
 1. Drawing—Study and teaching (Higher)—United States.
 2. Art teachers—Training of—United States. I. Title.
 NC590 .R634 1999 741'.071'1-dc21 99-37642

9 8 7 6 5 4 3 2 1

Printed in the United States of America
on acid-free paper

For my mother, my teacher

Ella Mae Rockman

1931–1997

Contents

*P*reface

Teaching is a noble profession. *Webster's Dictionary* says that to teach is "to impart knowledge of or skill in; to give instruction." Clearly one must first have a degree of knowledge or skill in order to reveal it to another. Preschool, elementary, and secondary educators not only have apparent knowledge or expertise in the subjects that they teach, but they are also required to receive training in and exposure to a variety of techniques, theories, and philosophies of teaching.

Unfortunately for many, this is not the case for postsecondary educators teaching at colleges and universities across the country. We have all heard the horror stories of the brilliant scientist or mathematician or writer or artist who is awarded a position on the faculty of an institution based on his or her professional performance and accomplishments only to fail miserably at communicating his or her wealth of knowledge and experience to an eager but disappointed group of students.

In general, the only requirement for teaching at the postsecondary level is to have a terminal degree in your field of expertise. In the case of the studio arts, a master of fine arts degree is the terminal degree. While this may provide the aspiring educator with a certain amount of skill and knowledge, it by no means ensures the ability to be an effective teacher. The communication skills required of a visual artist are not necessarily the communication skills required of a teacher of the visual arts.

To complicate matters further, many beginning instructors at the college or university level are thrust into the classroom not only lacking training or experience in teaching techniques, but without an adequate understanding of *what* information is most important to impart to a student in the initial and formative stages of an education in the visual arts. Many institutions that offer graduate degrees also provide their graduate students with an opportunity to teach foundation-level courses in the undergraduate program. Unfortunately, there is often very little if any preparation or

mentoring offered for the GTA (graduate teaching assistant), and they are left struggling to determine appropriate course content, teaching methodologies, grading criteria, classroom procedures, etc.

The bottom line is that many first-time art instructors at the postsecondary level, whether they be GTAs, adjuncts, temporary sabbatical replacements, or new full-time hires, are left feeling stranded in the studio classroom. The end result is often one of frustration for all involved—a dissatisfying teaching experience for the instructor, and an inadequate learning experience for the student that translates into additional frustration as the student finds that he or she is insufficiently prepared for more advanced course work.

In my nearly twenty years of teaching experience, I have identified what I consider to be vital studio experiences for students of art and design, particularly at the introductory or foundation level. These experiences ultimately influence the students' work throughout their academic training. This book thoroughly addresses those studio experiences, and is intended to serve as a guideline for the beginning teacher of art, or as a reference and refresher for the experienced teacher seeking new ideas and approaches or seeking affirmation for current classroom practices. While I am addressing the educator, I am confident that this book is also an invaluable resource for students. It is my desire to share my teaching expertise, but also to impart my love and enthusiasm for teaching. Teaching with authority, energy, and humility is essential. It nurtures in your students a love for learning, and that is perhaps the most important lesson you can teach.

—d. a. r.

Acknowledgments

Many people have encouraged and assisted me in preparing *The Art of Teaching Art*.

Thanks to my colleagues at Kendall College of Art and Design, who have shared with me their encouragement and expertise, and from whom I have learned so much—Ralph Allured, Jay Constantine, Thomas Gondek, David Greenwood, Darlene Kaczmarczyk, Sandra Lummen, Boyd Quinn, Margaret Vega, and Diane Zeeuw.

Thanks for professional guidance, support, and friendship to Dana Freeman, Aquinas College of Grand Rapids; Patricia Hendricks, Grand Valley State University; Robynn Smith, Monterey Peninsula College; Sandra Starck, University of Wisconsin at Eau Claire; and Lambert Zuidervaart, Calvin College of Grand Rapids.

Thanks to Michelle Sullivan for her perspective on the graduate school experience; to Tom Clinton and Carol Fallis for legal counsel; to Jen Dividock and Dani McIntyre for technical assistance; to Paris Tennenhouse for technical assistance and unwavering emotional support; to Patrick Foley, Barbara Corbin, Joyce Recker, and Dan Dauser for helping me to see the light at the end of the tunnel. Thanks to Chad Jay, Mary Kolenda, and Erli Gronberg for sharing resources and for technical support. Thanks to everyone at the Camera Center—Ellis, Paul, Larry, Bob, and Hal—for generously sharing your enthusiasm and expertise. Special thanks to Kendall College of Art and Design for providing me with release time and technical/financial support.

Thanks to my students. It is all of you who inspired me most to share my experience of teaching and all that it encompasses. The illustrations of your work breathe life into my words. Although I am unable to use examples of everyone's work, I am grateful to all of you who provided me with permission to use your drawings throughout *The Art of Teaching Art*.

Thanks to Moorhead State University in Minnesota for having faith in me and for giving me my start in teaching, and to Phil Harris and Anne Schiesel-Harris for their support and friendship during those first few difficult years.

Thanks to my editor, Joyce Berry, for guiding me through the publication process.

Finally, and most important, love and thanks to my family. Words cannot express my gratitude for the gift that we are to each other.

The Art of Teaching Art

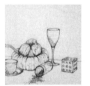

Introduction

A Philosophy of Teaching

In a field of study where there are few absolutes and where self-expression and personal experience are vital elements, recognizing and nurturing the individual temperaments and natural abilities of the students in my charge is perhaps the most important and difficult challenge facing me as an instructor of art.

My students are challenged to challenge themselves. Through my example, they are encouraged to develop within themselves a genuine sense of enthusiasm, self-motivation, personal commitment, and professionalism. They learn, as I have learned, to embrace the unfamiliar as an opportunity to grow, to be challenged and driven ahead by what they do not know rather than clinging solely to comfortable and familiar experience.

Lectures, handouts, class discussions, gallery visits, demonstrations, and slide presentations are important aspects of my instructional approach, with the work of both historical and contemporary masters as well as student work serving as examples and inspiration. Individual and group critiques are held in all courses and consider technical, formal, and conceptual issues in both a contemporary and historical context. The role of both objective and subjective interpretation is explored, with emphasis on the interdependence of process and product. My students are urged to recognize the value of mistakes as an important learning tool, and to develop critical thinking skills, enabling them to identify both strengths and weaknesses in their own work and the work of others. I am confident that my approach to teaching commands the respect of my students, providing a solid foundation for further investigation of drawing and related disciplines at both a personal and professional level.

This is the formal statement of my teaching philosophy, first developed when I initially sought a position in postsecondary art education. Although it has been finetuned and slightly revised over the years, it remains an accurate reflection of what I strive for in the teaching of art, and more specifically in the teaching of drawing.

The memory of walking into a classroom of students for which I had complete responsibility for the first time still fills me with wonder and terror. I was no longer the student waiting to be showered with pearls of wisdom from my instructor. I *was* the instructor. The sense of awe and responsibility that I felt was simply overwhelming, especially since I had come from an undergraduate experience that seemed to promote the laissez-faire approach—for the most part, there was not a lot of active teaching taking place. The unspoken philosophy during my undergraduate years seemed to be one of passive instruction, supported simply by the primarily silent and stoic presence of the faculty member in the classroom. With few exceptions, there were no lectures or demonstrations given, there were no slides shown as examples, there were no textbooks or reference materials recommended or required, no group critiques or discussions of materials and media, no mention of current philosophies or issues in the art world. As students, we were often left to fend for ourselves. For the student with some natural ability, it may not have been a traumatic experience, but for the student who needed more guidance and encouragement, it was often an experience filled with frustration and a sense of failure. This was not the environment I wanted to re-create for the students for whom I was responsible. Once again, although in a very different role, I found myself on my own.

As I gathered teaching experience in the classroom, I saw with increasing clarity the significance of the foundation experience for the student of visual arts. The quality of this introductory experience had the power to broadly influence a student's entire attitude toward his or her education in the arts. In considering all the variables involved in a student's educational environment—facilities, location, class size and makeup, socioeconomic background, access to scholarships and financial aid, maturity level, etc.—no factor was more important than the teacher. She or he had the capacity to create an atmosphere of wonder, confidence, enthusiasm, and joyful anticipation for the experience of discovery that is learning, or to create an atmosphere of dread, defeat, confusion, discouragement, and apathy. As the director of the learning experience, I learned that the instructor's attitude, whether positive or negative or indifferent, is highly contagious.

I quickly realized to what degree I was responsible for my own development as a teacher. Although student textbooks provided some guidance for classroom activities and emphases, I found myself overwhelmed by innumerable questions about teaching, with no consistent or reliable resource for answers. "What do I teach? When do I teach it? What are the best techniques for presenting information? How much homework should I assign? What kind of homework should I assign? How do I set up a syllabus and materials list? What kinds of restrictions or boundaries should I set for the classroom? What do I need to consider in grading student work? How do I handle a difficult student? What should I do if I am asked a question and I don't know the answer? . . ." The list was very long.

Initially I imagined that I was alone in my anxiety and uncertainty. But in retrospect, this was clearly not the case. After countless conversations over the years with new and entry-level teachers, including graduate teaching assistants, adjunct faculty, new full-time hires, and even seasoned veterans of the studio classroom, it became evident that my early experiences as a teacher were and are all too common. Many colleges, universities, and private educational institutions offering degrees in studio art continue to struggle with the financial and budgetary strains of technological

requirements and dwindling governmental support, and cost-cutting measures are sought. With greater frequency, full-time faculty numbers are reduced in favor of graduate teaching assistants and/or adjunct faculty, saving money through smaller salaries and a reduction in required benefit packages. At the expense of the quality of studio art education, there is a long-standing tradition of thrusting graduate teaching assistants into the classroom with little or no experience, preparation, guidance, or supervision. When new full-time faculty *are* hired, budgetary constraints often dictate that vacancies be filled at the lower salary rank of entry-level instructor or assistant professor. These new hires are often fresh out of graduate school, with virtually no teaching experience beyond a graduate teaching assistantship. An increase in these hiring trends is anticipated as a high proportion of current full-time faculty approach retirement age or consider early retirement initiatives. These graduate teaching assistants, adjunct faculty, and entry-level new hires stand to benefit the most from *The Art of Teaching Art.*

While there are numerous textbooks that provide guidance and instruction for *students* of art, the fledgling college or university art teacher is often left empty-handed. A few institutions may offer a seminar course that focuses on preparation and guidance for graduate students about to enter the classroom as teachers, but these classes often do not have the support of an appropriate book. And in the absence of a course of this nature, more experienced faculty acting as mentors may attempt to suggest a book that will help. But a serious search of the current market reveals nothing specifically geared toward the preparation of postsecondary, college-level art teachers. And *every one of us* begins our teaching career from a place of relative inexperience. There are a number of books on the market for high-school art teachers, but they do not begin to address the very different needs of the college or university art instructor.

Over the years, I have personally reviewed hundreds of textbooks in an effort to inform my teaching. While many of these are well written and somewhat helpful, they do not address the many facets of instructor preparation for teaching, and there are key studio experiences that either are not addressed at all or are not satisfactorily fleshed out for either the student or the instructor. Examples of this include the process of sighting, the variety of ways to apply it, and techniques for effectively explaining and presenting the process; meaningful methods and reasons for creating line variation; scaling techniques for determining accurate size relationships of figurative and nonfigurative forms; various methods for conducting group or individual critiques; and many more. The material that is available is nearly always directed to the needs of the student (the *making* of art), which are very different from the needs of the instructor (*teaching* the making of art).

A faculty member at a college in Alberta, Canada, has self-published a paper under the title *Surviving Teaching Practices in University and College Studio Art Programs: A Guide for Artists Who Want to Become Better Teachers.* This paper briefly addresses some theory and philosophy of teaching in postsecondary art education while purposely avoiding any specific discussion of *what* is being taught or *how* it is being taught, which are significant components of *The Art of Teaching Art.* The paper is also extremely critical of some teaching methods, such as group critiques, which I believe have significant value when implemented with knowledge and sensitivity.

The Art of Teaching Art answers the broadly recognized need for a book directed toward the training and preparation of college-level studio art instructors. It is

primarily intended to address the needs of teachers in the formative stages of their academic careers, but it may also serve even the most seasoned instructors seeking affirmation or inspiration. It is especially geared toward teachers who respect the classic model of drawing-based studio art education and seek guidance in their desire to be a significant and effective force in the classroom. *The Art of Teaching Art* addresses the fact that, while many studio art faculty are employed based on their abilities or achievements as artists, it is a mistake to assume that this ability naturally extends to the special skills required of a teacher of art.

Drawing as the Backbone of Visual Communication

In 1981, following the completion of my MFA degree, I began my career as a teacher of art and coordinator of the drawing and figure-drawing programs at a university in the great northern plains. Two years later I had the great fortune to be hired at Kendall College of Art and Design, where I have remained since. It was here that I first encountered a group of colleagues who were as active and enthusiastic in the classroom as they were in their own studios. Their energy and commitment as both artists and art educators were exactly what I had been looking for. The recognition that the two activities could in fact nourish each other rather than deplete each other was a reflection of my own beliefs. Many of us had had similar experiences as undergraduate students, and were anxious to provide our students with a more substantial education. Ironically, it was here as a teacher that I found myself feeling most like a student, and it was here that I came to recognize that learning is an integral part of teaching.

Although this book could serve as a textbook for students, it is intended as a guide for teachers in effectively preparing and communicating some of the most basic and vital information necessary for the development of students in the visual arts, both the fine arts and the applied arts. This book reflects my belief that drawing is the backbone of all forms of visual arts, that drawing is at the source of effective visual communication of ideas. Whether it is used as support for other forms of expression (painting, sculpture, printmaking, illustration, story boards, furniture design, industrial design, interior design, architecture, advertising design, etc.), or as an end unto itself, drawing is an invaluable skill.

The Art of Teaching Art is organized into two parts. Chapters one, two, and three address fundamental drawing experiences that are necessary for a solid two-dimensional foundation experience rooted in observation and eye-hand coordination. The intention is to ensure on the part of the instructor a thorough awareness and understanding of key concepts and drawing experiences as a vehicle for effectively communicating this information to students.

Chapter one addresses drawing experiences that are broadly applicable to any subject matter. Included are methods for observing and recording proportion and the relationship between parts and the whole; a comprehensive outline of multiple aspects of composition and key points that should be specifically addressed in relation to theory and application, consideration of compositional variables, and methods for developing the illusion of space and depth on a two-dimensional surface; methods for

understanding and developing line variation; methods for effectively introducing and exploring tonal or value structure; basic spatial and tonal aspects of color as an elaboration of achromatic drawing; scaling techniques for establishing consistent size and placement of multiple forms in a spatial environment; discussion of the Golden Section as an organizational device; and considerations for putting together an effective still life.

Chapter two addresses the application of these basic drawing principles in relation to the human figure, and introduces key information that is specific to studying and drawing the human form. Included are guidelines for classroom etiquette when working with a model; male and female comparative proportions; key considerations in gesture drawing; guidelines for introducing portraiture; the significance of artistic anatomy in the study of the figure; and a comprehensive outline of significant skeletal and muscle information that should be addressed in introducing artistic anatomy to students.

Chapter three addresses technical and freehand perspective with an emphasis on the significance of a perfect cube as the geometric basis for creating a wide variety of forms and structures that define and describe space and volume. Following a discussion of the importance of proficiency in perspective and a list of relevant materials and vocabulary terms, clear and concise instructions are given for one- and two-point cube construction. An understanding of basic cube construction provides the building blocks (quite literally) for in-depth investigations of gridded ground planes; cube multiplication and division; construction of ellipses; inclined planes such as stairways, rooftops, and box flaps; geometric solids derived from cubes; and transparent construction as a method for drawing a variety of cube-based objects. Additional information includes the sequencing of lesson plans to maximize comprehension, the appropriate use of sliding and multiple vanishing points, specific instructions for creating 30°/60° and 45°/45° cubes, and the use of measuring lines for exploring regular and irregular cube division and multiplication. This is followed by an introduction to three-point perspective as a more dramatic elaboration of one- and two-point perspective. Finally, suggestions are offered for in-class and homework assignments that offer more creative opportunities for the exploration of both techinical and freehand perspective.

Chapter four and appendices A and B focus on the aspects of teaching that support and nourish the directed drawing experiences of the classroom. This information acknowledges the fact that there is a great deal involved in teaching beyond direct instruction in the classroom, and that considerable preparation is required in order to adequately meet the continuous challenges—some anticipated and some not.

Chapter four addresses considerations for creating a dynamic classroom environment that is most conducive to teaching and learning, including various techniques for effectively presenting information. The process of critiquing student work is discussed in great depth. A number of different formats or approaches are introduced for conducting a group critique, along with discussion of the significance of group critiques and some of the issues specific to critiquing the work of beginning-level students collectively or individually, which requires special awareness and sensitivity on the part of the instructor. A discussion of the kinds of technical and formal issues that repeatedly surface in foundation-level work provides guidance for identifying and diagnosing

what ails a drawing and what is required to facilitate progress and improvement. Key questions that should be considered while critiquing are provided to help guide the process of identifying strengths and weaknesses. Finally, the often difficult issue of grading is examined, with suggestions for developing a personal philosophy and approach to grading that best serves each individual instructor while acknowledging the need for some general agreement regarding the use of a traditional grading system.

Appendix A addresses much of the preparatory work required prior to actually teaching. A significant amount of the work involves mental preparation, organization, and decision making, much of which must then be translated into written documents and handouts that are passed along to students. Numerous examples of syllabi and other documents for a variety of courses are provided, along with illustrations of student work specific to in-class and homework assignments referred to in the syllabi. Step-by-step instructions for documenting student work in 35mm slide format are included, as well as suggestions for organizing a slide library of student work, which is an invaluable teaching tool.

Appendix B touches on the assortment of information that may be requested of an instructor, and includes guidelines and examples for addressing requests about career opportunities in the visual arts, building a student résumé, instructing students in the art of shooting slides of their work, writing letters of recommendation for both students and colleagues, and answering questions concerning the possibility of pursuing a graduate degree.

Without question, the teacher of drawing embarks on a journey of great challenge, reward, and responsibility. In the preface to his book, *Drawing* (1967), the late Daniel M. Mendelowitz of Stanford University wrote most eloquently about the role of drawing in educating today's artists:

> Drawing has reappeared as one of the cornerstones of art training . . . one that incorporates the attitudes and concepts of the Bauhaus and the inner discipline of modern painting with the meaningful aspects of tradition. Now most colleges, universities, and professional art schools, like the academies of the past, again commence the artist's training with drawing, and while much latitude prevails as to the content and procedures in today's drawing classes, certain convictions seem widely shared. First it is generally agreed that, well taught, drawing establishes a habit that is fundamental to expression in the visual arts, the habit of looking, seeing, and expressing one's perceptions in graphic, painterly, or plastic form. Second, drawing familiarizes the beginner with certain elements of the artist's vocabulary—line, value, texture, form, space—and also color, for even when drawing is limited to black and white, an increased consciousness of color often accompanies the greater awareness of the external world that is experienced when individuals commence to draw. . . . In the final analysis it is the more incisive awareness of the concrete, visual world that is the artist's most precious heritage, and it is stimulated more by drawing than by any other activity.
>
> Whether . . . a professional artist, a student with professional ambitions, or an alert, uncommitted observer with a lively interest in the arts, it is the total engagement of mind with eyes, hands, body, and feelings that will make possible drawing as a genuinely creative act and bring about the taste and judgment essential to artistic growth and enlightened connoisseurship.

Whether you are a graduate student who has been given a teaching assistantship, a newly hired faculty member just embarking on your teaching career, an experienced teacher looking for new ways to introduce information, or an experienced teacher seeking validation and affirmation, *The Art of Teaching Art* has something to offer you. It is the culmination of nearly twenty years of full-time teaching experience and represents my love for teaching and a desire to assist others who recognize the responsibility involved in the role of an art educator.

Chapter *1*

Essential Skills and Information

What Every Teacher and Every Student
Should Know about Drawing

Sighting and the Use of a Sighting Stick

Students often go through the motions of sighting without really understanding what they are doing and why it works. A little understanding of the principles of sighting goes a long way toward encouraging students to use the process to their advantage.

Why Use Sighting?

Many students have found that they are shining stars when it comes to copying photographs or working from other existing two-dimensional sources. They are often confounded when they discover that drawing from observation of three-dimensional forms does not yield the same strong results, the same degree of accuracy they are accustomed to. It is helpful for both the instructor and the student to understand why this occurs.

Drawing or representing a three-dimensional form on a two-dimensional surface requires, in essence, a language translation. The language of two dimensions is different from the language of three dimensions. We must observe the three-dimensional form and translate it into a language that will be effective on a two-dimensional surface, such as a piece of drawing paper. When students draw from an existing two-dimensional source, the translation from 3-D to 2-D has already been made for them. But when they are referring to the actual form, they must make the translation themselves. The process of sighting provides the method for making this translation easily and effectively.

Guidelines for Sighting

A sighting stick is the basic tool for the process of sighting. I recommend using a 10" to 12" length of ⅛" dowel. Suitable alternatives include a slender knitting needle, a

shish-kebab skewer, or a length of metal cut from a wire clothes hanger. Your sighting stick should be straight. I discourage the use of a drawing pencil as a sighting stick simply because the thickness of the pencil often obscures information when sighting. The more slender the tool, the less it interferes with observing the form or forms being drawn. However, in the absence of a more suitable tool, a pencil will suffice.

In presenting sighting principles to a class, it is vital to go beyond a verbal explanation. For students to effectively understand the process, it is strongly recommended that teacher and students walk through the process together, exploring the various ways of applying sighting. It is difficult to demonstrate these techniques to beginners when drawing from a still-life or a live model because everyone in the room has a different view and you cannot compare observations and identify problems or incorrect applications of sighting for the group—this must be done on an individual basis. Using a projected slide of a drawn or photographed still life or figure allows each student a shared view of the same information, and makes demonstration and discussion much clearer. If, for example, you ask students to measure the height of the head of a figure from a projected slide and then determine how many head lengths tall the figure is, everyone should arrive at approximately the same answer if the technique is being utilized correctly. If the answers of some students are significantly different from the rest of the class, you can discuss their process and identify the source of inaccuracies.

It is advisable to explain to students the reasons for initially using projected slides to explore sighting, making sure they understand that sighting from two-dimensional information is much easier than sighting from three-dimensional information because the image has already been translated from 3-D to 2-D. Once you begin exploring sighting in relation to actual three-dimensional forms, students will recognize the increased complexity. At this point, one-on-one assistance helps them to understand the most effective way to problem solve and to approach sighting any given form.

Because the objective of sighting is to translate information into a two-dimensional language, all of your observations will take place in an imaginary two-dimensional plane that is parallel to your face. It is helpful to imagine that a pane of glass is floating directly in front of your face at arm's length. If you are looking straight ahead, the glass is parallel to your face. If you are looking up or down, the glass will tilt along with your head. It is always parallel to the plane of your face. This imaginary pane of glass represents your picture plane or your drawing surface, and all of your measurements and observations will take place in this two-dimensional plane.

Always keep your arm fully extended and your elbow locked when sighting. This establishes a constant scale, which is especially important when you are sighting for relative proportional relationships. You can rotate your sighting stick to the left or right, but you cannot tip it forward or backward. This is especially tempting when sighting forms that are foreshortened. You can reinforce keeping the sighting stick within the 2-D pane of glass by imagining that if you tip the stick forward or backward, you will break the glass. It is helpful to close one eye when sighting, which further reinforces the translation to a two-dimensional language by using monocular vision (one eye) rather than binocular vision (two eyes).

If more than one object, or a still-life arrangement of multiple objects, are to be drawn, you must begin by establishing which object will serve as your POINT OF REFERENCE or UNIT OF MEASURE. Ideally it should be an object that you can see in

its entirety, and that can be visually broken down into at least two observable relationships—height and width (Figures 1–1 and 1–2). When working with the human figure, the head serves as a good unit of measure (Figure 1–3). In instances where the head is not visible or partially obscured, another unit of measure will need to be established.

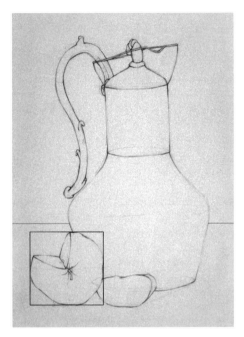

Figure 1–1. Student work. Jennie Barnes. The apple in the foreground of this simple still-life arrangement, boxed in to show relative height and width, makes a good unit of measure.

Figure 1–2. Student work. Jennie Pavlin. The extensions of the beet (root and stalks) are extraneous to the main body of the form, and so are excluded in sighting the height and width relationship.

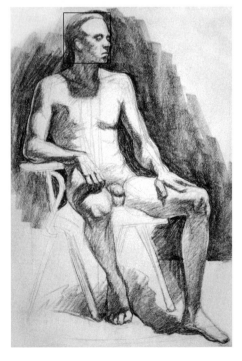

Figure 1–3. Student work. Gypsy Schindler. The head as a unit of measure is sighted from farthest points left to right and farthest points top to bottom.

When sighting, you are often dealing with what I refer to as "landmarks." A landmark is any identifiable point on any form that you can refer back to. It will not necessarily have a name or appear to be a significant part of the form, but it will be an easily identifiable reference point.

Applications of Sighting

There are three essential uses for sighting that aid in observing and recording information accurately. The first deals with relative proportional relationships, the second deals with angles and their relationship to verticals and horizontals, and the third deals with vertical and horizontal relationships between distant points or landmarks.

First Application: Sighting for Relative Proportions

Before beginning the actual sighting process, it is helpful to observe through a viewfinder the form(s) you wish to draw and do a delicate gesture drawing based on what you see. This helps to "break the ice" of a blank piece of paper and gives a sense of how the forms being referred to will occupy the paper surface. (More information on using a viewfinder is given later in this chapter.)

In beginning the actual sighting process, remember that your point of reference should be sighted and drawn first (Figure 1–4). By aligning one end of the sighting stick visually with one part of a form and placing the tip of your thumb on the sighting stick so that it corresponds visually with another part of that form, you are able to make a relative measurement of the distance between any two parts or points on the form. By understanding this simple procedure, you can apply sighting techniques in a number of ways to help you attain greater accuracy in your drawings. When sighting for relative proportions, begin by establishing the relationship between the total width of the object (distance from farthest left to farthest right point) and the total height of the object (distance from highest to lowest point) (Figure 1–5). For example, you can sight the width of a fruit or vegetable or a bottle at its widest point by extending your

Figure 1–4. Student work. Kirk Bierens. The body of the wine glass has been chosen as a unit of measure. Horizontal lines show the height of the unit of measure in relation to the entire still life.

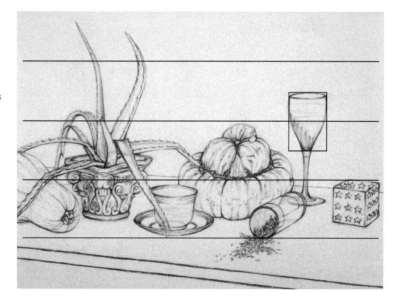

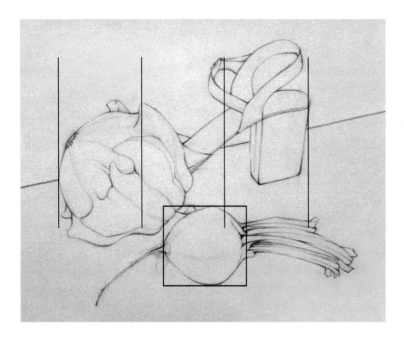

Figure 1–5. Student work. Emily LaBue. The body of the beet is isolated as a unit of measure from the root and the stalks. Vertical lines show the width of the unit of measure in relation to the entire still life.

sighting stick at arm's length and recording the distance from one edge to the other. Keeping your thumb in position on the sighting stick, rotate the stick and observe how many times the width of the form repeats itself in the height of the form. You can then maintain the same relationship in drawing the form, regardless of how large or small you choose to represent it on your drawing surface. It is recommended that you sight what you perceive as the smallest measurement first, and then compare it to the larger measurement. Remember to begin the process with the form that you wish to use as your unit of measure.

Begin to break down the form, if it is more complex, into component parts, sighting the size relationships between different parts. Work from general to specific, observing and recording the larger, simpler relationships before attending to more detailed information. Whenever possible, sight from one "landmark" to another. A landmark indicates any point on a form that you can find or refer back to over and over again. Landmarks usually occur at places where different parts of a form meet or come together (also called POINTS OF ARTICULATION) or where there is a sudden directional change along the edges or surface of a form. Draw the forms using the size relationships that you have observed (Figure 1–6). Sighting can be applied horizontally, vertically, or diagonally. These same size relationships can be observed between a form or part of a form and other forms or their parts. In this way, it is possible to maintain an accurate size relationship between all the parts of a more complex form or between the various individual forms found in a complex still life.

Foreshortening can be especially challenging since it is often recorded with a significant amount of inaccuracy and distortion. This is due to the fact that our experience with forms will often override what is visually presented before us. For example, a bottle lying on its side can present a foreshortened view that measures wider from side to side than it does in length from top to bottom (Figure 1–7). Because of our awareness of the bottle as a form that is generally greater in length than in width,

Figure 1–6. Student work. Sheila Grant. The garlic bulb in the foreground is the unit of measure. Its height in relation to each individual form in the still life is shown. Broken lines indicate half the height of the unit of measure.

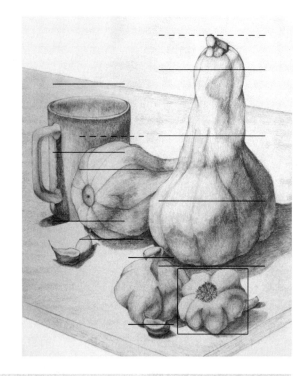

Figure 1–7. Student work (detail). Laura Gajewski. In this foreshortened view, the height and width of the bottle are nearly the same. The height of the bottle would be nearly twice the width if the bottle was not foreshortened.

we bypass what is observed and draw what we know a bottle to look like. This creates problems in presenting a convincing illusion of a foreshortened bottle resting firmly on its side.

While sighting is an ideal way to overcome this inaccuracy, there are a few things to be particularly attentive to. First, make your students aware of the fact that when foreshortening is evident, the apparent relationship between the length and width of forms is altered to varying degrees, depending on the severity of the foreshortening. While the length may appear to "compress" considerably, the width may remain relatively unaltered (Figure 1–8). Second, caution your students against tilting their sighting sticks in the direction of the foreshortened axis. This is easy to do without even being aware of it. If the measurement is no longer being taken in the imagined two-dimensional picture plane, it will not present an accurate translation from the

Figure 1–8. Student work. Ann Drysdale Greenleaf. In this foreshortened figure study, the length of the torso from shoulders to buttocks is significantly compressed, measuring less than half the width of the hips. Due to foreshortening, the legs and feet are not visible at all.

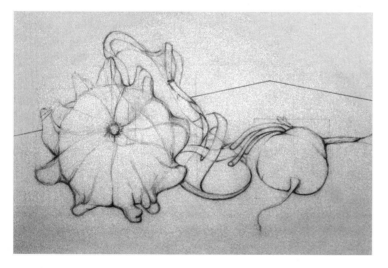

Figure 1–9. Student work. Jennie Pavlin. Note the increased evidence of overlapping in the foreshortened views of the beet and the "crown of thorns" gourd.

three-dimensional form to the two-dimensional surface of the drawing or painting. A final note regarding foreshortening: Be aware that instances of overlapping—where one part of a form meets another part—are more pronounced in a foreshortened view and require greater attention to the interior contours that give definition to this (Figure 1–9).

Second Application: Sighting for Angles and Axis Lines

An axis line is an imaginary line that runs through the core or the center of a form. It indicates the longest or most dominant directional thrust of that form. More complex forms can have more than one axis line, as there may be directional thrusts in a

Figure 1–10. Student work.
Glenda Sue Oosterink. A number of
different axis lines can be found in this
drawing of a seated figure. The angles
of these axis lines are compared to
fixed verticals and/or horizontals.

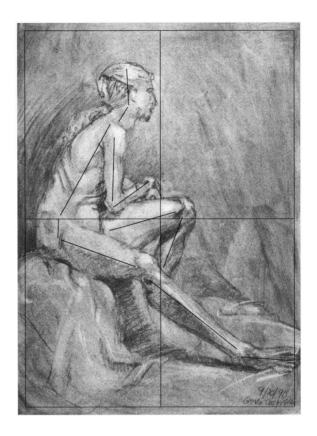

number of directions (Figure 1–10). By determining the correct angle of the axis line, one can then begin to draw the edges and contours of a form around the axis line.

Angles observed on a form may be very obvious (such as the corner of a box or a table) or less obvious (such as the implied angle found along the edge of a shoe). Whether the edge observed is an obvious, straight-edged angle or a less obvious, implied angle, it can be sighted to provide for greater accuracy. Simply align your sighting stick visually along the observed edge or axis (without tipping the stick forward or backward) and observe the relationship between the angle (indicated by the position of your sighting stick) and a true vertical or horizontal, whichever it relates to more closely. When drawing the angle of the edge or axis line, try to maintain the same relationship to a vertical or horizontal that you observed. The left and right edges of your drawing paper provide fixed verticals for comparison, and the top and bottom of your drawing paper provide fixed horizontals for comparison. If you need more guidance, you can lightly draw a few more vertical and horizontal lines through your drawing format against which to compare sighted angles, and these can be erased when they are no longer needed (Figure 1–11).

A second approach can be used to help you correctly record an observed angle. After you have aligned your sighting stick along the edge/angle that you are observing, imagine that the stick is running through the face of a clock and relate it to a specific time of day—one o'clock, ten-thirty, etc. (Figure 1–12). The observed angle can then be duplicated in your drawing, keeping in mind its relationship to the face of the clock.

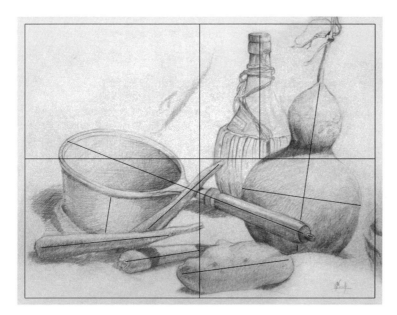

Figure 1–11. Student work. Clarkson Thorp. Both major and minor axis lines are identified in this still life.

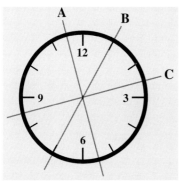

Figure 1–12. Clockface for sighting angles. Angle *A* is at 5:30 or 11:30, angle *B* is at 1:00 or 7:00, and angle *C* is at 2:30 or 8:30.

Third Application: Sighting for Vertical or Horizontal Alignments

Sighting for vertical and horizontal alignments can be applied to a single form (such as the human figure) or to a grouping of forms (such as a still life). This sighting process is closely related to sighting for angles and axis lines, but is used to observe a vertical or horizontal alignment (or a deviation from a vertical or horizontal alignment) that is less apparent, or to observe a vertical or horizontal alignment between more distant reference points. It is useful for observing the correct position of one part of a form in relation to another part or for observing the correct position of one entire form in relation to another entire form.

To seek out these plumb lines or alignments, visually move your sighting stick through a form or grouping of forms and look for two, three, or more major landmarks that fall within a straight line along your sighting stick, forming either a vertical or a horizontal line (Figures 1–13 through 1–17). Once you have observed these alignments, repeat that alignment in your drawing. It is especially useful to observe alignments between more distant points, which are less apparent to the eye than alignments between fairly close points.

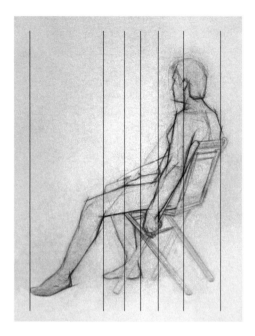

Figure 1–13. Student work. Jacquelin Dyer DeNio. Vertical sight lines pulled through a seated figure show a number of vertical alignments—front of right knee and back of left knee, right wrist and right heel, front of neck and back of left elbow, etc.

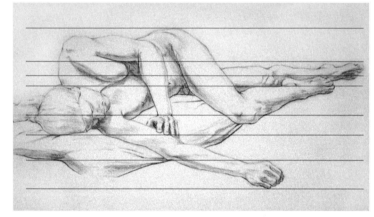

Figure 1–14. Student work. Joshua Ball. Horizontal sight lines pulled through a reclining figure show a number of horizontal alignments— inside edge of left upper arm and upper edge of right foot, upper edge of jawline and upper edge of left lower leg, pony tail and bridge of nose and left wrist, etc.

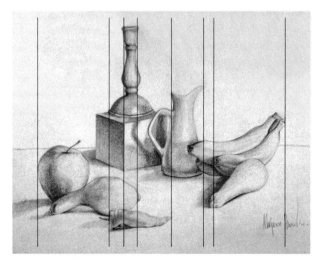

Figure 1–15. Student work. Maryann Davidson. Vertical sight lines pulled through a still life show a number of vertical alignments—left edge of candlestick base and left edge of pepper, right edge of candlestick and right end of gourd, right edge of pitcher spout and right edge of base of pitcher, etc.

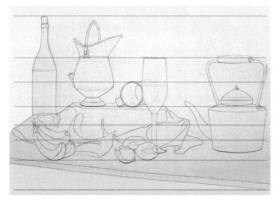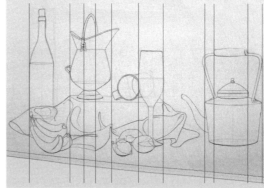

Figure 1–16 and Figure 1–17. Student work. Lea (Momi) Antonio. The same still life drawing is shown with both vertical sight lines and horizontal sight lines, helping to determine relative size and placement of objects in this fairly complex arrangement of forms.

When you observe a vertical or horizontal alignment between landmarks, it is fairly simple to translate this alignment since a vertical or horizontal is fixed or constant. If, however, you observe a diagonal alignment (which could also be considered a deviation from a vertical or horizontal alignment), you must then observe the relationship of that diagonal either to a vertical or a horizontal (whichever it relates to most closely), or to the face of a clock, and maintain that same diagonal alignment in your drawing. Any of these three observed alignments are helpful, but a diagonal alignment must be more carefully translated than a vertical or horizontal alignment because of the increased possibility of error.

The Principles of Composition: Theory vs. Application

Composition is an intricate and complex issue. Whether considering music, literature, theater, or the visual arts, composition plays a significant role from its most basic to its most sophisticated application. A strong and sensitive awareness of composition is vital to the creation of a work that is unified. The way in which the artist expresses concern for compositional devices can make or break a piece of music or literature or visual art. And it is only with a command of composition that an artist can consciously explore alternatives to the generally accepted canons of composition.

It is one thing to understand the concepts behind the development of sound composition, and another thing altogether to be able to apply these concepts successfully. In the classroom compositional principles are often discussed only in abstract or theoretical terms, and exercises in the application of these principles (particularly in a two-dimensional design course) may be limited to the use of abstract elements such as circles or squares or swatches of color or texture. This is a valid approach for the study of composition at an introductory level, but the student of visual arts must also understand the *application* of these principles at a more concrete level. How do these principles apply to a composition involving a still-life arrangement, a portrait study, an urban or rural landscape, a figure in an interior space, a figure in the landscape, or an abstract image?

Bear in mind that a discussion of the principles of composition should broadly address the application of these principles in actual drawings, paintings, sculptures, prints, and mixed-media works that include concrete, recognizable imagery. There are numerous works by masters that provide excellent examples of the principles of composition in practice. In addition to the great Renaissance and classical masters, there are a number of more contemporary artists whose work provides strong and interesting examples of different applications of compositional principles in relation to a variety of subject matters. Consider the work of Edgar Degas, Richard Diebenkorn, Mary Cassatt, William Bailey, Edvard Munch, Martha Alf, Vija Celmins, Claude Monet, Philip Pearlstein, Donald Sultan, and Edward Hopper—to name just a few.

Too often composition is a point of focus in an introductory design class and is neglected as a significant consideration in subsequent coursework, where the emphasis may be on a particular media or technique or subject matter. Make composition an integral part of your instruction at every opportunity—in slide lectures and discussions, demonstrations, critiques, homework assignments, and reading assignments. Theory is one thing, application is another.

Following are some key concepts considered to be basic to the study of composition and its application. Use them as a guideline in discussing, analyzing, and critiquing both student work and the work of recognized masters.

Review of Some Simple Definitions

COMPOSITION: The way the parts of a drawing (the elements) are arranged in the given space. The elements include line, shape, value, form, texture, color, positive space, and negative space (Figure 1–18).

POSITIVE SPACE: The figure(s) or object(s) or tangible thing(s) in a composition. Sometimes an object can be both positive and negative, depending upon its relationship to other forms in the composition.

NEGATIVE SPACE: The "empty" areas; the space that exists between, around, and behind positive forms. Tangible forms may act as negative space to other tangible forms (Figure 1–19).

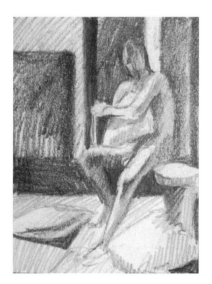

Figure 1–18. Student work. Jamie Hossink. This thumbnail study shows concern for the arrangement and distribution of value, shape, and texture.

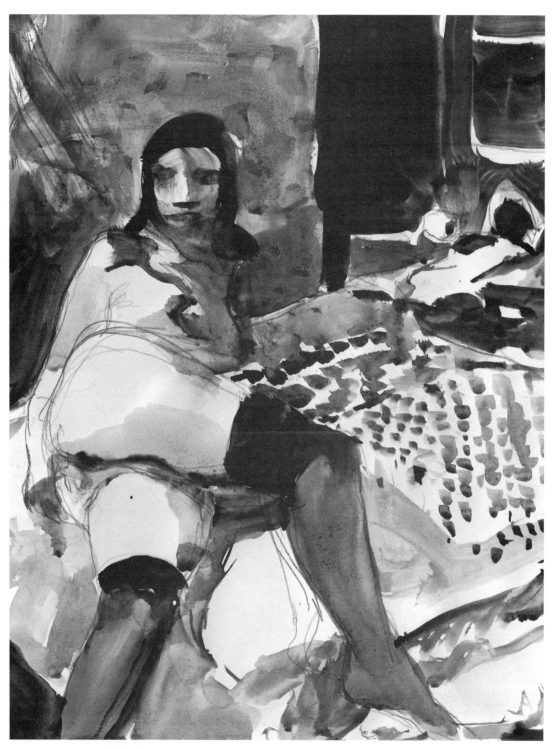

Figure 1–19. Richard Diebenkorn. *Untitled,* 1962. Pen and ink, ink wash, and pencil on paper, 17 x 12-½ inches (43.2 x 31.8 cm). San Francisco Museum of Modern Art. Purchased through anonymous funds and the Albert M. Bender Bequest Fund. Because of Diebenkorn's stacked space, many tangible forms function as both positive and negative space. The bed, for example, is negative space to the figure and positive space to the wall and window behind it.

Figure 1–20. Student work. Gypsy Schindler. Numerous formats are explored in these compositional studies of a still life of keys, scissors, and paintbrushes.

FORMAT: The given space in which a drawing is composed; the relative length and width of the bounding edges of a drawing surface. Format, in part, controls the composition (Figure 1–20).

Using a Viewfinder

- A viewfinder is your window to the world, blocking out visual distractions and helping you to focus your attention on what you are drawing, in much the same way as the viewfinder of a camera.
- It reflects your actual drawing format in the same proportions. For example, an 18" x 24" drawing format is reflected in a 1-½" x 2" viewfinder, each of which has a ratio of 3:4.
- It binds and gives boundaries to your negative space, forming specific shapes and allowing you to observe these shapes outside of and around the major forms that you are drawing (Figure 1–21).
- It provides constant verticals (along the left and right sides) and horizontals (along the top and bottom) against which to compare angles in the forms.
- It enables you to "image" or visualize how the forms will fill or occupy the paper surface.
- It helps you to determine whether a vertical or horizontal orientation of your format is best, depending upon which is most effective in utilizing the entire format and establishing a strong composition (Figure 1–22).
- If you choose to crop your composition closely, it helps you to focus on an isolated passage (Figures 1–23 and 1–24).
- It can be of further assistance to you if you mark ½ and ¼ divisions along the perimeters of the viewfinder, and then lightly repeat the marks on your drawing format (Figure 1–25). This is helpful in locating landmarks in the forms. These divisions help you to make an effective translation of the information observed in the viewfinder to the drawing format.

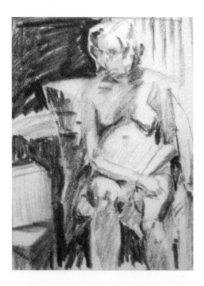

Figure 1–21. Student work.
Kevin Wadzinski. In this thumbnail
study using a viewfinder, note the tonal
emphasis on negative spaces around
the figure, which are defined in part by
the edges of the viewfinder.

Figure 1–22. Student work.
Gypsy Schindler. Even though
the figure is primarily vertical
in this seated position, the stu-
dent chose a horizontal format
to allow for exploration of the
forms in the space around the
figure.

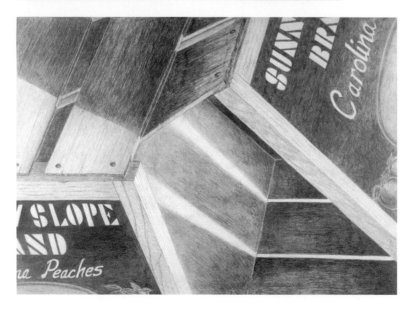

Figure 1–23. Student work,
University of Cincinnati.
Elizabeth Reid. A close-up
view of peach crates provides
an interesting and somewhat
abstract composition.

Figure 1–24.
Deborah Rockman.
Dark Horse #8, 1981.
Black colored pencil
and white charcoal on
paper, 8 x 10 inches.
Private collection.
The human form
takes on a different
character when
aspects of the form
are isolated from the
rest of the body.

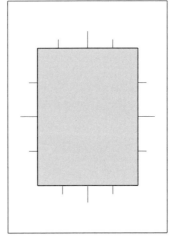

Figure 1–25. The toned area
of the viewfinder indicates the
window or opening through
which you view the subject
you are drawing.

It is important to recognize that your viewfinder is ineffective unless it reflects the same proportional dimensions as the format on which you are going to work. There is a simple way to find the dimensions of a viewfinder for any rectangular format you wish to work on. You can determine the size of the viewfinder window based on the size of the full-size format, or you can determine the size of the full-size format based on the size of the viewfinder. Drawing a diagonal line from one corner to the opposite corner of any rectangular form and extending the diagonal line allows you to then scale the rectangle up or down by building any larger or smaller rectangle that also utilizes the corner-to-corner diagonal (Figure 1–26).

Figure 1–26. The toned area indicates the original rectangle, which has been proportionately reduced and enlarged using a corner-to-corner diagonal.

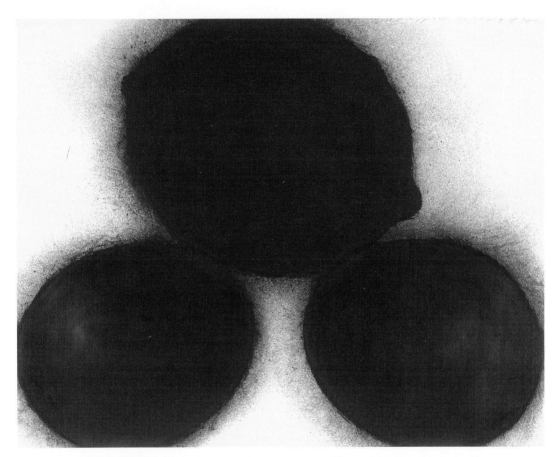

Figure 1–27. Donald Sultan. *Lemon and Eggs March 15, 1989,* 1989. Charcoal on paper, 60 x 48 inches. Courtesy of Knoedler & Company. Collection Richard Rubin. Photograph by Ken Cohen.
The large dark shapes moving off the edges of the composition emphasize the lighter shapes of the negative space.

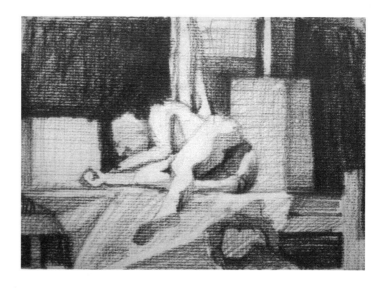

Figure 1–28. Student work. The smaller scale of the figure in this thumbnail study requires that greater attention is paid to the negative space in order to activate the composition fully.

General Guidelines Concerning Composition

Pay Attention to Both Positive and Negative Space

Think of positive and negative space as puzzle pieces locking together, sharing the same edges, dependent upon one another. Would a cup still be a cup without the negative space inside of it?

Consider How the Forms Occupy the Format

The forms can dominate the format in terms of size, which creates a natural division or break-up of negative space into tangible and identifiable shapes (Figure 1–27). Or the forms can be smaller in the format, forcing greater attention to the development or activation of negative space (Figure 1–28).

Watch General Placement of the Forms

- Consider directional thrusts and visual paths of movement—think of them as stepping stones that lead one through the composition. Elements that are similar to each other in some way are visually attracted to one another, creating implied visual paths of movement (Figure 1–29). Provide room in your placement of the forms for movement to occur.
- With the human figure as subject matter, consider psychological directional thrusts—the direction of the gaze of the figure carries visual weight. Consider this in the placement of the figure (Figure 1–30).
- Be aware that similar or like forms are attracted to each other and the eye will move back and forth between them in an effort to join them together (Figure 1–31). How are they distributed throughout your format? What visual path of movement are you encouraging in the viewer?
- Avoid "shared edges." The edge of some portion of a form and the edge of the paper should generally not be the same for any duration, as this creates an ambiguous spatial relationship. Individual forms should not share edges with one another if spatial clarity is desired.

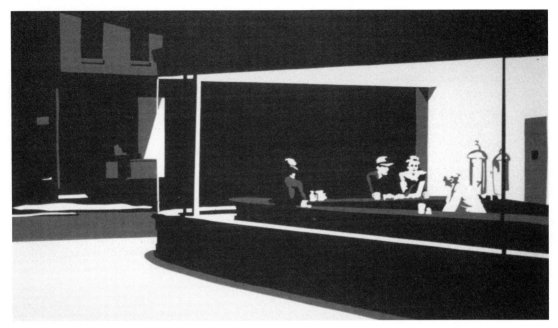

Figure 1–29. Student work (after Edward Hopper). Dave Hammar. The recurring values, rectangular shapes, and vertical elements help to create visual paths of movement.

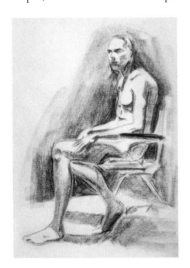

Figure 1–30. Student work. Erik Carlson. One consideration in placing the figure closer to the right side of the page is the visual weight of the figure's gaze as he looks toward the left.

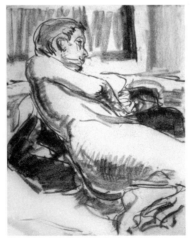

Figure 1–31. Student work. Jack Snider. In this thumbnail study, there is careful considera- tion for the distribution of repeated tones and textures as a way of encouraging visual paths of movement through the composition.

Figure 1–32. Student work.
Michael Moore. The main forms
of this still life are shifted slightly
to the left of the composition to
account for the handles of the
spatula and pans thrusting into
the space on the right.

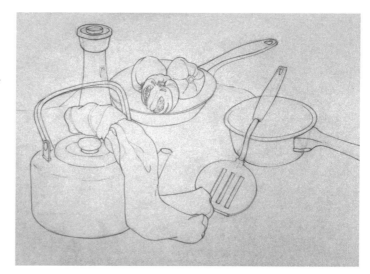

Figure 1–33. Student work.
Emily LaBue. In establishing
compositional placement and
scale of forms, the stalks of the
beet extending to the left in this
simple still life must be consid-
ered in relation to the self-con-
tained nature of the other forms.

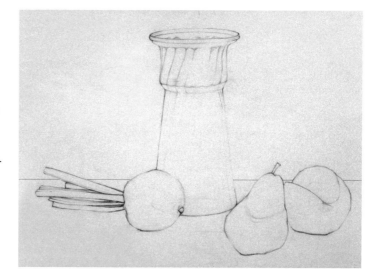

Figure 1–34. Student work.
Jody Williams. In this cropped study
of the figure, notice that no forms
are halved by the edges of the
composition or cropped at a point
of articulation.

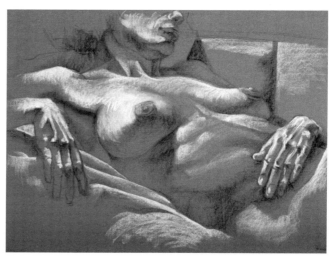

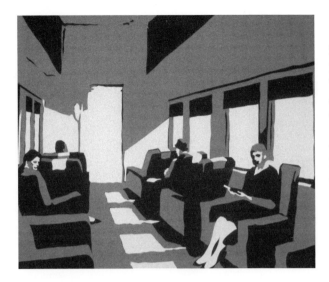

Figure 1–35. Student work (after Edward Hopper). Ralph Reddig. The combination of strong diagonals and vertical elements, which diminish as they recede (creating implied diagonals), pulls the viewer into and through the limited space of the train car interior.

- Consider the outermost contours of forms in terms of sound or movement—quiet vs. loud, active vs. inactive—and give these outermost contours the appropriate amount of room needed for them to breathe and move (Figure 1–32).
- Consider whether the shapes composing the forms thrust out into the surrounding space or remain close to the major mass. How does this affect both placement and scale (Figure 1–33)?
- Avoid cutting your composition in half. Avoid cropping forms at points of articulation (where two parts come together) or cutting forms in half. If cropping, strive for an unequal and dynamic division such as ⅓ to ⅔ or ⅖ to ⅗ (Figure 1–34).

Consider the Kind of Space You Wish to Establish

Consider vertical, horizontal, and diagonal paths of movement (both actual and implied) and be aware of the role they play in establishing different kinds of space in a composition—shallow, deep, ambiguous, etc. (Figure 1–35). When vertical and/or horizontal elements dominate a composition, they reinforce the two dimensionality of the surface being worked on, seeming to move across the picture plane from side to side and top to bottom (Figure 1–36). When diagonal elements dominate a composition, they reinforce the suggestion of depth or space, seeming to move into the picture plane (Figure 1–37).

Consider Viewpoint in Your Composition

Don't assume that the most obvious viewpoint is the best one. Alternative and unusual viewpoints offer visual excitement and an element of the unexpected. Try viewing your subject matter from a position well above or well below the subject matter, looking down or looking up (Figure 1–38). Try viewing your subject matter from off to one side or the other, rather than approaching it from a direct frontal view.

Consider the position or location of your light source, exploring unusual directional light sources. Try lighting your subject matter from below, from the side, from above. Notice how the information changes (especially patterns of light and shadow) based upon direction of the light source (Figure 1–39).

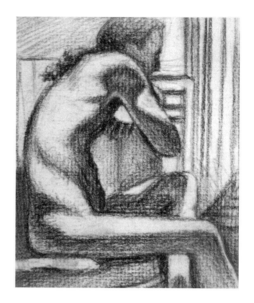

Figure 1–36. Student work. Gypsy Schindler. Even though the figure is a three-dimensional form, the strong repetition of vertical and horizontal elements serves to reinforce the two-dimensionality of the drawing surface in this composition.

Figure 1–37. Student work. Scott Luce. Numerous diagonals in this composition suggest depth or space. The same subject viewed from a different vantage point would provide a number of horizontal elements.

Figure 1–38. Student work. Colin Nuner. Looking down at one's own body provides an interesting and unusual perspective in this nontraditional self-portrait.



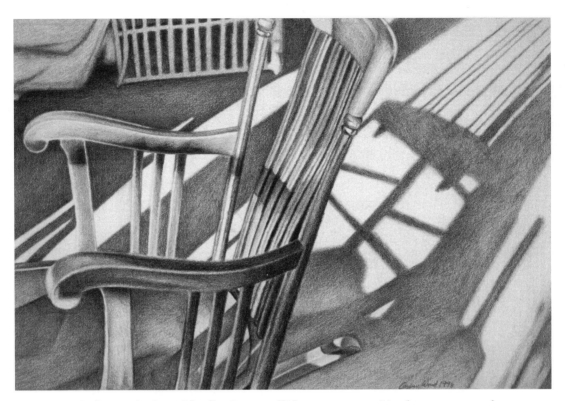

Figure 1–39. Student work. Gypsy Schindler. Because of light source, compositional arrangement, and viewpoint, this drawing is as much about the patterns of light and shadow created by cast shadows as it is about the rocking chair itself.

Consider Options for the Development of Negative Space or Environment
- You can respond to the actual information before you, editing what seems unnecessary for your compositional or expressive needs (Figure 1–40).
- You can respond to the actual information before you as a reference for the simple geometric division of space (Figure 1–41).
- You can develop a nonliteral space, a space that focuses on mood or atmosphere (Figure 1–42).
- You can invent a "real" or literal space or environment based on a working knowledge of perspective principles and scaling methods (Figure 1–43).

Visual Principles of Composition

BALANCE: A feeling of equality or equilibrium in the weight or emphasis of various visual elements within a work of art. Balance can be symmetrical, nearly symmetrical (approximate symmetry), or asymmetrical. Most simply, think of the VISUAL WEIGHT of the elements of line, value, color, shape, and texture.

HARMONY: A consistent or orderly arrangement of the visual elements of a composition forming a pleasingly unified whole. Most simply, think of RECURRING SIMILARITIES in the elements used: recurring line, recurring value, recurring color,

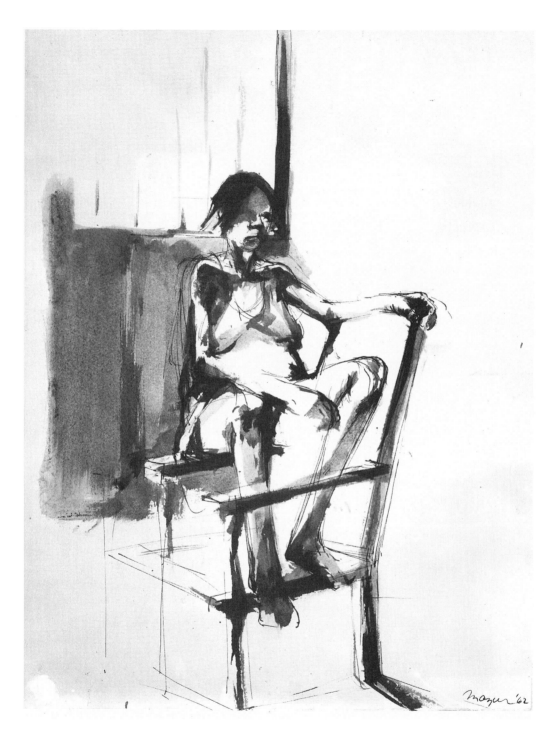

Figure 1–40. Michael Mazur (1935–). *Her Place #2: Study for Closed Ward #12*, 1962. Brush and pen and brown ink, 16-¾ x 13 inches. The Museum of Modern Art, New York. Gift of Mrs. Bertram Smith. Photograph © 1999 The Museum of Modern Art, New York. Mazur maintains a highly simplified negative space to focus our attention on the stark figure of the woman.

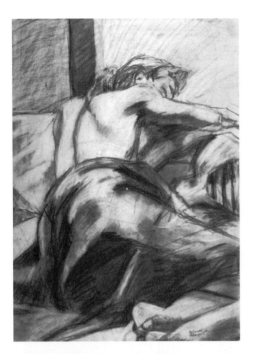

Figure 1–41. Student work.
Andrea Helm Hossink. The negative
space behind the figure is subdivided
into four rectangular shapes in response
to a wall and a small column.

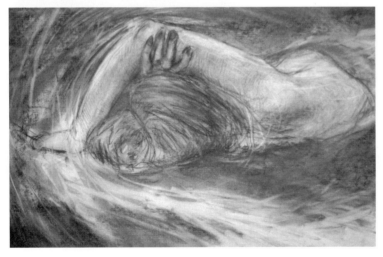

Figure 1–42. Student work,
Moorhead State University.
Kevin Olson. The negative space
around the figure is invented
with the intention of suggesting
water or a fluid-like atmosphere.

recurring shape, recurring texture, and recurring directional thrusts (Figure 1–44).
For creating harmony, consider the use of repetition, rhythm, and pattern.

REPETITION: In repetition, some visual element(s) are repeated, providing step-
ping stones for our eyes to follow.

RHYTHM: Rhythm is the orderly repetition of visual elements, or repetition in
a marked pattern, which creates flowing movement.

PATTERN: A two-dimensional application of rhythm or repetition, such as the
repeated motif in a wallpaper or textile design, results in pattern.

VARIETY: Variety is the compliment or counterpart of harmony, introducing
change, diversity, or dynamic tension to the recurring visual elements of harmony.
Most simply, think of RECURRING DIFFERENCES in the elements used:

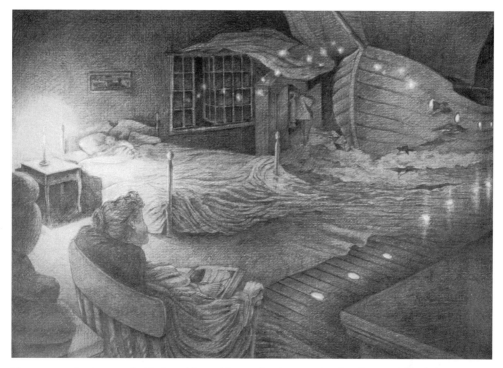

Figure 1–43. Student work. Clarkson Thorp. This student's exceptional understanding of perspective allowed him to invent a spatial, dream-like environment in this investigation of metamorphosis.

differing line, differing value, differing color, differing shape, differing texture, and differing directional thrusts.

EMPHASIS/DOMINATION: The development of focal point(s) created through some form of contrast or difference—contrast of value, contrast of color, or contrast in the degree of development or definition (Figure 1–45).

MOVEMENT/DIRECTIONAL FORCES: The development of primary and secondary visual paths of movement. It is helpful to keep in mind the basic notion that influences our visual priorities. Our eyes are inclined to try to join together things that are the same or similar in some visual way. If there are a number of instances of a particular shape in a composition, our eyes will move back and forth between those repeated shapes in an effort to group or organize or bring them together. The same idea holds true for textures, values, etc. Repetition of similar elements is key to creating visual paths of movement (Figure 1–46).

PROPORTION: Consider the proportion of one compositional element to another: dark values to light values, large shapes to small shapes, rough textures to smooth textures, foreground space to background space, positive space to negative space, near elements to far elements, stable shapes or masses to unstable shapes or masses (Figure 1–47).

ECONOMY: Economy involves the idea of sacrificing detail for the sake of unity. Consider how you are interpreting what you see, particularly in the negative space or background information. You don't have to include everything you see. Whether your interpretation of positive and negative space or background information is

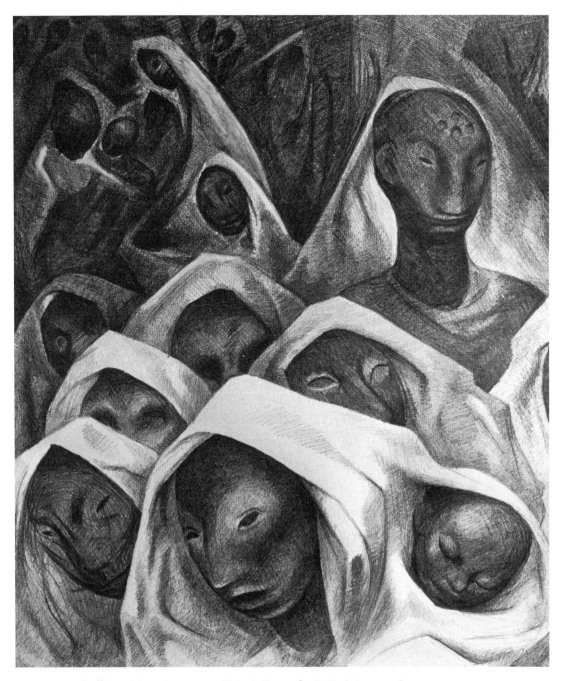

Figure 1–44. Guillermo Meza. *Proyecto para El Exodo (Project for the Exodus),* 1952. Crayon on paper, 23-⅝ x 19-⅝ inches (60 x 49.9 cm). San Francisco Museum of Modern Art. Latin American Fund Purchase. Meza uses recurring shapes and values to reinforce the feeling of an endless and crowded procession of fleeing figures.

Figure 1–45. Student work. Vickie Marnich Reynolds. This drawing investigates four different compositions created by shifting the tonal focal point in each study.

literal (based on actual visual information), or nonliteral (based on invention), consider the option to edit or simplify the composition (Figure 1–48).

UNITY: Very simply, does it all work together?

Variable Compositional Elements to Consider

SIZE: Large or small, long or short, size is relative. For example, a long line appears even longer when juxtaposed with a short line, and a small shape appears even smaller when seen next to a large shape.

POSITION: The primary positions of forms in space are horizontal, vertical, and diagonal. In a given format, the positions of forms can be changed in relation to one another. The relation of one form to another may be parallel, perpendicular, diagonal, oblique, overlapping, end to end, etc. The position of forms can be changed in relation to the total format as well.

DIRECTION: When the position of a form implies motion, it is thought of as moving in some direction. The direction of movement can be up or down, side to side, on a diagonal, toward or away from you, back and forth, over or under, etc.

NUMBER: A single form may be repeated, added to or multiplied any number of times. A form can have one number, or many numbers.

DENSITY: The density of a form is determined by the number of units within its area. The units may be close together or far apart. By increasing the density of a form, we can increase its visual weight or its visual energy. For example, by massing

Figure 1–46. Richard Diebenkorn (1922–1993; American). *Still Life: Cigarette Butts and Glasses,* 1967. Ink, conte crayon, charcoal, and ball-point pen on wove paper, 13-¹⁵⁄₁₆ x 16-¾ inches (36 x 43 cm). © 1999 Board of Trustees, National Gallery of Art, Washington, DC. Gift of Mr. and Mrs. Richard Diebenkorn, in Honor of the 50th Anniversary of the National Gallery of Art. Diebenkorn repeats rectangular shapes of various sizes, oval and round shapes, and slender elongated shapes throughout this still-life study to create a number of primary and secondary visual paths of movement.

a number of lines (units) closely together, a dense shape or form may be implied. If those same lines are spaced farther apart, the density of the implied form decreases—it carries less visual weight.

INTERVAL: The interval is the space between forms. There can be equal intervals, unequal intervals, small intervals, large intervals, progressively smaller intervals, progressively larger intervals, intervals forming a pattern, etc.

PROXIMITY OR NEARNESS: The nearer forms are to each other, the more we group them together. Individual forms can have enough proximity to create a totally new form by their tendency to group together.

SIMILARITY: As forms correspond to one another in shape, size, direction, value, color, texture, or some other characteristic, we perceptually tend to link or pull them together.

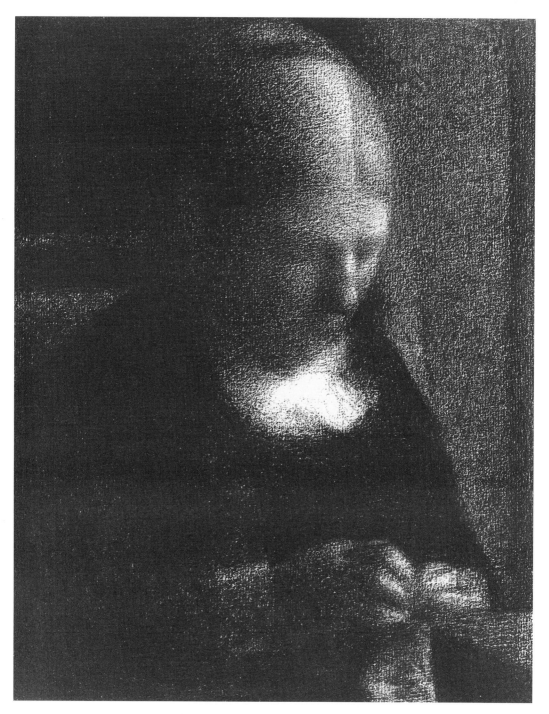

Figure 1–47. Georges Seurat (1859–1891). *The Artist's Mother (Woman Sewing),* 1883. Conte crayon on paper, 12-¼ x 9 ½ inches (32.7 x 24 cm). The Metropolitan Museum of Art, New York. Purchase, Joseph Pulitzer Bequest, 1955. (55.21.1) In this image of the artist's mother, Seurat seems to be considering the proportional relationship of dark to light shapes, large to small shapes, and background to foreground area. The limited areas of strong light on the face, chest, and hands help to emphasize her concentration on the act of sewing.

Figure 1–48. Student work. Jamie Hossink. Keeping the negative space sparse and economical helps to focus our attention on the strong light and dark contrast that gives form to this portrait study.

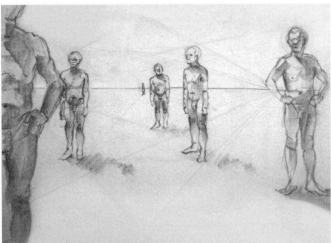

Figure 1–49. Student work. Jody Williams. The graduated size and placement of these standing male figures creates a strong illusion of depth and space.

Suggesting Space or Depth on a Two-Dimensional Surface

SIZE: Large forms suggest nearness, while smaller forms suggest distance. Two objects or forms that are in reality exactly the same size will appear different in size depending on their proximity to us (Figure 1–49).

BASELINE OR POSITION: Baseline refers to the imaginary point at which a form makes contact with a ground plane. The position or spatial location of objects is judged in relation to the horizon line (eye level). The bottom of the picture plane or drawing format is seen as the closest visual point to the viewer, and the degree to which a form "rises" on the page toward the horizon line or eye level indicates

Figure 1–50. Wayne Thiebaud. *Untitled (Lipsticks),* 1972. Pastel on paper, 16 x 20 inches. Courtesy of Allan Stone Gallery, New York City. Thiebaud's study of tubes of lipstick provides an excellent example of shifting baselines as an indicator of the spatial position of forms.

increasing depth or receding spatial positions (Figure 1–50). This relationship is reversed when we are dealing with forms that are floating above the horizon line or eye level. Clouds are a good example of this. As a cloud is positioned lower on the page, closer to the horizon line or eye level, it is perceived as being farther away; as a cloud is positioned higher on the page, farther from the horizon line or eye level, it is perceived as being closer (Figure 1–51).

OVERLAPPING: If one object covers part of the visible surface of another object, overlapping occurs and the first object is assumed to be nearer. The form that is most visible or complete is perceived to be nearer than the form that is partially hidden due to overlapping. Keep in mind that overlapping can contradict the spatial indicator of diminishing size (Figure 1–52).

SHARP AND DIMINISHING DETAIL: Close objects appear sharp and clear in definition, while objects at great distances appear blurred and lacking in definition, focus, and detail. Close objects will reveal more texture, while distant objects appear to have less texture. Close objects will reveal a fuller value range (higher contrast), while distant objects will reveal a limited value range with a reduction in strong darks and strong lights (low contrast). High contrast advances, while low contrast recedes. This is related to the concept of ATMOSPHERIC PERSPECTIVE (Figure 1–53).

Figure 1–51. Deborah Rockman. *Skyscape #1, 1990.* Oil pastel on gessoed paper, 32 x 50 inches. Private collection. Contrary to forms on the ground plane, clouds or any forms that are above our eye level are considered farther away as they approach the bottom of a composition and are considered nearer as they approach the top of a composition.

Figure 1–52. Student work. Clarkson Thorp. The many instances of overlapping in this still life help to reinforce the sense of depth. Note that there are many examples of spatial contradiction as smaller forms repeatedly overlap larger forms.

43

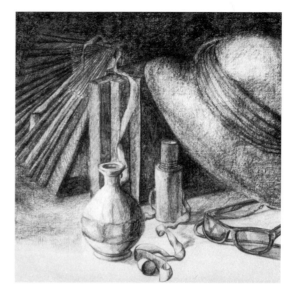

Figure 1–53. Student work. Movement into the composition progresses from full tonal structure in the foreground to greatly reduced tonal structure in the background.

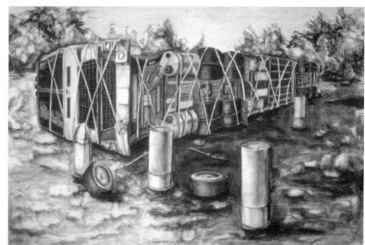

Figure 1–54. Student work. Craig Pennington. The converging parallel edges of this two-point perspective view of a truck strengthen the illusion of depth in this drawing.

Figure 1–55. Student work. John Douglas. The illusion of depth and volume in this drawing creates plastic space.

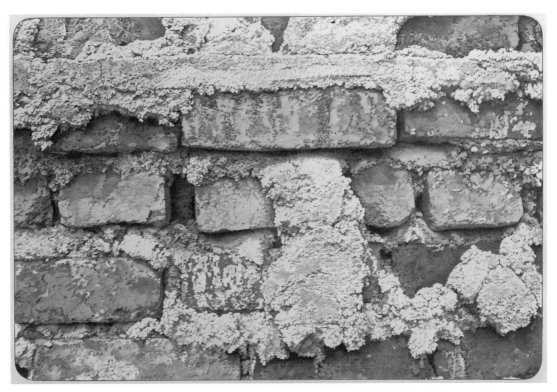

Figure 1–56. Robert Rohm. *Untitled,* 1975. Graphite on paper, 19 ¾ x 26 ½ inches. Collection of The Whitney Museum of American Art. Gift of Dr. Marilynn and Ivan C. Karp. (75.50) Photograph by Geoffrey Clements. In Rohm's exquisitely rendered drawing of a weathered brick wall, there is little sense of movement beyond the picture plane, creating shallow space.

CONVERGING PARALLELS: Any set of parallel lines (a railroad track, for example) will appear to converge or meet as the lines move back in space and away from the viewer toward the horizon line. This idea is closely related to LINEAR PERSPECTIVE (Figure 1–54).

LINEAR PERSPECTIVE: A geometric/mathematical system used for converting sizes and distances of known objects into a unified spatial order, consistent in scale, and assuming a view from a single, fixed position at a particular moment in time. (Linear perspective will be discussed more thoroughly in chapter three.)

Different Kinds of Space

DECORATIVE SPACE: A depthless surface or a space that exists across the picture plane rather than into it. Distances between images or elements can be measured across the picture plane. It is essentially two-dimensional space.

PLASTIC SPACE: A space which seems to extend beyond the surface of the picture plane by creating the illusion of depth and volume. Images or elements have relationships in depth as well as in length and width. It is essentially the illusion of three-dimensional space (Figure 1–55).

Figure 1–57. Georges Seurat. *Place de la Concorde, Winter*, c. 1882–1883. Conte crayon and chalk on Michallet paper, 23.5 cm. x 31.1 cm. (9-¼ x 12-¼ inches). Solomon R. Guggenheim Museum, New York. Gift, Solomon R. Guggenheim, November 14, 1941. Photograph by Robert E. Mates ©The Solomon R. Guggenheim Foundation, New York. (FN 41.721) Even with the strong presence of vertical and horizontal elements in this winter scene, Seurat's use of implied diagonals and atmospheric perspective suggests deep space.

SHALLOW SPACE: Sometimes called "limited depth" because the artist controls the visual elements so that no point or form appears to move beyond the picture plane or surface. Shallow space can be compared to the restricted space of a box or a stage (Figure 1–56).

DEEP OR INFINITE SPACE: An illusion of space that has the quality of endlessness found in the natural environment; also referred to as "atmospheric perspective" (Figure 1–57). Size, position, overlapping images, sharp and diminishing detail, converging parallels, and perspective are traditional methods of indicating deep space.

The Spatial and Volumetric Effects of Color

VALUE AND SPACE: Any light colors (light in value) on a dark ground will advance or come forward according to the degree of lightness of value. On a light ground, this effect is simply reversed—colors of a light value recede and colors of a dark

value advance, according to their degree of lightness or darkness. It is always important to determine which colors are acting as the ground against which other colors interact.

TEMPERATURE AND SPACE: Among cool and warm colors of equal value, the warm colors will advance and the cool colors will recede. If value contrast is also present, the spatial effects will be increased, decreased, or canceled out accordingly.

INTENSITY AND SPACE: Differences or contrast in the purity or intensity of colors also affects spatial properties. A pure color advances relative to a duller color of equal value, but if value or temperature contrasts are also present, the spatial relationships shift accordingly.

One must also consider the role that other spatial indicators play, independently of the presence of color. The presence of overlapping, size variation, position on the page (baselines), sharp or dull focus, detail, and texture can support or contradict the role of color in suggesting space.

When a form is to be modeled or shaded to suggest volume and dimension, the spatial properties of color (chromatic) may be used to enhance the sense of volume and dimension. VALUE, TEMPERATURE, INTENSITY, and TEXTURE play a significant role in establishing volume and dimensionality when using color. The following are good general guidelines to communicate to students, with the reminder that there are always exceptions.

VALUE AND VOLUME: Darker colors are used to define areas in shadow, and lighter colors are used to define areas that are illuminated or in light.

TEMPERATURE AND VOLUME: Cooler colors are used to define areas in shadow, and warmer colors are used to define areas that are illuminated or in light.

INTENSITY AND VOLUME: Dulled and low-intensity colors are used to define areas in shadow, and bright, high-intensity colors are used to define areas that are illuminated or in light.

TEXTURE AND VOLUME: Reduced texture is used in applying colors used to define areas in shadow, and greater texture is used in applying colors used to define areas that are illuminated or in light.

Line Variation and Sensitivity

First Things First: Medium and Surface

When thinking about line quality and line sensitivity, some of the first factors that should be taken into consideration are MEDIUM and SURFACE. What medium is being used and to what surface is it being applied? Different media respond in a variety of ways depending upon the surface employed and the technique used in applying the media.

What Is Meant by "Sensitive" Line?

SENSITIVE: Having the power of sensation; ready and delicate in response to outside influences; able to register minute changes or differences; degree of responsiveness to stimuli; having power of feeling; of such a nature as to be easily affected.

Figure 1–58. Student work. Jody Williams. The weight and value variation of line in this straight-line study of the figure suggests an overhead light source.

Sensitive line is sensitive in its description of and response to both inner and outer contours or edges of a form. If desired, sensitive line is able to register minute changes or differences found along the contours or edges of a form. Sensitive line is responsive to both subtle and not–so–subtle activity found along the contours or edges of a form. Sensitive line has the power to convey a strong sense of volume, mass, form, weight, dimensionality, and feeling.

Sensitive line, in addition to its responsiveness to the form being described or interpreted, is also sensitive in its own right, independent of subject matter. Whether it addresses a particular form or exists independently, it can display various qualities— textured or smooth, dark or light, continuous or broken, curvilinear or rectilinear, heavy or delicate, thick or thin.

The quality of line is determined by the artist's response to the medium being used, the surface on which the medium is being applied, and the subject matter or form with which the artist is concerned.

Achieving Line Variation and Line Sensitivity

Line as used by artists to indicate the boundaries and edges of forms is the oldest known method for depicting both animate and inanimate forms. Paleolithic cave paintings provide us with evidence of early humans' use of line in their description of the various animals they hunted for food, clothing, and tools. Lines vary tremendously in character, and each type of line has its own expressive potential.

There are no specific formulas for achieving line quality and sensitivity. The kind of line employed by the artist to depict a particular form is a decision based on the artist's personal response to the form, and that response is undoubtedly influenced by a multitude of factors.

Listed below are some examples of various ways to approach the development of sensitive, descriptive line as it concerns itself with the edges or contours or surface of a form. The examples focus on the development of tonal or dimensional line, which through its changes suggests form, volume, and/or space.

Figure 1–59. Student work. Clifford Towell, Jr. Weighted line along the model's left leg and left elbow reinforces these as areas where the model's weight is supported. Line work is lighter and more delicate at the bent knees to suggest the stretching and thinning of the skin as bone and muscle strain against the surface.

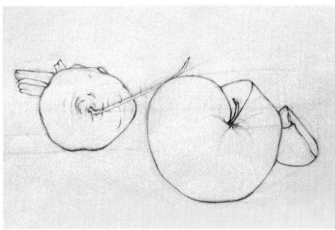

Figure 1–60. Student work. Jennie Barnes. The line along the contour where the apple and beet rest on the ground plane is darkened to indicate contact with another surface. The point of contact of the stem with the apple is also emphasized through darker line.

Light and Dark or the Illumination of a Form

This can include concern for both the effects of an actual light source or an imagined light source. Edges bathed in shadow may be depicted with a darker, heavier line, and edges washed in light may be depicted with a lighter, more delicate line (Figure 1–58).

Weight and Tension in a Form

This method concerns itself not only with the actual weight of forms as masses in space, but also with surface tension resulting from internal or structural activity. In relation to the human form, for example, the effects of the skeletal structure and musculature on surface form are considered. Where weight is supported, a darker or heavier line can be used. The point or edge where one form rests on or presses against another form can be emphasized through a darker or heavier line. When the underlying structure of the figure (bone or muscle) pushes or strains against the containment of the

Figure 1–61. Student work. Clarkson Thorp. Slower contours, where directional changes occur or where different edges meet, are described with a darker line that reinforces the volume of the forms.

Figure 1–62. Student work. Jody Williams. Slower and faster contours of the figure are indicated by darker and lighter lines respectively.

skin, a lighter or more delicate line can be used to suggest the "stretching" and "thinning" of the skin, whereas a more flaccid area may be suggested by the use of a heavier or darker line (Figures 1–59 and 1–60).

The "Speed" of Contours and Edges

The quickness or slowness with which an edge or contour seems to move in space is to be considered and influences the kind of line used to describe that movement. If one thinks of the contours as a path or roadway being traveled, contours that require more careful negotiation because of complexity (slower contours) would be suggested by an appropriately darker or heavier line; contours that do not require such careful

Figure 1–63. Student work. Rene Adrian Rogers. In this combined contour and cross-contour study of the figure, surfaces or edges that dip toward the major mass of the body are darkened according to the strength of the dip, and surfaces or edges that swell away from the major mass of the body are lightened accordingly.

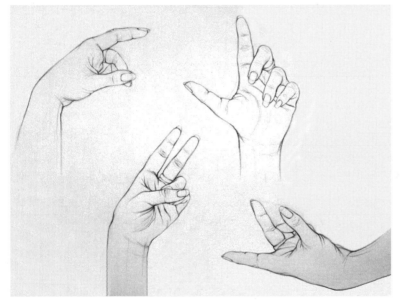

Figure 1–64. Student work. Lea (Momi) Antonio. The delicate lightening and darkening of line work in this page of hand studies suggests the richness and subtlety of contour and surface variations in the hands.

negotiation (faster contours) would be suggested by an appropriately lighter or more delicate line (Figures 1–61 and 1–62).

High and Low Points in the Contours of a Form

This process, very simply, suggests that as contours dip into or toward the major mass of a form (depressions), they theoretically move away from light and into shadow, and can be suggested through use of a darker or heavier line. Conversely, as contours swell away from the major mass of a form (projections), they theoretically move away from shadow and into light, and can be suggested through use of a lighter or more delicate line. One can also think of a depression into the form as a more flaccid edge, suggesting darker line work, and a projection out of the form as a more taut or stretched edge, suggesting lighter line work (Figures 1–63 and 1–64).

Figure 1–65. Student work (after Albrecht Dürer). Amy Allison. The range of stronger and weaker edges or contours found in the face are explored by working with a variety of factors—hard, medium, and soft drawing material; increased and decreased pressure on the drawing tool; and shifts from the tip of the drawing tool to the side of the drawing tool.

Figure 1–66. Student work. Kirk Bierens. Both firm and delicate edges are described with great sensitivity in this simple still-life arrangement of a human-made and a natural form. The side of the drawing pencil is used quite effectively in describing the especially delicate contours found in the interior of the gourd.

The Strength or Force of an Edge

When using line to define and describe edges, it is vital to recognize that not all edges are equal in strength or force. Most exterior edges, like the outermost edge of a bulb of garlic or the outermost edge of the human figure, are firm and definite. They are the result of a form meeting negative space. But other edges, typically found in the interior of a form, can range from firm to fairly gentle to extremely delicate, and the line work used to describe these edges must reflect this difference. Think of the delicate edges found on the interior of a garlic bulb as the surface curves and undulates. Think of the delicate edges found on the interior of the human form based on the ripple of muscles or tendon, the delicate projection of a bony landmark, the hollows in the neck or buttocks. When describing a more delicate or tentative edge, it is important to vary not only the tone of the line, but the thickness and clarity as well. Changing one's grip on the drawing tool and favoring the side over the point of the tool provides a way of gently building up a softer, lighter, and less focused line, which

Figure 1–67. Student work. Chris Schroeder. Because the hands of the model and the book recede in space, the line work used to describe them is narrower in tonal range, moving toward the lighter end of the value scale to more closely identify these receding forms with the light value of the background or negative space.

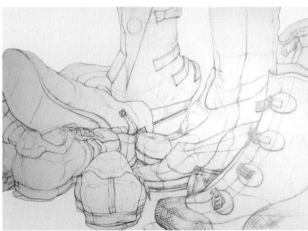

Figure 1–68. Student work. Laurie Rousseau. The shoes in the foreground are drawn using a broader tonal range in the line, while the shoes positioned farther from the picture plane are drawn using a limited tonal range.

is very capable of describing more delicate interior edges. The combination of strong, crisp lines and soft, unfocused lines greatly enhances the sense of dimension and volume (Figures 1–65 and 1–66).

The Spatial Sequence of Forms

This applies not only to the spatial relationships between various forms, but also to the spatial relationships found within a single form that is volumetric or three-dimensional. On a light drawing surface, darker lines advance or come forward and lighter lines recede or move back in space. This relationship is reversed on a dark drawing surface. Using a full range of value in lines used to describe forms, one can suggest full volume and a clear separation between foreground, middle ground, and background (Figures 1–67 and 1–68).

Figure 1–69. Henri de Toulouse-Lautrec (French, 1864–1901). *Le Pere Cotelle (The Lithographer),*
c. 1893. Charcoal with red and blue crayons. 20 x 13-⅝ inches. Collection of The Art Institute of
Chicago. Gift of Mr. and Mrs. Carter H. Harrison. 1933.880. Photograph © 1999, The Art Institute
of Chicago. Through the use of heavier and more emphatic line work to describe the figure in this
drawing of a lithographer, Lautrec focuses our attention on the man.

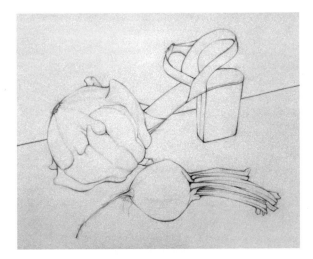

Figure 1–70. Student work. Emily LaBue. The line variation in this still-life study shows concern for a variety of factors, including light source, speed of contours, delicate and firm contours, and weight distribution.

Figure 1–71. Student work. Michelle Velez. Although this study of the skeleton remains in progress, line variation begins to emphasize light source, points of articulation, weight distribution, speed of contours, etc.

Degrees of Importance

This method implies the development of focal points in a composition through greater development of line. Areas of greater or lesser importance are described to a greater or lesser degree through line, creating dominant passages in a composition, or focal points (Figure 1–69). The decision to lend greater or lesser importance to a particular area is a subjective one based on the artist's personal response.

Combining Different Methods

Although discussed individually, the above methods for achieving line sensitivity and variation need not necessarily be considered separately in their application. Various methods can be combined and made to work together depending on the needs and desires of the artist (Figures 1–70 and 1–71).

Figure 1–72. Student work.
Jennifer Malleaux-Schut.
This figure study serves as an
example of cross-contour line
as surface analysis.

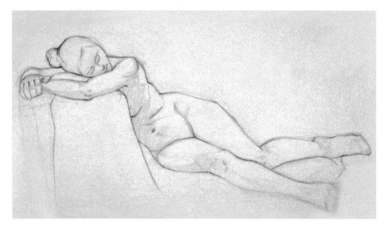

Figure 1–73. Student work.
Janelle Songer. This figure study
shows the delicate and precise
character of classical line.

There will be instances when consideration for one method, such as the effects of
light source, will conflict with consideration for another method, such as speed of con-
tours or weight and tension. In situations where one consideration would suggest the
use of lighter line, and another consideration would suggest the use of a darker line,
one must simply decide which consideration seems most important, and apply line
variation accordingly.

Different Kinds and Functions of Line

CONTOUR LINE: Contour line is a single line, deliberately and slowly executed. It
defines edges—edges of planes as well as interior and exterior edges. There is typically
no erasure work or correction in pure contour line. BLIND CONTOUR indicates that
one looks only at the subject being drawn, and not at the paper. The work of Henri
Matisse and Pablo Picasso provides some good examples of simple contour line.

MODIFIED CONTOUR LINE: Modified contour line allows one to draw a bit more
quickly, with only occasional glances at the drawing surface to monitor propor-
tions, still focusing primarily on the subject being drawn.

Figure 1–74. Student work. Greg Nichols. This linear composition of hand studies is especially attentive to anatomical factors, such as the heads of the metacarpal bones and the phalanges (knuckles), the styloid process of the radius (wrist bone), the tendonous extensions of muscle on the back of the hand, and the thenar and hypothenar muscles of the hand.

CROSS-CONTOUR LINE: Cross-contour lines describe an object's surface *between* edges. Rather than following the edges of planes, cross-contour lines move from side to side *across* planes, describing dips and swells and surface changes, and enhancing the sense of volume and dimensionality (Figure 1–72). Henry Moore's drawings provide good examples of cross-contour line.

CLASSICAL LINE: Rooted in classical art, classical line is disciplined, restrained, and precise. It is typically crisp and delicate in character, lacking significant variation in value or weight. It usually focuses on exterior contours with minimal description of interior information and yet is capable of evoking a strong sense of volume and form (Figure 1–73). The drawings of Jean-Auguste-Dominique Ingres provide excellent examples of classical line.

ANATOMICAL LINE: Anatomical line strongly denotes the presence of the internal or underlying structure of a form. Most often used in reference to the human figure, it suggests the presence of structural or anatomical factors such as skeletal structure or muscle structure, which directly or indirectly influence the appearance of the surface of the figure (Figure 1–74). Anatomical line is sometimes called structural line, referring to underlying structure as opposed to planar form, which is described below in the definition of structural line. The figure drawings of Alex McKibbin and Egon Schiele provide good examples of anatomical line.

ORGANIZATIONAL LINE: Organizational lines act as the underpinnings of a drawing, and are most often absorbed into the finished work without being especially evident in the end result. Organizational lines can include axis lines indicating the major and minor directional thrusts of a form, and lines indicating spatial relationships between foreground, middleground, and background forms.

Figure 1–75. Alberto Giacometti. *Still Life,* 1948. Pencil on paper, 19-¼ x 12-½ inches. Collection of the Modern Art Museum of Fort Worth. Gift of B. Gerald Cantor, Beverly Hills, California. © 1999 Artists Rights Society (ARS), New York/ADAGP, Paris. Giacometti's drawings, both figurative and nonfigurative, consistently utilize organizational line as an integral and visible element.

Organizational lines are a construct, not actually existing to be directly observed. Alberto Giacometti's work, however, relies strongly on the enduring presence of organizational line as an integral part of his figurative and nonfigurative drawings (Figure 1–75).

STRUCTURAL LINE: Structural line reveals the structure of a form by describing the various planes that make up the form. Line can describe the edges of planes (contour line), with structural line added to indicate the main directional thrusts of these planes, enhancing the sense of volume and dimensionality. When clustered together, structural lines can also describe value or tonal structure (Figure 1–76). The drawings of Robert Smithson and Christo provide some good examples of structural line.

Figure 1–76. Student work (after Vincent van Gogh). Gypsy Schindler. The use of structural line in this study of a drawing by van Gogh reinforces the directional thrust of a variety of planes while also creating tonal structure.

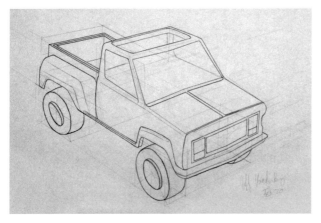

Figure 1–77. Student work. Jeff VandenBerg. Mechanical line is employed in this transparent construction study of a truck seen in two-point perspective.

MECHANICAL LINE: Mechanical line is objective as opposed to subjective, and remains constant in character, without significant changes in width or value or texture. Its most obvious application would be found in the field of architecture, in architectural blueprints, or in other kinds of technical drawings (Figure 1–77). The drawings of Stuart Davis and Sol LeWitt provide examples of mechanical line.

ANGULAR LINE: Angular line can be used to develop a precise definition of contours that are not typically considered to be angular in nature. It employs the use of a series of straight lines to interpret a curved edge or contour, without the straight lines being particularly dominant in the end result (Figure 1–78). The visual result provides a sense of full and descriptive contours. Some drawings by Oskar Kokoschka, Henri de Toulouse-Lautrec (Figure 1–79), and Pablo Picasso provide examples of the use of angular line, and an examination of any number of historical or contemporary drawings will reveal additional examples.

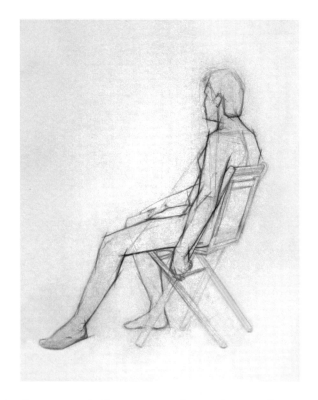

Figure 1–78. Student work. Jacquelin Dyer DeNio. The use of angular line in this study of a seated figure is especially helpful in defining subtle directional changes in both interior and exterior contours.

DECORATIVE LINE: Decorative lines are typically more curvilinear than rectilinear, and are generally rooted in interpretation rather than objective observation. They convey a sense of spontaneity, ease, and relaxation, moving gracefully and fluidly across the page. The drawings of Henri Matisse and Pierre Bonnard provide some good examples of decorative line.

CALLIGRAPHIC LINE: Calligraphic line resembles handwriting and makes use of fluid, continuous movement. Eastern artists developed the art of calligraphy, in which the tool, media, surface, and technique are all considered equally important, with ink, brush, and paper being used in both contemporary and traditional calligraphy. The calligraphic line explores extremes of thick to thin, heavy to delicate, long to short. The work of Japanese artist Hokusai provides excellent examples of calligraphic line in drawing.

BROKEN OR IMPLIED LINE: Relying on the principle of CLOSURE (a perceptual phenomenon in which the viewer participates by visually filling in the "missing information"), broken or implied line is the mere suggestion of an edge or contour as opposed to the explicit definition of an edge or contour (Figure 1–80). The use of broken or implied line creates an "open" shape (as opposed to a "closed" shape), allowing a free exchange between positive and negative space. The drawings of Rico Lebrun and Egon Schiele provide some good examples of broken or implied line.

ALTERED LINE: Characterized by a reworking of line, altered lines are smeared, rubbed, blurred, softened, or erased to create an imprecise line. Subjective in nature, altered lines are capable of conveying motion or movement or a sense of ambiguous form or space, because of their imprecision (Figure 1–81). The drawings of Larry Rivers and Michael Mazur provide good examples of altered line.

Figure 1–79. Henri de Toulouse-Lautrec (French, 1864–1901). *The Model Nizzavona,* c. 1882–1883. Charcoal, 61 x 47 cm. Collection of The Art Institute of Chicago. Gift of Mr. and Mrs. Carter H. Harrison. 1933.881. Photograph © 1999, The Art Institute of Chicago. Lautrec's drawing of a seated male figure shows a number of passages that utilize angular line to describe the movement of contours. Note especially the model's right foot, left knee, and right arm and hand.

Figure 1–80. Student work.
Broken or implied line is utilized in
those areas where the contour is not
engaged in significant directional
changes or overlapping—the model's
right thigh, right lower leg, left
shoulder, etc. Some areas, such as
the hands, are undeveloped and not
representative of an intentional use
of implied line.

Figure 1–81. Student work.
Jason Roda. Erasers are used
to shift, smear, blur, and soften
nearly all the line work in this
drawing of anthropomorphized
clothing.

AGITATED OR ANGRY LINE: Characterized by irregular or choppy strokes, agitated
or angry line conveys a sense of agitation, anger, tension, or a similarly negative
emotion (Figure 1–82). Rooted in subjective interpretation rather than objective
observation, and considered the opposite of decorative line, agitated or angry line
should be reserved for a fitting subject. The drawings of George Grosz and Ben
Shahn provide good examples of agitated or angry line.
PROCESS OR SEARCHING LINES: Process lines or searching lines refer to the pres-
ence of the initial marks made by the artist in seeking out the correct or "true"

Figure 1–82. Mauricio Lasansky. *The Nazi Drawings #26*. Lead pencil, water-based earthcolor, brown turpentine base, 45-½ x 43 inches. The University of Iowa Museum of Art and Richard S. Levitt Foundation, Des Moines, Iowa, © The Lasansky Corporation—all rights reserved (369.1972). Lasansky's drawing of a child-victim of the Holocaust utilizes line work that appropriately conveys agitation and tension.

edges and contours of a form (Figure 1–83). They are often considered to be mistakes by beginning drawers and are erased, leaving only a single line to describe an edge or contour. If delicate process or adjustment lines are selectively allowed to remain visible to the viewer, they can add much vitality and life to a drawing and convey a strong sense of the process and search involved in drawing. Numerous examples can be found in both historical and contemporary drawings.

Figure 1–83. Student work. Mary Evers. Process lines in this figure study show evidence of the search for proportion, placement, and contour changes.

TONAL OR DIMENSIONAL LINE: Although addressed here as an individual kind of line, tonal or dimensional line is frequently an integral part of other functions of line previously discussed, and is particularly important in conveying a sense of dimension through line. Variation of the line, specifically in the tone of the line (light and dark), the width of the line (thick and thin), and/or the weight of the line (heavy and light), is required. This variation can include changes in texture, focus, continuity, degree of forcefulness, etc., and in its variation can address a wide range of concerns based on the artist's response to the information at hand. Tonal line, as it explores the contours and edges of form, can respond to the effects of illumination or light source, to the strength or force of an edge, to the peaks and valleys of form, to weight and/or tension, to the speed of contours and edges, to the spatial sequence of forms, or to a combination of these factors (Figures 1–84 and 1–85).

Working with Value Structure

A General-to-Specific Approach to Building Value Structure

Often, when an inexperienced drawing student begins to address value structure or tonality in his or her drawing, there is a tendency to focus first on detail and the darkest areas of shadow, regardless of the subject matter. This can result in a very spotty and uneven drawing, with no sense of the underlying geometric structure of the forms upon which detail is based. The human head, for example, can be simplified into a

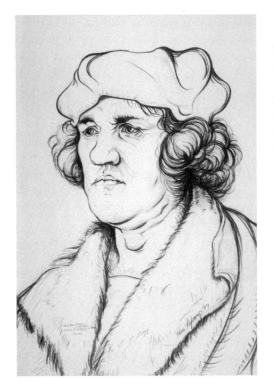

Figure 1–84. Student work (after Hans Burgkmair the Elder). Kerre Nykamp. This study of a master's portrait drawing utilizes a broad range of tonal changes in the line work, which supports the illusion of dimensionality even in the absence of shading.

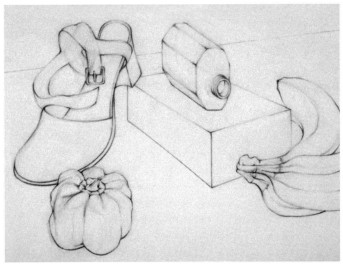

Figure 1–85. Student work. Laura Gajewski. This still-life study relies on variations in the tone and sharpness of line to describe many different kinds of contours and edges.

basic egg-like shape, but it is the detail of the individual features that often first catches the eye. Regardless of how accurately the features themselves may be represented, if they do not relate correctly to the basic shape of the head, then a likeness is unlikely. If darkest values are addressed initially, the subtleties of tonality and form may be lost.

Utilizing a general-to-specific approach can help to keep the drawing unified and coherent, and allows for much more adjustment, when necessary, as the drawing is developed. A general-to-specific approach allows for a well-orchestrated drawing, with all parts working together in a cooperative and complementary fashion.

Figure 1–86. Student work. Sharon Wissner-Tabaczka. Studying the folds of drapery provides a great opportunity for developing a general-to-specific tonal range. This drawing shows a variety of stages of tonal development using a general-to-specific approach.

Figure 1–87. Student work. Jody Williams. Layering of tone from lightest to darkest results in a well-balanced tonal structure. The darkest areas of emphasis, especially core shadows and cast shadows, are developed in the later stages of the drawing.

Imagine Building a House

Even with an understanding of the benefits of working from general to specific, it is often difficult for the inexperienced drawer to apply the principles. Creating an analogy is a good way to illustrate the principle of general to specific at work in a situation other than drawing. In my teaching, the "house-building" analogy has proven effective in illustrating the application of this principle.

When a house is being constructed, there is a certain order in which things are done, with each step building upon previously completed steps. Each step in the process is carried out for the entire structure before moving on to the next step. The steps include building a concrete foundation, raising the studs for the walls and roof of the structure, framing in the windows and doorways, laying the floors, putting in the plumbing and electrical wiring, putting up the drywall, and installing doors and windows. After these general steps have been completed, the process slowly moves

Figure 1–88. Deborah Rockman. *Dog,* 1997. Charcoal on paper and vinyl on glass, 29 x 23 inches. Courtesy of the artist. Chiaroscuro produces a strong illusion of volume based on a singular light source and the distribution of a full tonal range.

toward more detailed or finished work, such as laying carpet and other flooring, painting walls, hanging wallpaper, installing cupboards, putting up switch plates and socket covers, and installing light fixtures. Clearly the work progresses from general to specific, from the largest and most general aspects of the structure to the more detailed and specific aspects of the structure. When one step in the process takes place, it is completed for the entire structure before the next step begins. That is, when a house is built, the builders do not go through the entire process—from constructing the foundation to building the walls to painting and carpeting, etc.—for one room and then begin the entire process again for the next room. And although the earliest, most generalized steps in the process are absolutely vital in the development of the house, they are not obvious or apparent factors in the end result. Their significance remains relatively unseen.

Figure 1–89. Jody Williams. *"Eli, Eli, Lema Sabachthani?",* 1994. Oil on paper, 32 x 24 inches. Characteristic of tenebrism, this torso study utilizes dramatic lights and darks, while numerous exterior edges dissolve into the dark negative space surrounding the body.

This house-building process parallels the process of utilizing a general-to-specific approach when building a drawing, and is especially relevant when applied to the building of value structure or tonality. The largest, simplest planes of value are identified first, and blocked in with a value that falls somewhere in the mid-light range of the value scale (Figure 1–86). This is best accomplished by using a drawing tool (whether it be lead, graphite, or charcoal) that is hard, such as a 2H pencil, or a light to mid-light-value ink wash. As additional layers of value are added, addressing variations within the larger, simpler planes, and as some simpler details begin to be addressed, a gradual shift is made to softer drawing materials, such as a 2B pencil, or to middle-value ink washes (Figure 1–87). Finally, as full detail and darkest values are addressed, yet softer/darker drawing materials can be utilized to yield a rich and complete value range. This assumes, of course, that a full value range is desired, one that describes the broad range of light and shadow—highlight, light, shadow, core shadow, reflected light, and cast shadow. If, however, the desired results are for a high key drawing (see definitions below), then the softest and darkest drawing media would not need to be utilized, while a low key drawing would encourage a shift to softer and darker drawing media earlier in the process.

Figure 1–90. Deborah Rockman. *Study #1 for "Death Dream,"* 1989. Graphite on gessoed paper, 29 x 23 inches. Private collection. The absence of strong highlights and overall dark tonal range emphasizes the somber and subdued mood of this drawing.

Using Value to Establish an Effect or a Mood

CHIAROSCURO: Originating in the Renaissance, chiaroscuro is a representational use of value that uses an even, gradual transition from light to dark to produce three-dimensional, volumetric effects (Figure 1–88).

TENEBRISM: Also originating in the Renaissance, tenebrism is an exaggeration or emphasis of the effects of chiaroscuro producing strong contrast, creating a dramatic or theatrical mood (Figure 1–89). Often the light source comes from unexpected and unusual locations.

PLASTIC VALUE: Value used to describe volume and space or plastic form.

LOW KEY VALUE: Predominately dark values often used to create an effect of gloom, mystery, drama, menace, or heaviness (Figure 1–90).

HIGH KEY VALUE: Predominately light values often used to create an effect opposite of low key value, such as light-heartedness, delicateness, or whimsy (Figure 1–91).

Figure 1–91. Student work. Maryann Davidson. This high key still-life study uses a limited tonal range that emphasizes mid to light values and generally excludes the darker end of the tonal scale.

Figure 1–92. Deborah Rockman. *Bitch,* 1996. Graphite on gessoed paper and vinyl on glass, 23 x 29 inches. Private collection. Analysis of information in this drawing reveals that the singular light source is positioned above and to the right of the dog.

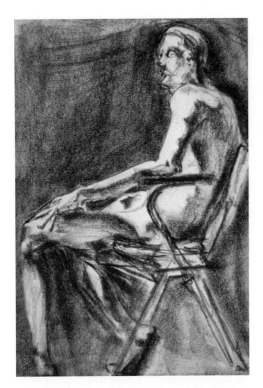

Figure 1–93. Student work.
Cosme Castanon III. The interdependent
shapes of shadow and light are clearly
identifiable in this study of a seated
figure. Note that reflected light is
subdued to help maintain its identity as
part of the shadow areas of tone and
to clearly distinguish it from areas
receiving direct light.

Four Things to Look for When Identifying Value Structure on a Form

LIGHT SOURCE. It is important to identify the light source, and for beginning drawing students it is most helpful to keep the light source as singular as possible. What direction is the light source coming from? How strong is the light source? How does this affect the shadows found on the forms being drawn (Figure 1–92)? A good way to demonstrate the importance of the direction of the light source is to do a simple demonstration. Take a clip-on light and illuminate the subject being drawn, then slowly move the light to different positions, observing how the pattern of shadow and light shifts as the direction of the light source changes.

THE SHAPE OF AREAS OF SHADOW AND LIGHT. What is the shape of the shadow in its largest, simplest form, and how does that shape relate to the form in its entirety? Where is the shape located? How large or small is it in relation to the surrounding area? How does it relate to other shapes of value on the form in terms of size and position and darkness or lightness (Figure 1–93)?

Conversely, what is the shape of the light in its juxtaposition with the shadow? Observing the shape of areas of light helps to more clearly define the adjacent areas of shadow. It is also helpful to think of light and shadow as puzzle pieces that lock together and are interdependent. Because the emphasis is on identifying and drawing areas of shadow in an additive drawing process, there is a tendency for the beginner to ignore the relationship between shapes of light and shapes of shadow in identifying form and its response to a particular light source.

VARIATIONS WITHIN LARGER SHAPES OF VALUE. Once the largest, simplest areas of shadow have been identified and blocked in, begin to note the subtle variations found within that larger, simpler shape. A large shape of middle tone value, for

Figure 1–94. Odd Nerdrum. *Girl with a Twig,* 1991. Charcoal on paper, 48 x 39 inches. The Arkansas Arts Center Foundation Collection: Purchased with a gift from the Collectors Group, 1991. In Nerdrum's drawing, many subtle variations of tone can be seen in the larger shapes of light and dark, contributing to the strong description of volume and mass. Note, for example, the delicate reflected light and deepened core shadows found in the large shadow located on the figure's head, face, ear, neck, and shoulder.

Figure 1–95. Student work. A subtractive drawing process allows one to identify and construct shapes of both light and shadow by erasing highlights and adding dark tones to a middle-value ground. Careful examination reveals that both shapes of light and dark vary tremendously in their edge character, transitioning from extremely crisp to extremely soft as the character of the drapery fold changes.

example, will often contain smaller passages of somewhat lighter and darker values (Figure 1–94). It is especially helpful to understand the six divisions of light and shadow to help identify these subtler variations. An awareness of highlight, light, shadow, core shadow, reflected light, and cast shadow is useful in identifying variations and in making sense of them.

EDGE QUALITY OF VALUE SHAPES. What do the edges of the shape of value look like? Is the edge quality the same throughout the shape? Probably not. Does the value end abruptly on one edge and make a gradual transition to a different value on another edge? Is the edge of a value hard or soft or somewhere in between? Does the edge quality change as you move along the edge or does it remain constant? Is an edge so soft that it is difficult to determine where the value actually ends (Figure 1–95)?

Exercises for Promoting a General-to-Specific Approach

When drawing from observation, such as from a still-life arrangement or from the human form, it can be a difficult task for the inexperienced student to overlook the seductive details of form that initially attract the eye. But the importance of overlooking detail in the early stages of value or tonal development cannot be overemphasized. It is one thing to understand the concept on an intellectual basis, but an entirely different experience when attempting to apply the concept to an actual drawing. One simple suggestion that I always offer my students is to squint as they begin to observe value structure. This softens details and allows for observation of broader, generalized groupings of tone.

There are two particular exercises that are recommended to reinforce the principle of general-to-specific in relation to the process of observation and the recording of observations. The first is theory based while the second addresses a more practical application. Both are helpful in demonstrating the effectiveness of a general-to-specific approach through a hands-on drawing experience.

Using an Inverted, Out-of-Focus Slide

For this exercise, a slide of a black-and-white drawing or photograph with a fairly clear division of value structure is most effective. A still life, landscape, or figurative image are all suitable options. Students must not be aware of what the image is prior to or during the drawing process. Neither should they be aware that the projected image to which they are referring is inverted. Only upon completion of the exercise will the actual slide image be revealed to them in focus and in its correct orientation. They should know only that the image is either vertical or horizontal in orientation, or that it is closer to being square. This will help them determine which way to position their drawing paper. It is recommended that vine charcoal be used in the early and middle stages of the drawing because of its flexibility and the ease with which it can be erased and adjusted. As the drawing nears completion, compressed charcoal sticks and pencils can be utilized in addressing darker values and increasingly greater degrees of detail.

The slide is projected upside down and severely out of focus so that it is essentially a soft blur of shapes of limited value range. Students should not be positioned too far off to one side or the other of the projected image, as this will result in distortion. Students are instructed to begin the exercise by drawing as accurately as possible exactly what they see in the projected image. Every few minutes, focus the projected image a bit more, revealing increasingly greater amounts of information: the emergence of new shapes, an increased range of values, and increasingly sharper edges on the shapes of value.

The students should be paying attention to the size and position of shapes in relation to the total image area, the size and position of shapes in relation to each other, and the actual value of the shapes and their tonal relationship to each other. Rags can be used to soften and blend shapes of value, and an eraser is vital for making changes and corrections as the student becomes aware of errors in size or placement. The eraser also becomes important as a shape that was initially soft-edged begins to take on sharper edges as the projected image is increasingly focused.

As the projected image draws closer to being completely focused, students may become aware that it is an inverted image and will begin turning their heads to observe the image in its correct orientation. This should be discouraged so as not to interfere with the pure observation of shapes. As soon as the students can begin to name different aspects of the projected image, their own private symbol systems can begin to interfere with careful and accurate observations. Only after the image has been put into complete focus and the final observations have been made and recorded should both the drawing and the projected image be turned over to reveal the subject matter. At this point, the students will be able to evaluate how well they recorded the information as the drawings and the projected slide are compared.

It is recommended that, immediately following the completion of the exercise, a class discussion take place regarding the students' experiences during the exercise.

Figure 1—96. Honoré Daumier (1808—1879). *Don Quixote and Sancho Panza.* Charcoal washed with india ink, 7-⅜ x 12-⅛ inches. The Metropolitan Museum of Art, Rogers Fund, 1927. (27.152.1) Charcoal and ink are combined to investigate simplified tonal structure in Daumier's gestural study of Don Quixote and Sancho Panza.

Throughout this discussion, remind them of the information they began with and the drawing process that brought them to the completed image. Reinforce the process of working from general to specific and of observing shapes and placement independently of subject matter during the discussion.

This exercise can be done in a number of different time frames, depending upon how quickly you wish to move the students through the experience, and depending upon the complexity of the projected image. If you wish to extend the exercise over an hour or longer, it is important to monitor the heat of the slide projector and take frequent breaks, allowing the projector to cool so that the bulb will not burn out.

A Sustained Approach to Gesture Drawing

The preceding exercise is very valuable in demonstrating the basic idea of a general-to-specific approach while drawing, but it is somewhat artificial in that students observing actual three-dimensional information as a source for drawing and tonal development will not have the luxury of being able to put the information out of focus and then slowly bring it into focus again. The following exercise is another way to explore the benefits of working from general to specific while referring to an actual three-dimensional form. Although the exercise described here is specific to the human figure as subject matter, it can be tailored to address a variety of different subject matters.

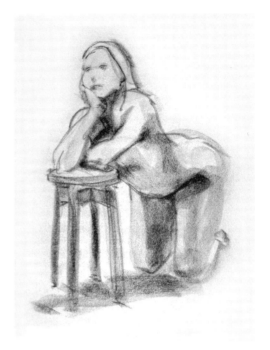

Figure 1–97. Student work. Carolee Heynen. Detail is sacrificed in favor of emphasizing the large, simplified planes of light and shadow in this six-minute sustained gesture drawing.

This exercise is a variation of the traditional three-minute linear gesture drawing of a human figure, and involves extending the gesture to a five- or six-minute study. (The additional time is used to record a simple division of light and shadow on the figure.) It is important that the light source be singular and fairly strong in order to facilitate the observation of simple tonal divisions on the figure. It is also very helpful, as mentioned above, to squint when trying to observe value in a simplified form during this exercise.

To encourage a rapid, generalized approach to value, instruct students to work with the broad side of a stick material, such as charcoal, conte, or graphite stick, about 1" to 1-½" long. Ink wash may also be used, applied with a brush that is broad enough to discourage detail but small enough to control (Figure 1–96). A linear gesture can be completed first to provide a framework. The remaining time is devoted to observing and recording the simple division of value, with the paper tone (white or off-white) used to describe all surfaces considered to be lit, and a drawn tone (approximately middle-gray) used to describe all surfaces considered to be in shadow. Reinforce the fact that detail, such as that observed in faces, hands, and feet, is relatively unimportant in this particular instance and can be highly simplified (Figure 1–97).

It is important to acknowledge that in actuality there are many different degrees of both light and shadow on the figure, but in this exercise the intention is to simplify and generalize as a means of reinforcing the general-to-specific approach. Keep the added tone (which signifies planes or surfaces in shadow) in the mid-value range so that it remains "open" and translucent. Students sometimes tend to make the value nearly black, which ultimately flattens and denies the form. When done successfully, students are often very pleasantly surprised at the additional descriptive properties inherent in the application of the most basic value structure.

Additional Considerations When Working with Value

Controlling Some Variables of Value Structure

- When dealing with halftones or middle values (belonging clearly to neither dark shadow or bright light):
 - —Halftones associated most strongly with lit surfaces should be drawn *lighter* than they appear to be.
 - —Halftones associated most strongly with shaded surfaces should be drawn *darker* than they appear to be.
- Think of value in terms of two distinct groups—areas of shadow and areas of light. Simplify your value structure. Do not allow these two separate areas to overlap or get mixed up.
- The greatest contrast of value should occur between general massed areas of light and general massed areas of shadow.
- If possible, keep the balance or proportional relationship of values (light, medium, dark) uneven or irregular; in ratio terms, think 3:3:1 (a lot, a lot, a little). Avoid an equal amount of light, medium, and dark values.

Value Structure as a Component of Color

- Colors of greatest intensity or purity, or tinted pure colors (those with white added) are usually relegated to areas of light or to halftones.
- Color in shadows should not exceed the intensity of color in light. Exception: bright, direct sunlight can wash out color or burn it out, revealing more pure color in areas of shadow.
- Local color should never lose its identity in an area of shadow (i.e., the shadow on a red shirt should have some degree of red in it).
- A colored light source will tend to cast its complement in a resulting shadow, whether it be a cast shadow or a form shadow. For example, yellow sunlight yields violet in shadows.
- Warm colors will be more brilliant when seen in warm light; cool colors can lose some intensity or be neutralized when seen in warm light.
- Conversely, cool colors will be more brilliant when seen in cool light; warm colors can lose some intensity or be neutralized when seen in cool light.
- When you want to maintain a specific large shape of light or shadow within which subtle value shifts and changes are occurring, describe the subtle value shifts through chroma or color changes, but keep the *value* of the color changes constant.
- Good use of color rests most importantly on a strong balance of color *value*.

The Technique of Scaling

Scaling is a process based in perspective that determines the accurate size relationships of forms in an illusionistic three-dimensional space. Although it is helpful to have a fundamental understanding of perspective principles (chapter three) to effectively apply scaling, it is included here because of its significance to drawing and because it is a skill that can be learned in the context of basic drawing essentials without a background in technical perspective.

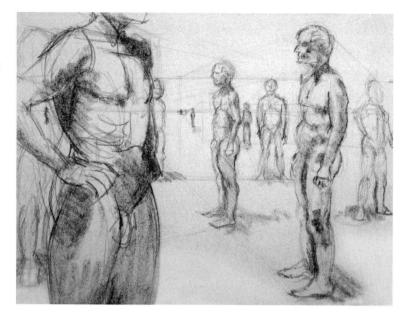

Figure 1–98. Student work. Roberta Weldon. Using scaling techniques, figures are moved to various locations in space with emphasis on size and position changes to describe depth and space on a firm ground plane.

The process of scaling establishes a CORRIDOR OF CONVERGENCE, which determines the change in apparent size or scale as a given form is moved to different positions within the illusionistic three-dimensional space of a drawing. Scaling also maintains an accurate size relationship between different forms within the illusionistic three-dimensional space (Figure 1–98). Although the examples provided focus on the figure, scaling can be applied to any forms that have measurable height.

Establishing Scale Successfully

The same factors that must be predetermined to develop a perspective drawing—scale, eye level, and station point—must also be predetermined to explore scaling in any capacity.

Scale or Unit of Measure

A scale of 1" = 1' indicates that 1" of measurable distance on your picture plane represents 1' in actual dimensions. Scale is variable, depending on what you are drawing, but once scale is established, it is used to indicate both the height of the EYE LEVEL and the position of the STATION POINT.

Height of Eye Level (EL) or Horizon Line (HL)

The height of your eye level is determined by the measurable distance on your picture plane from GROUND LINE (GL) to eye-level or horizon line, which are synonymous (Figure 1–99). If the measurable distance from the ground line (which represents the intersection of the picture plane and the ground plane) to the horizon line is 7", and the established scale is 1" = 1', the eye level is set at 7'. A lower eye level suggests a worm's-eye view, and a higher eye level suggests a bird's-eye view. An eye level of 5 or 6 feet represents average eye level for a standing adult.

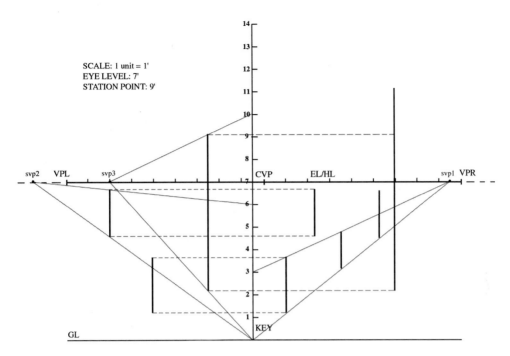

Figure 1–99. Scaling principles are demonstrated in this computer-generated model. Gray diagonal lines indicate corridors of convergence for diagonal scaling, and dotted lines indicate horizontal scaling. The corridor of convergence to svp 1 represents a 3-foot height scaled in space. The corridor of convergence to svp 2 represents a 6-foot height scaled in space. The corridor of convergence to svp 3 represents a 1 o-foot height scaled in space. Two instances of vertical scaling, or stacking, are represented on the far right of the illustration.

Station Point

The station point indicates the distance of the viewer from the picture plane. The station point is indicated by the placement of and distance between VANISHING POINT LEFT (VPL) and VANISHING POINT RIGHT (VPR) in two-point perspective, or by the placement of special vanishing points left and right in one-point perspective. If your scale is 1" = 1', and your VPL and VPR are 18 inches apart (or 9 inches each from the central vanishing point), your station point is determined by one-half of the distance between the VPL and VPR, or by the distance from the CVP to either VPL or VPR. In this example, the station point is 9' (represented by a measurement of 9"), telling us that the viewer is positioned 9' away from the picture plane. Note that all three factors must remain constant while drawing!

Additional Guidelines for Scaling

- The scaling guide or "key" (a vertical measuring line) originates at the ground line and moves vertically up the drawing format. It is perceived as being on the picture plane, and reflects actual measurable lengths. (See Figure 1–99.)
- All scaling makes direct or indirect reference to this key.

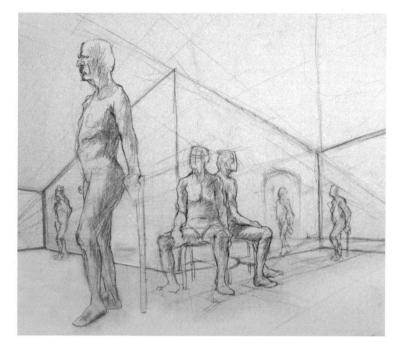

Figure 1–100. Student work. Nancy Lautenbach. Both standing and seated figures are scaled in this study, with the eye level positioned at knee height. The placement of vanishing points left and right just outside of the picture plane creates a rapid rate of convergence, which makes this two-point perspective view a bit more dramatic than if the vanishing points were positioned farther apart.

- Any form that is accurately scaled from the original scaling guide or key can then be used to scale additional forms.
- SPECIAL VANISHING POINTS (SVPs), which are used to establish CORRIDORS OF CONVERGENCE for accurate scale, can be placed anywhere on the horizon line, including placement on an extension of the horizon line off the drawing surface. There is no limit to the number of SVPs you can use.
- Scaling can occur diagonally either forward or backward, indicating that the subject is further away from or closer to the picture plane. This calls for the use of SVPs to establish the corridor of convergence (Figure 1–100). Scaling can also occur vertically or horizontally, indicating movement up or down or sideways rather than forward or backward in space. This does not call for the use of SVPs because there is no size change when scaling forms vertically or horizontally.
- The farther apart your vanishing points are, the farther away you are placing the viewer from the picture plane. This generally creates a more realistic viewpoint and is less dramatic than if the viewer is positioned close to the picture plane, indicated by vanishing points that are closer together.
- When applying scaling, identify the point of contact of the form or figure with the ground plane first, and scale up from this point of contact, which is called the BASE-LINE. In this way, what you draw will be firmly planted on the ground plane. If you wish to make a form appear to float above the ground plane or position it on an elevated surface, you would simply apply vertical scaling (Figure 1–101).
- You may use multiple sets of vanishing points (VPL and VPR) to reflect various rotations or positions of forms as long as each set remains the same distance apart on the horizon line.
- A higher eye level should be placed nearer the top of your drawing format; a lower eye level should be placed nearer the bottom of your drawing format.

Figure 1–101. Lucas Van Leyden. *Christ Presented to the People,* 1510. Engraving. The Metropolitan Museum of Art. Harris Brisbane Dick Fund, 1927. (27.54.4) Van Leyden's mastery of spatial illusion is evident in this exploration of one-point perspective and scaling techniques. The height of every structure and every figure can be determined based on its relationship to the predetermined height of a figure or vertical structure in the foreground.

The Golden Section

The study of composition often begins as theory in two-dimensional design courses and should continue to be developed and reinforced in an applied sense throughout a student's fine arts training. Along with informal systems and principles of organization, it is important to investigate the various formal systems of organization that have withstood close scrutiny and the test of time. The most prominent of these is the Golden Section. Although it can be a bit overwhelming to the uninitiated with its strong foothold in mathematics, Euclidian geometry, and Pythagorean theory, proficiency in these subjects is not necessary to a basic understanding of the Golden Section and its role in nature and the arts. If you or a student find your interest is piqued and you wish to investigate further, there are a number of resources listed in the Bibliography. But a fairly basic discussion and demonstration (with good, clear handouts), along with some examples from art and nature showing the application and presence of the Golden Section, is sufficient to make the students aware of the prevalence and significance of this aesthetic device and the underlying organization found in seemingly random or chaotic structures.

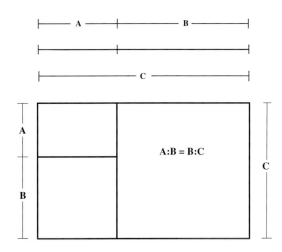

Figure 1–102. The Golden Section. A rectangle whose dimensions reflect the Golden Section is subdivided vertically and horizontally at points of Golden Section to create yet another Golden Rectangle. This point of division can be applied to a line, to a rectangular plane, or to a three-dimensional solid.

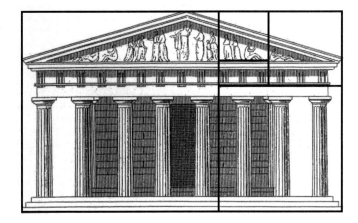

Figure 1–103. Eastern Front of the Parthenon. Courtesy of Dover Pictorial Archive Series, Dover Publications, Inc. This illustration superimposes the Golden Section on the eastern facade of the Parthenon, showing the presence of the Golden Section proportions in the entire facade as well as the entablature and pediment.

What is the Golden Section?

The Golden Section (also known as the Golden Mean, the Golden Proportion, the Golden Ratio, and the Divine Proportion) is a system of aesthetically pleasing proportions based on the division of space into parts that correspond approximately to the proportion of three parts to five parts (3:5) or five parts to eight parts (5:8). In other words, the smaller part relates to the size of the greater part in the same way as the greater part relates to the size of the whole. On any given line, there is only one point that will bisect it into two unequal parts in this uniquely reciprocal fashion, and this one point is called the point of Golden Section (Figure 1–102). This principle can be applied to a line, to a two-dimensional plane, or to a three-dimensional solid. This "divine" proportion is credited by some with various mystical properties and exceptional beauties both in science and in art.

Evidence of this principle is found in architectural forms, in the human body, and in the capital letters of the Latin alphabet (Figure 1–103). In fractions, the Golden Section can be generally expressed as a ⅗ or ⅝ division of space. Based on a Euclidean theory, Vitruvius worked out the Golden Section in the first century B.C. to establish architectural standards for the proportions of columns, rooms, and whole buildings,

with the understanding that individual variations were expected of the architect. Leonardo da Vinci, Piero della Francesca, and Alberti all were aware of the significance of the Golden Section, and evidence of its application can be found in their work. Statistical experiments are said to have shown that people involuntarily give preference to proportions that approximate the Golden Section. In an October, 1985 newspaper article distributed by the Associated Press and printed in the *Grand Rapids Press*, the following observations were made:

> When a newborn baby first identifies its mother's face, it's not by color, shape, smell or heat, but the way the eyebrows, eyes, nose and mouth are arranged in proportions artists have known for centuries as the "golden ratio," says a noted child psychiatrist.
>
> "It seems clear that nature has built a certain sense of proportions into the human organism which have survival value," said Dr. Eugene J. Mahon. "In other words, because it's essential for children to get to know the imprint of their mother's face, nature has not left it to chance."
>
> Those proportions, Mahon said, happen to be the same as the famous proportion known for centuries by artists and architects as the "golden ratio," or "golden section." The golden ratio has been proven by experiments as particularly harmonious and pleasing to the human senses. It is not surprising, therefore, if it catches even the untrained eyes of a newborn, he said.
>
> The Irish psychiatrist, who is on the faculty of Columbia University's Psychoanalytic Clinic for Training and Research as well as the Columbia College of Physicians and Surgeons, presented his findings in "The Psychoanalytic Study of the Child."
>
> "A mask constructed with two eyes, a nose and a mouth enclosed in an oval that resembles the human face will hold the attention of the infant as much as the human face itself," Mahon said in an interview, citing his and others' experiments.
>
> "A mask with features out of proportion to expectable human anatomy, or the human face itself in profile, does not attract the attention of the infant nearly as intently as a human face. The distance from the top of the human head to the eyebrows and the distance from the eyebrows to the end of the chin are roughly 5 and 8, no matter what units of measurements are used. The distance from the tip of the nose to the lips and the distance from the lips to the end of the chin also relate to each other as 5 and 8. In the human face and body, we can find many combinations of the golden section."
>
> The human preference for this particular proportion, which abounds in nature, architecture and classical paintings, has been known through the ages, the psychoanalyst said. Examples of golden rectangles are found on paper money, traveler's checks and credit cards, he said.

Constructing a Golden Rectangle

The "ideal" proportions of a rectangle are determined by the Golden Section, which explores projections of a square within itself and outside of itself to create pleasing and harmonious proportional relationships. Geometrically, the Golden Section may be constructed by means of the diagonal of a rectangle composed of two squares

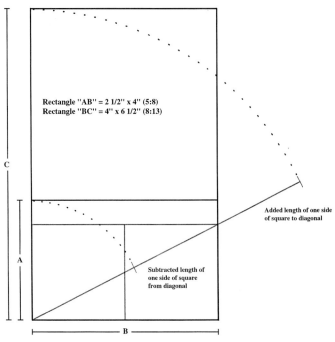

Figure 1–104. Construction of a Golden Section rectangle based on the diagonal of a rectangle composed of two squares.

Rectangle "AB" = 2 1/2" x 4" (5:8)
Rectangle "BC" = 4" x 6 1/2" (8:13)

C

Added length of one side of square to diagonal

A

Subtracted length of one side of square from diagonal

B

• Rectangle "AB" reflects the dimensions of the Golden Section
• Rectangle "BC" reflects the dimensions of the Golden Section
• Rectangles "AB" and "BC" are reciprocal; the long side (B) of "AB" is equal in length to the short side (B) of "BC"

(Figure 1–104). From the diagonal of a rectangle composed of two squares (1 x 2), add or subtract the length of one side of the square and place the remainder against (at a 90-degree angle to) the longer side of the original rectangle. *Adding* the length of one side of the square creates the longer side of the resulting Golden Section rectangle. *Subtracting* the length of one side of the square creates the shorter side of the resulting Golden Section rectangle. The ratio of the two sides of the rectangle works out numerically to 0.618 to 1, or approximately 5 to 8.

A second method for constructing a Golden Rectangle is based on the projection of a square outside of itself (Figure 1–105). Starting with a square, find the center point of the base of the square and from this point draw a line to the upper left or upper right corner of the square. Rotate this line left or right from the center point of the base of the square until it aligns with and extends the base of the square. Constructing an additional vertical and horizontal line from this point of extension defines the proportions of a Golden Section rectangle.

The Golden Section is unique in that its mathematical equivalent represents the only instance in which a ratio is the same or equal to a proportion. In other words, the expression of the Golden Section as a fraction is equal to the expression of the Golden Section as a ratio.

It is often claimed that the Golden Section is aesthetically superior to all other proportions. A significant amount of research and data supporting this claim has been collected over the years, from both the scientific community and from the arts community. Some resources which provide in-depth information on particular applications

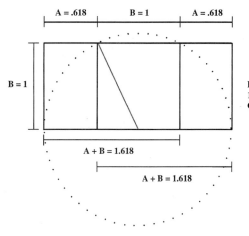

A = .618 B = 1 A = .618

B = 1

A + B = 1.618

A + B = 1.618

Rectangles .618 x 1 and
1 x 1.618 are reciprocal
Golden Rectangles

Figure 1–105. Construction of a
Golden Section rectangle based
on the projection of a square
outside of itself.

or instances of the Golden Section and other formal systems of organization can be found in the Supplemental Reading for Design Principles (see Bibliography).

The Fibonacci Series

The Fibonacci Series is a system of expanding size relationships connected with the Golden Section. In mathematics, the Fibonacci Series is known as a summation series in which each number is the sum of the two previous ones. Leonardo of Pisa, also known as Fibonacci (1175–1230), discovered that if a ladder of whole numbers is constructed so that each number on the right is the sum of the pair on the preceding rung, the arithmetical ratio between the two numbers on the same rung rapidly approaches the Golden Section. This numerical sequence, carried out a few times, yields the following series of numbers:

1, 2, 3, 5, 8, 13, 21, 34, 55, 89, 144, 233, 377, 610, 987, 1597, 2584, 4181, 6765, 10946, . . .

Any number in this series divided by the *following* one (i.e., 5 divided by 8) approximates 0.618, while any number in this series divided by the *previous* one (i.e., 8 divided by 5) approximates 1.618 (Figure 1–106). These are the proportional rates between minor and major parts of the Golden Section: 0.618 (A) is to 1 (B) as 1 (B) is to 1.618 (C), or A:B = B:C. Note that the expression of the Golden Section as a fraction (⅝ or ⁸⁄₁₃) represents the same point of division as the expression of the Golden Section as a ratio (5:8 or 8:13).

The numbers in the Fibonacci Series result from the following simple additions, beginning with the first two whole numbers and adding each number in the sequence to the preceding number:

1 + 2 = 3, 2 + 3 = 5, 3 + 5 = 8, 5 + 8 = 13, 8 + 13 = 21, 13 + 21 = 34, 21 + 34 = 55, 34 + 55 = 89, 55 + 89 = 144, . . .

In the study of phyllotaxis, which is the spiraling arrangement of leaves, scales, and flowers, it has been found that fractions representing these spiral arrangements are

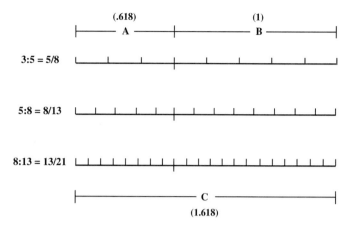

Figure 1–106. The relationship of the Fibonacci Series to the point of Golden Section on a line.

$$A\ (.618) : B\ (1) = B\ (1) : C\ (1.618)$$

often members of the Fibonacci Series, which supports the notion that numerous instances of the Golden Section can be found in nature. Botanists have discovered that the average-size sunflower head, which is arranged in opposing spirals, shows exactly 55 rows of seeds in one direction and exactly 89 rows of seeds in the other direction. Smaller and larger sunflower heads show the same ratio of opposing spirals, such as 34 to 55 spirals, and 89 to 144. Nautilus shells and pine cones show similar ratios in their natural growth patterns.

Setting Up an Effective Still Life

Still lifes are generally considered to be an effective method for introducing students to the processes, methods, and techniques of drawing that are based on direct observation. In examining what constitutes a good still life for student reference, a variety of considerations are taken into account.

What Kinds of Objects Should Be Included?

While nearly any object that one can see is potentially a good subject for drawing, one must consider the level of the drawing course and the specific ideas being focused upon in setting up a classroom still life.

For introductory-level coursework, it is important to begin with forms that are somewhat limited in their complexity, allowing students to build some skills in eye-hand coordination and to develop some confidence before introducing more complicated forms. It is also wise to present a variety of object types, as they will provide different characteristics that encourage the development of different skills. While not all possible still-life subjects are easily categorized, there are three basic categories under which many objects fall. When possible and appropriate to the focus of a particular drawing session, you are encouraged to provide examples of all three categories when setting up a still life.

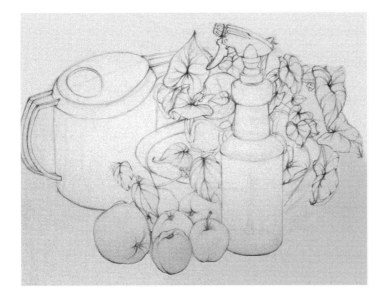

Figure 1–107. Student work. Michael Moore. Example of a still life incorporating the regular forms of a watering can, a spray bottle, and a plant pot.

Regular Forms

First is what are referred to as regular or symmetrical forms, which are typically human-made or mechanical forms and are somewhat predictable in their structure. Although not always strictly symmetrical, they often require more careful analysis to capture a sense of the familiarity and function of the form. Their relationship to or basis in geometric solids (cubes, spheres, cylinders, cones, wedges, etc.) is typically more apparent than in irregular forms. Examples include bottles, vases, tools, utensils, shoes, hats, and a wide variety of objects that can be found in most households (Figure 1–107). The advantages to including them in a still life, with consideration for degrees of complexity, are numerous. They provide ample opportunities for utilizing axis lines around which to guide the construction of symmetrical or nearly symmetrical forms; they often provide ellipses that warrant repeated freehand drawing experiences to gain proficiency; they provide opportunities to draw regular and predictable curves and contours freehand (without the aid of mechanical guides or templates); and they will remain constant in appearance over an extended period of time without decaying or shriveling or changing in appearance dramatically.

Irregular Forms

Second is what are referred to as irregular or natural forms, which are typically organic or derived from nature. They range from extremely simple forms, symmetrical or nearly symmetrical, to highly complex forms with or without apparent predictability or formal organization. Their relationship to geometric solids may be clear and direct (an orange or an apple is clearly spherical), or may be vague or lacking entirely (the tangled mass of roots found in a root ball are difficult to associate with a geometric solid). Examples include the entire range of fruits and vegetables and any forms found in nature, from driftwood to bugs to boulders to trees to all forms of plant and animal life (Figure 1–108). Animal skulls and other skeletal parts provide an especially rich and interesting resource for drawing.

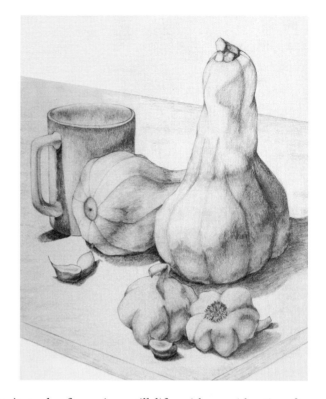

Figure 1–108. Student work. Sheila Grant. Example of a still life incorporating the irregular forms of squash, gourds, and garlic bulbs and cloves.

The advantages to including irregular forms in a still life, with consideration for degrees of complexity, are multiple. They discourage an inexperienced student's tendency to stylize or simplify information as this will render the drawing much less convincing; they provide a rich resource for line variation and tonal structure due to the infinite range of edge and surface character; and they can be manipulated for variety and interest in a way that regular or mechanical forms often cannot. You can slice an apple, peel an orange, break off cloves from a garlic bulb, partially peel a banana, snap a twig in two, and generally observe and record changes in many natural forms over a relatively short period of time as they decay or dry or mold or shrivel.

Cubic Forms

Third is what are referred to as cubic-based forms, which are generally composed of primarily flat planes and straight edges. They include any kind of box or box-like structure such as a book, and any form that is composed primarily of flat planes (Figure 1–109). While they can provide surfaces upon which to place other forms, varying the height of different objects in your still life and creating object relationships, they most importantly provide drawing experiences that test a student's knowledge of basic perspective principles such as convergence, diminution, and consistent eye level.

Additional Considerations

How a still life is lit is extremely important. Adequate lighting, both on the still life and on the drawing surface, is important in order for the students to be able to see information without visual confusion or eye strain. When exploring line variation or

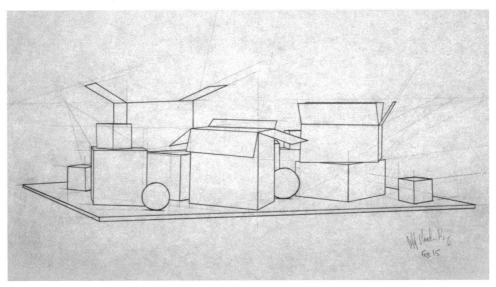

Figure 1–109. Student work. Jeff VandenBerg. Example of a still life focusing on cubic forms and two-point perspective.

value structure or any other concern that relates to tonal structure, it is important to keep the light source as singular as possible, especially at an introductory level. A consistent light source, not too strong or weak, is most effective in defining and revealing form. While experimentation with different locations of the light source is advisable—overhead, side lighting, under lighting—and helps the student to understand the significance of directional lighting, a singular and raking light source is generally best for form definition.

Placing a still life on a white or light-colored cloth or sheet helps to enhance reflected light, which plays an important role in helping to describe and define volume. Because reflected light frequently eludes students in their early investigations of tonal structure, it is helpful to make it easily visible. Striped cloth can also add some pattern and interest to a still life. Incorporating drapery with folds into a still life not only provides options for more complex and unified compositions, but also provides an element of softness as well as additional opportunities to explore line work and tonal structure.

In addressing a still life, whether in class or as a homework assignment, encourage students to ground the forms they are drawing by clearly indicating the surface upon which the objects rest. Table edges can be shown in their entirety or can be cropped by the edges of the drawing format. In addition to grounding objects, indicating the surface upon which objects rest provides an additional visual element for breaking up space and enhancing compositional interest.

In many instances, the number of students in a class may prohibit setting up a single still life that all students will be able to see clearly. It is advisable, when numbers warrant, to set up two separate still lifes and have half the class work with one and the remaining half work with the other.

Chapter *2*

Teaching Essential Drawing Principles in Relation to the Human Figure

The Human Figure

Why Study the Human Figure?

There is perhaps no more significant experience in the study of drawing than the study of the human figure. One needs only to look to the ancient Greeks and to the Renaissance masters to recognize the historical importance of the human form in the study of the visual arts and the refinement of visual expression. Although the figure's presence and significance during the period known as modernism and in contemporary art has ebbed and flowed, its influence is always felt to some degree, and no classical or traditional art education would be complete without a substantial focus on drawing and studying the human form.

Much debate is currently taking place about the changing role and responsibility of foundation courses for students studying both the fine and applied arts. If we examine those aspects that the fine and applied arts have in common, we find that a concern for communication is paramount, whether it takes place in a gallery or museum, in a television or magazine ad, on a showroom floor, on a computer monitor, or in any number of other locales. The power of the human form to communicate cannot be overstated, primarily because *it is what we are.* We have things in common with other humans that we have in common with nothing else. Looking at a human form in any context has the potential to provide us with the experience of looking in the mirror, of seeing our own reflection, so to speak. It follows that any significant experience in visual communication must thoroughly examine the role of the figure, and for the visual artist this requires experience with drawing the figure.

The fine and applied arts also have in common a concern for principles of design and aesthetics. If we acknowledge the presence of these principles in nature, then we may also recognize an element of universality. Quite simply, I can think of no finer example of the application of principles of design and aesthetics than the living, breathing human form, and the human form is universal. In all of our variations, we are exquisitely designed and literally embody a number of design principles or systems

Figure 2–1. Student work. Heather Powers. The human face exhibits proportional relationships that reflect the Golden Section. In simplifying the Golden Section to a ⅗ fraction or a 3:5 ratio, we observe this same relationship in the major division between the cranial area and the facial area, the length of the nose from eye level to the chin, and the placement of the center line of the mouth from the nose to the chin.

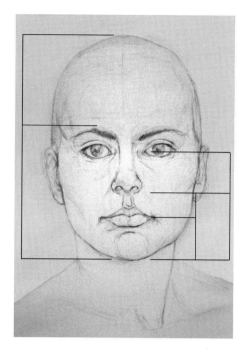

Figure 2–2. Illustration of the Theory of the Art of Drawing. Proportions of the Human Body. Courtesy of Dover Pictorial Archive Series, Dover Publications, Inc. Based on a standing figure that measures eight head-lengths tall, the Golden Section proportions are reflected in a number of ways, either as fractions of ⅔, ⅗, or ⅝, or as ratios of 2:3, 3:5, or 5:8. The length of the body is divided by ⅝ or 3:5 at the waist, the length of the arm is divided by ⅔ at the elbow, and the length of the outstretched arm in relation to the width of the torso is 2:3.

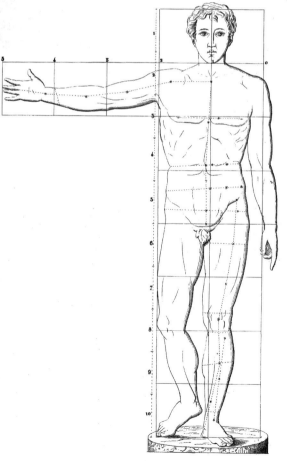

of organization, such as the Golden Section (Figures 2–1 and 2–2), discussed at length in chapter one.

Bear in mind that the same characteristics that make the figure such an important source of study are often what make the figure such an intimidating presence for many beginning students. The element of nudity can create some discomfort initially for the inexperienced student of drawing, but experience indicates that this discomfort is short-lived and the students, with few exceptions, quickly come to terms with nudity in the classroom as a necessary element for the study of the human body.

Because the figure is a highly complex form, it tends to present a greater challenge for the beginning art student. We are visually quite familiar with the human form in the sense that we know when something is "off." The difficulty for the uninitiated lies in the challenge of identifying why things don't look quite right, and what to do about it. Therefore, it is strongly recommended that a student have some successful drawing experience with simpler forms before approaching the subject of the figure. This not only prepares the student for the greater complexities of the figure, but also serves to build confidence. Of course not all formal programs are in agreement with this philosophy of course sequencing, and some foundation programs do not require basic drawing as a prerequisite or even a corequisite to figure drawing. If, however, you have the flexibility to determine sequencing for yourself, consider the benefits for the student of having some experience and success with the tools and processes of drawing before approaching the figure.

Classroom Etiquette for Working with a Nude Model

Modeling is hard work. Unless you have done it before, it is difficult to realize the amount of work involved in modeling well. Everyone in the classroom deserves to be treated with respect, and this is especially true for the models, who find themselves in an especially vulnerable position because of their nudity and because all eyes are upon them. For the inexperienced student of figure drawing, it is advisable to take a few minutes prior to the first session with the model to discuss some of the etiquette involved, and even experienced students may need to be reminded on occasion. The model's personal space is to be respected, and no one should ever touch the model while he or she is at work. There are some instances, with the model's permission, when it is appropriate for the instructor to make contact with the model in order to point something out—when teaching anatomy, when helping the model to get back into a particular pose, etc. But the generally accepted notion is that under no circumstances should a student make contact with a model.

Students should also be reminded that it is inappropriate to make audible comments concerning the model's body or appearance, or to laugh out loud in a way that may lead the model to think that he or she is being laughed at. Again, because of the model's vulnerability, it is courteous and professional to be particularly attentive to their well-being. Make sure to provide the model with adequate additional heat if the room is cold. Although it may seem unnecessary to review here what could be considered obvious, experience suggests that you can never be too sure what kind of behavior you may encounter from the students or the models.

The models, too, should be made aware of some guidelines for their behavior. During a break, the models should wear robes or otherwise cover themselves until it is time to take the stand again. Models should be advised, under typical circumstances, not to offer comments on student work since they may unwittingly reinforce something the instructor is trying to discourage or discourage something the instructor is trying to reinforce. Models should be made aware that personal hygiene is of importance. This is not to suggest in any way that models are, by nature, neglectful of their personal hygiene. However, over the years I have encountered a number of models who chose not to bathe on a regular basis. The body odor was overwhelming, and students had great difficulty staying focused. In general, common sense and courtesy provide the best guidelines.

Sighting in Relation to the Human Form

The procedure for sighting has been thoroughly discussed in chapter one. There are, however, some factors worth mentioning that relate specifically to sighting the human form.

Sighting the Human Figure for Relative Proportions

It has been determined that a unit of measure or point of reference must first be established for comparative measurements. When working with the figure, the head is most frequently used as the point of reference (Figure 2–3). This assumes, of course, that the

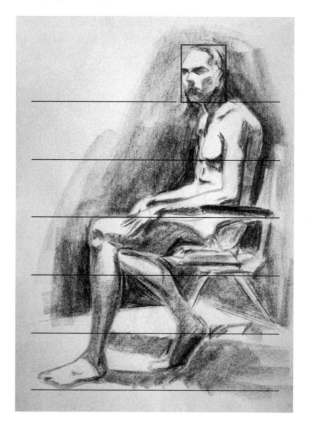

Figure 2–3. Student work. Erik Carlson. The length of the head from crown to chin is repeated down through the figure, revealing that this seated figure measures nearly six head-lengths from uppermost to lowest point. Note that the second head-length brings you to the line of the nipples, and the third head-length brings you to the top of the thigh, both easily identifiable as landmarks on the body.

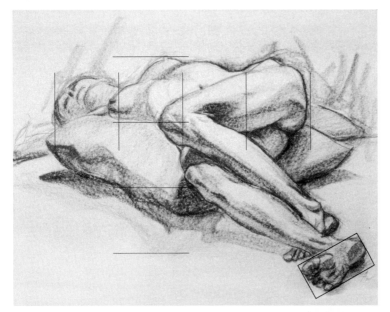

Figure 2–4. Student work. Stephen Amor. Because of the extreme foreshortening of the head and the fact that it is partially obscured, the foot is used as the unit of measure. Lines show the length of the foot pulled horizontally and vertically through the figure. Note that the length of this foreshortened reclining figure from head to buttocks is four foot-lengths.

Figure 2–5. Student work. Janet Drake Helder. The foreshortened thigh of the reclining model measures greater in width than in length, which is contrary to what we might expect to see based on what we know about a thigh.

head is visible in its entirety. In views of the figure that do not provide an unobstructed view of the head, such as an extremely foreshortened position, an alternative point of reference must be established. Depending upon your viewpoint, a hand or a foot may provide a workable point of reference (Figure 2–4). Any part of the figure will suffice as a point of reference as long as there is a clear width and length that can be observed and measured.

Foreshortening in the figure is often recorded with a significant amount of inaccuracy and distortion. This is due, of course, to the fact that our experience with the human form will often override what is visually presented before us. For example, a foreshortened view of the thigh may measure wider from side to side than it does in length from the hip area to the knee area (Figure 2–5). Because of our awareness of the thigh as a form that is generally greater in length than in width, cylindrical-like,

Figure 2–6. John Singer Sargent (1856–1925). *Study of a Nude Man.* Pencil on paper, 9-⅞ x 7-¾ inches.
Wadsworth Atheneum, Hartford. Bequest of George A. Gay. Given that we are low and looking up at the figure,
the head-length repeats itself only twice to bring us near the pubic arch. In a standing figure without foreshorten-
ing, the head-length would repeat itself nearly three times to bring us to this same point. While the length of the
torso is compressed, the width of the torso remains relatively unaffected by foreshortening.

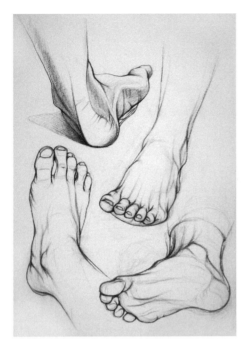

Figure 2–7. Student work. Gypsy Schindler. Overlapping is intensified when foreshortening is present. Interior contours are more pronounced in numerous places in this page of foot studies. Note especially the toes of the center foot and the ankle bone, or medial malleolus, of the lower right foot.

we bypass what is observed and draw what we "know" a thigh to look like. This then creates problems in presenting a convincing illusion of a foreshortened limb.

While sighting is an ideal way to overcome these inaccuracies, there are a few things to be particularly attentive to. First, make your students aware of the fact that when foreshortening is evident, the apparent relationship between the length and width of figurative forms (limbs, torso, hands, feet) is altered to varying degrees, depending on the severity of the foreshortening. While the length of a form may be greatly compressed in foreshortening, the width may remain relatively unchanged (Figure 2–6). Second, caution your students against tilting their sighting sticks in the direction of the foreshortened plane. This is easy to do without even being aware of it. Because the measurement is no longer being taken in the imagined two-dimensional picture plane, it will not present an accurate translation from the three-dimensional form of the figure to the two-dimensional surface of the drawing or painting. A final note regarding foreshortening: Be aware that instances of overlapping, where one part of the body meets another part of the body, are more pronounced in a foreshortened view and require greater attention to the interior contours that give definition to this (Figure 2–7).

Sighting the Human Figure for Vertical or Horizontal Alignments

Keep in mind that the human form is rich in visual landmarks. Although many of these landmarks are readily apparent and easily identified verbally (the tip of the nose, the back of the heel, the tip of the elbow, the right nipple, the wrist bone, the navel, the inside corner of the eye, etc.), many more landmarks are available that are a bit more difficult to describe when assisting a student with a drawing. These landmarks can provide helpful reference points for seeking vertical or horizontal alignments between distant points on the figure, and these alignments help to maintain an accurate relationship of size and placement when drawing the figure and its component parts

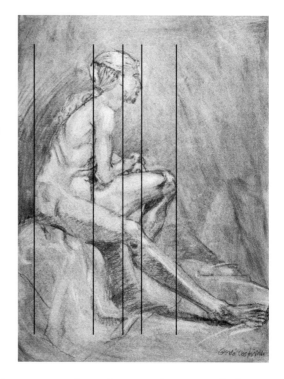

Figure 2–8. Student work. Glenda Oosterink. Vertical sight lines are pulled through the figure at various points using a sighting stick. Vertical relationships between identifiable points or landmarks are sought, with the intention of maintaining these observed relationships in the drawing.

(Figure 2–8). Some examples include the contour where the upper leg meets the lower torso; the point at which the contour of the upper, inner arm disappears into the shoulder area; and the outermost part of the curve of the calf muscle. Be creative in finding ways to verbally describe these landmarks on the figure.

Sighting for vertical or horizontal alignments between figurative landmarks that are far apart is especially helpful. These alignments can be difficult to observe without the aid of a sighting stick when they occur at distant points on the figure. In addition, you can use sighting to observe when a significant landmark falls to the left or right of a vertical extension of another landmark, or when a landmark falls above or below a horizontal extension of another landmark (Figures 2–9 and 2–10). As always, these concepts become clearest for the student when they are actually applied to a drawing experience. While a clear and concise explanation along with visual aids such as projected slides is important, the student will learn most quickly through the practical application of sighting techniques.

Comparative Proportions in the Male and Female Figure

As students begin their exploration of the human figure, it is helpful to provide information that furthers their understanding of basic proportional relationships. An awareness of classical and idealized figure proportions, derived from the Greeks and the Renaissance, is important in understanding both the historical and contemporary depiction of the human form. But in reality, very few human forms fall so neatly into these canons of proportion. We know that there is considerable variation of proportional relationships within human forms, especially with regard to the length of the limbs.

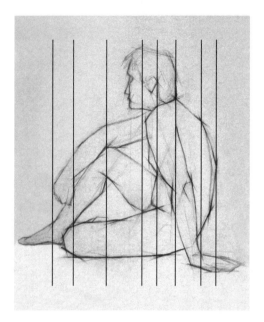

Figure 2–9. Student work. Jacquelin Dyer DeNio. Vertical sight lines can also help identify when two or more points do not precisely align, with one point falling to the left or right of another point. In this example, note that the wrist is positioned to the right of the back of the head. Although this may seem obvious in looking at the drawing, it is much less apparent when scanning an actual three-dimensional figure without the aid of a sighting stick.

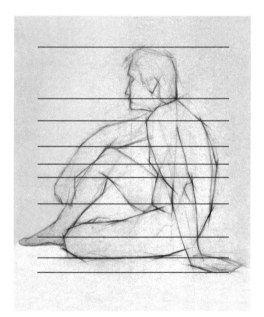

Figure 2–10. Student work. Jacquelin Dyer DeNio. Both vertical and horizontal sight lines can be used in seeking alignments or nonalignments between significant points or landmarks on the figure. This particular pose offers a wealth of helpful information based on both vertical and horizontal sighting.

While the idealized canon of proportions tells us that a standing adult figure is eight head-lengths tall, experience tells us that many figures are closer to seven and a half heads tall, and some fall close to being only seven heads tall (Figure 2–11). And this information becomes applicable only when dealing with a standing figure. Careful observation and utilization of the sighting process is most important in establishing actual proportions, whether the figure is standing, seated, reclining, crouching, or in any number of other positions.

Some general information regarding comparative differences in proportion between the female and male form is provided below. Differences are most evident

Figure 2–11. Edgar Degas (French, 1834–1917). *A Ballet Dancer in Position Facing Three-Quarters Front,* 1872. Graphite, black crayon, and white chalk on pink paper, 41 cm x 28.4 cm. Courtesy of the Fogg Art Museum, Harvard University Art Museums. Bequest of Meta and Paul J. Sachs. Rather than applying the idealized figure proportions of eight head-lengths tall, Degas records in this standing figure a height of approximately six and a half head-lengths, probably due to some minimal foreshortening. The drawn grid is used to transcribe the drawing to another surface rather than representing head lengths.

Figure 2–12. Jean-Auguste-Dominique Ingres (French, 1780–1867), *Studies of a Man and a Woman for "The Golden Age,"* c. 1842. Graphite on cream wove paper, 41.6 cm. x 31.5 cm. Courtesy of the Fogg Art Museum, Harvard University Art Museums. Bequest of Grenville L. Winthrop. Ingres's drawing provides an opportunity to compare the subtle proportional variations between a standing male nude and a standing female nude.

when comparing standing figures (Figure 2–12). These observations pertain to adult figures who have reached their full height, and it should be noted that there are exceptions to these comparative proportions.

Female
- Torso longer (from shoulders to hips) in relation to total body length, due to greater distance between rib cage and pelvis.
- Lower limbs (legs) shorter in relation to total body length.
- Neck longer in relation to head height.
- Shoulders narrower than males.
- Pelvis or hips broader than males.
- Hips deeper from front to back than males.
- Hips shorter from top to bottom than males.
- Pelvis tipped farther forward, creating a stronger curve in the lower back.
- Hips are typically the broadest part of the body, wider than shoulders.
- Arms shorter in relation to total body length, due to a shorter humerus.
- Elbow positioned higher in relation to torso.
- Hand positioned higher in relation to the upper leg or thigh.

Male
- Torso shorter in relation to total body length, due to less distance between rib cage and pelvis.
- Lower limbs longer in relation to total body length.
- Neck shorter in relation to head height.
- Shoulders broader than females.
- Pelvis or hips narrower than females.
- Hips shallower from front to back than females.
- Hips longer from top to bottom than females.
- Pelvis more upright, diminishing the curve in the lower back.
- Shoulders are typically the broadest part of the body, wider than hips.
- Arms longer in relation to total body length, due to a longer humerus.
- Elbow positioned lower in relation to torso.
- Hand positioned lower in relation to the upper leg or thigh.

When using the head as a unit of measure, one can make some general proportional observations about a standing adult figure, whether male or female. Beginning with the head-length and repeating that length down the body toward the feet, you can anticipate some figurative landmarks that the head-lengths will come close to.

The first head-length is determined by measuring from crown to chin, taking into account the axis of the head if it is tipped (Figure 2–13). The second head-length will bring you near the nipples of the breasts, although there is considerable variation here in women based on breast size. The third head-length will bring you to the region of the navel, which will also correspond roughly to the position of the elbows with the arms hanging at the sides. The fourth head-length brings us slightly below the actual midpoint of the body, which is located at the pubic bone in the male form and slightly above the pubic bone in the female form. Continuing to measure down the body in

Figure 2–13. Statue of Germanicus, from the fifteenth century. Courtesy of Dover Pictorial Archive Series, Dover Publications, Inc. This representation of a standing male figure approximately seven and a half heads tall shows the location of head-lengths when they are repeated through the length of the body. Head-lengths are more likely to fall near a landmark in the upper body than in the lower body.

Figure 2–14. Student work. Regina M. Westhoff. In this student drawing, which appropriates a Renaissance image of the Christ child and the virgin Mary, the difference between adult and infant proportions as they relate to head length is clear.

head–length increments will usually bring you to regions which lack significant landmarks, such as the mid-thigh area and the middle of the lower leg.

At birth, the human head is much larger in relation to total body length, and progressively reaches adult proportions (Figure 2–14). In old age, the proportion of the head to the body changes slightly once again as bone mass shrinks somewhat and there is some loss of height.

Gesture Drawing or Rapid Contour Drawing

Gesture drawing is an essential exercise for "warming up" prior to a more extended drawing session. Although it is most often used in relation to the figure and its inherent energy and potential for movement, it is viable to apply gesture drawing principles to any subject matter. When applied to the figure, gesture drawing helps to energize not only the student, but also the model. It gets the body moving and the blood flowing, which can in turn energize a sluggish brain. This can be especially valuable in starting a class that meets first thing in the morning, when many people are still struggling just to wake up; right after lunch, when food is being digested and our biological clocks often desire an afternoon siesta; or in the evening following a long and tiring day.

In addition to its preparatory value, gesture drawing is a great exercise in and of itself, and provides the perfect complement to a longer, more sustained drawing experience that eventually focuses on details and specifics. The generalized nature of information gathered in a gesture drawing (Figure 2–15) provides solid reinforcement for the process of working from general to specific, and helps the student to gain experience in making rapid observations of overall figurative placement and proportion.

A typical gesture drawing/gesture pose lasts anywhere from fifteen or thirty seconds to three minutes. Some instructors prefer to begin with shorter poses and progress to longer poses, while I find it best to begin with three-minute poses and work toward fifteen-second poses, which students generally find more challenging in their brevity. To facilitate the qualities of energy and immediacy, encourage students to hold their drawing material (whether it be pencil or stick or brush) loosely so that they can utilize their entire arm. Often the tendency is to grip the tool in the same way

Figure 2–15. Student work, Moorhead State University. Kevin Olson. Note the absence of any detail or refinement of specific information in this gesture drawing.

one would if writing, but writing generally requires more precise and constricted movement than is desirable in gesture drawing.

Steps for Successful Gesture Drawing

Seeing Is the Key

- Spend some time just looking at the pose before beginning to draw.
- Spend the majority of time looking at the model rather than at the drawing.
- The movement of your hand should duplicate the movement of your eyes as you scan the figure for proportion and general disposition.
- Establish general scale and proportion purely through visual observation. A formal use of the sighting stick and the sighting process is inappropriate in gesture drawing because of the limited time involved.
- Stand at arm's length from the drawing surface in a position allowing a broad view of both the model and the drawing surface. Keep the drawing surface at a height that is most comfortable for you.

Use Axis Lines

- Use axis lines to indicate directional thrusts or to show the major masses of the body (head, upper torso or rib cage, lower torso or pelvis, limbs) in opposition.
- Indicate the angle of the head, the curve of the spine, the angular relationship between left and right shoulder, between left and right hip bone, between left and right breast, between left and right foot in a standing or crouching figure.
- Be attentive to the shape and placement of the feet (Figure 2–16). The foot may seem like a minor element of the figure, but in fact it plays a very important role

Figure 2–16. Student work. Susan Cannarile-Pulte. The shape and placement of the feet in this gesture study are key elements in accurately describing posture, weight distribution, and position in space.

in anchoring the body. Finding the correct shape and placement of the foot is essential in creating a convincing ground plane, which gives the figure its proper position in space and a sense of weight and grounding.

Keep it Simple

- Details of the figure, such as facial features or individual fingers and toes are unimportant in gesture drawing and should not be of concern.
- Try to be economical with marks—don't overwork the gestures. Let gesture drawing be a statement of essentials or essence.
- Define the general characteristics of the figure—movement or directional thrusts, shape, weight distribution or muscle tension (through weighted line), basic position of head, hands and feet, position in space, etc. (Figure 2–17).
- Generally speaking, do not be concerned with light and dark or value structure of the figure unless the emphasis is on sustained gesture, which is a variation of gesture drawing that allows for a rapid and simplified indication of planes of light and shadow.

Pick Up the Pace

- The figure and its position should be suggested in its entirety within the first few seconds of drawing. This is accomplished by recording the largest and most apparent axis lines first.
- Think energy and immediacy. Gesture drawing is a record of the energy and movement that goes into making the marks.

Figure 2–17. Student work. Lisa Kolosowsky-Paulus. This gesture drawing, executed with a stick dipped in ink, utilizes principles of closure in defining the general characteristics of the figure.

Figure 2–18. Student work. Key points of articulation, such as where the thigh meets the hips or where the hips meet the torso, are addressed through marks that move into the interior of the figure.

- Use the entire arm and wrist and shoulder to draw; use your whole body. Stand up when doing gesture drawings to enable fluid and rapid drawing.

Work from the Inside Out

- Have an awareness of underlying structure, which acts as the armature for the flesh of the figure. Indicate the simple underlying masses of the skeletal system—skull, rib cage, pelvis—using geometric simplification of these forms.
- Indicate general points of articulation, such as the joining of the limbs with the torso. These are good places to cross over into the interior of the figure, and doing so reinforces the idea that gesture drawing should not focus solely on outermost contours (Figure 2–18).

Gesture drawings of the figure certainly call for an awareness of the model's body and movements, and it is helpful for the students to extend this awareness to themselves. Encourage your students to be aware of the relationship of their own body to the drawing easel (assuming a standing position, which is recommended for executing gesture drawings). It is best to be turned slightly in relation to the model so that there is no need to constantly peek around a drawing board or drawing pad to see the figure. Right-handed students should position themselves so that they are looking to their left to see the model. This allows for the greatest range of motion with their right arm. Conversely, left-handed students should position themselves so that they are looking to their right to see the model. Position the height of the drawing surface so that eye level falls within the top half of the drawing surface. This helps to prevent arm or back fatigue caused by reaching too far up or down, especially during an extended gesture-drawing session.

Figure 2–19. Student work. Aaron Phipps. Rich linear variation plays a significant role in describing the form and movement of a cellist playing her instrument.

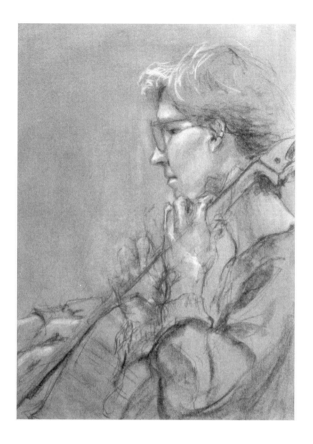

Enhancing the Illusion of Volume and Space in the Human Form

Line Variation

Chapter one provides an in-depth discussion of line work in relation to a variety of subject matter. It is worth noting, however, that the human form provides a particularly rich opportunity to explore the relationship between line and edge, and the power of line to convey volume, mass, movement, weight, form, gesture, dimensionality, emotion, and nuance (Figure 2–19).

The tremendous variety that is inherent in the human body, both at rest and in motion, explains in part its value in the study of drawing. There is also a powerful psychological element that makes the study of the human form an especially rich and satisfying experience. The simplicity and directness of line as an element of image making lends itself well to the expression of both the physical and psychoemotional presence of the human form.

Scaling Techniques

Scaling as a means of developing accurate spatial and size relationships is especially useful when approaching more complex compositions that utilize the figure as a primary subject. Beginning-level figure drawing often focuses on a single figure only, without the added challenge of relating the figure to other forms or relating the

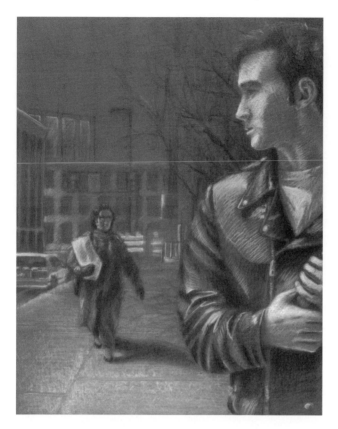

Figure 2–20. Student work. Catherine Swiatek Schaeffer. With the help of scaling, the figures are composed in correct scale and placement to each other, and invented forms and structures are convincingly represented.

figure to one or more additional figures. In encouraging students at more advanced levels to explore the relationship of a figure to an interior architectural space, to furniture or other inanimate forms, to exterior landscape elements, or to other figures, it is vital that they have an understanding of scaling methods, especially if they are being encouraged to invent or imagine these forms without the aid of visual observation (Figure 2–20). Scaling principles are consistent, regardless of subject matter, with chapter one providing a thorough explanation of and introduction to the process of scaling.

One interesting exercise for exploring scaling in relation to the human form is applicable to students at all levels of figure drawing, and can be made more or less complex by controlling the pose of the model. After providing instruction and practice with scaling techniques, instruct the model to vacillate between two different poses, perhaps one seated pose and one standing pose, for about fifteen or twenty minutes in each pose. Instruct the students to use a refined or sustained gestural approach in drawing the figure, and to place the figure five or six times on a ground plane with a clearly established horizon line (Figure 2–21). Variety of pose is provided through the two different poses and also by encouraging the students to move around the room in order to see the two poses from different vantage points. If desired, a student may explore scaling more thoroughly by drawing additional forms in relation to the figure, such as walls, windows, doorways, or other architectural or furniture forms. The results will provide a clear indication of those who understand scaling and those who do not.

Figure 2–21. Student work. Jody Williams. Based on this student's solid understanding of scaling and perspective, a standing and seated figure are convincingly repeated through-out an invented interior space, with one seated figure placed in the environment outside of the window on the left.

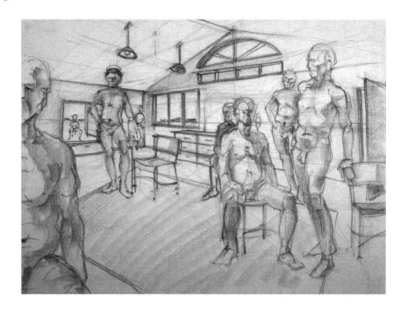

A General-to-Specific Approach

A general-to-specific approach to building value structure is discussed at length in chapter one. Figure drawing in particular benefits significantly from the application of general-to-specific principles. The philosophy of working from general to specific is intended primarily to assist in seeing large, generalized forms as the foundation upon which smaller forms or details are based. Because there are many aspects of the figure that are rich in detail, it can be especially difficult for the uninitiated to remain focused first on the larger, simpler forms. Instead, there is premature attention given to details at the expense of the larger forms, which typically results in problems with proportion and a loss of coherent volume. It is a natural tendency for our eyes to note areas of detail or areas of increased visual information. Consequently, the need to suspend interest in this information is especially challenging for the beginning student. (Emphasizing the house-building approach as an example of the application of general-to-specific techniques is invaluable to your students. See chapter one.)

The head, the hands, and the feet are frequent trouble spots in the figure when considering the need to suspend interest in details until the larger, simpler forms are clearly and proportionately established. The inexperienced drawing student often focuses on the individual features of the face while overlooking their relationship to each other and to the larger form upon which the features are based, the ovoid-shaped head. The same is true for the hands and the feet. Attention is given to the individual fingers or toes without concern for their relationship to each other or to the larger, simpler planes of the hand or foot. When this happens, it often results in a loss of unity of the form, and because value structure must also be seen in its broadest context first, a loss of volume is also to be expected.

The exercises suggested in chapter one as a method of introducing and reinforcing this invaluable approach to building form can easily accommodate the figure as sub-ject matter. Spending time studying the head, hands, and feet as individual units of the figure with their own hierarchy of general and specific information helps the student

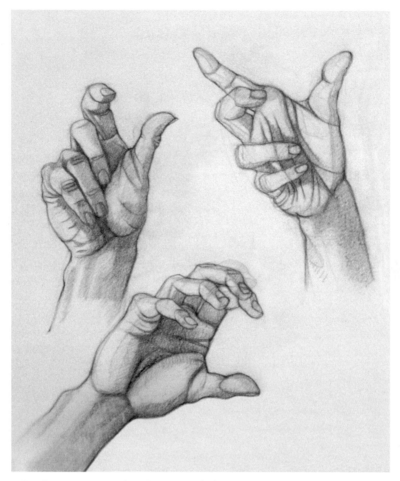

Figure 2–22. Jay Constantine. *Hand Studies,* 1987. Black conte crayon on paper, 24 x 18 inches. Courtesy of the artist. Following the initial linear investigation, basic tonal structure is blocked in using the broad side of a conte crayon and/or parallel linear strokes. Significant form begins to emerge with the use of only two tones that describe planes in light and planes in shadow.

to keep these forms generalized in the initial stages of drawing the figure in its entirety (Figure 2–22). It is especially helpful to encourage the students to first observe and record a simple planar structure with line, progressing to assigning simplified value structure to these planes. In order to discourage a premature involvement with detail, consider imposing a few limitations on the students. When working on an 18" x 24" format or larger, limit them to the use of sticks of charcoal or conte or graphite as opposed to pencils, which encourage greater attention to detail and small areas (Figure 2–23). Limit the amount of time they are given to do a study of the full figure— between fifteen and twenty minutes—with emphasis on a simplified and proportion- ate indication of the head, the torso, the limbs, the hands, and the feet. Suggest that no fingers or toes or individual features are permitted, and again, limit the material to stick form as opposed to pencil form. Finally, consider working on thumbnail sketches of the full figure that are small enough to discourage attention to fine detail (Figure 2–24).

Figure 2–23. Student work. Michael Pfleghaar. Use of the broad side of a stick of conte allows for a more generalized description of the form of the figure. A shift to the end of the conte stick can facilitate greater definition of detail if desired.

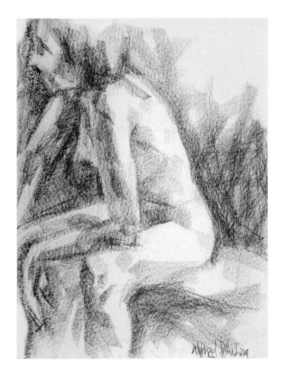

Figure 2–24. Student work. Vickie Marnich Reynolds. This small and rapid study of the figure and the surrounding environment, measuring about 3 x 4 inches, is highly simplified. The nature of a thumbnail study discourages premature attention to detail.

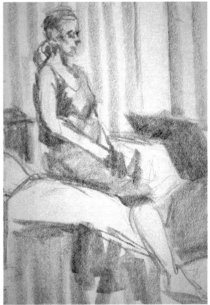

An Introduction to Portraiture

Two things in particular are necessary in teaching a student how to approach doing a portrait study in a way that will yield a likeness, or at least approximate a likeness while presenting believable human proportions. First, you must undo the bad habits and dispel the myths that often surround portraiture; and second, you must teach the student to really see the human face, bypassing assumptions and cursory examinations of the head and the facial features.

Making the students aware of the most frequent errors that occur in portrait studies is a good place to start, followed by a discussion/lecture/demonstration of placement, proportion, individual variations, etc., of the head and its component parts. Sighting is an integral part of the process of observation. Because of the detail involved in portrait studies, effective sighting and informed observation requires that the student be closer to the subject than when doing a full-figure study.

The following information, which begins with a discussion of common errors, is a guideline for the study of portraiture, progressing from general information to more specific information. It is most effective when accompanied by demonstration drawings and direct observation of the human head.

Common Errors

With the human head as subject matter, there are two critical errors that occur in our perception more often than any others, and these errors are typically reflected in our drawings. The first is the placement of the eye level in relation to the total length of the head, from the crown of the head to the tip of the chin. The second is the placement of the ear, particularly in profile and three-quarter views.

Most people perceive the eye level to be approximately one-third of the way from the top of the head. This perceptual error occurs in part because, in comparison to the rest of the face, the forehead, hairline, and top of the head are relatively uninteresting, lacking specific features or significant landmarks. Things that may psychologically seem less important are typically perceived to be physically smaller. As a result, the forehead and the top of the head are diminished in size, resulting in what Betty Edwards, in *Drawing on the Right Side of the Brain,* refers to as the "cut-off skull" error.

All proportions can be perceived merely by looking for size relationships. In a direct view of the head in an upright position, look for the following size relationships:

- Measure the distance from the inside corner of the eye to the tip of the chin.
- Compare this distance to the distance from the inside corner of the eye (eye-level line) to the uppermost part of the head (the crown).
- The distances are approximately the same, and possibly the upper measurement is even greater when accounting for the height of the hair.
- Therefore, the eye-level line is approximately central in the head (Figure 2–25).

In a profile or three-quarter view, similar perceptual errors occur. Because the "cheek" area and the side of the face lack specific features or strong landmarks, most people perceive these areas to be less important and diminish them in portraiture. As a result, the ear is thrust forward closer to the other features of the face, often appearing to be growing out of the cheekbone. This also diminishes the total width of the head in profile and three-quarter views, since the back of the head is often placed or drawn in relationship to the back of the ear. This again results in a variation of the "cut-off skull" error. Look for the following size relationships for placing the ear in profile and three-quarter views, assuming a direct view of the head in an upright position:

- In a pure profile view, measure the distance from the inside corner of the visible eye to the tip of the chin.

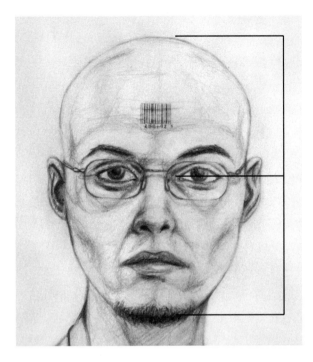

Figure 2–25. Student work. Rian E. Morgan. The location of the eye-level line in relation to the distance from crown to chin is approximately half.

- This measurement or distance should approximately repeat itself from the *outside* corner or back of the eye to the back edge of the ear.
- In a three-quarter view, measure the distance from the inside corner of the eye closest to you to the tip of the chin.
- This measurement or distance should approximately repeat itself from the *inside* corner or front of the eye to the back edge of the ear (Figure 2–26).

It is important to understand that these measuring systems are for the purpose of comparison—something to check against. There are all kinds of subtle proportional differences from one head or person to another, and this includes variables based on gender, age, and ethnic origins (Figure 2–27). Therefore, these measurements are not intended as rules, but rather as guidelines to help you discover true proportions for each individual.

General Guidelines for Locating Facial Features and Other Landmarks

The following guidelines assume a direct view of the head in an upright position.

The CENTRAL AXIS (an imaginary line running through the center of the forehead, the nose, and the mouth) is always at 90 degrees (a right angle) to the eye-level line (Figure 2–28). Even when the head is tilted, creating a tilt in the central axis, a 90-degree relationship will be maintained between the central axis and the eye-level line. In an extremely foreshortened three-quarter view, this angle may differ slightly from 90 degrees due to the effects of perspective and convergence.

The LENGTH OF THE NOSE (the point at which the nose meets the face above the mouth) is typically between one-third and one-half of the distance between the eye-level line and the tip of the chin (Figure 2–29). Rarely will the length of the nose be less than one-third of this distance or more than one-half of this distance.

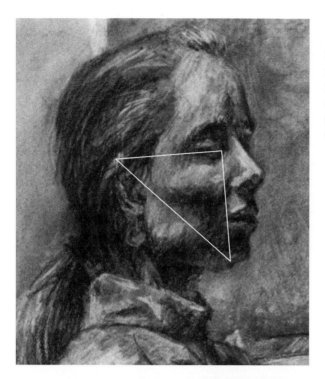

Figure 2–26. Student work (detail). Jamie Hossink. Placement of the ear in a three-quarter view of the head relates to the distance from eye level to chin.

Figure 2–27. Student work. Gypsy Schindler. A comparison of differences and similarities in facial features based on gender and ethnic origin.

Figure 2–28. Student work (detail). Patricia Hendricks. The eye-level line and central axis maintain a 90-degree angle in a frontal view of the face even when the head is tilted.

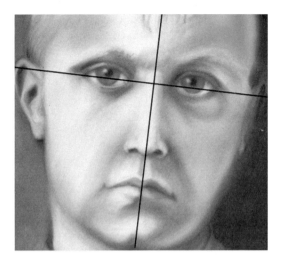

Figure 2–29. Student work (detail after Albrecht Dürer). Amy Allison. The length of the nose in relation to the distance from eye-level line to chin is typically between one-half and one-third.

The CENTER LINE OF THE MOUTH (the line formed where upper and lower lip meet) is located approximately one-third of the distance from the end of the nose (where the nose joins the face) to the tip of the chin (Figure 2–30).

The DISTANCE BETWEEN THE EYES IN A FRONTAL VIEW (and some three-quarter views) is approximately one eye width. The distance from the outside corner of the eyes to the apparent edge of the head is again approximately one eye width in a frontal view. This means that in a frontal view of the head, the total width at eye level is approximately five eye widths (Figure 2–31).

The EDGES OR WINGS OF THE NOSTRILS, in determining the width of the base of the nose in a frontal view, form an approximate vertical relationship with the inside corner of the eyes (Figure 2–32). Based on individual differences, there is significant variation in the width of the base of the nose, but the vertical relationship with the inside corner of the eyes provides a point of comparison.

The OUTSIDE CORNERS OF THE MOUTH, in determining the width of the mouth in a frontal view, form an approximate vertical relationship with the center of the eyes

Figure 2–30. Student work (detail). Gypsy Schindler. The center line of the mouth in relation to the distance from nose to chin is approximately one-third.

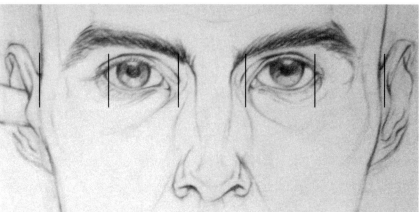

Figure 2–31. Student work (detail). James Peterson. A comparison of the width of one eye in a frontal view to the width of the full face at eye level reveals five nearly equal units—two containing the eyes, one containing the space between the eyes, and two containing the space adjacent to each eye.

(see Figure 2–32). Again, this vertical relationship is intended to provide a point of comparison.

The TOP OF THE EARS, where the ears meet the head, are approximately level with the eye-level line, forming a horizontal relationship between the top of the ears and the eye-level line when the head is upright (Figure 2–33).

The BOTTOM OF THE EARS, or the bottom of the earlobes, form an approximate horizontal relationship with the space between the nose and the mouth when the head is upright (see Figure 2–33).

The WIDTH OF THE NECK is generally greater than one might think, although there is a tremendous amount of variation from female to male and from person to person. Note carefully the point at which the neck appears to emerge from the

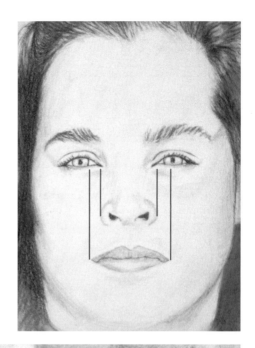

Figure 2–32. Student work (detail). Gypsy Schindler. In a frontal view of the face, the wings of the nostrils can be compared to the inside corners of the eyes by extending a vertical sight line. Similarly, the width of the mouth can be compared to the middle of the eye. Notice the subtle variations and asymmetry in alignment from the left to right side of the face.

Figure 2–33. Student work (detail). Jamie Hossink. The top and bottom of the ears often relate horizontally to the eye level and the space between the nose and upper lip. If the head is tipped up or down, the horizontal sight line tilts with it.

contour of the face, and the frequent asymmetry of these points of emergence, especially when the shoulders or head are turned even slightly (Figure 2–34).

In a THREE-QUARTER VIEW, the symmetry or "sameness" that we associate with the features of the face is radically altered. The eyes take on different shapes and different sizes in relation to each other, the far side of the nose and near side of the nose appear radically different, and the far side of the mouth and the near side of

Figure 2–34. Student work. Rian E. Morgan. Because the shoulders and neck are slightly turned away from the picture plane, the point where the neck appears to emerge from the contour of the face is different from the left to right side.

Figure 2–35. Student work (detail after Hans Burgkmair the Elder). Kerre Nykamp. A three-quarter view of the face reveals asymmetry in the shape and size of the facial features.

the mouth also appear different—all due to the turning of the head and the effects of perspective (Figure 2–35). As always, careful observation will help you to perceive these differences and avoid drawing what you "know," instead drawing what you actually see.

The Features and Other Significant Aspects of Portraiture
The Eyes

Look carefully at the actual shape of the eyes (Figure 2–36). Observe the angle or axis line, in a frontal view, from the left to right side of each individual eye. Does the eye angle up from inside to outside corner? Does it angle down, or does it remain

Figure 2–36. Student work (detail). James Peterson. A detail view of a self-portrait emphasizes the eyes and the use of line and line variation to represent them.

Figure 2–37. From illustrations of the psychological relations of the brain (Phrenology). Courtesy of Dover Pictorial Archive Series, Dover Publications, Inc. In a profile view of the face, the upper and lower eyelid rest at an angle. This angle is frequently misrepresented as a vertical, which makes the eye appear to bulge unnaturally.

horizontal from inside to outside corner? Even in a frontal view, the two eyes are often shaped somewhat differently. Note in a frontal view that the highest point of the curve of the upper lid is usually located nearer the inside corner of the eye, while the lowest point of the curve of the lower lid is usually located nearer the outside corner of the eye. The tendency is to place the peak of both curves in the same location, but this does not accurately represent the shape of the eye.

When drawing the iris, remember that it is circular in shape. Look at the white of the eye, and draw the white shapes around the iris that are bound by the upper and lower lid. Sometimes this will be one large white shape, unbroken beneath the iris, but more often it will be two separate shapes divided where the iris meets the upper and

Figure 2–38. Student work (detail). Patricia Hendricks. A detail view of the eyes in this portrait study of a young boy reveals information about tonal changes in and around the eye.

lower lid. Notice that the eyelashes are often not even apparent and can be indicated simply by darkening the line used to define the edge of the eyelid. Eyelids are not paper thin, but have thickness, and the eyeball is seated behind the lids—it is recessed. This is particularly evident in a profile view. Especially in a profile view, notice that the front edge of the eyeball does not sit vertically in the face but slants back slightly from top to bottom (Figure 2–37).

When incorporating tone or value, notice the value changes that occur on the eyeball itself (Figure 2–38). This is of course affected by the light source, both the strength of the light and the direction of the light. The white of the eye is not actually white and because the eyeball is a sphere and recessed behind the eyelid, there is frequently a shadow cast on the eyeball by the upper lid. Look for strong highlights in the eye, resulting from the moisture in the eye picking up and reflecting your light source. This highlight information adds life to the eyes, although it may not be evident if the eyes are in deep shadow. Look for the value changes around the eye, and note carefully the shape of these areas of value. This information is particularly important in showing that the eyes are recessed in the head, set back in the sockets, and resting beneath the ridge of the brow to protect them. By observing the shadows around the eyes and drawing them carefully, you will avoid a portrait drawing in which the eyes appear to be floating in the face.

The Nose

Notice the shape of the nostrils, which is different in a frontal view than in a profile view as only one nostril is visible (Figure 2–39). In a three-quarter view the two nostrils take on entirely different shapes. Depending on the structure of the nose and the view from which you are observing it, note that some nostril openings will be more angular, some gently curved, some full and "open," some narrow and "closed." Note the overall axis of the nostril, even though it may be very subtle. Is the axis

Figure 2–39. Student work (detail). Heather Powers. This detail of a self-portrait provides a frontal view of the facial features. Notice the shape of the nostrils, their slight asymmetry, and their width-to-height relationship.

Figure 2–40. Deborah Rockman. *Self-Portrait*, 1990 (detail). Graphite on gessoed paper, 23 x 17 inches. Courtesy of the artist. High side lighting in this self-portrait creates shadow on one side of the nose and light on the other. If represented with line only, the length of the nose could be described with a delicate line along the shaded edge.

vertical, horizontal, or does it move on a diagonal? Careful observation will reveal key information.

In a profile view, you are able to perceive a definite edge along the length of the nose and this can be carefully observed and drawn with a line. In a three-quarter view, this edge may be observed as a linear edge even though it may not be as clearly distinguished from the surrounding information as in a profile view (depending on the degree of the three-quarter view). In a frontal view one does not actually observe a firm linear edge running along the length of the nose (Figure 2–40). Defining, through

Figure 2–41 and Figure 2–42. From illustrations of the psychological relations of the brain (Phrenology). Courtesy of Dover Pictorial Archive Series, Dover Publications, Inc. Extending vertical sight lines through the facial features helps us to identify the relationship of one part of the face to another in terms of size, placement, etc. In comparing these two different profiles, note that in the older man's face, the bridge of his nose aligns with the point where his lower nose meets his face, while his upper lip is positioned behind this alignment. In the face of the younger man, the bridge of the nose aligns with the back of the wing of the nostril and the contour of the upper lip is well in front of this alignment. Further analysis of the two profiles reveals a number of differences in the relationship of the features to each other.

line, the form of the nose in a frontal view depends upon the strength and direction of light source, and requires a delicate touch. With side lighting, creating shadow on one side and light on the other, you can use an appropriately delicate line to draw the contour along the length of the shaded side of the nose. With overhead lighting, you can delicately draw both the left and right contour of the length of the nose, defining the top plane of the length of the nose and distinguishing it from the delicately shaded side planes.

Observe the location of the tip of the nose, which varies greatly from individual to individual. In some cases, the tip of the nose is considerably higher than the place where the base of the nose meets the face. This is often referred to as a "turned-up" nose. In some cases the tip of the nose coincides with the place where the base of the nose meets the face, and in other cases the tip of the nose is positioned below the place where the base of the nose meets the face (this is sometimes called a "hooked" nose).

In a profile view, note the relationship between the point between the eyes where the nose meets the face (the bridge of the nose) and the point where the base of the nose meets the face (Figures 2–41 and 2–42). Do these two points align vertically, or is one point positioned behind or in front of the other point? Notice the negative space adjacent to the profile and use it to guide your drawing (Figures 2–43 and 2–44).

The Mouth

In all views of the mouth, the shape of the upper and lower lip is best defined through a combination of sensitive line work and value changes rather than solely through line. A strong line drawn all the way around the mouth will look artificial, more like a lipstick line than the actual shape of the lips, due to the fact that the edges along the outermost contours of the mouth vary in strength. Some areas that we perceive as edge, particularly along the left and right side of the lower lip, are often not edges at all but simply a color shift.

Figure 2–43 and Figure 2–44. From illustrations of the psychological relations of the brain (Phrenology). Courtesy of Dover Pictorial Archive Series, Dover Publications, Inc. In again comparing these two profiles, notice the significant differences in the negative space around the profiles bounded by diagonal extensions from the tip of the nose to the tip of the chin and from the tip of the nose to the outermost projection of the forehead. Note also that the older man's forehead slopes away from the plane of his face more dramatically than the younger man's forehead.

Figure 2–45. Student work (detail). Jamie Hossink. In this detail view of a self-portrait, the mouth is almost exclusively defined by the center line where upper and lower lip meet. Although the facial hair obscures the mouth somewhat, there is evidence of delicate line work used to describe some of the outermost contours of the upper and lower lip.

The center line of the mouth where the upper and lower lip meet is a strong edge, and can be represented by the darkest line work in drawing the mouth (Figure 2–45). Carefully observe the length of the center line of the mouth and the directional changes that occur all along the length of the center line. Note that the center line of the mouth is not equally dark along its length, but changes subtlely in value as well as direction. It is often not exactly the same on one side of the mouth as on the other. The center line of the mouth is of particular importance in capturing the personality and expression of the model.

Note the direction of the center line of the mouth at the corners, as well as value changes and shapes of value found at the outermost corners. Do the corners of the mouth slant down, slant up, or does one corner of the mouth slant one way and one corner another? Typically speaking, you may notice that the upper lip is darker in value than the lower lip, and that the lower lip's shape and size can be indicated by drawing

Figure 2–46. Student work
(detail after Albrecht Dürer). Amy Allison.
This detail of a student's drawing after Dürer
illustrates the fact that the upper lip, with
overhead lighting, is often darker in value than the
lower lip and that the lower lip is often defined by
the delicate shadow that it casts below itself. A
linear contour of the lower lip typically breaks
at the outside edges in acknowledging that the
illusion of a tangible edge is in fact only a
color shift.

Figure 2–47. Student work (detail).
This detail of a portrait study in profile shows
the relationship of the contour of the lips to a
diagonal sight line joining the tip of the nose
and the chin. In this instance both upper and
lower lip rest behind this diagonal. Note, too,
the extreme difference in the angle of the
forehead (nearly vertical) and the angle
of the nose.

the shadow that it casts just beneath itself, noting that this shadow varies greatly in size and shape from one person to another (Figure 2–46). Observe carefully the activity at the outermost corners of the mouth. Again, this information is vital in capturing the expression of the model.

Pay attention to the relationship between the upper and lower lip in terms of length from side to side and width from top to bottom. There is great variation from person to person. Are the top and bottom lip roughly equal in their width or fullness, or is one lip or the other much fuller or much narrower? In terms of length, does the upper lip appear longer than the lower lip, the same, or shorter than the lower lip? Does the upper lip protrude beyond the lower lip, or vice versa?

In a profile view, there are many places where contours change direction, creating landmarks, and this is certainly true of the mouth area, or the space between the base of the nose and the tip of the chin. Notice the relationship in placement between outermost and innermost projections, or landmarks. Note the angles between these points, and the negative space found adjacent to these contours. Often, although not always, the lower lip is positioned slightly behind the upper lip. It can be helpful to draw a sight line that joins the tip of the nose and the outermost projection of the chin, observing then the relationship of the contour of the lips to this diagonal line (Figure 2–47).

The Ears

Whether in a frontal, three-quarter, or profile view, the correct placement of the ear or ears is vital. Always take note of the position of the ear in relation to other features or landmarks in the face or head that you have already drawn (Figure 2–48). Note the overall shape of the ear—squared-off, rounded, long and narrow, full at the top and narrow at the bottom—and describe to yourself the shape as you are drawing it.

In a three-quarter or profile view, note that the ear is often not purely vertical in its placement, but is slightly diagonal with the top of the ear leaning more toward the back of the head (Figure 2–49). This diagonal orientation is most evident when looking at the front edge of the ear where it attaches to the head.

Look carefully for shapes of light and dark within the overall shape of the ear. As with all the features, ears vary tremendously from one individual to another. Note whether the earlobes are "attached" or "unattached."

Figure 2–48. Student work (detail). Jamie Hossink. This detail view of a self-portrait shows the ears rising somewhat in relation to the eyes and nose due to the fact that the subject's head is tilted slightly forward. Note, too, the asymmetry of the ears in both shape and placement. Many of us have one ear positioned higher than the other, which accounts for the fact that glasses often rest crookedly on our face without an adjustment to the ear pieces.

Figure 2–49. Student work (detail). Chris Schroeder. This detail view of a head and hand study shows the diagonal orientation of the ear.

Figure 2–50. Student work. Heather Powers. Because the shoulders are turned slightly, the neck appears to emerge from the contour of the face in slightly different places from left to right side. Notice, too, that the neck (the sternomastoid muscle) overlaps the shoulder area on one side and not on the other due to the subtle turning of the form.

The Neck

In frontal and three-quarter views, take note of where the contour of the neck appears to emerge from the head (Figure 2–50). This will vary depending on your viewpoint, the position of the model, and gender to some degree.

In a profile view, use the negative space in front of the neck to help you observe the correct contour of the underside of the chin and the neck. The front contour of the neck is usually at a diagonal, slanting back away from the profile, and in a male will

Figure 2–51. Edgar Degas (French, 1834–1917). *Study for the Portrait of Diego Martelli (half length),* 1879. Black chalk heightened with white chalk on tan paper, 45 cm x 28.6 cm. Courtesy of the Fogg Art Museum, Harvard University Art Museums. Bequest of Meta and Paul J. Sachs. In Degas's three-quarter-view portrait study, the shape and size of the shoulders vary greatly from left to right side because the upper body is also seen in a three-quarter view. Note, too, that because the viewpoint is above the model looking down, the shoulders appear to emerge from a point much higher in the head than if viewed from a less dramatic angle.

include a more prominent projection of the Adam's apple. Notice in a profile view that the point at which the back of the neck appears to emerge from the head is considerably higher than the point where the front of the neck emerges. The back of the neck typically emerges at a point that relates horizontally to the bottom of the ear.

The Shoulders
Make sure that the shoulders are wide enough, and observe the height of the shoulders in relation to each other. The angular relationship or axis line from one shoulder

Figure 2–52. Deborah Rockman. *Study of Man's Head,* 1982. Black conte crayon on paper, 24 x 18 inches. Courtesy of the artist. The shape of the hairline and the forehead reflects the asymmetry associated with three-quarter views of the head and face.

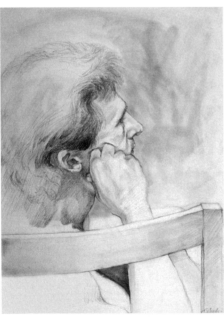

Figure 2–53. Student work. Chris Schroeder. The strokes used to selectively describe the hair show concern for both the direction the hair grows and falls and the patterns of light and shadow found in the hair.

to the other shoulder is important in capturing the attitude of the model and is often complementary to a tilt in the central axis of the head.

If the shoulders do not face you directly, note the difference in size and overall shape between the shoulders (Figure 2–51). The contour of one shoulder may emerge far beyond the contour of the head, while the contour of the other shoulder may not. If the shoulders are drawn too large, the head will appear too small. If the shoulders are drawn too small, the head will appear too large. Careful observation will help you to perceive the true appearance of forms.

The Hair

Observe the shape of the hairline. Use the negative shape of the forehead to help you see the shape of the hairline. Note the differences in the shape of the hairline from one side to the other, particularly in a three-quarter view (Figure 2–52). In drawing the hair, use strokes that move in the direction that the hair grows or in the direction that the hair falls, and use line to indicate places where the hair separates. Rather than drawing individual strands of hair, which is contrary to our actual perceptions of hair, look for shapes of light and dark values within the hair and draw these (Figure 2–53). Hair contains light and dark passages just as flesh does, and by observing these value changes you can avoid drawing hair that appears flat and wig-like.

In drawing the overall shape of the hair, make sure that you account for the presence of the skull beneath the hair. Try to see the skull shape underneath or through the hair and indicate it lightly, adding the hair to this underlying shape.

In observing the hair that makes up eyebrows, take careful note of the shape and placement of the eyebrow in relation to the eye, and indicate the subtle value changes in the eyebrow based on the density of the hair at different points in the eyebrow. Notice that the two eyebrows are often shaped somewhat differently, and one may be positioned higher or lower than the other.

Value Structure

Value structure is important in defining the volume and three-dimensionality of the head. In observing value structure (Figure 2–54), look for the following: What are the shapes of light and dark values observed? How do these shapes relate to the surrounding features in terms of size and placement? Are the edges of these shapes of light and dark crisp and sharp, or soft and fuzzy, or somewhere in between? Does a single shape of value contain both crisp edges and soft edges? Does the value change from light to dark occur suddenly, creating a sharp edge, or does the value change occur gradually, creating a soft transition from one value to another?

Are there subtle value changes that occur within a shape of light or dark? Does a large dark shape of value contain some lighter areas? Does a large light shape of value contain some darker areas? Keep your light and shadow distinct from one another. Make careful observations.

An Alternative Viewpoint

In discussing the placement of features in portraiture and the general appearance of these features, we assumed a direct view of an upright head. Even with this assumption, a tremendous amount of variety is possible.

In instances where the viewpoint is significantly altered, it must be noted that proportional relationships, placement of features, and general appearances are also significantly altered. An altered viewpoint implies that the model's head is thrust forward or backward, and possibly tilted significantly to one side or the other, or that the artist drawing the portrait is positioned well above the model and looking down, or is positioned well below the model and looking up. When the viewpoint is so altered, careful observations must be made to capture a sense of the viewpoint.

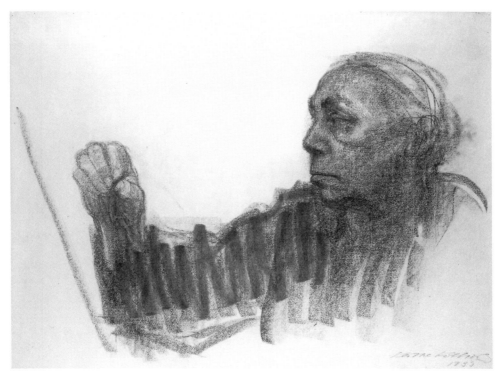

Figure 2–54. Kathe Kollwitz (1867–1945). *Self-Portrait, Drawing,* 1933. Charcoal on brown laid Ingres paper, 18-¾ x 25 inches. © 1999 Board of Trustees, National Gallery of Art, Washington, DC. Rosenwald Collection. In this powerful self-portrait, Kollwitz defines the form of the face almost exclusively through value structure. Note in particular the shapes of darker value that define the eye and eye-socket area, the cheekbone, the underside of the nose, the upper lip, the area below the lower lip, and the underside of the chin and jawline. All of this information describes her specific facial structure in response to a light source positioned above her head.

If, for example, the model's head is thrown back or the artist is below the model and looking up, several things will change (Figure 2–55):
- The eye-level line in relation to the total length of the head will rise, appearing closer to the top of the head and above the halfway point of the height of the head. This is particularly true in a frontal view as opposed to a profile view.
- The ear level will drop in relation to the other features of the face.
- More of the underside of the nose will be visible and the apparent length of the nose will be shorter.
- More of the underside of the jaw will become visible.
- Less of the hair and the top of the head will be visible.

If, for example, the model's head is thrown forward or the artist is above the model and looking down, several things will change (see Figure 2–51):
- The eye-level line in relation to the total length of the head will drop, appearing closer to the chin and below the halfway point of the height of the head. This is particularly true in a frontal view as opposed to a three-quarter or profile view.
- The ear level will rise in relation to the other features of the face.

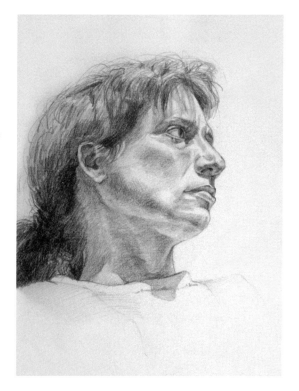

Figure 2–55. Student work. Chris Schroeder. In viewing the model's face and head from a position well below the model's eye level, proportional relationships, placement of features, and general appearances deviate significantly from what we might expect to see with a more direct viewpoint.

- The apparent length of the nose will increase in relation to the distance between the eye-level line and the chin.
- Less of the underside of the nose and the jaw is visible.
- More of the hair and the top of the head is visible.
- The apparent contour of the shoulders may appear to emerge from the head or a point much higher than we are accustomed to observing. The apparent length of the neck will be shortened.

In discussing with students the different aspects of portraiture, it is very useful to have a model on hand who is comfortable with having his or her head and face and features scrutinized. For the sake of clarity, it is recommended that your model be free of facial hair or, if the model normally wears makeup, to refrain for the portrait study. Depending upon the size of the class, things can get a little tight when trying to insure that all students are close enough to observe carefully during a discussion, but it is worth it. Have the students come prepared with sighting sticks so that you can walk through each proportional observation together, sighting it on the model's face.

When discussing the tremendous variation in details of facial features, such as the shape and slant of the eyes, the shape and size of the nostrils, the fullness of the lips, the size and shape of the ears, and so on, it is very informative to select two or three students who are willing to serve as examples and bring them forward to offer a specific facial feature for examination and comparison. Choose students whose features are noticeably different so that the contrast is easily observed. For example, if you are comparing eyes, try to select one student whose eyes slant up from inside to outside corner, one student whose eyes slant down from inside to outside corner, and one student whose eyes are relatively horizontal from inside to outside corner. Or look for

differences in the heaviness of the upper lid and the space between lid and eyebrow. Although you must be careful to assure the students that a discussion of the variation in their facial features is never a criticism of one variation over another, it has proven to be both entertaining and extremely informative for the students to note actual differences in facial features based on careful visual comparison. If you, as the instructor, are willing and comfortable, it is also interesting and instructive to allow the students to verbally compare your features with someone else's.

The Figure and Anatomy

Artistic Anatomy vs. Medical Anatomy

The human form is a complex form, whether studying it from an artistic, medical, or physiological perspective. It is important to distinguish the study of anatomy as it relates to the artist from the study of anatomy as it relates to other disciplines. Artistic anatomy, as it has come to be known, concerns itself primarily with the substructure of the human form as it influences surface appearance. With the exception of those who are pursuing an interest in medical illustration, the typical emphasis of artistic

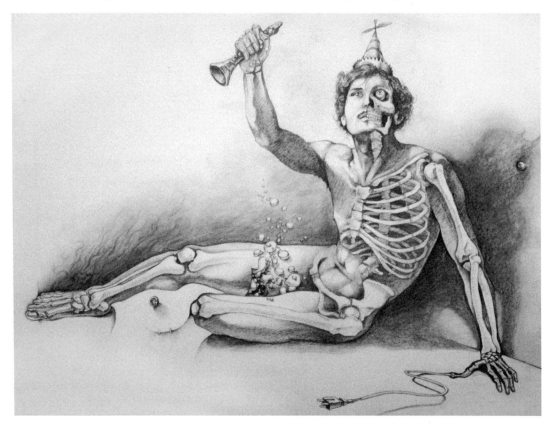

Figure 2–56. Student work (after Edgar Degas). Sean Hemak. Based on a drawing by Degas, this highly imaginative study of the skeletal structure's relationship to the exterior surface of the body indicates a solid understanding of the influence of bony masses and bony landmarks on the surface appearance of the figure.

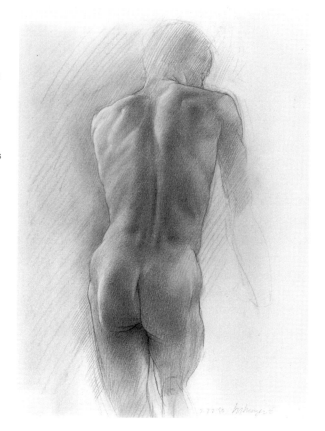

Figure 2–57. Martha Mayer Erlebacher. *Male Back,* 1980. Graphite on paper. The Arkansas Art Center Foundation Collection. Erlebacher's command of media and subject reveals the complex and subtle interaction of superficial muscles and bony landmarks as they ripple across the surface of the model's torso.

anatomy falls upon the skeletal structure, the muscle structure, and their relationship to each other and to the visible surface of the fleshed figure (Figure 2–56).

In the earliest experiences of drawing directly from observation of the human form, students are focused on what they see along the contours and on the surface of the figure. As anyone who has drawn the figure knows, there are an enormous number of dips and curves, bumps and knobs, projections and indentations encountered along the way, and sensitivity to these is vital for a convincing study of the figure. Some of this surface activity is remarkably subtle while some is rather abrupt, seeming nearly disruptive at times. While the beginning student need not complicate matters further by trying to fully understand the anatomical explanation for every hill and valley, it is advisable to ease into an awareness of the source of this visual information as early as possible in a student's figure-drawing experience.

An understanding of artistic anatomy takes some of the mystery out of drawing the figure, and helps to prevent the displacement of surface landmarks and other key information (Figure 2–57). If a student understands the anatomical source of a gently bulging area of muscle in the forearm, or a bony projection of the skeleton in the pelvic region, it encourages not only attention to that particular information but correct placement of that information in relation to the larger form. There is also an element of satisfaction with having an increased awareness and understanding of one's own body. As often as possible in discussions of the skeletal structure or the muscle structure, encourage students to identify the location of significant forms on their own

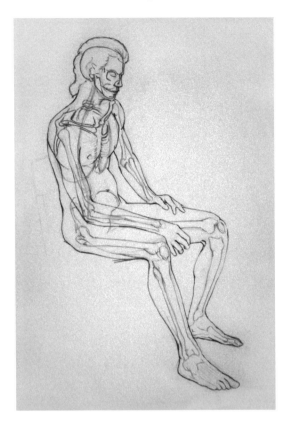

Figure 2–58. Student work.
Dennis M. O'Rourke II.
A seated model in the classroom
provides an excellent challenge
for the student of figure drawing
to accurately construct the
skeletal structure within
the body.

body in addition to pointing out the presence of anatomical landmarks on the class-room model.

Anatomy Reveals Itself

Depending upon when or where you received your art education, there may not have been any significant exposure to anatomy. Consequently, this is an area of focus that often calls for a lot of brushing up or self-teaching on the part of the instructor before it can be comfortably communicated to your students to the degree it warrants. It is one thing to study the skeleton, for example, as an isolated entity. It is an interesting and complex form in and of itself, and provides a rich and challenging drawing experience. But the greatest value in studying the skeleton lies in understanding its relationship to the living, breathing human form, and in understanding its influence on the appearance of the figure both in its entirety and in specific areas where skeletal structure rises to the surface and makes itself evident (Figure 2–58). This requires more in-depth awareness than simply being able to identify and name the major bones of the body, and it is wise to remember that if you are asking your students to do something, you should also be capable of doing it yourself. If you are asking your students to know something, you should know it, too.

Many of us, as we prepare to teach figure drawing for the first time or as we adjust our course syllabi to include skeletal structure and muscle structure, come to realize that

Figure 2–59. Student work (after Julius Schnorr von Carolsfeld). Kerre Nykamp. In this student study after a drawing by Picasso, an understanding of the location of bony landmarks in the body provides important clues in imaginatively constructing the skeleton within the body.

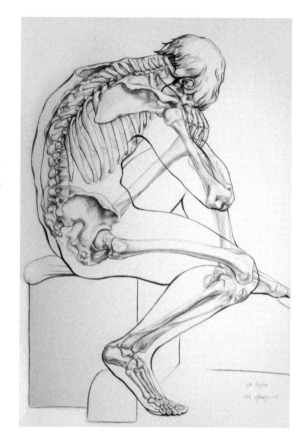

Figure 2–60. Student work. Jason Roda. This sketchbook study of the torso of a crucified figure reveals an awareness of musculature and other anatomical landmarks in relation to the specific pose. Some of the anatomical forms studied include the sternomastoid muscles, the deltoid muscles, the biceps, the flank pad of the external obliques, and the thoracic arch.

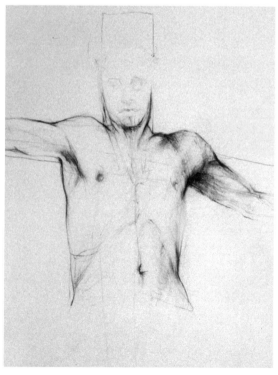

we may not have received enough instruction in artistic anatomy (if any) and that our knowledge is lacking. Or we recognize that the anatomy class we may have had in high school or college seems like—or actually was—decades ago. If this is the case, don't be too discouraged or intimidated. It is a rich and satisfying experience to acquaint or reacquaint yourself with this important aspect of figure drawing, and this can be accomplished with a good reference book and some time dedicated to the task. Each time you present the material to your students, it becomes increasingly familiar to you.

The locations on the body where the skeletal structure consistently reveals itself—regardless of gender, age, weight distribution or other variables—are commonly referred to as "bony landmarks." Bony landmarks are particularly helpful in identifying the placement or location of skeletal structure within the mass of the body (Figure 2–59). They are usually a specific part of a larger bone or bony mass, often located along the edge or the end of an individual bone, and warrant specific study as an elaboration of general skeletal structure.

Skeletal and muscle structures are closely related. Initially, it is valuable to be able to identify the major superficial muscle masses, but it is also important to understand to some degree the relationship of the muscles to the skeletal structure and to various movements and positions of the body (Figure 2–60). Because of the relative complexity of the muscles when compared to the skeletal structure, it is wise to reserve an in-depth study of muscle structure for intermediate or advanced students.

There are a number of excellent references for the study of artistic anatomy (see Supplemental Reading for Artistic Anatomy in the Bibliography). These may prove helpful for introducing basic artistic anatomy into beginning-level figure-drawing courses. Some teachers may choose to present artistic anatomy in great depth, while others may find it desirable to simplify the presentation of artistic anatomy. Consider the role anatomy may play for the particular group of students you are teaching, and refine your approach accordingly.

Major Bones of the Human Skeletal Structure

Following is a list of bones that influence to varying degrees the external appearance of the human figure. While this is a fairly comprehensive list of all the bones in the human body, it does not include a specific breakdown of some groupings of smaller bones, but rather identifies them by the name given to the collection of bones that creates a larger mass. For example, the grouping of eight small bones found in the region of the wrist are simply identified as the carpal bones, and the grouping of seven bones found in the region of the ankle are identified as the tarsal bones. For some bones, the commonly used lay term is provided in parentheses. Bones that are found in groupings of more than two are indicated by a number following the name of the bone.

A number of bones are subdivided into specific parts of that bone, such as the sternal and acromial end of the clavicle. These are significant in that they are bony landmarks, and the reader will find them cross-referenced under the heading "Bony and Other Landmarks in the Figure," along with a more comprehensive list of other significant bony landmarks. The number which precedes each bone or bony landmark identifies its location in the illustrations provided of the full skeletal structure (Figures 2–61 and 2–62).

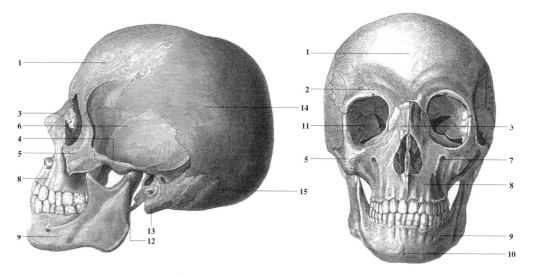

Figure 2–61. The Bones of the Head. Courtesy of Dover Pictorial Archive Series, Dover Publications, Inc. A profile and frontal or anterior view of the human skull with specific bones and bony landmarks identified.

The Skull/Cranium
1. Frontal Bone
2. Superciliary Ridge (Brow Bone)
3. Nasal Bone
4. Zygomatic Arch
5. Zygomatic Bone (Cheek Bone)
6. Temporal Bone
7. Canine Fossa
8. Maxilla
9. Mandible (Jaw Bone)
10. Mental Protuberance
11. Orbit (Eye Socket)
12. Styloid Process
13. Mastoid Process
14. Parietal Bone
15. Occipital Bone

The Torso
Vertebral Column (Spinal Column)—26 total:
 16. Cervical Vertebrae—7
 17. Thoracic Vertebrae—12
 18. Lumbar Vertebrae—5
 19. Sacrum
 20. Coccyx (Tailbone)
21. Clavicle (Collar Bone):
 22. Sternal End
 23. Acromial End

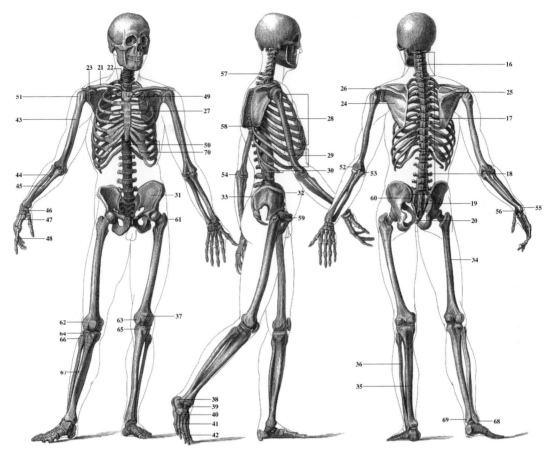

Figure 2–62. Anatomy of the Bones. Courtesy of Dover Pictorial Archive Series, Dover Publications, Inc. A profile, anterior, and posterior view of the full skeleton with specific bones and bony landmarks identified.

24. Scapula (Shoulder Blade):
 25. Spine of Scapula
 26. Acromion of Scapula
27. Sternum (Breastbone)

Ribs—24 total:
 28. True Ribs—7 pairs
 29. False Ribs—3 pairs
 30. Floating Ribs—2 pairs
31. Pelvis (Hip Bone):
 32. Anterior Superior Iliac Spine
 33. Posterior Superior Iliac Spine

The Leg and Foot
 34. Femur
 35. Tibia (Shin Bone)
 36. Fibula

37. Patella (Kneecap)
38. Calcaneus (Heel Bone)
39. Talus
40. Tarsals—7 total, including calcaneus and talus
41. Metatarsals—5
42. Phalanges—14

The Arm and Hand

43. Humerus
44. Radius
45. Ulna
46. Carpals—8
47. Metacarpals—5
48. Phalanges—14

Bony and Other Landmarks in the Figure

27. Sternum (Breastbone)
49. Suprasternal Notch
50. Infrasternal Notch
22. Sternal End of Clavicle
23. Acromial End of Clavicle
51. Head of Humerus
52. Lateral Epicondyle
53. Medial Epicondyle
54. Olecranon Process (Elbow)
55. Styloid Process of Ulna (Wrist Bone)
56. Styloid Process of Radius
57. Spine of Seventh Cervical Vertebra
25. Spine of Scapula
58. Inferior Angle of Scapula
32. Anterior Superior Iliac Spine
33. Posterior Superior Iliac Spine
59. Pubic Arch
60. Sacral Triangle
61. Great Trochanter
62/63. Lateral and Medial Condyle of Femur
64/65. Lateral and Medial Condyle of Tibia
66. Head of Fibula
37. Patella (Kneecap)
67. Tibial Shaft (Shin Bone)
68. Lateral Malleolus of Fibula (Ankle Bone)
69. Medial Malleolus of Tibia (Ankle Bone)
70. Thoracic Arch or Border

Figure 2–63. Student work.
James Anderson. The ulnar crest
is evident in the forearm of this
cropped study of a female figure.

Superficial Muscles of the Human Figure

Following is a list of significant superficial muscles that influence to varying degrees the external appearance of the human figure. There is considerable complexity in the musculature of the human body, but it is not necessary to overwhelm a student of figure drawing by delving into muscle structure to the degree that would be expected of a medical student. The emphasis here is on the outermost layer of muscles that most often affect how the figure appears in a variety of positions and activities.

The muscles are grouped according to the area of the body in which they are located, although some muscles (such as the deltoid) are listed twice if their location is associated with two different parts of the body (both the upper arm and the torso). In those instances when the muscle presents itself as more than one significant mass, it is broken down into its component parts (such as the clavicular head and the sternal head of the sternomastoid muscle).

When a number of smaller muscles are perceived visually as a single unit or mass, they are listed first as a grouping and then a breakdown is provided. Some examples of this include the grouping of muscles in the lower arm known collectively as the extensor muscles, or the grouping of muscles in the upper inner-thigh area known collectively as the adductor muscles. You may choose to study these either as a group of muscles or as individual muscles or as both. Some muscles, such as the medial head of the tricep, are rarely visible in the fleshed figure and consequently bear little influence on the surface form. These muscles, although considered superficial muscles, are not included in the listing because of their relative visual insignificance.

Occasionally an anatomical form is listed that is not actually a muscle but is a significant landmark that is related to muscle structure. Examples of this include the thyroid cartilage (commonly known as the Adam's apple), or the ulnar crest, which is a grooved landmark in the forearm visually separating the flexor muscles from the

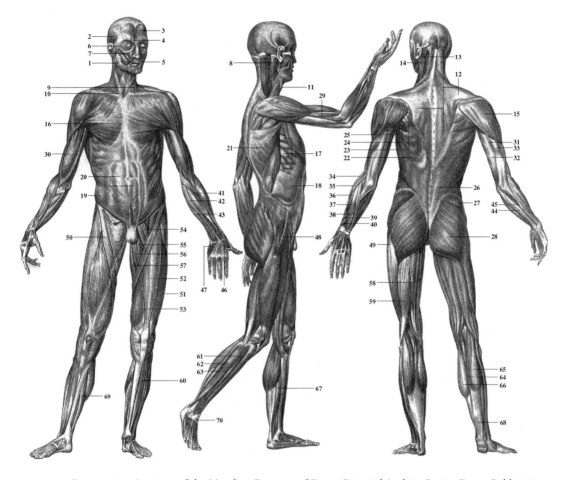

Figure 2–64. Anatomy of the Muscles. Courtesy of Dover Pictorial Archive Series, Dover Publications, Inc. A profile, anterior, and posterior view of the superficial layer of muscles with specific muscle masses identified.

extensor muscles (Figure 2–63). You may or may not wish to emphasize this information as part of the study of the muscle structure. The number which precedes each muscle or muscular landmark identifies its location in the illustration provided of the full superficial muscle structure (Figure 2–64). Some key anatomical terms are included to facilitate the study of both the skeletal structure and the muscle structure.

The Face and Head
1. Masseter
2. Temporalis
3. Frontalis
4. Corrugator
5. Orbicularis Oris
6. Orbicularis Oculi
7. Zygomaticus Major

The Neck
8. Sternocleidomastoideus (Sternomastoid):
 9. Clavicular Head of the Sternomastoid
 10. Sternal Head of the Sternomastoid
11. Thyroid Cartilage (Adam's Apple)
12. Trapezius (extends into torso)
13. Splenius
14. Scalenus Medius

The Torso
15. Deltoid (extends into upper arm)
12. Trapezius (extends into neck)
16. Pectoralis Major
17. Serratus Anterior
18. External Obliques
19. Flank Pad of External Obliques
20. Rectus Abdominis
21. Latissimus Dorsi
22. Rhomboid
23. Teres Minor
24. Teres Major
25. Infraspinatus
26. Sacrospinalis (Erector Spinae)
27. Gluteus Medius
28. Gluteus Maximus (extends into leg)

The Arm and Hand
15. Deltoid (extends into torso)
29. Brachialis
30. Biceps
31. Triceps:
 32. Long Head of Triceps
 33. Lateral Head of Triceps

Extensor Muscles of the Forearm are located on the lateral side of the forearm with the arm dangling at rest, and on the top side of the forearm with the hand in pronation. Extensors (also known as Supinators) are responsible for extending the wrist, opening the hand, and lengthening forms.
34. Brachioradialis (Supinator Longus)
35. Extensor Carpi Radialis Longus
36. Extensor Carpi Radialis Brevis
37. Extensor Digitorum
38. Extensor Carpi Ulnaris
39. Abductor Pollicus Longus
40. Extensor Pollicus Brevis

Flexor Muscles of the Forearm, not individually identifiable on the surface of the body but rather seen as a group, are located on the medial or inner side of the forearm with the arm dangling at rest, and on the underside or underbelly of the forearm with the hand in pronation. Flexors (also known as Pronators) are responsible for flexing the wrist, closing the hand or grasping, and shortening forms.

41. Flexor Carpi Radialis
42. Palmaris
43. Flexor Digitorum
44. Flexor Carpi Ulnaris
45. Ulnar Crest: Grooved landmark on the forearm separating flexor muscles and extensor muscles
46. Thenar: Located on the thumb side of the palm of the hand
47. Hypothenar: Located opposite the thumb on the palm of the hand

The Upper Leg
28. Gluteus Maximus (extends into torso)
48. Tensor Fasciae Latae
49. Iliotibial Band
50. Sartorius: Longest muscle in the body

Quadriceps Femoris (extensor muscles) form the muscle group on the front of the thigh with some individual definition (also called Quads).

51. Vastus Lateralis
52. Rectus Femoris
53. Vastus Medialis

Upper Inner-Thigh Muscles (adductor muscles) are not individually identifiable on the surface of the figure and are seen as a group.

54. Pectineus
55. Adductor Longus
56. Adductor Magnus
57. Gracilis

Back Thigh Muscles (flexor muscles) are not individually identifiable on the surface of the figure and are seen as a group (also called Hamstrings).

58. Semitendinosus: Forms medial tendon at knee
59. Biceps Femoris: Forms lateral tendon at knee

The Lower Leg and Foot
60. Tibialis (Anterior location)
61. Extensor Digitorum Longus (Lateral location)
62/63. Peroneus Longus/Peroneus Brevis (Lateral location)
64. Gastrocnemius (Posterior location)
 65. Lateral Head
 66. Medial Head
67. Soleus (Posterior location)

68. Achilles Tendon (Posterior location)
69. Flexor Digitorum Longus (Medial location)
70. Extensor Digitorum Brevis (Lateral location on foot)

Anatomical Terminology

MEDIAL: Positioned toward the center or midline of the body
LATERAL: Positioned toward the outside of the body
ANTERIOR: Positioned toward the front of the body
POSTERIOR: Positioned toward the back of the body
SUPERIOR: Toward the top or a higher position
INFERIOR: Toward the bottom or a lower position
EXTENSOR/EXTENSION: To open a hinged joint fully in order to straighten or lengthen a form
FLEXOR/FLEXION: To close a hinged joint fully in order to bend or shorten a form
ROTATOR/ROTATION: Spiraling or twisting motion often originating at a ball-and-socket type of joint
ABDUCTOR/ABDUCTION: Movement away from the center of the body
ADDUCTOR/ADDUCTION: Movement toward the center of the body
SUPINATION: For the arm, positioned with palm side of hand up
PRONATION: For the arm, positioned with palm side of hand down
LONGUS: Long
BREVIS: Short
MAGNUS: Large
CONDYLE: Joint surface where two parts (usually bone) meet
EPICONDYLE: Area above (*epi*) the condyle
TENDONS: Extension of muscle that leads to attachments with bones or other tissue
ORIGIN ATTACHMENT/POINT OF ORIGIN of muscle to bone: Less mobile or moveable and positioned nearer the greater mass of the body
INSERTION ATTACHMENT/POINT OF INSERTION of muscle to bone: More mobile or moveable and positioned farther from the greater mass of the body
ISOMETRIC TENSION: As the muscles on one side of a limb contract, those on the other side must relax if the limb is to move. Equal tension on both sides results in no motion at all, as the pull of the muscles on one side opposes and neutralizes that of the muscles on the other side.

Chapter *3*

Spatial Thinking and Visualization

Teaching the Essential Principles of Perspective Drawing

An Introduction to Perspective

What Is Perspective?

Perspective drawing is a system for creating a two-dimensional illusion of a three-dimensional subject or three-dimensional space. Information, whether observed (empirically based) or imagined (theoretically based), is translated into a language or system that allows three-dimensional forms and space to be illusionistically represented on a two-dimensional surface.

Although Brunelleschi is credited with the discovery or creation of perspective theory during the Renaissance in Italy, it is Albrecht Dürer, a German artist, who is best known for his exploration of perspective theory in his prints and drawings.

Different Types of Perspective

Perspective theory is often separated into two parts: TECHNICAL OR MECHANICAL PERSPECTIVE (Figure 3–1), which is based on systems and geometry and is the primary focus of this chapter; and FREEHAND PERSPECTIVE (Figure 3–2), which is based on perception and observation of forms in space and is a more intuitive exploration of perspective theory. Freehand perspective relies to a significant degree on the process of sighting to judge the rate of convergence, depth, angle, etc. Technical or mechanical perspective utilizes drafting tools such as T-squares, compasses, and triangles, while freehand perspective generally explores perspective principles without the use of technical tools. While it is useful to study perspective in its most precise form with the aid of drafting tools and a simple straight-edge, it is also useful to explore these same principles in a purely freehand fashion, which allows for a more relaxed application of perspective principles.

In studying perspective, it also becomes important to make a distinction between linear perspective and atmospheric perspective. LINEAR PERSPECTIVE addresses how the shapes, edges, and sizes of objects change in appearance when seen from different positions relative to the observer—off to one side, directly in front, close or far away,

Figure 3–1. Student work.
This transparent construction
drawing of a toy mailbox utilizes
technical perspective systems
and mechanical aids such as
rulers and a 30°/60° triangle.

Figure 3–2. Student work.
Clarkson Thorp. Three studies
of an antique plane rely on the
freehand method of sighting for
proportions and angles to
achieve accuracy of form.

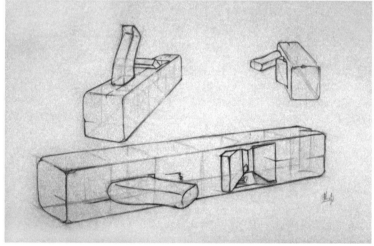

above or below, or any number of infinite variations (Figure 3–3). ATMOSPHERIC PER-
SPECTIVE describes other characteristics seen in objects that are some distance from
the observer. A veil of atmospheric haze affects and decreases clarity, contrast, detail,
and color. Atmospheric perspective, which is not mathematically or geometrically
based, is a powerful complement to linear perspective, and when used together the
illusion of three-dimensionality and space can be powerful (Figure 3–4).

This chapter focuses primarily on linear and technical perspective and their
emphasis on changes in apparent size as a foundation for understanding and exploring
freehand perspective. Understanding perspective is critical in developing the skill of
VISUALIZATION, which is the process of constructing an illusionistic image of a sub-
ject that cannot be or is not drawn by direct observation (Figure 3–5). It is based on
theoretical circumstances, allowing one to construct a form based on imagination,
without the support of direct observation.

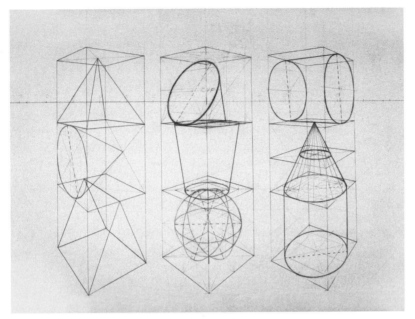

Figure 3–3. Student work. Dean E. Francis. The relationship of various geometric solids to a cubic solid are explored in this linear perspective study. Cubes, cones, cylinders, vessels, a wedge, a pyramid, and a sphere are shown at different positions in relation to the eye level and the central vanishing point.

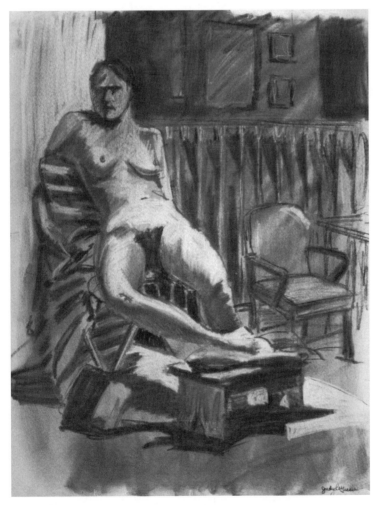

Figure 3–4. Student work. Judy Lemieux. A form of atmospheric perspective is used in this figurative composition study to exaggerate the space between the foreground and the background. Contrast of tonal range is especially evident in the limited tonal range of the background compared to the full tonal range of the foreground.

Figure 3–5. Student work.
Gill Whitman. An understanding
of three-point perspective
enables this student to visualize
and draw an imaginary cityscape.

Basic Principles of Linear Perspective

There are a number of different methods for drawing in perspective, which becomes readily apparent in paging through the wide range of books that address the subject. All of the methods, however, assume some shared principles:

- A perspective drawing creates the illusion of reality by relating the observer or viewer, the picture plane, and the object or objects being drawn.
- The observer or viewer is in a fixed position and sees with one eye, like a camera. The position of the viewer, or the viewer's eye, is called the station point.
- The surface on which the drawing is made is called the picture plane. The PICTURE PLANE is assumed to be a plane placed between the observer or viewer and the object(s) observed, and is perpendicular to the observer's line of sight.
- The horizon is assumed to be at an infinite distance from the observer, so that parallel lines meet or converge at the horizon and objects on the horizon appear to be points. These points of convergence are called VANISHING POINTS.
- Objects drawn in perspective are reduced to lines (representing edges) and planes, which are then observed for degrees of diminution (how the lines and planes diminish as they recede in space).
- The cube is the most basic form in perspective, having uniform height, width, and depth, and is used as a perspective unit to measure these values concurrently. In theory, the perspective cube can be multiplied and divided into any combination of height, width, and depth to provide an underlying structure for drawing any object.

Perspective and Sighting

It is interesting to note the relationship between perspective principle and theory, and the practice of sighting, which is discussed in depth in chapter one. While the strict

Figure 3–6. Student work. Scott Luce. In this study for a homework assignment, students were instructed to draw a two-point perspective view of their living environment using only sighting to discover angles, rates of convergence, and proportional relationships.

application of perspective can result in a convincingly illusionistic depiction of three-dimensional forms in space, the careful application of sighting techniques can result in an equally convincing depiction (Figure 3–6). Sighting techniques generally have more relevance than technical perspective when dealing with forms that are less apparent in their relationship to geometric solids, such as the human figure. Technical perspective is more applicable when dealing with forms whose relationship to geometric solids is more apparent, such as buildings, architectural structures, furniture, and other forms that are obvious variations on a basic cubic structure.

There are some clear parallels between perspective methods and sighting methods, with perspective methods based on a more technical approach, and sighting methods based on a more freehand approach. Devices that aid in checking the relative size and position of the parts of a subject or multiple subjects help tie together what the artist sees (visual perspective) with the theories of linear or technical perspective.

- The concept of diminution and scaling methods in linear or technical perspective are roughly equivalent to sighting techniques for determining relative proportions (visual perspective).
- The location of vanishing points along the horizon line and degrees of foreshortening and convergence in linear or technical perspective are roughly equivalent to the process of sighting for angles in relation to the fixed elements of verticals and horizontals (visual perspective).

Limitations of Linear Perspective

Although the principles of perspective are based on precise geometric and mathematical systems, perspective is a system with limitations. It is important to recognize these limitations when exploring perspective:

- A fixed viewing position or fixed position of the head is implied in perspective, even though in actuality, we typically move our viewing position and/or our head in any number of directions when observing the world around us.
- The application of perspective principles yields an image that is based on monocular rather than binocular vision. Monocular vision suggests that we are observing the world through one eye only, while binocular vision suggests that we are observing the world through two eyes simultaneously.
- There are boundaries or limitations of the picture plane in perspective that are not a part of actual observation of the world around us. One example is the CONE OF VISION. When approaching these boundaries in a perspective drawing, distortions will begin to occur in the resulting drawing. But in actual observation, we are able to make perceptual adjustments that correct these distortions.
- In perspective drawings, the horizon line is idealized in that it is always parallel to the ground line or ground plane, which we know is not always the case in the real world.
- There are some distortions that occur in the application of perspective principles that do not coincide with the real world. For example, using strict perspective techniques in a drawing for duplicating a precise cube as it recedes spatially will eventually result in a cube-like form that no longer describes a precise cube. The degree of error increases as the duplicate cubes move farther away from the original cube.

Being aware of some of the limitations from the onset allows the student of perspective to make adjustments at his or her discretion. Even with the limitations of the system, an understanding of perspective and its most basic principles is vital to spatial thinking and the ability to visualize spatially. Experience suggests that, without an understanding of perspective, this ability to think and visualize spatially is one of the most difficult things for a student of drawing to accomplish successfully.

Recommended Sequencing for Maximum Comprehension

In understanding perspective processes and their applications, each new technique or concept introduced typically builds upon techniques and concepts already presented. A broad and working knowledge of perspective requires comprehension of one skill before moving on to the next skill. For example, a student who does not understand cube multiplication processes will not be able to explore with success the process of transparent construction. A student who does not understand ellipse construction will be unable to effectively represent various geometric solids. A student who does not understand the scaling process will be unable to explore multiple forms and their proper size relationships to each other.

To facilitate ease of comprehension, the following list is given as suggested sequencing for introducing perspective processes and concepts. Although some argument can be made for variations in the sequencing, experience suggests that presenting information in this particular order will allow for more effective presentation on the part of the instructor and more effective comprehension on the part of the student.

- What is perspective?
- Review of materials list

- Perspective vocabulary and definitions
- One-point cube construction
- Two-point cube construction (estimation of depth)
- Estimating cube depth in two-point perspective
- One-point gridded ground plane
- Two-point gridded ground plane using measuring line, fence-post, and converging diagonals method
- Scaling methods for cube-based forms (see chapter one)
- Multiple and sliding sets of vanishing points
- Cube multiplication using the fence-post method and the measuring line method
- Cube division using the Xing method and the measuring line method
- Precise 30°/60° cube construction
- Precise 45°/45° cube construction (center and off-center)
- Alternatives for constructing a 45°/45° cube
- 30°/60° gridded ground plane
- 45°/45° gridded ground plane
- Ellipse construction in relation to cubes
- Measuring lines for regular (equal) and irregular (unequal) cube division
- Inclined planes, including stairways, rooftops, and box tops
- Geometric solids derived from cubes and ellipses
- Transparent construction based on geometric solids
- Three-point perspective made simple

Suggestions for Effective Perspective Drawing

Before introducing initial exercises in perspective drawing, it is wise to consider some suggestions that are broadly applicable to all perspective drawings and are intended to facilitate the making as well as the reading of a perspective drawing.

Determining the Variable Elements of Perspective Drawing

On each drawing a key should be provided that indicates information that remains fixed or constant in that particular drawing, and provides a means of checking the accuracy of the drawing (Figure 3-7). Three elements must be indicated in the key—scale, eye level, and station point—with a fourth optional element, the size of the key cube or "mother cube," which should accurately reflect the scale used in the drawing. All four of these elements are variables to be determined by the artist at the onset of a drawing. Once these variables are determined, establishing the perspective environment, they must remain constant for that particular drawing. In reviewing these elements, we can elaborate on definitions given in the section on perspective terminology.

Regarding SCALE, if you are drawing on a standard piece of 18" x 24" paper, and you wish to explore forms that relate to human scale, then a scale of 1" = 1' is quite convenient. If, however, you wish to explore forms that are well beyond human scale, such as large buildings or skyscrapers or airplanes or space stations, your scale must reflect this. In this case, 1" could equal 10' or more. Scale is a variable determined by the artist.

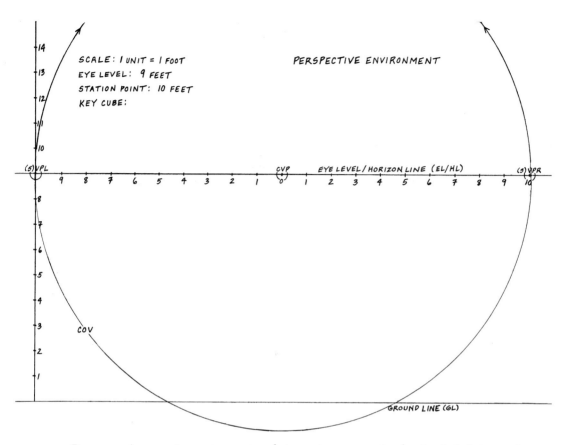

SCALE: 1 UNIT = 1 FOOT
EYE LEVEL: 9 FEET
STATION POINT: 10 FEET
KEY CUBE:

PERSPECTIVE ENVIRONMENT

(S)VPL

CVP

EYE LEVEL/HORIZON LINE (EL/HL)

(S)VPR

COV

GROUND LINE (GL)

Figure 3–7. A perspective environment ready to receive a perspective drawing. Included are scale, vanishing points (indicating station point), eye-level or horizon line, ground line, cone of vision, and units of measure established vertically and horizontally.

Regarding EYE LEVEL (EL), if you wish to explore a worm's-eye view or a relatively low eye level, then place your eye-level line closer to the bottom of the page to accommodate this viewpoint. If you wish to explore a bird's-eye view or a relatively high eye level, then place your eye-level line closer to the top of the page to accommodate this viewpoint. You may even choose to place your eye-level line beyond the confines of the drawing surface.

Establishing the height of the eye-level line in your drawing requires that you place your GROUND LINE (GL) appropriately. The ground line represents the intersection of the picture plane and the ground plane. If, for example, you wish to work with an eye level of 6 feet in your drawing, and you have determined a scale of 1" = 1', then place your ground line 6 inches below the eye-level line to effectively establish the height of the eye level.

STATION POINT (SP) indicates how close to or far from the picture plane the viewer is positioned. This is important information because the proximity of the viewer to the picture plane determines, in part, how forms will appear. Like the other three elements, the station point cannot be moved or adjusted during the construction of a drawing.

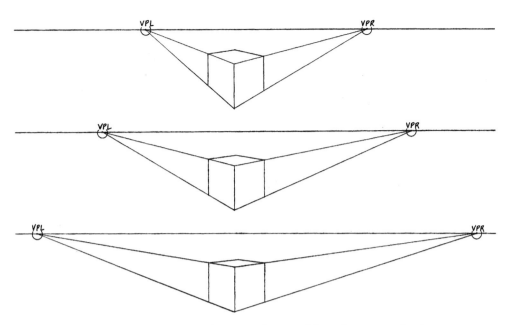

Figure 3–8. This drawing illustrates how the same cube viewed from the same eye level can appear very different based on the position of the vanishing points, which indicates the distance of the viewer from the picture plane.

Assuming that a cube's position does not change and its relationship to the picture plane does not change, how that cube appears in a perspective drawing is different if the viewer is very near to the picture plane than if the viewer is farther away from the picture plane. For example, imagine a cube resting on the ground plane. With the viewer positioned near the picture plane, more of the top face of the cube is visible than if the viewer is positioned farther from the picture plane (Figure 3-8).

The station point, in one-point perspective, is indicated by the distance between the CENTRAL VANISHING POINT (CVP) and SPECIAL VANISHING POINT (SVP) LEFT OR RIGHT. For example, with a scale of 1" = 1' and a desire to place the viewer 6 feet from the picture plane, you place an SVP 6 inches to the left and right of the CVP. The SVP then acts as a guide in determining the depth of a true cube in one-point perspective when seen from a position 6 feet away from the picture plane.

The station point, in two-point perspective, is indicated by the distance between VANISHING POINT LEFT (VPL) and VANISHING POINT RIGHT (VPR). Half of that total distance, in relation to the established scale, indicates the station point. For example, with a scale of 1" = 1' and a distance of 18 inches between VPL and VPR, half of that distance (9 inches) establishes a station point of 9 feet. This tells us that for this particular drawing, the viewer is positioned 9 feet away from the picture plane. If you wish to place the viewer closer to or farther from the picture plane, simply move the VPL and VPR accordingly.

The KEY CUBE, or "MOTHER CUBE" as it is sometimes called, is an optional element that may be included in a drawing as a reference point. It reflects the scale indicated in the key of the drawing, and for this reason the key cube should always be drawn with the leading edge or leading face in the nearest foreground, resting on the

ground line. In this way we know that the key cube is in contact with the picture plane, positioned as far forward as possible, and that its leading edge or face is a measurable reflection of scale.

Before advancing to a more in-depth study of perspective, it is vital that one have a clear understanding of these elements and the role they play in determining the character of a particular perspective drawing. Without a clear understanding, it is difficult or impossible to progress to the study of more complex processes of perspective drawing.

Keeping Things Simple

In introducing perspective to a group of students for the first time, it is advisable to consider working initially with a standardized format, one in which all students are working on the same size paper with a prescribed scale, eye level, and station point. While it is important that students understand the significance of these variables and the processes for arriving at them, it is beneficial at first to standardize them when checking for accuracy or errors, and students will be more easily able to compare and contrast their work with others. As understanding increases, the opportunity to work with different scales, eye levels, and station points reinforces comprehension and clearly illustrates the impact they have on end results. However, if extreme scales, eye levels, and station points are introduced prematurely, confusion and error usually result.

In the study of technical linear perspective, a degree of accuracy and precision is required. Verticals must be vertical, horizontals must be horizontal, lines of convergence must meet at a shared point, and so on. There are ways to insure a greater degree of accuracy for the beginner, particularly if a student is attempting to explore technical perspective with a limited number of tools. Although a T-square and a triangle are recommended, there are ways to work effectively in the absence of these tools:

- Working on nonphoto-blue gridded or graph paper, which comes in a variety of sizes, provides visible guidelines for keeping horizontal and vertical lines true without visually interfering with lines drawn in lead or graphite.
- Keeping drawing pencils sharpened or working with a fine lead mechanical pencil will facilitate crisp and precise lines. Sharp pencils will also provide a higher degree of consistency and precision when using a ruler to draw a line between two points. A dull, fat lead will deposit a line along a straight-edge differently than a sharp lead, and will make it more difficult to connect two points accurately.
- Using a nonskid ruler will help to insure that a carefully placed ruler will remain in place as the student pulls his or her pencil along the length of the ruler. If a cork-backed ruler is not available, placing a strip of masking or drafting tape along the back of the ruler will help to prevent sliding. Make sure, that the tape used is narrower than the ruler itself, so that the tape does not interfere with the true edge of the ruler.
- Construction lines are an integral part of any perspective drawing, although when a more refined drawing is desired they may be deleted from the end result. Most student work will include construction lines as a way of indicating process and providing a means of checking for inaccuracies or errors in process. By decreasing the

pressure on the drawing tool and using harder leads, construction lines can be kept as delicate as possible to prevent visual confusion and overload.

Perspective Materials List

30"-36" metal T-square, ruled
18" ruler (preferably metal)
Drawing pencils, 4H, 2H, H, HB, B, 2B, 4B
Technical pencil, 0.5mm maximum, HB drop lead
45° triangle—12" or 8"
30°/60° triangle—12" or 8"
Protractor
Pink Pearl erasers
Kneaded erasers
Roll of drafting tape—½", ¾", or 1" (not masking tape)
Compass with minimum 6" span
Lead sharpener or sanding pad
Pad of gridded or graph paper, nonphoto blue, 11" x 14" or larger
18" x 24" pad of smooth white Bristol drawing paper
Drafting brush
Eraser shield
Drawing board large enough to accommodate drawing paper (commercial or homemade)
⅛" dowel stick, 12" long
Viewfinder, 2-¼" x 2-¾", 2-¾" x 3-½", 2" x 2-⅔", 3" x 4"

Optional Items

Straight pins
Small roll of string
Roll or pad of tracing paper
Single-edge razor blades
Assorted colored pencils (Verithin by Berol)

The Terminology of Perspective

It should be understood that many of these terms will not be fully comprehended without the accompaniment of direct, hands-on experience. Rather than an alphabetical arrangement, they are organized roughly in the order in which they may be encountered in a progressively in-depth study of perspective principles.

ONE-POINT PERSPECTIVE: A drawing is in one-point perspective when one "face" or plane or side of a cube or cube-like form is parallel to the picture plane, facing the observer directly. The left and right sides, and the top and the bottom of the cube all converge on a single vanishing point located on the horizon line or eye level. In other words, all edges that are *perpendicular* to the picture plane converge on a single vanishing point. All vertical edges (*perpendicular to* the ground

plane and *parallel* to the picture plane) are represented as vertical lines in your drawing, with no evidence of convergence. One-point perspective is also referred to as PARALLEL PERSPECTIVE.

TWO-POINT PERSPECTIVE: A drawing is in two-point perspective when no face or plane or side of a cube or cube-like form is parallel to the picture plane, but rather all planes are at an oblique angle to the picture plane. This means that the front or LEADING EDGE of a cube is closest to the observer or to the picture plane. All vertical edges (*perpendicular to* the ground plane and *parallel* to the picture plane) are represented as vertical lines in your drawing, with no evidence of convergence. The top, bottom, and all four side planes of the cube converge on two different vanishing points located on the horizon line or eye level. Two-point perspective can be combined with one-point perspective. Two-point perspective is also referred to as OBLIQUE PERSPECTIVE.

EYE LEVEL (EL): The eye level always represents the height of the station point (or observer) in a perspective drawing. As the height of the artist's eyes changes (e.g., the difference between sitting or standing), so does the eye level of the drawing. Eye level is synonymous with horizon line, which is the place in reality where earth and sky seem to meet. The eye level is an important reference line in every perspective drawing. The horizon may be blocked from view by tall buildings or it can be placed beyond the limits of the page. Regardless, in every perspective drawing there exists an eye level (horizon) that appears as a horizontal line drawn across the picture plane or an extension of the picture plane. The eye level is a variable determined by the artist.

HORIZON LINE (HL): In perspective drawing, the horizon line is synonymous with the eye level.

SCALE: Scale is the actual size of the subject in a drawing in relation to the actual size of the subject in reality. If the scale of a drawing is $1" = 1'$, then every measurable inch on the picture plane represents one foot in reality. Scale is a variable determined by the artist.

STATION POINT (SP): The station point is either the actual or imagined location of the observer in a perspective drawing. Based on the assumption in perspective that the artist's position and direction of sight does not change during the making of the picture, the station point cannot be moved during the construction of a drawing. The station point is a variable determined by the artist.

PICTURE PLANE (PP): The picture plane is an imaginary, transparent, flat surface, infinite in size, on which the drawing is made. The picture plane is located between the subject being drawn and the observer. The drawing surface (paper) is synonymous with the picture plane in perspective theory, representing a portion of the infinite picture plane.

GROUND PLANE (GP): The ground plane is the surface upon which objects rest. The most obvious example of a ground plane would be the surface of the earth or the actual ground in an exterior space, or the floor of a room in an interior space.

GROUND LINE (GL): The ground line represents the intersection of the picture plane and the ground plane. The ground line is always drawn parallel to the eye-level line or horizon line. The measurable distance from the ground line to the horizon line tells us what the eye level of the observer is in relation to the scale established for the drawing.

Cone of Vision (cov): The cone of vision represents a limited area that can be clearly seen at any one time by the observer and remain in focus. It can be visualized as an imaginary three-dimensional cone with the station point as the vertex of the cone. Trying to draw objects beyond or outside of the cone of vision results in pronounced distortion.

Vanishing Point (vp): A vanishing point is where two or more parallel receding edges or lines appear to converge. The vanishing points for all horizontal parallel edges or receding lines are always located on the eye-level line or horizon line.

Central Vanishing Point (cvp): The central vanishing point is the point of convergence (meeting point) for all lines or edges perpendicular to the picture plane. A central vanishing point is used in one-point perspective and is located directly in front of the observer's station point, at the intersection of the observer's line of vision and the eye level (this intersection forms a 90-degree or right angle).

Special Vanishing Point (svp): Special vanishing points are vanishing points that are established for measuring foreshortened lines or edges or planes and for other construction purposes. A special vanishing point is formed by the point where one or more diagonal measuring lines intersect the eye-level line or horizon line. There is no limit to the number of svps that may be found on the eye-level line or horizon line.

Auxiliary Vanishing Point (avp): Auxiliary vanishing points are for parallel lines or edges on receding diagonal or inclined planes, such as angled box flaps or rooftops or stairways. Auxiliary vanishing points are never on the eye level, but rather are located at the appropriate position along a vertical extension of a vanishing point located on the eye level. This vertical extension is referred to as a trace line or vertical trace. avps are also sometimes referred to as trace points.

Vanishing Point Three (vp3): Vanishing point three is the vanishing point for receding *vertical* lines or edges or planes. This occurs only in three-point perspective, when the observer is positioned at a very low eye level, looking up (a worm's-eye view), or at a very high eye level, looking down (a bird's-eye view), which causes the picture plane to tilt.

Measuring Line (ml): Measuring lines (also called horizontal measuring line [hml]) are used for direct scale measurements in a drawing. These lines must be parallel to the picture plane. As an example, the ground line can be used as a measuring line. In one- and two-point perspective, vertical lines in the drawing can also be used as measuring lines (vml) as they too are parallel to the picture plane.

Diagonal Measuring Line (dml): Diagonal measuring lines are used in one-point perspective to determine the actual depth of a true, equal-sided cube, and in one- and two-point perspective to determine consistent scale for cubes in relation to the key cube or mother cube (scaling). Diagonal measuring lines always converge at a special vanishing point (svp) located on the eye-level line or horizon line.

Other Relevant Terminology

The following terms, although not specific to formal perspective theory, are vital to the understanding of perspective.

FORESHORTENING: Foreshortening is the apparent diminishing of the length of lines or edges or planes to create the illusion of depth. Lines or edges or planes appear progressively shorter as their angle to the picture plane increases. Therefore only lines, edges, or planes that are parallel to the picture plane show their true or actual length.

CONVERGENCE: Lines or edges that in reality are parallel to each other appear, in perspective, to come together (converge) or meet as they recede from the observer toward the horizon line. A classic example of this is railroad tracks appearing to converge at a single vanishing point on the distant horizon line.

POSITION OR BASE LINE: The closer an object is to the viewer on the ground plane, the lower its apparent position on the drawing paper. Objects lowest on the page are considered to be closest to us and in the foreground, followed by objects in the middle ground, then objects in the background. This applies to objects at or below our eye level and the relationship is simply reversed for objects above our eye level (floating).

OVERLAP: Overlap is a device that defines which object is forward or in front of another. Without utilizing any other aspect of perspective principles, placing one object partially in front of another generates a sense of depth and spatial order in the picture.

DIMINUTION: Objects and forms appear to become smaller as they recede or move away from the observer.

Additional Terminology to Be Familiar With:

Convergence	Circle	Vessel
Perpendicular	Ellipse	Right Angle
Parallel	Axis	Acute Angle
Diagonal	Cube	Oblique Angle
Vertical	Pyramid	Diameter
Horizontal	Cylinder	Circumference
Plane	Cone	Vertex
Square	Sphere	Tangent Point
Rectangle		

Perspective and Cubes

Constructing a Cube in One-Point Perspective

1. Determine what conditions must prevail in order to use one-point perspective. One plane or face of the cube or cube-like form must be parallel to the picture plane (PP) or plane of vision (Figure 3-9).
2. Establish scale for the drawing (e.g., 1" =1').
3. Draw the horizon line or eye level (HL/EL). If you think you want a relatively high eye level, place your horizon line closer to the top of the page. If you think you want a relatively low eye level, place your horizon line closer to the bottom of the page.

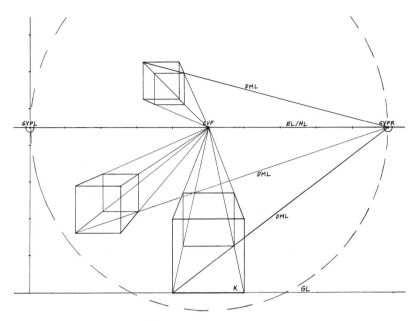

Figure 3–9. Constructing a cube in one-point perspective.

4. Locate the central vanishing point (CVP), typically located in the middle of the horizon line in one-point perspective.

5. Locate special vanishing points left and right (SVPL/SVPR). The placement of the SVPL and SVPR in relation to the CVP is determined by the chosen location of the station point (SP), which tells us the distance of the observer from the picture plane.

 For example, if your scale is 1″ = 1′, and your SVPL and SVPR are each located 7 inches from the CVP, then you are establishing that the SP (the position of the observer) is 7 feet away from the picture plane. The location of the SVPL and the SVPR is used in conjunction with a diagonal measuring line (DML) to determine the actual depth of a true cube in one-point perspective.

6. Lightly mark horizontal units of measure along the eye-level line that correspond to the established scale.

7. Determine the location of the ground line (GL) based on a chosen height for the eye-level or horizon line. Place the ground line by measuring the vertical distance from the horizon line to the ground line in relation to the established scale.

 For example, with a scale of 1″ = 1′ and a chosen eye level of 5 feet, the ground line would be drawn 5 inches below the horizon line. The ground line can be no farther below the horizon line than the distance between the CVP and SVPL or SVPR without violating the cone of vision.

8. Lightly mark vertical units of measure from the ground line to the horizon line and above the horizon line that correspond to the established scale. These can

be used later for applying scaling techniques, and are an abbreviated form of a key cube.

9. Determine the cone of vision (COV) by lightly drawing a circle whose center is at the CVP and whose circumference passes through SVPL and SVPR. The diameter of the cone of vision would then equal the distance from the CVP to either SVPL or SVPR. All cubes must remain within the COV.

10. Draw the front face of a cube (which is an exact square) on the ground line according to the desired scale. For example, with a scale of 1" = 1', and a desired 4-foot cube, the initial cube face would sit on the ground line and measure 4 inches by 4 inches. Make sure that this initial square cube face is constructed of true vertical and horizontal lines that are at right angles to each other.

11. Draw a line of convergence from each corner of the face of the cube to the CVP.

12. Extend a diagonal measuring line (DML) from either bottom corner of the cube face to the *opposite* SVP. The point where the DML intersects the line of convergence for the base of the cube face indicates the true depth of the cube by defining where the back face of the cube begins to rise vertically.

13. Using this point of intersection, build the back face of the cube as an exact square parallel to the front face of the cube, and connecting to all lines of convergence. The cube is now complete and precise. This cube becomes the key cube (K) or the mother cube, which determines the scale for all subsequent cubes in the drawing.

Note that all edges parallel to the picture plane or plane of vision and perpendicular to the ground plane remain *vertical* in your drawing. All remaining edges of the cube converge on the CVP.

When drawing multiple cubes, remember to initially draw all cubes transparently in order to clearly establish the base of the cube and to help determine if any cube is trespassing on any other cube or occupying the same space on the ground plane (Figure 3–10).

Constructing a Cube in Two-Point Perspective
Based on Estimation of Cube Depth

1. Determine what conditions must prevail in order to justify the use of two-point perspective. No planes of the cube or cube-like form are parallel to the picture plane (PP) or the plane of vision. An edge of the cube (place where two planes meet) is closest to the picture plane, and this edge is referred to as the leading edge (Figure 3–11).

2. Establish scale for the drawing (e.g., 1" = 1').

3. Draw the horizon line or eye level (HL/EL). If you think you want a relatively high eye level, place your horizon line closer to the top of the page. If you think you want a relatively low eye level, place your horizon line closer to the bottom of the page.

4. Locate the central vanishing point (CVP), typically located in the middle of the horizon line in two-point perspective.

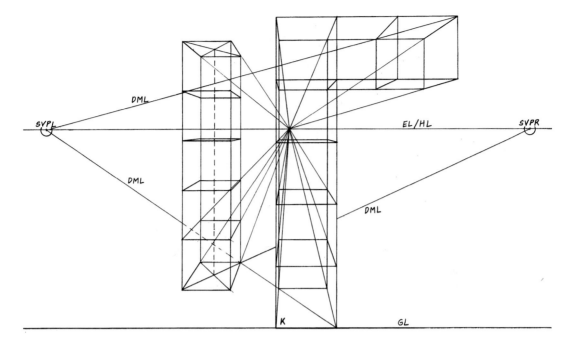

Figure 3–10. Stacking and sliding transparently drawn cubes in one-point perspective to create "elevator shafts." Note that corresponding vertical and horizontal edges of each cube remain constant, indicating that all cubes are the same size.

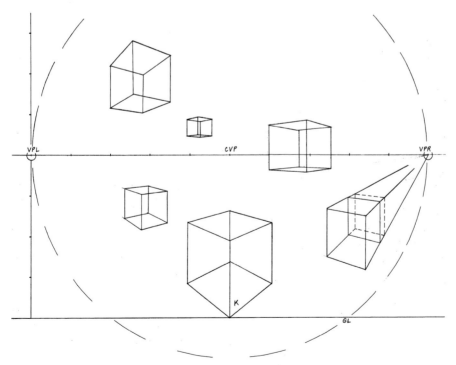

Figure 3–11. Estimating cube depth in two-point perspective. The dotted lines indicate an adjustment to a cube that was originally drawn too shallow from front to back.

5. Locate vanishing points left and right (VPL/VPR). The placement of the VPL and VPR in relation to the CVP is determined by the chosen location of the station point (SP), which tells us the distance of the observer from the picture plane.

 For example, if your scale is 1" = 1', and your VPL and VPR are each located 7 inches from the CVP (14 inches apart total), then you are establishing that the station point (the position of the observer) is 7 feet away from the picture plane.

6. Lightly mark horizontal units of measure along the eye-level line that correspond to the established scale.

7. Determine the location of the ground line (GL) based on a chosen height for the eye-level or horizon line. Place the ground line by measuring the vertical distance from the horizon line to the ground line in relation to the established scale.

 For example, with a scale of 1" = 1', and a chosen eye level of 5 feet, the ground line would be drawn 5 inches below the horizon line. The ground line can be no farther below the horizon line than the distance between the central vanishing point and VPL or VPR without violating the cone of vision.

8. Lightly mark vertical units of measure from the ground line to the horizon line and above that correspond to the established scale. These can be used later for applying scaling techniques, and are an abbreviated form of a key cube.

9. Determine the cone of vision (COV) by lightly drawing a circle whose center is at the CVP and whose circumference passes through VPL and VPR. The diameter of the cone of vision would then equal the distance from the CVP to either VPL or VPR. All cubes must remain within the COV unless adjustments are made to correct the resulting distortion.

At this point, methods for constructing an exact cube in 30°/60° two-point perspective and 45°/45° two-point perspective can be explored, and separate instructions are available in this chapter. The following additional steps for two-point cube construction, however, are based on visual estimation of true cube depth in relation to the height of the leading edge of the cube.

10. Draw the leading edge (front edge) of the cube on the ground line and within the COV. This is a vertical line. The height of the leading edge is a random decision unless a specific scale has been requested or indicated.

11. Extend lines of convergence from the top and bottom of the leading edge to both VPL and VPR (four separate lines of convergence). This is a good time to check for distortion if you are approaching the limits of the cone of vision in the placement of your leading edge. Distortion occurs when the angle found at the front base corner of the cube is less than a 90–degree or right angle.

12. Watch for distortion and continue building the cube by estimating the depth of each foreshortened plane based on the visual clues provided. Guidelines for estimating cube depth can be found in "The Leading Edge of a Cube" section that follows.

13. When cube depth has been estimated, indicate this by drawing a vertical line between the lines of convergence drawn from the bottom and top of the leading edge. Repeat this procedure for both the right-hand and left-hand planes.

14. From each of these two vertical edges, draw lines of convergence to the *opposite* vanishing point from both the top and the bottom of the vertical edge.

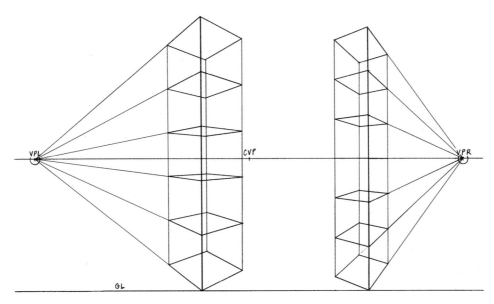

Figure 3–12. Stacking transparently drawn cubes in two-point perspective to create "elevator shafts." Note that corresponding vertical edges of each cube remain constant, indicating that all cubes are the same size.

Where these lines of convergence intersect indicates the location of the back vertical edge of the cube. Your cube is now complete. This cube becomes the key cube (K) or the mother cube, which determines the scale for all subsequent cubes in the drawing.

Note that all edges parallel to the plane of vision or picture plane and perpendicular to the ground plane remain *vertical* in your drawing. All remaining edges converge on either VPL or VPR.

When drawing multiple cubes, remember to initially draw all cubes transparently in order to clearly establish the base of the cube and to help determine if any cube is trespassing on any other cube (Figure 3–12).

Estimating Cube Depth in Two-Point Perspective

In studying cubes in two-point perspective, you can use precise methods for cube construction as described in relation to 45°/45° and 30°/60° cubes, or, if absolute precision is not required or desired, you can draw cubic forms based on estimation of cube depth. Following are some guidelines for accurately estimating cube depth and avoiding distortion in a variety of positions within the perspective environment (see Figure 3–11).

Respecting the Cone of Vision

The cone of vision must be respected to avoid cube distortion. If a cube's leading edge falls outside of the cone of vision, even partially, cube distortion will occur at the leading corner of the cube. The cube will appear to be "dropping" too suddenly, or in the

case of a cube that is positioned above the ground plane (floating), it will appear to be "rising" too suddenly.

There is a clear way of identifying this kind of distortion. Very simply, if the leading corner of a cube measures less than 90 degrees, it is distorted. It must measure 90 degrees or greater. Either its position within the perspective environment needs to be adjusted, or the vanishing points need to be moved slightly to adjust the cone of vision and consequently correct mild distortion.

Proximity to Vanishing Points Left and Right and to the Central Vanishing Point

In estimating the depth of foreshortened planes in a cube, consider the placement of the cube in relation to the VPL and VPR. As a cube approaches the VPL, the rate of convergence and degree of foreshortening for the left-hand plane increases, resulting in a visually shortened plane. Conversely, the rate of convergence and degree of foreshortening decreases for the right-hand plane in relation to its proximity to the VPR. These relationships simply reverse as a cube approaches the opposite vanishing point. A cube placed halfway between VPL and VPR, directly above or below the central vanishing point, would have two equally foreshortened planes.

The Leading Edge of a Cube

The closer the foreshortened plane of a cube is to a vanishing point, the shorter its length will appear visually. The farther away the foreshortened plane of a cube is from a vanishing point, the longer its length will appear visually.

In estimating the length of foreshortened planes and edges, it is important to note that the leading edge of a cube is the most forward edge, and is a true vertical unaffected by foreshortening. Because we know that a cube consists of six equal planes with all edges equal in length, it follows that no receding edge or plane may be greater in measured length than the length of the leading edge. In two-point perspective, the *leading* edge is always the *longest* edge of a true cube.

Using Perspective Grids

A grid, when not seen in perspective, is a series of lines parallel and perpendicular to one another that indicate units, usually squares, of uniform size. The units of this grid, when presented in perspective, provide an accurate reference for the size, scale, placement, angles, and proportions of various objects.

Perspective grids can serve a number of very useful purposes, either as a drawn environment in which to practice constructing a variety of perspective forms such as cubes, "elevator shafts" of stacked cubes, ellipses in vertical and horizontal planes, and geometric solids derived from cubes, or as a precise guide when objects and/or spaces to be drawn are more elaborate or complex.

Perspective grids can be drawn in one-point or two-point perspective. In two-point perspective, they may be based on a foreshortened horizontal square seen from a 45°/45° view, or a 30°/60° view. If less precision is acceptable, the grid may be based on an estimated foreshortened square without relying on the technical approaches required to create a precise foreshortened square. Perspective grids can be enlarged, multiplied, divided or subdivided, stacked, layered, and used again and again.

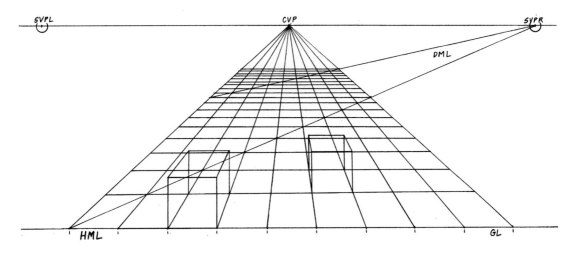

Figure 3–13. Constructing a gridded ground plane in one-point perspective. If each section of the grid represents 1 square foot, the ground plane would measure 9 feet wide by 18 feet deep. The outermost squares in the front row of the grid are outside of the cone of vision, and distortion begins to be evident.

When working with a grid based on a foreshortened square, you will note that, as the grid extends toward the limits of the perspective environment (as defined by vanishing points left and right and the cone of vision), distortion is more pronounced. This can be addressed in advance by adjusting/increasing the space between vanishing points left and right, effectively enlarging or reducing your cone of vision as necessary.

Constructing a Gridded Ground Plane in One-Point Perspective

1. All preliminary information should be established and drawn, including scale, eye-level or horizon line, ground line, station point, central vanishing point, special vanishing points left and right, units of measure along the horizon line that reflect your scale, units of measure along a vertical measuring line that reflect your scale, and cone of vision (Figure 3–13).

2. Construct a one-point cube below the CVP and within the cone of vision, following the instructions provided for one-point cube construction earlier in this chapter. To most fully utilize your perspective environment, you can position your cube so that it rests on the ground line. Erase all parts of the cube except the base plane, which serves as the first foreshortened square in your gridded plane.

3. Draw a horizontal measuring line extending to the left and right of the front edge of the foreshortened square. If the cube base lies on the ground line, then the ground line functions as the horizontal measuring line (HML).

4. Mark off increments along the HML that equal the width of the front edge of the cube base. From these increments draw lines of convergence back to the CVP. Extend the back edge of the original cube base to the left and right, creating the back edge for all foreshortened horizontal squares in the front row.

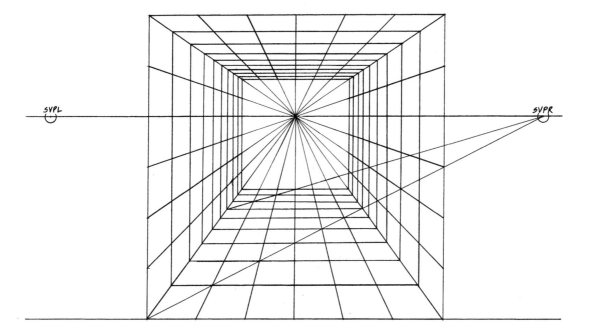

Figure 3–14. A one-point gridded box or room interior. If each section of the grid represents 1 square foot, the box would measure 6 feet tall by 6 feet wide by 9 feet deep. If each section of the grid represents 2 square feet, the box would double in dimensions to 12' x 12' x 18'.

5. Through the foreshortened square on the far left or right of the front row, draw a diagonal measuring line to the *opposite* special vanishing point. Remember that the diagonals for all horizontal planes of cubes in a one-point perspective environment will converge on a common point (SVP) on the horizon line.
6. Draw a horizontal line through the points where the diagonal measuring line (DML) intersects each line of convergence. These horizontal lines define the depth for each new row of foreshortened horizontal squares in a one-point gridded ground plane.

By utilizing the DML to the SVPL or SVPR, you can extend the gridded ground plane all the way to the horizon line. Note that the width of each square remains the same in any horizontal row of squares, and that each horizontal row appears shallower from front to back as it recedes in space. Note that if the grid extends beyond the cone of vision, distortion will occur. Using the gridded ground plane as a guide, you can construct corresponding walls and a ceiling, in effect constructing a gridded room interior or a gridded box interior (Figure 3–14).

Constructing a Gridded Ground Plane in Two-Point Perspective

1. All preliminary information should be established and drawn, including scale, eye-level or horizon line, ground line, station point, central vanishing point, vanishing points left and right, units of measure along the horizon line that

Figure 3–15. Constructing a two-point gridded ground plane using the (horizontal) measuring line method. This ground plane is drawn in a 30°/60° orientation to the picture plane.

reflect your scale, units of measure along a vertical measuring line that reflect your scale, and cone of vision.

2. Construct a two-point cube below the horizon line and within the cone of vision, following the instructions provided for two-point cube construction earlier in this chapter. You may construct a cube using cube estimation to determine the height/width/depth relationship, or you may construct a precise cube using one of the methods outlined for 45°/45° cube construction or 30°/60° cube construction. To most fully utilize your perspective environment, you can position your cube so that its front or leading corner touches the ground line. Once completed, erase all parts of the cube except the base plane, which serves as the first foreshortened square in your two-point gridded ground plane.

At this point, you may develop your grid by employing one of three approaches: the measuring line method, the fence-post method, or the method that relies on the fact that all individual squares in the grid have a diagonal that converges on a common SVP (special vanishing point) located on the horizon line. It is interesting to note that, although all three methods are legitimate, each will yield slightly different results. As the grid units approach the outer limits of the cone of vision and distortion becomes more pronounced, the differing results of the three methods become increasingly evident.

To Continue Using the Measuring Line Method:

3. Draw a horizontal measuring line extending to the left and right of the front or leading corner of the foreshortened square. If the leading corner touches the ground line, then the ground line functions as the horizontal measuring line (HML) (Figure 3–15).

 Remember that your HML, like your horizon line, can extend infinitely to either side, and may extend beyond the edges of your drawing format if necessary.

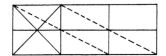

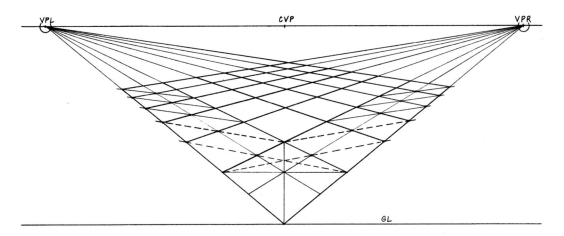

Figure 3–16. Constructing a two-point gridded ground plane using the fence-post method. The upper left drawing shows the fence-post method applied to vertical planes facing us directly.

4. Mark off equal increments along both sides of the HML from the point where the leading corner touches the HML. These increments should be small enough to accommodate the number of units in your grid, but large enough to prevent error and inaccuracy. These increments represent the depth of the foreshortened square (originally the cube base) and each additional square in the grid.

5. From the first increment to the left and right of the leading corner, draw a diagonal measuring line (DML) through the back corner of each foreshortened side and extend it to meet the horizon line, creating two separate SVPs.

6. Draw DMLs from each additional increment to its respective SVP. Where the DML intersects the lines of convergence for the original foreshortened square indicates the depth of the right and left foreshortened sides of each additional square or unit in the grid. From these points of intersection draw lines of convergence to the left and right VPs to create your grid.

To Continue Using the Fencepost Method:

3. Find the center of your foreshortened square by drawing two corner-to-corner diagonals and noting their point of intersection. Draw lines of convergence through the center point to vanishing points left and right (Figure 3–16).

4. Use the fence-post method for cube multiplication as it applies to horizontal planes. Draw a line from one end of a forward edge through the center of the opposite edge and extend it until it intersects an original line of convergence. Where these two lines intersect indicates the depth of each additional grid unit. Repeat this process until you have the desired grid.

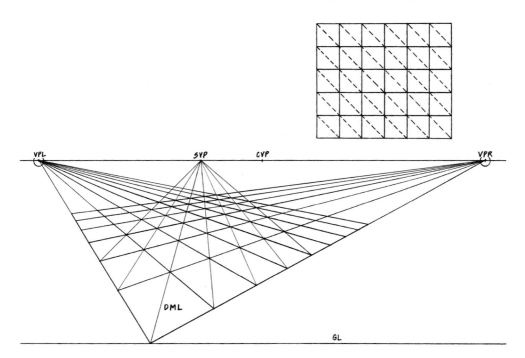

Figure 3–17. Constructing a two-point gridded ground plane using the common point of convergence (converging diagonals) for foreshortened squares. The upper right drawing shows the parallel relationship of corner-to-corner diagonals in a vertical gridded plane facing us directly.

To Continue Using the "Converging Diagonals" Method:

Remember that the front to back diagonal for all horizontal planes of cubes in two-point perspective will converge, when extended, on a common point (SVP) on the horizon line. If the cube is a 45°/45° cube, the front to back diagonal will converge on the CVP.

3. Draw the front-to-back diagonal for the foreshortened square and extend it until it meets the horizon line. This establishes your SVP, the point at which all front-to-back diagonals will converge in a two-point gridded ground plane (Figure 3–17).

4. From the left and right corners of the foreshortened square, draw a DML to the SVP established in step three. The point at which the DML intersects an original line of convergence indicates the location of the opposite corner of a foreshortened square.

5. Drawing lines of convergence through these points of intersection to the corresponding vanishing point left or right creates an additional unit of the grid and provides the framework for repeating the process. By utilizing the extended front-to-back diagonal converging on an SVP, you can construct a gridded ground plane of any desired size.

Note that if the grid extends beyond the cone of vision, pronounced distortion will occur. Using the gridded ground plane as a guide, you can construct corresponding walls and a ceiling, in effect constructing a gridded room interior or a gridded box interior (Figures 3–18 and 3–19).

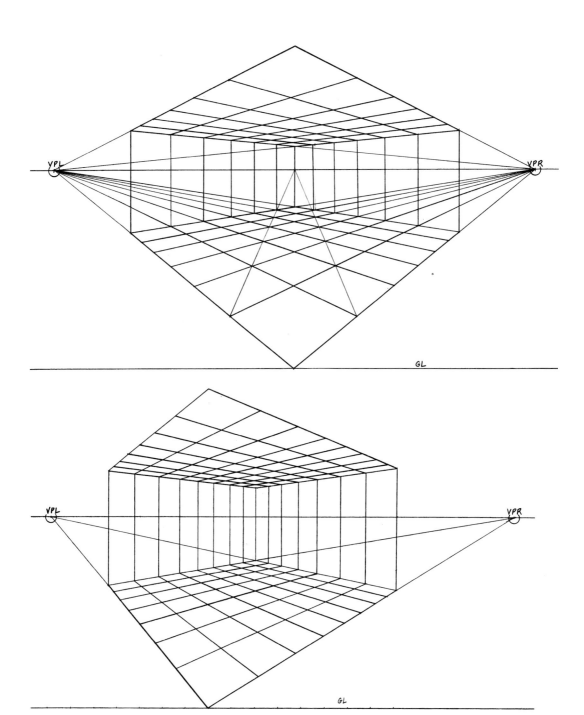

Figure 3–18 and Figure 3–19. A two-point gridded box or room interior seen in a $45°/45°$ view and a $30°/60°$ view. The floor and ceiling planes are fully gridded while the side walls are vertically gridded only to create some visual variety.

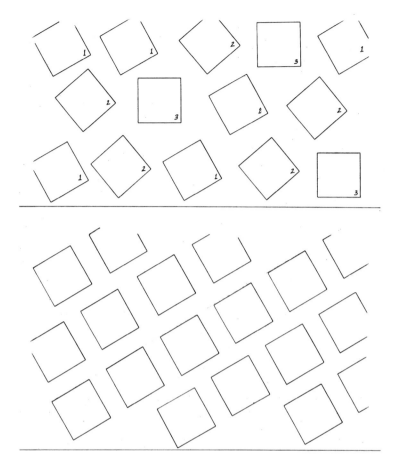

Figure 3–20. The lower section of aligned squares, viewed from overhead, shows that all edges converging to the right and left are parallel to each other. The upper section shows misaligned squares viewed from above. The numbers indicate which squares would converge on common sets of vanishing points, indicating that three sets of vanishing points would be necessary to represent these squares if seen in perspective.

Increasing Complexity in the Perspective Environment

Multiple or Sliding Vanishing Points

In two-point perspective, a single set of vanishing points is sufficient as long as all horizontal edges receding to the left are parallel to each other and all horizontal edges receding to the right are parallel to each other. But if cubic forms are not all aligned, you need multiple sets of vanishing points to accommodate the different rates of convergence toward the horizon line (Figure 3–20). You can also use multiple sets of vanishing points (also known as sliding vanishing points) to correct cube distortion resulting from a cube falling outside of the cone of vision. By sliding your vanishing points left or right, you shift the position of the cone of vision as needed. Remember that distortion is indicated when the leading corner of an accurately drawn cube is *less* than a 90-degree angle.

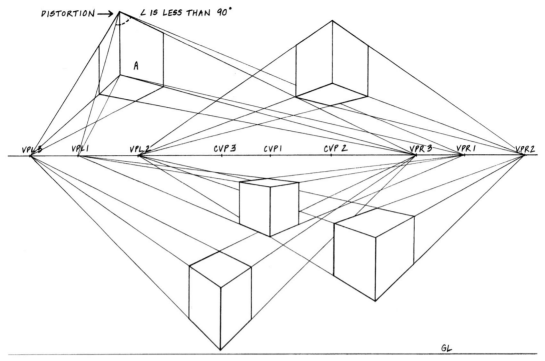

DISTORTION →

∠ IS LESS THAN 90°

A

VPL3 VPL1 VPL2 CVP3 CVP1 CVP2 VPR3 VPR1 VPR2

GL

Figure 3–21. Two-point cubic forms with multiple sets of vanishing points. Three different sets of vanishing points are used to accommodate the different orientations of the cubes to the picture plane. The central vanishing points shift as well, remaining midway between the corresponding vanishing points left and right. Cube *A* illustrates how sliding vanishing points can be used to correct a cube that is distorted due to a violation of the cone of vision.

As the position of a cube rotates in relation to the picture plane, the vanishing points shift. Because the distance between the vanishing points indicates the station point, which must remain constant, the VPL and VPR must remain the same distance apart as they are shifted along the horizon line (Figure 3–21). To accommodate cubic forms in a variety of positions or rotations in relation to the picture plane, you can use as many sets of vanishing points as necessary. To avoid confusion and facilitate an accurate drawing, it is wise to label each set of vanishing points clearly: VPL/VPR, VPL1/VPR1, VPL2/VPR2, VPL3/VPR3, etc.

Cube Multiplication and Division

Multiplying Cubes

Cube multiplication allows you to repeat a cubic-based form with correct foreshortening and rate of convergence as it recedes in space along a shared "track" or corridor of convergence. Examples of applications in the real world include a line of railroad cars along a length of track, a row of boxes on a conveyor belt, or a series of rowhouses along a city street.

Cube multiplication techniques can also be used to repeat horizontal or vertical planes as they recede in space along the same plane, as these are the planes that make

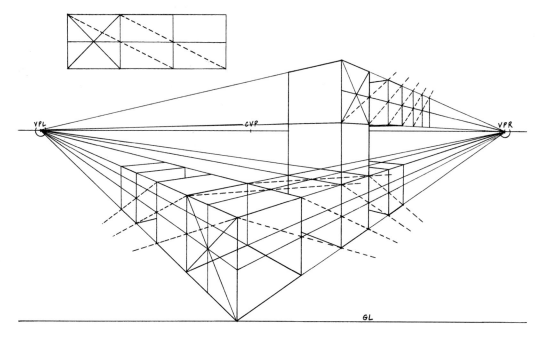

Figure 3–22. The fence-post method shown here for cube multiplication can be applied to vertical and horizontal planes. Note the distortion that begins to occur in the partially obscured cube at the far left as cube multiplication extends well beyond the original cube. The leading edge ceases to be the longest edge as it should be in a true cube. The upper left drawing shows the fence-post method applied to vertical planes facing us directly.

up a cubic form. Examples would include the receding segments of a sidewalk (horizontal planes) or the receding segments of a fence (vertical planes).

Reducing the cubic form further, the vertical edges of cubes can be repeated with equal spacing as they recede along the same plane using cube multiplication techniques. Real-world examples include fence posts, telephone poles, equally spaced trees, and people standing in formation.

There are two different methods for implementing cube multiplication—the fence-post method and the measuring line method. While both provide convincing results, it is interesting to note that the two systems yield results that sometimes differ slightly from one another. Both methods require that the depth of the original cubic form or cubic plane be defined as the basis for further repetition.

The Fence-Post Method

To use the fence-post method, bisect the vertical or horizontal plane to be multiplied (it is either an individual plane or one plane of a cubic form) by constructing corner-to-corner diagonals, identifying the perspective center at the point of the diagonals' intersection, and pulling a line of convergence through the point of intersection to the corresponding vanishing point (Figure 3–22).

To identify the correct depth of the adjacent vertical or horizontal plane, draw a line from the corner of the front edge of the original plane through the middle of the opposite edge and extend it until it intersects the line of convergence for the original

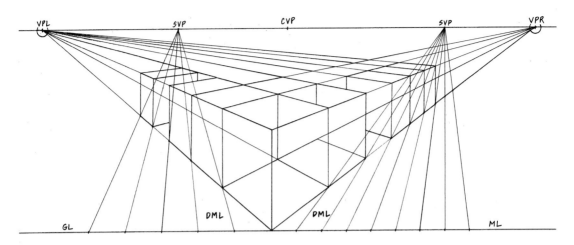

Figure 3–23. The (horizontal) measuring line method for cube multiplication can be applied to verti-
cal and horizontal planes. Like the fence-post method, distortion will occur and become more pro-
nounced in perfect cubes as you move farther away from the original cube, appearing increasingly
shallow in relation to their height.

plane. This point of intersection identifies the location of the depth of the repeated
plane as it recedes in space. If desired, it may also identify the depth of an empty space
that is equal in size to the original plane. This same process can be used in reverse to
multiply a form that is advancing in space rather than receding. Be careful not to vio-
late the cone of vision when multiplying forms forward to avoid distortion.

If this plane serves as one side of a cubic structure, simply complete the cube by
constructing the remaining sides of the cube along the corresponding track or corri-
dor of convergence. Repeat the procedure for each repetition desired. Vertical or hor-
izontal forms such as fence posts, telephone poles, or railroad ties correspond to the
edges of the vertical or horizontal planes.

The Measuring Line Method

To use the measuring line method, draw a horizontal line that touches the nearest cor-
ner of the plane (vertical or horizontal) or cubic structure you wish to multiply and
extend it to the left and right (Figure 3–23). This measuring line (also called a hori-
zontal measuring line) should be parallel to both the ground line and the horizon line.
In the case of a cube whose nearest corner rests directly on the ground line, the ground
line will function as the measuring line. Since the measuring line is parallel to the pic-
ture plane, it is not affected by diminution and can provide constant measurable units.

To begin the multiplication process, you must mark a length or increment of your
choosing along the horizontal measuring line that represents the depth of the plane or
cubic structure you wish to repeat. This increment originates at the point where the
measuring line touches the nearest corner. If you are multiplying a form toward VPR,
your increment would be drawn to the right along the measuring line, and vice versa.
The length of the increment is arbitrary, although if it is too small it can more easily
lead to error, and if it is too large it can require extensions of your paper surface and
become unwieldy. Common sense should prevail.

For purposes of explanation, imagine that a half-inch increment on the horizontal measuring line represents the depth of the original plane or cube to be multiplied. Draw a DML from the half-inch mark through the back corner or edge of the original form and extend it until it intersects the horizon line. This point of intersection establishes an SVP upon which all other DMLs will converge when multiplying that particular form. To determine the depth of a second form, establish a second half-inch increment adjacent to the first one on the measuring line. Draw a DML from this point to the SVP. Where this DML intersects the line of convergence for the original form indicates the depth of the second plane as it recedes in space.

If you have a plane or a cubic form that you wish to multiply ten times along the same corridor of convergence, then you will have ten half-inch increments along your horizontal measuring line. It is equally viable that you initially decide to use a quarter-inch increment on the measuring line to represent the depth of the original plane or cube to be multiplied. Each quarter-inch increment on the measuring line represents the depth of a duplicate of the original form when the quarter-inch increment is drawn back to the SVP and intersects the original line of convergence.

Taking this idea a step further, if you desire to repeat only half the depth of a cubic form, you can subdivide your established increment along the horizontal measuring line and work with it accordingly. You can also repeat the depth of the original form and allow it to function as an empty space between repeated forms. A solid understanding of the use of the horizontal measuring line is especially important because it serves a variety of other significant purposes that will be addressed in the section on using measuring lines in this chapter.

Distortion in Cube Multiplication

Based on the techniques presented above, we should be able to multiply an accurately drawn cube in any direction and use it as a blueprint for constructing a great variety of forms ultimately rooted in cubic structure. But you may note that cube multiplication, whether using the measuring line method or the fence-post method, yields cubes that are distorted in appearance as they move farther away from the original cube. They may appear more rectangular than cubic (Figure 3–24). And these distorted cubes are found within the "safe" area defined by the cone of vision. We cannot correct these distortions in perspective language without resorting to extremely lengthy, technical, and confusing methods that ultimately increase the incidence of error, and so we must learn to accept these distortions as part of the limitations of the perspective system. In the event that these distortions must be corrected, or if you are interested in studying the process for correcting these distortions, refer to Jay Doblin's *Perspective: A New System for Designers,* listed in the Supplemental Reading Perspective section of the bibliography.

It is important to remember that, in technical perspective drawing, accuracy is relative. With all of the possibilities technical perspective offers us for creating the illusion of depth and space on a two-dimensional surface, it remains limited to *symbolizing* what the eye actually sees. For general drawing purposes, it is most effective when combined with careful observation and sighting.

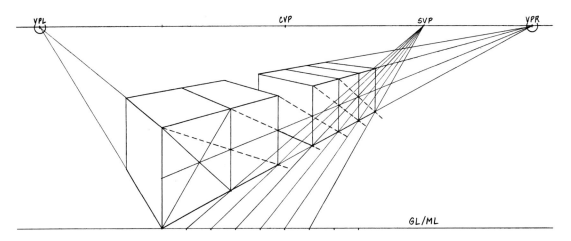

Figure 3–24. Cube multiplication using both the fence-post and the measuring line methods will yield the same results. Again, note the increased distortion as the multiplied cubes move farther away from the original cube.

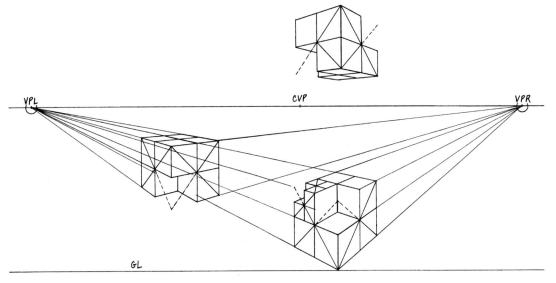

Figure 3–25. This illustration shows cube division and subdivision based on increments of one-half, one-quarter, one-eighth, etc.

Dividing Cubes

Cube division allows us to divide and subdivide a cube into increasingly smaller units, carving away sections of a cube. Cube multiplication and cube division, combined, form the basis for transparent construction, which uses the cube and the broad range of geometric solids derived from it as the framework for constructing countless dimensional forms as if we can see through them to the parts that are obstructed from view.

Cube division can be approached in two basic ways. The first method, which relies on finding the center of any given plane at the point where the two corner-to-corner diagonals intersect, allows us to divide and subdivide a cube in increments of

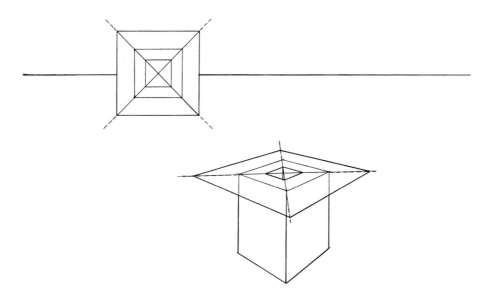

Figure 3–26. Corner-to-corner diagonals can be used to proportionally enlarge or reduce a rectangular plane. The upper left drawing illustrates the technique of proportionally enlarging and reducing a vertical plane with no foreshortening.

½, ¼, ⅛, ⅟₁₆, ⅟₃₂, etc., by dividing any given area into two equal halves (Figure 3–25). The second method, which relies on the use of a measuring line, allows us to divide and subdivide a cube into regular *or irregular* increments. The measuring line method allows for cube divisions that are not available using the corner-to-corner, or "Xing," method. Related to the use of measuring lines for cube multiplication, this method is described in detail in this chapter under the heading "Using Measuring Lines for Regular (Equal) and Irregular (Unequal) Divisions of an Area."

Corner-to-corner diagonals can also be used to proportionally scale down or reduce a square or rectangular plane and, when extended beyond the corners, can be used to proportionally scale up or enlarge a square or rectangular plane (Figure 3–26). Additionally, once a point of division has been identified on one side or plane of a cubic form, the corresponding point can be found on any other plane of the cube by simply wrapping the cube with construction lines which correspond to the vanishing points used to construct the original cube (Figure 3–27).

Mathematically Precise Cubes in Two-Point Perspective

Constructing a 30°/60° Cube Based on the Height of the Leading Edge

The following steps create the height of the leading edge of a cube and a horizontal foreshortened square that becomes the *base* of a cube in 30°/60° two-point perspective. A 30°/60° cube in two-point perspective is a cube whose foreshortened sides are at different angles to the picture plane, one at 30 degrees and one at 60 degrees (Figure 3–28).

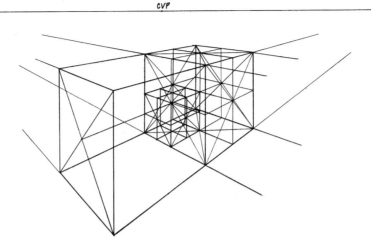

Figure 3–27. This drawing illustrates how a point identified on one edge or plane of a cube can be located on other edges or planes by wrapping lines of convergence around the cube, much like wrapping ribbon around a package.

1. All preliminary information should be established and drawn, including scale, eye-level or horizon line, ground line, station point, central vanishing point, vanishing points left and right, units of measure along the horizon line that reflect your scale, units of measure along a vertical measuring line that reflect your scale, and cone of vision.

2. Bisect the distance between the CVP and VPL or VPR to locate point *A*. (Figure 3–28 uses VPL.)

3. Bisect the distance between *A* and VPL to locate measuring point *B*.

4. Draw a vertical line through point *A* and determine on this vertical the desired location of the leading corner (*L*) of the cube, which may be positioned above or below the horizon line. (In the example, it is located below the horizon line.)

5. Draw a horizontal measuring line through *L*. If you placed your leading corner on the ground line, the ground line functions as the horizontal measuring line.

6. Determine the height of the leading edge from *L*. Rotate the leading edge to the left and right from point *L* to the horizontal measuring line, locating points *X* and *Y.*

7. Draw lines of convergence from *L* and *F* to vanishing points left and right to construct the leading corner and to begin cube construction.

8. Draw a line from CVP to *X*, locating its point of intersection (*C*) along the line of convergence. Draw a line from *B* to *Y*, locating its point of intersection (*D*) along the line of convergence.

9. Draw lines of convergence from *C* and *D* to the opposite vanishing points to complete the base/horizontal square of the cube (*LCGD*).

10. Draw verticals at the sides (*C* and *D*) and back corner (*G*) of the square. Draw the remaining lines of convergence to VPL and VPR to complete your cube.

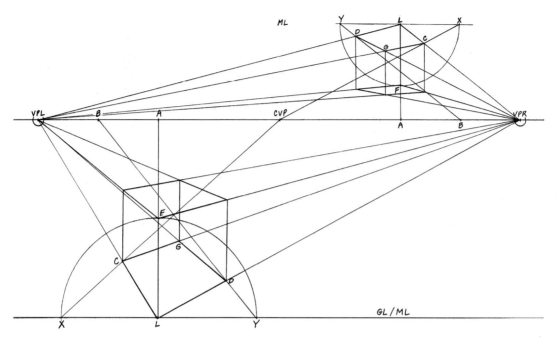

Figure 3–28. Constructing a 30°/60° cube based on initial determination of the height of the leading edge.

This is an accurate 30°/60° cube that can be positioned noncentrally in a perspective environment. Keep in mind that distortion will become pronounced if the cube, through cube multiplication, crosses over the center of the perspective environment (indicated by the location of the CVP) or approaches either vanishing point too closely.

Constructing a 45°/45° Cube Based on the Size of the Base Square

The following steps create a horizontal or foreshortened square in 45°/45° two-point perspective, which becomes the *base* of a cube in 45°/45° two-point perspective. A 45°/45° cube in two-point perspective is a cube that rests halfway or nearly halfway between the VPL and VPR, and whose foreshortened sides are each at a 45-degree angle to the picture plane (Figure 3–29).

1. All preliminary information should be established and drawn, including scale, eye-level line or horizon line, ground line, station point, central vanishing point, vanishing points left and right, units of measure along the horizon line that reflect your scale, units of measure along a vertical measuring line that reflect your scale, and cone of vision.

2. Drop a vertical line (in the case of the *exact* 45°/45° method) or a slightly diagonal line (in the case of the *off-center* 45°/45° method) from the CVP to the ground line (GL). This line will become the diagonal of the foreshortened base square (Figure 3–30).

3. Draw two lines of convergence, one each from VPL and VPR, to intersect at the point along the vertical (or diagonal) line where you wish to position the nearest angle or corner of the foreshortened base square (*L*).

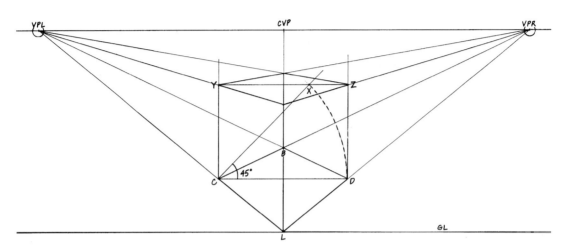

Figure 3–29. Constructing a 45°/45° cube directly aligned with the CVP based on initial determination of the size of the base square. The upper right drawing illustrates the geometric principle guiding the process.

4. Draw two more lines of convergence from VPL and VPR to intersect at a second point along the vertical (or diagonal) line based on the desired *depth* of the cube, and *through* the vertical (or diagonal) line to intersect the original lines of convergence established in step 3. This defines the back angle or corner of the foreshortened base square (*B*), locates points *C* and *D*, and completes the base plane or square of the foreshortened cube (*CBDL*).

To complete the cube by building off the base square:

5. Draw vertical lines up from all four corners of the square (*C, B, D,* and *L*).
6. Rotate *CD* 45 degrees upward to create point *X* (*CX* is equal in length to *CD*), and draw a horizontal line through point *X* to intersect the two side verticals of the cube (*Y* and *Z*).
7. Construct the upper square or plane of the cube by drawing four lines of convergence from these two points of intersection (*Y* and *Z*) to VPL and VPR. Two of these lines of convergence must also be pulled forward to meet at the leading edge of the cube and define its height.

This is an accurate 45°/45° cube that can be positioned in a variety of centrally located positions in a perspective environment. Keep in mind that distortion will occur if the diagonal of the base square deviates significantly from a true vertical. In cube multiplication, distortion will become pronounced as the cube approaches the point halfway between the CVP and VPL or halfway between the CVP and VPR.

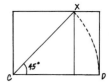

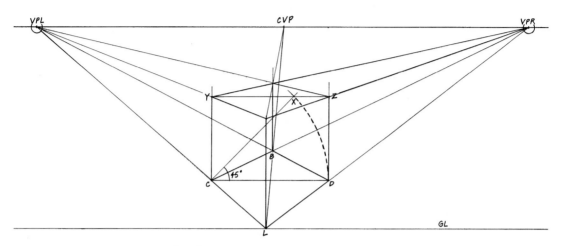

Figure 3–30. Construction of a 45°/45° cube slightly off-center of the CVP based on initial determination of the size of the base square. The upper right drawing illustrates the geometric principle guiding the process.

First Alternative Method for Constructing a 45°/45° Cube Based on the Height of the Leading Edge

1. All preliminary information should be established and drawn, including scale, eye-level or horizon line, ground line, station point, central vanishing point, vanishing points left and right, units of measure along the horizon line that reflect your scale, units of measure along a vertical measuring line that reflect your scale, and cone of vision (Figure 3–31).

2. Draw the leading edge of a 45°/45° cube to the desired height. This is a vertical line that should be located directly below the CVP and should remain within the COV. The height of the leading edge is a random decision unless a specific height has been indicated.

3. Draw lines of convergence from the top and bottom of the leading edge to VPL and VPR.

4. From this leading edge (LA), construct a square to the left or right side, and extend the base of the square to the left and right to establish a measuring line. If the leading edge rests on the ground line, then the ground line functions as a measuring line. Draw the diagonal of the square (LB) from the bottom of the leading edge (L) to the opposite upper corner of the square (B).

5. Rotate the diagonal down in an arc from the upper corner until it intersects the measuring line. From this point of intersection (Z), draw a DML back to the opposite VP.

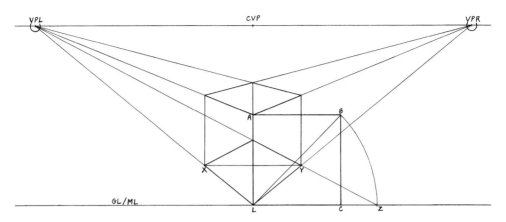

Figure 3–31. First alternative method for constructing a 45°/45° cube based on initial determination of the height of the leading edge.

6. Where the DML intersects the lower line of convergence (Y) indicates the depth of one side of the cube. From this point of intersection, draw a vertical line to meet the upper line of convergence. This establishes one foreshortened plane of the cube.
7. From this same point of intersection (Y), draw a true horizontal line (parallel to the ground line/measuring line) across the base of the cube until it intersects the opposite line of convergence. This point of intersection (X) indicates the depth of the remaining side of the cube.
8. From this point of intersection (X), draw a vertical line to meet the upper line of convergence. This establishes the remaining foreshortened plane of the cube. Note the depth of the two sides of the cube is equal.
9. From the four back corners of these foreshortened planes, draw lines of convergence to the opposite VPs. Where these lines intersect establishes the back edge of the cube, which aligns with the leading edge. Constructing a vertical between these points of intersection completes the 45°/45° cube.

Second Alternative Method for Constructing a 45°/45° Cube Based on the Height of the Leading Edge

1. All preliminary information should be established and drawn, including scale, eye-level or horizon line, ground line, station point, central vanishing point, vanishing points left and right, units of measure along the horizon line that reflect your scale, units of measure along a vertical measuring line that reflect your scale, and cone of vision (Figure 3–32).
2. Outside of your desired image area, construct a square whose height is equal to the desired height of the leading edge of a 45°/45° cube.
3. Draw the diagonal of the square (XY) and rotate the diagonal down in an arc until it meets a horizontal extension of the bottom edge of the square. From this point (Z), draw a vertical line up until it meets a horizontal extension of

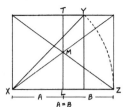

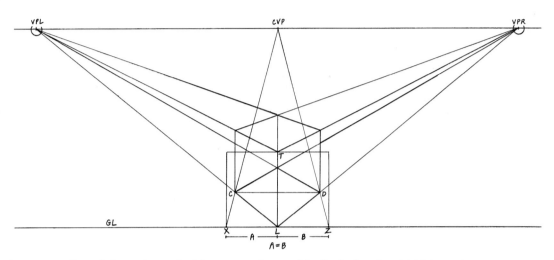

Figure 3–32. Second alternative method for constructing a 45°/45° cube based on initial determination of the height of the leading edge. The upper right drawing illustrates the geometric principle guiding the process.

the top edge of the square. You now have a rectangle that is derived from the diagonal of the original square.

4. Find the center of the rectangle by drawing the two corner-to-corner diagonals of the rectangle. Their point of intersection (M) is the center of the rectangle.

5. Draw a vertical line through the center point, bisecting the rectangle. This completes the schematic form which will be used to construct the 45°/45° cube.

6. Moving back to your perspective environment, draw the bisected rectangle in the desired location with the vertical bisection aligned with the CVP. This vertical bisection (LT) is the leading edge of your cube. Draw lines of convergence from the top and bottom of the leading edge to VPL and VPR.

7. From the lower right and left corners of the rectangle (X and Z), draw DMLs to the CVP. Where the DMLs intersect the lower lines of convergence indicates the depth of the left and right sides of the cube. From these points of intersection (C and D), draw vertical lines to meet the upper lines of convergence. This establishes the left and right foreshortened planes of the cube, which are equal in depth.

8. From the four back corners of these foreshortened planes, draw lines of convergence to the opposite VPs. Where these lines intersect establishes the back

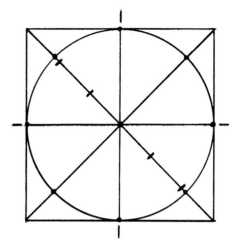

Figure 3–33. The relationship of a circle to a square and identification of the eight tangent points necessary for guiding ellipse construction.

edge of the cube, which aligns with the leading edge. Constructing a vertical between these points of intersection completes the 45°/45° cube.

Constructing Ellipses in One-Point and Two-Point Perspective

Simply speaking, an ellipse is a circle seen in perspective, a foreshortened circle. A circle fits precisely within a square, touching the exact midpoint of each side of a square and intersecting the square's diagonals in the same two places on each diagonal. With an awareness of how to construct squares and cubes in perspective, and with the knowledge that a cube consists of six equal squares, we are able to construct accurate ellipses using the foreshortened square as a guide.

The Eight-Point Tangent System for Ellipse Construction

Eight points (tangent points) within a square must be identified to guide the construction of a circle or an ellipse. These eight points can be recognized most clearly by first referring to a full view of a circle within a square, without any foreshortening of the circle or the square.

The point of intersection of two corner-to-corner diagonals drawn through the square identifies the midpoint or center of the square. Drawing a vertical and horizontal line through the center point and extending them to meet the sides of the square identifies the midpoint of each of the four sides of the square. These are the first four tangent points for guiding ellipse construction. A circle drawn within the square will touch the square at each of these four points (Figure 3–33). For a foreshortened square, the lines drawn through the center point that identify the midpoint of each side of the square must be drawn in perspective, converging on the appropriate vanishing point(s) when necessary.

To identify the remaining four tangents points, each half-diagonal, defined by the point of intersection with the other diagonal, is divided into equal thirds. A circle drawn within the square, and touching the first four tangent points, will fall just outside of the outermost one-third division of each half-diagonal. These outermost divi-

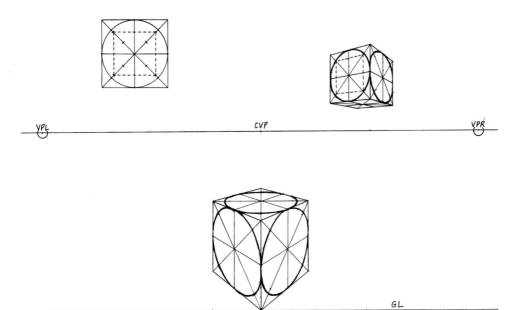

Figure 3–34. The relationship of ellipses to a variety of foreshortened cube faces. The upper left drawing notes the relationship of a circle to a square without the element of foreshortening.

sions of the diagonals comprise the second, and more flexible, set of four tangent points. For a foreshortened square, it is important to remember that the one-third divisions will not be equal in actual measurement because of the effects of diminution. It is acceptable to estimate the one-third divisions since the resulting tangent point is flexible. After identifying only one point of division, you can then pull a line originating from that point of division around the foreshortened square (with correct convergence when appropriate), and identify the remaining points of division based on the line's intersections with the corner-to-corner diagonals.

By applying the above process to any foreshortened square, whether seen in one-point or two-point perspective, you can identify the eight tangent points required to guide ellipse construction. Ellipse construction requires a lot of practice before one can confidently draw an ellipse that is accurate and convincing—uniform in its curvature, with no flat, high, or low spots (wobbles); no points or sharpness at the narrowest part of the ellipse (footballs); a correct tilt or angle (major axis) of the ellipse in relation to the foreshortened square from which it is derived; an identifiable major and minor axis at a 90–degree angle to each other; and other factors (Figure 3–34). Further discussion and examination of the illustrations will help to clarify the importance of these points.

Major and Minor Axes, Distortion, and Fullness of Ellipses

When a circle is foreshortened, becoming an ellipse, it has a major axis and a minor axis. The major axis is an imaginary line that bisects the ellipse at its widest or longest point, while the minor axis is an imaginary line that bisects the ellipse at its narrowest or shortest point (Figure 3–35). The major and minor axes of an ellipse will always

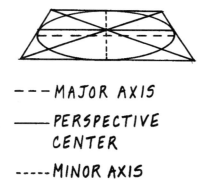

---- **MAJOR AXIS**

——— **PERSPECTIVE CENTER**

----- **MINOR AXIS**

Figure 3–35. The relationship between major and minor axes of an ellipse is 90 degrees. Because of foreshortening, the perspective center of ellipses is not the same as the major axis, and is positioned *behind* the major axis.

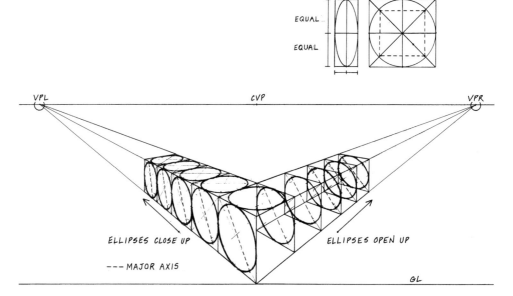

Figure 3–36. The behavior of ellipses receding in space in parallel planes and in the same plane is different. In parallel planes, ellipses lean more strongly as they recede, while in the same plane ellipses become more upright as they recede.

remain at 90 degrees to each other, regardless of their position in space or their degree of foreshortening. It is helpful to note that these major and minor axes rarely coincide with the diagonal or bisecting lines of the foreshortened square within which the ellipse lies, and the major axis falls in front of the perspective center of the ellipse.

The minor axis of an ellipse is perpendicular to the foreshortened square from which the ellipse is derived. It is important to remember, however, what has been noted about distortion in perspective. As squares and cubes are positioned farther away from the original cube or square from which they are derived, distortion increases. Elliptical forms drawn within these distorted squares are not true or precise ellipses, although they may appear to be. When this distortion is present, the 90–degree relationship between major and minor axes of ellipses is altered, as well as the perpendicular relationship of the minor axis to the square from which the ellipse is derived.

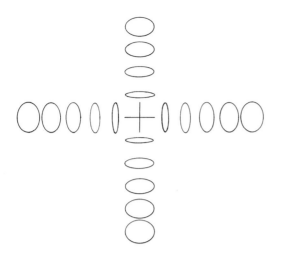

Figure 3–37. The changing appearance of ellipses based on their proximity to the eye level and the CVP is shown here. Note that ellipses appear as straight lines with no visible depth when they are positioned horizontally at eye level or vertically at the CVP.

Figure 3–38. The correct and incorrect relationships of ellipses in parallel planes are shown in these two forms, which are positioned well below eye level. The glass on the left shows an accurate relationship between upper (more closed) and lower (more open) ellipses, while the glass on the right is inaccurate, actually representing how the glass on the left might appear if viewed above the eye level.

When a series of ellipses is constructed in the same vertical plane, the major axis will be most strongly angled in the foreground, and as the ellipses recede in space along the vertical plane, the major axis is less angled, approaching a more vertical orientation. When a series of ellipses is constructed in parallel vertical planes, the opposite is true: the major axis will be closer to a vertical in the foreground, and will have a stronger diagonal orientation as the ellipses recede in space (Figure 3–36).

As ellipses approach the eye level in a horizontal plane, or the central vanishing point in a vertical plane, they narrow or close up dramatically. As they move farther to the left or right in a vertical plane, or move farther above or below the eye level in a horizontal plane, they widen or open up dramatically (Figure 3–37).

Because there are numerous degrees of foreshortening, ellipses can be very full when seen in relation to a square that is only minimally foreshortened, appearing to be nearly a full circle. When seen in relation to a square that is extremely foreshortened, ellipses can be very thin, appearing to be nearly a single straight line. When ellipses are positioned close to each other as part of the same form, such as at the top and bottom of a drinking glass or the outside and inside of a wheel, they must correspond correctly to each other in order to convey that the glass or wheel are seen from a fixed viewpoint (Figure 3–38). If one ellipse is extremely wide or open, and the other is extremely narrow or closed, the results are visually confusing, implying that the glass is being viewed from two different eye levels.

Using Measuring Lines for Regular (Equal) and Irregular (Unequal) Divisions of an Area

We have already seen how horizontal measuring lines can be used for multiplying any unit in perspective—a cube, a rectangular solid, a horizontal or vertical plane of any dimensions, or even an empty space. The use of an HML also allows us to divide and subdivide a cube, a plane, a rectangular solid or an empty space into either regular (equal) or irregular (unequal) increments. The measuring line method allows cube divisions that are not available using the corner-to-corner, or Xing method, as this technique is only capable of creating one-half divisions of any given area.

Setting Up the Measuring Line

To use the measuring line method, draw a horizontal line (the measuring line) that touches the nearest corner of the vertical or horizontal plane or cubic structure you wish to divide and extend it to the left and right. This line should be parallel to both the ground line and the horizon line. In the case of a cube whose nearest or leading corner rests directly on the ground line, the ground line will function as the horizontal measuring line. Since the measuring line is parallel to the picture plane, it is not affected by diminution and can provide constant measurable units. Remember that your HML, like your horizon line, can extend infinitely to either side, and may extend beyond the edges of your drawing format if necessary.

The Process of Dividing a Form

1. To begin the process of dividing a form into equal or unequal increments, you must mark a length or increment of your choosing along the measuring line that represents the total depth of the plane or cubic structure or space you wish to divide (Figure 3-39). This increment originates at the point where the measuring line touches the nearest corner. If you are dividing a form that converges toward VPR, your increment would be drawn to the right along the measuring line, and vice versa. The length of the increment is arbitrary, although if it is too small it can more easily lead to error or inaccuracy, and if it is too large it can require extensions of your paper surface and become unwieldy. Common sense should prevail.

2. For purposes of explanation, imagine that a 2" increment on the measuring line represents the depth of the plane or cube or space you wish to divide. Draw a DML from the 2" mark through the back bottom corner or edge of the form you wish to divide and extend it until it intersects the horizon line. This point of intersection establishes an SVP upon which all other DMLs will converge when dividing that particular form.

3. To determine the location of a point one-third of the way along the depth of the form, come back to the 2" increment on the HML and locate a point one-third of the way along its length. Draw a DML from this point to the established SVP. Where this DML intersects the base of the original form indicates a one-third division of the form as it recedes in space.

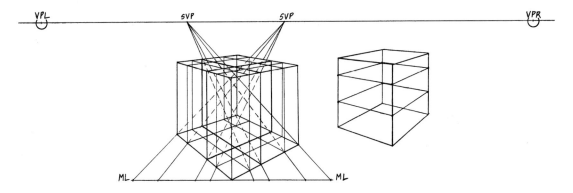

Figure 3–39. Irregular divisions of a cube or cube face using a horizontal measuring line can be wrapped around all faces of the cube. The cube on the right shows unequally spaced horizontal planar divisions of a cube using the leading edge as a measuring line.

4. If you are dividing a vertical plane, you can extend a line up from this point of intersection, and if the vertical plane is one side of a cubic structure, you can wrap the line of division around the cubic structure (respecting perspective convergence) to find the corresponding one-third division on additional faces of the form. If you are dividing a horizontal plane, you can pull a line across the plane from this point of intersection, making sure to respect the perspective convergence.

5. If you have a plane or a cubic form that you wish to divide into ten equal units, then you will have ten equal increments within the original 2" increment along your HML. If you have a plane or a cubic form that you wish to divide into a number of unequal units, then you will first establish these unequal units within the original 2" increment along your HML.

6. It is equally viable that you initially decide to use an increment other than 2", such as a half-inch increment on the measuring line to represent the depth of the original plane or cube to be divided. But if you are going to subdivide a number of times, whether regular or irregular divisions, an initial half-inch increment may be a bit small to work with comfortably.

These techniques assist you in identifying the location of a point from side to side on any given foreshortened plane. To locate the height of a point from top to bottom on a vertical foreshortened plane, you can use the leading edge of the plane as a vertical measuring line. Because this vertical edge is not foreshortened, you can apply measurements directly to it and pull them back across the foreshortened plane toward the appropriate vanishing point to identify the height of points located on the foreshortened plane.

Applications for the Use of Regular or Irregular Divisions

You may be asking yourself under what circumstances would you use this process of division, which essentially allows you to identify different points along a line or plane that is receding in space. There are innumerable applications. Imagine, for example,

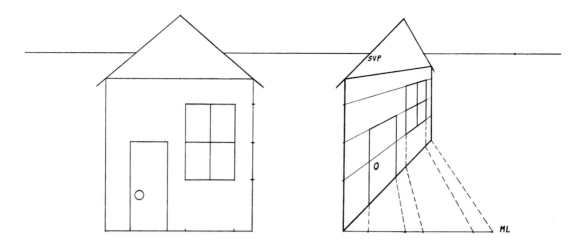

Figure 3–40. The use of a horizontal measuring line makes it possible to translate information found on a nonforeshortened plane (left) to a corresponding foreshortened plane (right).

that you are drawing a rectangular solid that represents a house based on the scale you have established for your drawing (Figure 3–40). On any given side of the house there are windows and doors and other architectural elements that are positioned at irregular intervals and at various heights, and you want to represent their location accurately on the foreshortened planes of the house. By determining the location of windows and doors on any given side of the house when you face the house directly, without foreshortening, you can translate that information to a foreshortened representation of that side of the house by using the measuring line system as described above. In order to identify the height of such architectural elements, use the vertical leading edge as a vertical measuring line. Again, because it is not foreshortened, it can be used to transfer measurements directly.

That same rectangular solid, with a different scale applied to it, may represent the basic geometric shape of a computer monitor, a child's toy, an automobile, an air-conditioning unit, a reclining chair, a gasoline-powered generator—the possibilities are endless. Using the measuring line system can help you identify the correct location of knobs, buttons, slots, wheels, doors, switches, and any other variations or elaborations of the form.

If the form you wish to represent is roughly a half-cube deep, two cubes tall, and three and one-half cubes long, you can create the basic geometric solid from which the form is derived by first drawing a precise cube, then finding the depth of a half-cube by using cube division techniques, then extending it up to a height of two cubes by stacking it, and finally extending it back in perspective three and one-half cubes by using cube multiplication techniques. This process forms the basis for transparent construction drawing, described later in this chapter.

Inclined Planes in Perspective

Inclined planes in perspective are neither parallel to the ground plane nor perpendicular, and so the rules that govern the construction of vertical and horizontal planes do

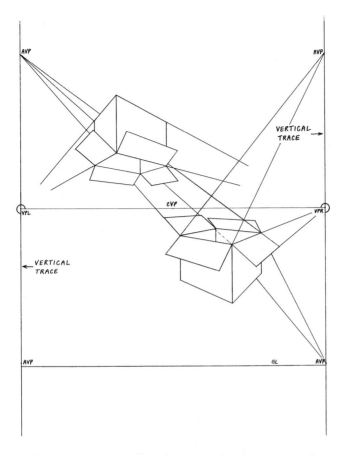

Figure 3–41. Inclined planes in the form of box flaps are explored in a variety of positions. Note that each flap has two points of convergence, one on the eye-level line at VPL or VPR and one above or below a vertical extension of VPL or VPR.

not fully apply to inclined planes. Inclined planes are tilted in space, angling up or down as they recede in space (Figure 3–41). Some examples of inclined planes include rooftops at various pitches, wheelchair ramps, box flaps in a variety of positions, and stairways, which are essentially a series of small vertical and horizontal planes that fall within a larger inclined plane.

Inclined planes, whether seen in one-point or two-point perspective, are governed by principles of perspective with which we are familiar, along with some variations of these principles. We know that a plane derived from any rectangular solid—whether inclined, vertical, or horizontal—is composed of four sides. The sides or edges opposite each other are parallel. Unless these edges are vertical in their orientation (perpendicular to the ground plane), we know that as they recede in space they will converge upon a common vanishing point that is located on the horizon line. Here is where the variation occurs. In representing an inclined plane, any parallel receding edges that are not vertical or horizontal (perpendicular or parallel to the ground plane) will converge on a common point positioned directly above or below the VPL or VPR. This vertical extension of the VPL or VPR is called a VERTICAL TRACE and any

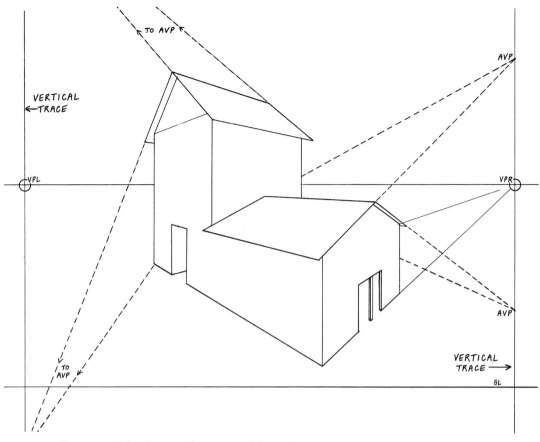

Figure 3–42. This drawing of a compound form shows two separate rooftops at different pitches or degrees of incline. Note that the greater the incline, the farther the AVP is positioned above or below the corresponding vanishing point. Both rooftops are equally pitched on either side, resulting in an equal distance above and below the vanishing point for the AVP.

vanishing points located on the vertical trace are called AUXILIARY VANISHING POINTS (AVPs).

Auxiliary Vanishing Points and the Vertical Trace

In the case of an inclined plane that angles *up* as it recedes away from us, the AVP will be positioned *above* the corresponding vanishing point. How far above the vanishing point the AVP is positioned is determined by the degree of the incline (Figure 3–42). In the case of an inclined plane that angles *down* as it recedes away from us, the AVP will be positioned *below* the corresponding vanishing point. How far below the vanishing point the AVP is positioned is determined by the degree of the incline. Vertical traces (the line along which AVPs are located) can be extended above and below VPL and VPR as far as you desire. It is important to note, however, that once an inclined plane reaches 90 degrees, it is no longer treated as an inclined plane but as a vertical plane whose vertical edges do not converge.

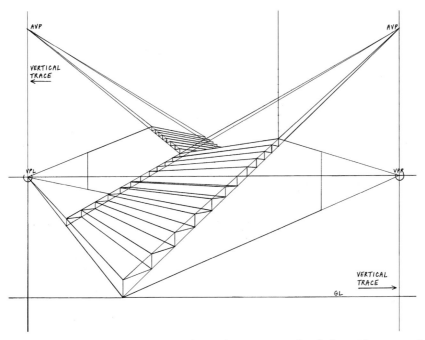

Figure 3–43. A two-point perspective view of ascending stairs as inclined planes. The greater the incline, the farther the AVP is positioned above or below the corresponding vanishing point.

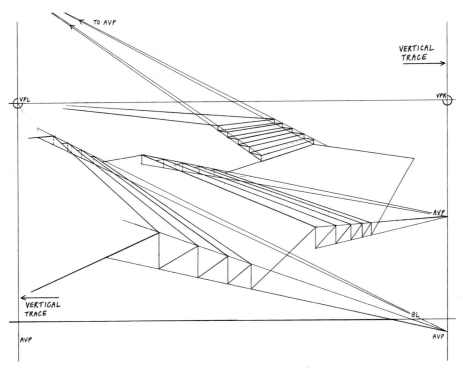

Figure 3–44. A two-point perspective view of descending stairs as inclined planes with periodic landings or extended planes. The two closest sets of stairs are at different pitches, the first steeper than the second. This is indicated by different positions of the AVPs. Dotted lines indicate unseen edges of the risers, or vertical planes of a stair.

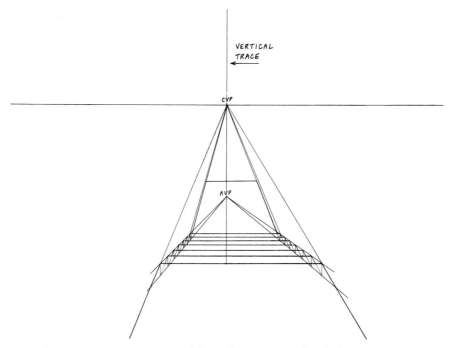

Figure 3–45. A one-point perspective view of descending stairs as inclined planes with a landing at the top and bottom. Note that the AVP is located along a vertical extension of the CVP. Only the treads, or horizontal planes of the stairs, are visible from this viewpoint.

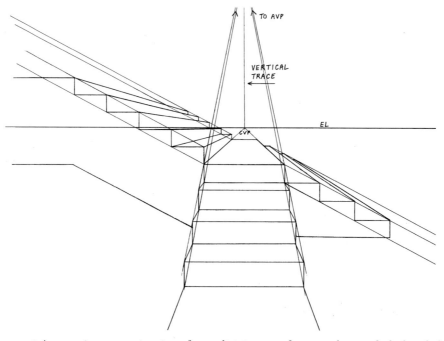

Figure 3–46. A one-point perspective view of two adjoining sets of stairs, only one of which includes an inclined plane that recedes. For the inclined plane that moves across the picture plane but not into it, no convergence for the pitch of the inclined plane is necessary.

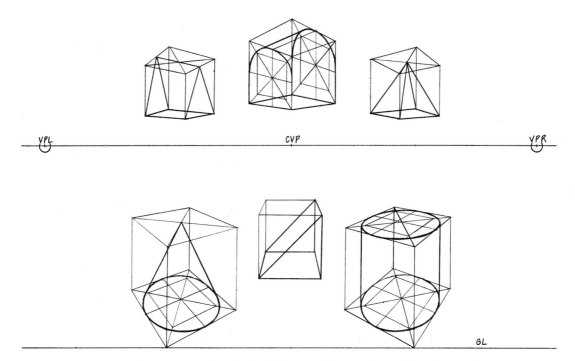

VPL CVP VPR

GL

Figure 3–47. A variety of geometric solids and related forms are shown in their relationship to cubes. As cubes such as the one on the lower right approach the cone of vision, some distortion in the resulting geometric solid begins to appear as evidenced by the tilting ellipses of the cylindrical form.

In the examples given of inclined planes (rooftops, box flaps, and stairs), it is important to note that each inclined plane seen in two-point perspective has one set of vanishing points located directly on the horizon line and one set of vanishing points located on a vertical trace, which is an extension of the remaining vanishing point. In the case of one-point perspective, vertical trace lines extend from the CVP. More specifically, those edges of an inclined plane that are horizontal (parallel to the ground plane) will converge on a traditional VPL or VPR. The two remaining edges that are neither parallel nor perpendicular to the ground plane will converge on an AVP located above or below the opposite vanishing point (Figures 3–43 and 3–44). In the case of one-point inclined planes, receding edges will converge on an AVP located above or below the CVP (Figures 3–45 and 3–46). All inclined planes in two-point perspective will have one point of convergence to the left and one point of convergence to the right.

In the case of a peaked rooftop that has an equal pitch on both sides, the AVPs for the upward pitch and downward pitch are positioned equal distances above and below the horizon line to assure uniform pitch on both planes of the roof (see Figure 3–42). For inclined planes that have no edges parallel or perpendicular to the ground plane, both left and right points of convergence will fall on an AVP located on a vertical trace, one above the horizon line and one below the horizon line.

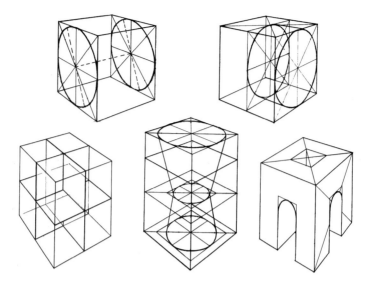

Figure 3–48. Cubes and cubic forms provide the basis for a variety of both simple and compound geometric solids and ellipses.

Figure 3–49. Student work. Scott Luce. Transparent construction drawing of a ski boot showing both the visible near side and the invisible far side.

Geometric Solids and Transparent Construction

The geometric solids known as the cube, the cylinder, the cone, and the sphere provide the basic forms from which all other forms are composed. All forms, to varying degrees, can be ultimately reduced to one of these geometric solids or a combination of these geometric solids (Figure 3–47). With an understanding of cube construction and ellipse construction as it relates to a cube, any of these basic forms can be created, as well as infinite variations of these forms.

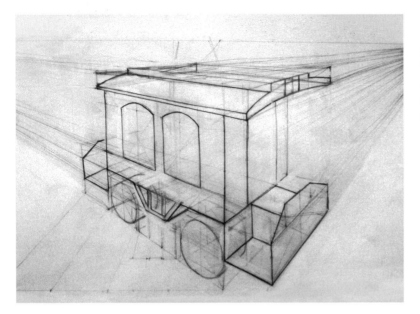

Figure 3–50. Student work.
Theron J. Willis.
An in-progress transparent
construction drawing of a
toy train car.

Figure 3–51. Student work.
Jeff VandenBerg. A fully
developed transparent
construction drawing of
a toy cash register.

What is Transparent Construction?

Geometric solids, along with gridded ground planes, cube multiplication, and cube division, also provide the foundation of understanding for transparent construction. Transparent construction involves the reduction of all three-dimensional forms, both simple and complex, to their basic geometric solids (Figure 3–48) and a depiction of these three-dimensional forms that suggests their transparency, essentially defining information that is not actually visible from a fixed viewpoint. For example, one may

Figure 3–52. Student work. Liisa Rupert-Rush. Identifying the cubic structure of a cowboy boot in adjacent schematic drawings prepares the student for a more informed investigation of the boot.

draw a shoe in which we see simultaneously both the near side of the shoe and the far side of the shoe—a perspective version of X-ray vision (Figure 3–49). The most basic skill necessary for exploring transparent construction is the ability to draw a transparent cube in perspective, defining all six faces of the cube as if it were made of glass.

To apply transparent construction to the depiction of an object, it is best to start with a form whose relationship to a cubic structure is readily apparent—a form that is composed of simple planes and perhaps some curvilinear contours, which are rooted in ellipses. Certain children's toys, for example, are excellent subjects for beginning to explore transparent construction because of their inherent simplification and their obvious relationship to a rectangular solid. Examples include toy cars, trucks, or trains, cash registers, telephones, work benches, and other simplified versions of cube-based forms that are typically constructed of wood or plastic (Figures 3–50 and 3–51). More complex forms may be introduced as comprehension of the process increases.

Establishing the Cubic Connection

The important first step in the process involves determining the relationship of the form to a cube. Pick up the object you are going to draw and, by viewing it from all sides, determine what its cubic dimensions are (Figure 3–52). An object that roughly measures 12" tall, 18" long, and 6" deep can be translated into cubic dimensions a few different ways. If you wish to work with a 12" cube as the basic unit of measure, then the object in its simplified form can be represented as one cube tall, one and one-half cubes long, and a half-cube deep, using cube multiplication and division to create the proper dimensions. If you wish to work with a 6" cube as the basic unit of measure, then the object can be represented as two cubes tall, three cubes long, and one cube

Figure 3–53. Student work. The cubic structure of this toy cash register is shown to be approximately five cubes wide including the side tray, three and a half cubes deep, and three and a half cubes high.

Figure 3–54. Student work. The cubic structure of this lunch box is shown to be approximately four cubes wide, two cubes deep, and two and a half cubes high.

deep. If you wish to work with a 3" cube as the basic unit of measure, then the object can be represented as four cubes tall, six cubes long, and two cubes deep. If you encounter dimensions that involve more irregular fractions of a cube, such as thirds, then you can either estimate thirds of a cube or use a measuring line for a precise determination of thirds. A gridded ground plane may also be used as a sort of template in helping to determine cubic dimensions. The object's relationship to a gridded ground plane in a plan or overhead view can be translated to the object's relationship to that same gridded ground plane when seen in perspective.

If you wish to begin your drawing with a cube whose dimensions are estimated, then you can place your initial cube in any number of positions within your perspective environment, being careful not to violate your cone of vision as you multiply the

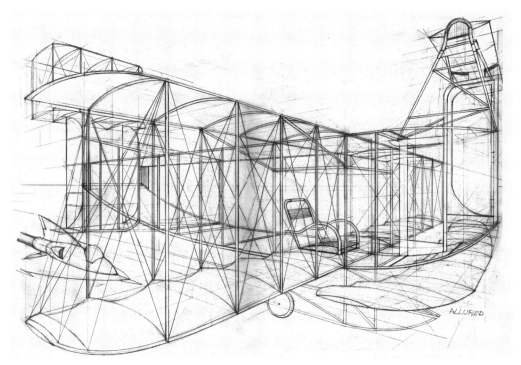

Figure 3–55. Ralph Allured. *Imaginary Flying Machine in Two-Point Perspective,* 1997. Graphite on paper, 11 x 17 inches. The large, basic shapes of the wings and body of this imagined flying machine were established first using technical perspective and some mechanical aids, followed by details in the structure of the wings and the body using both technical and freehand methods.

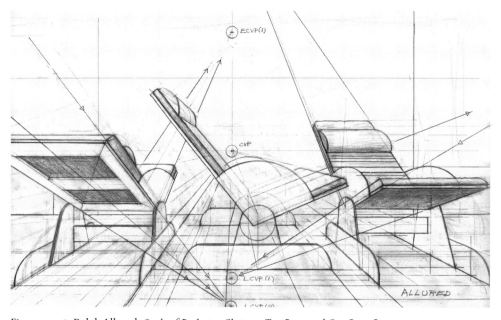

Figure 3–56. Ralph Allured. *Study of Reclining Chairs in Two-Point and One-Point Perspective,* 1997. Graphite on paper, 11 x 17 inches. A ruler, compass, and gridded ground plane are used in this technical perspective drawing of reclining chairs viewed in a variety of positions.

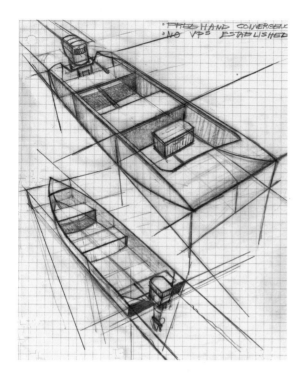

Figure 3–57. Ralph Allured. *Boat Studies in Three-Point Perspective,* 1997. Graphite on graph paper, 11 x 8-½ inches. As the artist's notes in the upper right corner indicate, these three-point perspective studies of two boats are drawn freehand, with no established vanishing points. A ruler is used to sharpen significant edges when considered necessary.

initial cube to create the overall dimensions (Figures 3–53 and 3–54). If you wish to begin with a drawn cube whose dimensions are precise, then you must determine whether you want to work with a 45°/45° view of the object you are drawing, or a 30°/60° view, and construct your initial cube using one of the appropriate cube construction methods described earlier in this chapter. With the object in front of you as a reference, you can represent the form from any desired vantage point—above or below or on eye level—without actually viewing it from that particular vantage point.

Initially, the process of transparent construction can be time-consuming and somewhat frustrating as it requires patience and some careful consideration about the best way to approach the form. It is helpful to work from general to specific, identifying and defining the largest and simplest characteristics of the form before addressing more detailed information that is rooted in the simpler form (Figure 3–55). If you are initially approaching transparent construction through technical perspective, then the use of rulers, T-squares, and other mechanical devices requires a bit more care and precision (Figure 3–56). Once you have an understanding of the process, it is wise to explore the application of transparent construction principles in a freehand manner as well, using no mechanical aids or using them minimally (Figure 3–57).

Three-Point Perspective

In one- and two-point perspective, it is assumed that all edges that are truly vertical (perpendicular to the ground plane) are also parallel to the picture plane, and therefore do not converge on a vanishing point but rather remain true verticals in the drawing. In three-point perspective, which is typically used to address forms which extend well above or below the eye-level or horizon line, it is acknowledged that in order to

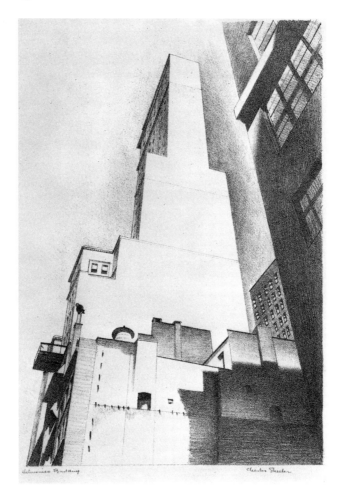

Figure 3–58. Charles Sheeler. *Delmonico Building*, 1926. Lithograph, printed in black, 9-¾ x 6-⅟₁₆ inches. The Museum of Modern Art, New York. Gift of Abby Aldrich Rockefeller. Photograph © 1998 The Museum of Modern Art, New York. In three-point perspective, shown here from a worm's-eye view, the vertical edges of the buildings converge on a single vanishing point that is positioned directly above the CVP on the eye-level line.

observe these forms we must tilt our head up or down. Because the picture plane remains parallel to the plane of our face in perspective, the picture plane must also tilt in relation to the object or objects being observed, and consequently no edges of a cube-based structure remain parallel to the picture plane. Therefore, all parallel edges (including verticals) must converge on vanishing points (Figure 3–58).

We already know that all edges that are parallel to the ground plane (horizontal) and moving away from us converge on either VPL or VPR. The third vanishing point, upon which vertical edges parallel to each other will converge, is positioned directly above or below the CVP, depending upon whether the form is viewed from a low or a high vantage point.

Three-point perspective is actually applicable far more often than it is used, but because of its increased complexity and time intensity, its use is reserved for drawings

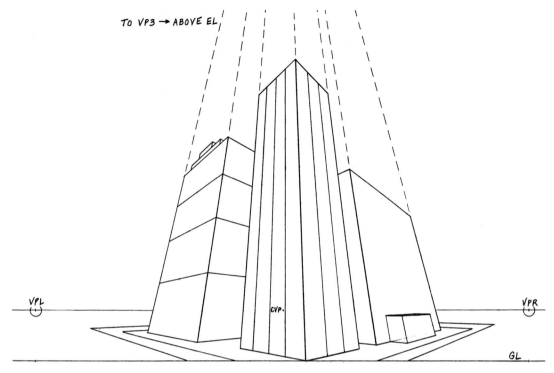

TO VP3 → ABOVE EL

VPL

CVP·

VPR

GL

Figure 3–59. Three-point perspective drawing from a low eye level or worm's-eye view. The perspective setup is the same as for a two-point perspective drawing with the addition of a third vanishing point upon which all vertical edges converge. This convergence of vertical edges is indicated by the dotted lines.

that demand three-point perspective for visual accuracy or effect. For some artists or designers, mathematical precision may be desirable or mandatory, and a more in-depth investigation of strict three-point perspective may be required for work of greater complexity. Because in three-point perspective there are many more steps required for the precise construction of even a simple cube, we allow here for informed estimation of heights, widths, and depths as often as possible to make the process more expedient and user-friendly. This more relaxed approach is especially applicable for artists whose work does not require absolute precision but are simply interested in the ability to convey the illusion of three-dimensional form and space convincingly.

Constructing a Form in Three-Point Perspective

1. All preliminary information should be established and drawn, including scale, eye-level or horizon line (EL/HL), ground line (GL), station point (SP), central vanishing point (CVP), vanishing points left and right (VPL/VPR), vanishing point three (VP3), units of measure along the horizon line that reflect your scale, units of measure along a vertical measuring line that reflect your scale, and cone of vision (Figure 3–59).
2. If your EL is high as in a bird's-eye view, position your EL/HL nearer the *top* of your drawing format. If your EL is low as in a worm's-eye view, position your

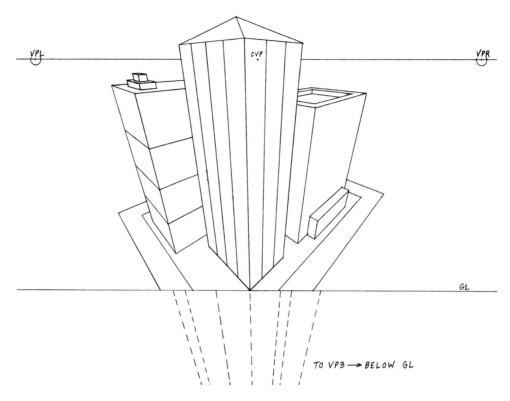

Figure 3–60. Three-point perspective drawing from a high eye level or bird's-eye view. The three main structures are similar to those presented in the worm's-eye view, but because they are viewed from such a different eye level, their appearance changes dramatically. A horizontal measuring line is used to determine the vertical divisions in the tallest structure.

EL/HL nearer the *bottom* of your drawing format. From this point on, we are assuming a worm's-eye view in three-point perspective for purposes of explanation.

3. In establishing the scale for your drawing, think in terms of a scale that can represent larger structures such as buildings (e.g., 1" = 10' or ½" = 10').

4. Draw a vertical line up from the CVP and off the top of the drawing format. The VP3, which identifies the point of convergence for all vertical edges in three-point perspective, must be plotted somewhere along this line. The *farther up* VP3 is located, the *less* the picture plane is assumed to be tilted, and the *less* the verticals will be foreshortened. This yields a more subtle effect. Conversely, the *closer* VP3 is located to the EL/HL, the *more* the picture plane is assumed to be tilted, and the *more* the verticals will be foreshortened. This yields a more dramatic effect. As a general rule, the *minimum* distance of VP3 from the EL/HL should be no less than the *total* distance between VPL and VPR. This serves to minimize distortion. If VPL, VPR, or VP3 is located outside of your drawing format, then wings will need to be attached.

5. Locate and *estimate* the height of the leading edge of a cubic structure in a centrally located position, along or near the vertical line that passes through the

CVP. This leading edge must converge upon VP3. Keep in mind the scale you have established in estimating the height of the leading edge. Because the leading edge is foreshortened (contrary to two-point perspective), it will be shorter than if the same size cubic structure was drawn in two-point perspective. This will be your key structure, which will help to determine the size of all other structures. Stay within the cone of vision to avoid distortion.

6. Draw lines of convergence from the top and bottom of the leading edge to VPL and VPR, estimate the desired width of the structure, and extend all verticals to converge at VP3. This completes your cubic structure in three-point perspective.

7. The height of the leading edge of additional structures can be scaled as usual from the leading edge of the key structure, using SVPs located along the horizon line. Additional structures can be made larger, smaller, or the same size as the key structure. This process is essentially the same process used for scaling the height of a leading edge in one- or two-point perspective, but all verticals determined by scaling will converge on VP3.

8. To determine divisions in the width of a structure (either equal or unequal divisions), use the familiar horizontal measuring line system explored in two-point perspective and explained earlier in this chapter (Figure 3-60).

9. For determining divisions in the height of a structure (comparable to the number of stories in a building), it is recommended that you estimate these divisions, keeping in mind that as you move up the structure (a worm's-eye view) or down the structure (a bird's-eye view), the increments will become increasingly smaller to reflect diminution.

10. For drawing inclined planes in three-point perspective, A VPS will still be located on vertical traces, but these vertical traces will extend from VP3 to VPL and VPR and beyond rather than being truly vertical.

Suggested Perspective Homework Assignments

Following are some suggestions for both technical and freehand homework assignments that encourage a creative exploration and application of more advanced and complex perspective processes and techniques. These assignments are accompanied by illustrations of student solutions. They require an understanding of the essential building blocks of perspective, including systems and processes such as one- and two-point cube construction, one- and two-point gridded ground planes, scaling techniques, sliding vanishing points, ellipse construction, various methods for cube multiplication and division, inclined planes, the relationship of geometric solids to transparent construction, and three-point perspective.

The instructor is encouraged to determine the specifics and the variables of the assignments, including any restrictions or requirements he or she wish to impose. While some assignments are better suited for technical perspective, it is reinforcing to explore a technical system using freehand techniques. It is strongly suggested that instructors incorporate at all levels of exploration the use of a variety of different eye levels, scales, and station points, including forms drawn below, at, and above the eye level, both grounded and floating.

- The Amazing Maze in Two-Point Perspective (Figures 3-61 and 3-62)
- Transparent Construction Drawing of a Three-Dimensional Form (Figures 3-63 and 3-64)
- Designing and Drawing an Imagined Game Board (Figures 3-65 and 3-66)
- Drawing a Two-Point Perspective View of an Observed Room Interior Using Sighting Techniques (Figures 3-67 and 3-68)
- Designing and Drawing an Imagined Room Interior (Figure 3-69)
- Designing and Drawing an Imagined Playground (Figures 3-70 and 3-71)
- Designing and Drawing an Imagined Three-Point Cityscape (Figure 3-72)

Figures 3–61 (Student work. Gill Whitman) and 3–62 (Student work).
Two examples of student responses to a homework assignment focusing on the construction of a maze in two-point perspective.

Figures 3–63 (Student work) and 3–64 (Student work). Two examples of student responses to a homework assignment focusing on transparent construction in two-point perspective. Figure 3–64 shows, in the tires, some of the struggles commonly encountered when drawing ellipses.

Figures 3–65 (Student work. Jennifer Rocco Castaneda) and 3–66 (Student work). Two examples of student responses to a homework assignment focusing on the construction of an imaginary game board. Figure 3–65 shows a finished drawing that was transferred from a working drawing on tracing paper. Figure 3–66 shows a working drawing of a complex, two-tiered game board.

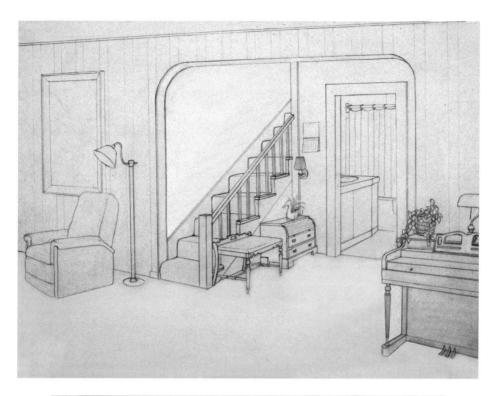

Figures 3–67 (Student work. Lea [Momi] Antonio) and 3–68 (Student work. Chris Johnson). Two examples of student responses to a homework assignment focusing on sighting and its relationship to perspective principles. The rooms are drawn from direct observation in two-point perspective with all angles determined through sighting only.

Figure 3–69. Student work. Dean E. Francis. An example of a student response to a homework assignment focusing on the construction of an imagined room interior. The circular format describes the cone of vision.

Figures 3–70 (Student work. Philip J. Martin) and 3–71 (Student work. Daniel J. Hedberg). Two examples of student responses to a homework assignment focusing on the construction of an imagined playground.

Figure 3–72. Student work. Dean E. Francis. An example of a student response to a homework assignment focusing on the construction of an imagined three-point cityscape.

Chapter *4*

Establishing the Classroom Environment, Conducting Critiques, and Assigning Grades

The Classroom Environment

Establishing Clear Boundaries

The kind of environment you wish to establish in your classroom is an individual decision that is in part determined by your particular personality and what makes you feel most comfortable. Some teachers prefer a very relaxed environment while others prefer a more controlled environment. Regardless of which approach most appeals to you, you must consider what will be most effective in helping the majority of students to be attentive and productive during class time.

In a studio class in which most students are college freshmen right out of high school, you may find it beneficial to keep a tighter rein on things since there seems to be a tendency for the atmosphere to escalate to noisy and chaotic if boundaries are not clearly established and adhered to. In a studio class in which the majority of students are older or more experienced, it will generally not be necessary to monitor things quite so closely. This reflects the simple fact that older students tend to be more mature and often take their studies more seriously. Of course this is a generalization that does not apply to all students, regardless of age or experience. You must gauge the situation and conduct yourself accordingly.

Experience indicates that if the atmosphere is too unstructured, with a lot of noise and chatter unrelated to the work being pursued, it is difficult for students to concentrate and to maximize their learning experience. It is therefore a good idea to make it very clear when it is okay to be a bit more relaxed or playful and interactive with fellow students, and when it is time to buckle down and get to some serious work and maintain an atmosphere conducive to this. When working with a model in a life drawing course, certain guidelines should be followed to insure a mutually comfortable and respectful atmosphere for the students and the model. These guidelines are discussed in chapter two under "Classroom Etiquette for Working with a Nude Model."

You must be clear about where you stand regarding such matters as students wearing headphones and listening to music during class time, students taking a break and being gone for twenty minutes or longer, students chatting with their friends in a tone that is audible to other students, students talking amongst themselves during lectures, slide presentations, or demonstrations, students falling asleep during class time, etc. In

some ways, it is less important what guidelines and boundaries you establish than how well you enforce the established guidelines and boundaries. Make your authority clear in a manner that is firm but pleasant if you wish to gain the respect of your students.

Questions and Answers

There will most certainly be instances when a student asks a question and you do not know the answer. You may or may not feel that you should know the answer, but it can nevertheless be an uncomfortable experience the first time you find yourself in this position. Get used to it! A challenging discussion or lecture with a room full of creative and inquisitive students can generate questions that fall well outside of the realms of your expertise or knowledge. Don't try to fake an answer, or pretend that you know when you don't. It serves no useful purpose. Instead, acknowledge that you do not know the answer to the question, and follow up with a couple of different options. You may pose the question to the entire class and see if someone else knows the answer. You may offer to find out the answer and get back to the student as soon as you can. You may decide to direct the student toward finding out the answer on their own and sharing their discovery with you, or you may decide to simply let it go. Perhaps what is most important is maintaining an atmosphere that lets the students know that you welcome all relevant questions, and you will do your best to provide an answer.

Respecting Diversity

As you look into the faces of the students in your classroom, you may encounter a wide range of differences in ethnic origin, age, socioeconomic background, cultural background, gender, marital status, sexual or gender orientation, physical ability or impairment, and numerous other variables that are inevitable in any cross section of people. It is vital that you be aware of these differences, and address any group of students in the most inclusive way possible. This may require that you do some soul-searching and address your own biases and prejudices, however unconscious they may be and whatever they may be. For example, you cannot talk to a life drawing class about the use of chalk pastels in relation to skin tones and address only Caucasian skin tones or only African American skin tones. This is true whether or not there is a cross section of racial and ethnic origins in that particular class. You cannot talk about the structure or proportion of facial features without addressing the wide range of variables that are based in ethnic and racial diversity. You must be careful not to make statements that assume all members of the class are heterosexual, or in a certain age group, or refer generically to all artists or students as "he" or as "she." Although this advice may seem like common sense, it is unsettling to recognize how often we unconsciously make assumptions about people and convey these assumptions verbally at the exclusion of some. All of the examples provided are based on personal experiences as both a teacher and a student. Be sensitive to this issue.

Laugh a Little

I find humor to be a remarkably useful tool in the classroom. An intense lecture, a difficult critique, or a challenging demonstration can be exhausting or intimidating to

a teacher or student, particularly the uninitiated. A little humor is a great way to take the edge off things before making the transition to something else. As you get to know individual student temperaments, you may adjust your approach with different students depending upon what you think is most effective in encouraging and motivating that particular student. You will find yourself wearing many different hats in the classroom. Some will fit better than others, some will feel more comfortable than others. Not all students will like all the hats you wear. But bear in mind that the best teacher is not always the most well liked. To be most effective as a teacher, you must gain and maintain the respect of your students. Knowing when to laugh (including at yourself) or when to lighten up can serve you well.

Techniques for Presenting Information
Instructor Demonstrations
The idea of standing or sitting in front of a group of eager students and conducting a demonstration of some process or technique of drawing strikes fear into the hearts of many instructors, experienced and inexperienced alike. The prospect of failing miserably or falling flat on your face while being observed by students who may have believed you to be capable of doing *anything* well (after all, you are the recognized authority in the classroom) is intimidating to say the least. But there are many instances when the best possible way to explain something to your students is to show them. For those of you with serious performance anxiety, it is wise to find the most effective way to communicate a concept or process or idea that you are comfortable with, while working toward the challenge of eventually giving a demonstration. If sheer numbers of watchful eyes is the debilitating factor, try giving a brief demonstration to small groups of students at a time, rather than to the entire class at once. If the class is large, this may be the best approach anyway in order to insure that everyone can see while you are giving your demonstration.

Picking a process to demonstrate that isn't subject to evaluations of quality will help to break the ice. Show the students how to apply a base tone of vine charcoal to paper for a subtractive drawing. Show them how to do a Xerox transfer using a colorless blender marker or another appropriate solvent. Show them the best way to spray a drawing with fixative in order to get uniform coverage while also respecting the need for proper ventilation. These will be easier places to start than, for example, demonstrating the process of gesture drawing. Usually my gesture drawing demos go very well, but sometimes the results are awkward and unconvincing. When this happens, it is a good opportunity to talk about the fact that you must expect to have bad days when no matter what you do, you can't seem to draw the way you want to, and that even an experienced artist has "off days." For the most part, the students will appreciate your candor and your willingness to be human. A little humor can also go a long way to relieving anxiety you may be experiencing.

There are many instances when you may feel inclined to work on an individual student's drawing with him or her, making proportional corrections or showing how to manipulate a drawing medium or demonstrating the development of line variation or any number of other possibilities. Most students are very receptive to this and learn a lot by watching you draw, but a few students may feel intruded upon if you work on their drawing, whether you have sought their permission or not. It is always best to

simply ask a student if they have any objections before you do anything to their work. Most will welcome your assistance.

Slide Presentations and Lectures

I have found that lecturing with the visual assistance of projected slides is an integral part of an effective teaching technique. Slides often serve to clarify an idea that may only be partially communicated through language, and slides acknowledge the fact that you are communicating with students who are often more visually than verbally inclined. Projected slides also have the advantage of being visible to a large group of people at once, so you may successfully engage an entire room of students.

Depending upon what information you are trying to convey, you may be showing slides of student work, or slides of contemporary or historical masters' work, or slides of forms from nature. With a good slide projector and a remote with an extension cord, you can easily make specific reference to your slide while lecturing on the topic at hand. One disadvantage to showing slides is that it calls for at least a partially darkened room, and invariably when the lights go down and you begin talking, some students begin to nod off. It means they miss out and you may be distracted by bobbing heads and closed eyes. There are ways to bring the sleepers to full attention (use your imagination), and the advantages of using slides to accompany a discussion or lecture far outweigh this sometimes annoying disadvantage.

It is generally a good idea to provide students with a handout if you are presenting a significant amount of information in a lecture. This allows them to concentrate on what you are saying and to study any slides that may accompany your lecture without the need to take notes as you are talking, which often results in the student absorbing less material as they focus on trying to write it all down. To further encourage their full attention when you are presenting, you can provide the handout *after* the lecture is completed, which allows them to review the material after the fact, at their own pace and as needed in the future.

If you are unable to provide a handout, or don't feel the lecture warrants one, you may choose to write some key words or phrases on the chalkboard while you are presenting. In this way, the information can remain accessible to the students until the class session is over, and if they feel inclined to write the information down in their notes, they can do so. Writing and/or drawing on the chalkboard to emphasize or illustrate a point also provides some movement for you, which can break the monotony of standing or sitting in one place while talking. I personally prefer to move around a lot when I am presenting, which seems to help convey my energy and enthusiasm and generate a sense of same in the students. I have come to refer fondly to these sessions as "chalk talks."

Establishing a studio classroom environment that effectively and dynamically serves both teacher and students extends to the process of critiquing and evaluating student work as well. Defining and maintaining boundaries, encouraging questions, respecting diversity among students, maintaining a sense of humor, recognizing the potential vulnerability of all participants—all of these conditions serve to strengthen the process of dialogue that is a critique and contribute to an atmosphere of mutual respect and trust.

Group Critiques

The Importance of Group Critiques

> It is not enough for a student to use a critique for advice on how to improve a piece, or a body of work. The whole process must somehow be internalized, lest the artist simply start to believe, to take at face value, what his or her teacher, friends, and critics say, instead of engaging them in a dialogue. Whether the work comes from heart-wrenching pain and passion, or cynically cool media manipulation, the artist has to acquire the ability to see it from the outside, lest one's vision cloud one's vision.
>
> —Michael Bulka, Artist

Twenty students have just come to class with their completed homework assignments, and most of them are eagerly awaiting your response to their work. Time constraints and practicality simply do not allow for you to meet individually with each student to discuss the strengths and weaknesses of their work. And if you did have the time to do so, your voice would give way before too long by virtue of the fact that you would often be repeating yourself to each of those twenty students regarding compositional decisions, proportional relationships, quality of line work, distribution of tonality, choice of materials, development of content, and other relevant issues.

Teaching, particularly at the foundation level, typically requires a lot of repetition and reinforcement of key concepts relating to technical, formal, and, to a lesser degree, conceptual issues. Since there is only one of you, you can convey the most information to the greatest number of students through the group critique format. While you may be able to provide more individual attention in a one-on-one critique, the students are missing out on the opportunity to learn by viewing the work of their classmates and hearing what feedback is offered to them regarding their work. In a group critique, students are learning to think critically and to deal with differing viewpoints. They are also given an ideal opportunity to develop verbal literacy concerning the visual arts. Through a guided analysis and assessment of technical, formal, and conceptual issues, they are encouraged to verbally offer their own responses to each other's work, and to develop those responses beyond the most basic "I like it," or "I don't like it."

Whether a group critique methodically focuses on each student's work one at a time, or becomes a format in which to make broad or generalized observations about recurrent strengths or weaknesses, it provides some distinct advantages over individual critiques. This is not to say that individual critiques are not valuable, but they are certainly less effective in some significant ways. And in preparing the student for eventual experiences in the arts outside of the relatively sheltered environment of the classroom, the group critique can begin the process of learning discernment, of learning to distinguish fact from opinion, of learning to give and receive praise and criticism with grace. As the teacher, you provide the primary example. It is a significant responsibility.

There are certainly potential dangers that may develop in a group critique setting, situations that present more than the usual difficulty, discomfort, and uncertainty about how to proceed. These will be discussed in greater depth, but always keep in mind that

exercising common sense and common courtesy will go a long way in working through a tough situation.

Various Group Critique Formats

There are a number of approaches to conducting a group critique that take into account different variables, such as the number of students involved, time restrictions, the skill level of the students (beginning, intermediate, or advanced, undergraduate, or graduate), the group's tolerance for public discussion and feedback (which is often directly linked to the level of the student), the goals aspired to in the work (technical, formal, and conceptual development), and more. Given the emphasis here on foundation- and intermediate-level teaching, the critique formats discussed will be especially relevant for students in these kinds of courses, but are also formats that are frequently utilized for group critiques at an advanced level.

Regardless of the specific structure of the critique, you need an adequately sized space in which to convene, a wall surface or some other suitable alternative for displaying work in a manner that makes it easily visible to all critique participants, adequate lighting, a blackboard for writing and/or drawing when necessary, and, in the event that a critique will last for two to three hours (which is often the case), some sort of reasonably comfortable seating arrangement for the students. As the teacher and the facilitator, you will hopefully be on your feet much of the time, pointing things out or writing things on the board or emphatically gesticulating to drive home an important point.

To facilitate the pace of the critique and to provide the instructor with an opportunity to point out a similar occurrence (positive or negative) in more than one drawing, it is suggested that you hang a number of drawings at once (as many as the space will comfortably accommodate) rather than one at a time. When that group of drawings has been thoroughly discussed, a new group of drawings can be put up for continued discussion.

Listed below are a variety of formats that your classroom critique can adopt or not.

Teacher Talks, Students Listen, No Questions

Although this is a critique format that I have observed a number of times, it is not one that I recommend. Quite simply, it involves the instructor doing all the talking while the students listen passively. Questions are not encouraged, dialogue does not take place, students do not offer nor are they asked for their observations, and they are not provided with an opportunity to explain or defend decisions or choices they have made. This format typically results in pronounced frustration on the part of the students, and delivers the unmistakable message that what the instructor thinks is of utmost importance, while what the students think is of no importance. It is also a very safe avenue for the instructor to take because there is no opportunity for the students to challenge or question or disagree with the instructor.

Everyone Talks, No One Listens, So Why Bother Asking Questions?

This is another critique format that I have observed and also do not recommend. While it attempts to allow everyone to have his or her say, it is characterized by chaos and a lack of structure and direction. Multiple conversations and discussions

are taking place simultaneously, focus on the work is fractured, and no one person has the floor at any given moment. This indicates that the instructor, as facilitator of the critique, has lost control of the situation. While a good facilitator senses when to step back and allow some temporary deviation from structure, she also knows when to pull in the reigns and direct the group back to the collective task at hand. Once the structure of a critique has been compromised, it may be difficult to regain or restore.

Teacher Talks, Students Listen; Students Respond, Teacher Listens; Any Questions?

In this approach to a group critique, the teacher begins by offering feedback concerning the work. Initially, some broad and general observations about all the work on display can be made to collectively address issues that are clearly going to be noted a number of times in individual drawings. For example, the instructor may note that while a particular surface was specified for an assignment (e.g., charcoal paper), many drawings were not executed on that surface. On a more positive note, the instructor may comment, for example, that there are a number of interesting approaches to composition in the group of drawings being addressed. Following any general comments, it is most helpful for the students if the instructor then focuses on individual drawings and discusses them specifically. The benefit to the student whose work is being discussed is that he is able to hear an assessment of his work regarding technical, formal, and conceptual issues without any biases that may form if the instructor and the rest of the students first hear what the student intended, and where he may have experienced difficulty in the process of creating the work. By getting feedback first, students are provided with a better sense of how their work is perceived in the absence of any verbal input from them. This approach tends to favor the viewer or audience response.

A disadvantage to this approach is that a student may adjust his comments about his own work to align with the comments that have already been made. This is not rooted in any intention to be devious or deceitful on the part of the student. It may simply be a desire to avoid embarrassment if his own assessment of his work was initially quite different from everyone else's, or to protect his somewhat fragile ego, which is to be expected in an inexperienced or developing artist.

Once the instructor has finished commenting, comments may be invited from the other students in the class, with the understanding that praise or criticism should always be offered respectfully. When all comments have been entertained, keeping in mind the amount of time that may be spent talking about each drawing, then the student who did the work is asked to comment. She may respond to feedback by agreeing or disagreeing and by clearly stating why she agrees or disagrees. She may discuss difficulties she had with process or materials or idea development, and ask for suggestions on how to address these issues. In moving on to the next piece, ask the student whose work was just critiqued what piece she would like to address next, and begin the process again.

Students Talk, Teacher Listens; Teacher Responds, Students Listen; Any Questions?

In this approach to a group critique, the student begins by discussing and critiquing her own work, with comments addressed to the instructor and the rest of the class. The

advantage to the student is that she has to formulate and verbally articulate her own ideas and thoughts about the work without the benefit of hearing the responses of others first. This approach to critiquing can also provide the instructor with a good idea of a student's level of awareness of the student's individual strengths and weaknesses. This approach tends to favor the artist's intentions. The disadvantage to this approach is that the student is not going to hear the untempered responses of others, responses that have not been influenced by the artist's own assessment. Consequently, it may be more difficult to ascertain the viewers' initial thoughts and reactions.

Once the student has finished commenting, the instructor can respond by agreeing or disagreeing with what was said, by elaborating on those points that appear to be most significant in the work, or by addressing important points that may have been overlooked in the student's self-assessment. Following the teacher's comments, comments may be invited from the rest of the class. A variation on this is to invite comments from the class first, after the student has critiqued her own work, and reserve the instructor's comments for last. This provides everyone with an opportunity to articulate his response without necessarily feeling intimidated by what the instructor has already said. Most beginning-level students will feel much more comfortable disagreeing with the instructor if they do not know ahead of time that that is what they are doing. Once again, in moving on to the next piece, ask the student whose work was just critiqued what piece she would like to address next, and begin the process again.

Regardless of the approach you use for any given critique, keep in mind your time constraints so that you can make an effort to insure that all students get a roughly equal amount of time for discussion of their work. In a three-hour class of twenty students with a fifteen-minute break period, you can provide each student with only about seven minutes of attention under the best of circumstances—no interruptions, distractions, or tangents that may develop during discussion.

In all critique formats, it is also wise to try to balance constructive criticism with praise and/or encouragement. More often than not, you will observe both strengths and weaknesses in the work of a student, although not necessarily in equal amounts. But sometimes you are faced with work that, for whatever reason, is quite inadequate in most respects, and finding something positive to say can be quite challenging. In this instance, when it is evident that the student has tried and has put effort into her work, try to ease into the criticisms, offering suggestions for improvement, and reserve the positive remark(s) for the end of the discussion. This provides a student who may otherwise feel very discouraged with a positive lift, something she can take along with the criticism. There are times when it will seem clear to you that a student's work is very deficient due to a lack of effort or due to rushing the work, waiting until the night before to begin working on a drawing that was assigned two weeks ago. If you pose the question in a nonthreatening way, you will frequently find that the students will acknowledge that they did not work very hard on the assignment, or did not invest very much time, or did indeed wait until the last minute. Acknowledge that you respect the students' honesty, letting *them* own the responsibility for their poor results. By explaining clearly to the students that it is often through our mistakes that we learn the most, they will ideally grow more comfortable with the notion that a critique is not simply a forum for praise and admiration, but more importantly an opportunity to learn about how to make their work the best that it can be.

The Guest Critic

After a period of time has passed in a given class with a given group of students, you may experience feeling like a broken record—saying the same things in response to student work over and over again—and the students may feel like they are hearing the same concerns and criticisms over and over again. Particularly with beginning-level students, this will often be the case, as it frequently takes a long time to break bad drawing habits, and the same errors or weaknesses will occur again and again before being resolved with any kind of consistency. Although repetition can be a valuable tool in teaching, it is good to toss in an element of the unexpected now and then.

Inviting a colleague or someone else whose feedback you generally respect to provide a guest critique for your class is a valuable experience for both students and the instructor. It provides the students with a "fresh eye," with feedback from someone who is not familiar with their work and therefore may have some new observations. Often students will hear the same essential message from a guest critic as they hear from their regular instructor, but expressed in different terms or in a different style. This can reinforce awareness in the students of salient issues in their work, and help them to see that their instructor just may have a point after all. On the other hand, a guest critic may offer very different praise and criticism than the regular instructor, which provides both the student and the instructor with new information to consider.

The guest critic may wish to follow a critique format that you, as the primary instructor, usually use, or they may wish to introduce a different format. Invite the guest critics to approach the critique in whatever manner they consider to be most appropriate under the circumstances. Generally, I have found that guest critiques are most helpful in critiquing the work of advanced-level students who are hopefully wrestling with content and conceptual issues more than technical or formal issues. But their usefulness at all levels of critiquing should not be underestimated.

Handling Trouble

It is unavoidable that you are going to encounter situations during a group critique that are potentially explosive, and it is helpful to be mentally prepared in advance. You may encounter a student who is especially belligerent or indignant when presented with criticism, regardless of how tactfully you present that criticism. While it is important to stand your ground, try to maintain an even and calm tone, avoiding the temptation to match the volume or intensity of the student's remarks. Do not attempt to engage other students in support of your stance, although some students may offer this support without your encouragement. This can too easily set up an "us-against-you" dynamic, which will help neither your position nor the student to eventually absorb the criticism as valid. If you feel fairly certain that your criticism was not overly harsh or unreasonable, it is possible that the student is having an especially bad day or is suffering from a lack of sleep or perhaps has problems with authority figures. If the discussion continues to escalate, let the student know that you are willing to discuss the matter further after class or during your office hours, and then move on to the next piece. If this does not work, call for a ten-minute break and do what you can to diffuse the situation while other students are out of the room. Removing the "audience" is often a successful way to calm down the situation, since neither the student nor the

instructor is attempting to save face in front of a group. This is one of those times when a little knowledge of psychology can be helpful.

On occasion, especially with a group of freshmen or beginning-level students, you may encounter the uncomfortable situation of critiquing the work of a student only to discover that he has collapsed into tears, and you are left feeling like a real ogre for reducing a student to such a condition. At this point, it is usually best to take the focus off of that student and his work. Wrap up your comments quickly and let the student know that the two of you can talk about the work a bit more after class or during office hours. You may also encourage the student to go grab a soda or catch a breath of fresh air, giving him an opportunity to step out of class and collect himself in private. Chances are that he is very embarrassed to be crying in front of his classmates, and it will help him if you provide a way out temporarily. Again, if you feel fairly certain that your criticism was not overly harsh or unreasonable, it is possible that the student is having an especially bad day or is not accustomed to or comfortable with receiving criticism of any kind. As the students grow more accustomed to critiques that provide both praise and constructive criticism, they will become more receptive to information that is clearly intended to help them improve their work.

Critiquing Beginning-Level Students

Before beginning a critique of the work of foundation-level students, verbally review the objectives of the assignment yourself, or ask them to verbally review the objectives. While this is happening, write down what is said on the chalkboard to provide a point of reference during discussion of the work. This helps the students to remain focused on significant issues while critiquing their work or the work of a classmate. For example, in a basic drawing critique of a still-life homework assignment, some of the primary points of discussion listed might focus on concern for technical and formal issues such as:
- Work should be executed on charcoal paper.
- Work should be developed using either a range of lead drawing pencils or a range of charcoal pencils.
- A variety of both regular and irregular forms should be included in the still life, with at least five different objects represented.
- At least one object should be presented in a foreshortened view.
- Objects should be arranged with concern for composition, including scale and placement on the page, a variety of positions or base lines in foreground, middle ground, and background, and minor compositional groupings within the larger compositional grouping.
- Objects should be proportionate in and of themselves, and should be proportionate in relation to each other, with sighting processes playing a key role.
- Line work should address both exterior and interior contours and edges, and should address these contours without overstatement or understatement—accuracy is desired.
- Line work should show a broad range of tonal variation and a range of crispness and softness in response to light source, speed of contours, spatial placement, weight of forms, etc.
- Line work should show delicate evidence of process and search.

This is a lot to write on a chalkboard to facilitate focused discussion of the drawings, so it is advisable to simply jot down key words such as "surface and medium; composition; line variation; sighting for proportional accuracy"; etc.

When critiquing beginning-level students, try not to assume that they know something unless you have instructed them or lectured on the subject. In most classes at this level there is a broad range of capabilities and knowledge. To address the group based on the awareness of the most knowledgeable students will leave a number of others behind and feeling confused and frustrated. On the contrary, if you repeatedly make reference to even the most apparent concerns or issues in a drawing exercise, it will help those who are less aware to absorb important new information and it will reinforce for others information that they have already been exposed to. It is sometimes a thin line to walk—trying to maintain the interest of more accomplished students while not neglecting or moving too quickly for less accomplished students. If you sense the more accomplished students losing interest, try engaging them more directly in the group critique or discussion. Instead of making a point yourself, pose a question to a student whose work shows evidence that he clearly understands, and allow him to address the issue for his classmates.

Discuss with your students, especially in relation to critiques of their work, how they define success. It may be very revealing to discover how many of them define success purely in terms of the finished product and in terms of the grade they receive for their work. At this point it is wise to engage the group in considering some different ways of looking at success. Even if their end result is not as effective or as strong as they would like it to be, they should be encouraged to consider what they learned during the process, and whether or not they think it will help them in their subsequent work. To have learned something that they can take with them and use in the future is certainly an indication of at least some degree of success. Consider other ways you can encourage your students, and possibly even yourself, to think of success in terms other than what we may be accustomed to.

As has been mentioned, you will frequently deal with some very fragile egos in beginning-level students (which is not to say that advanced-level students are not also endowed with fragile egos). Many of them who enter college right out of high school will suddenly find themselves to be little fish in a big pond after leaving a situation where they were comfortably established as big fish in a little pond. This can be most disquieting, particularly if they were accustomed to receiving frequent praise from friends and family and high-school teachers and now find themselves in a different situation, one in which their work is subjected to more careful scrutiny and more evaluative processes. A bit of discussion with the entire class around this point early in the semester, perhaps just prior to the first critique, can go a long way in helping the students to adjust to a change in status. Let them know that it is an accomplishment simply to be in that particular classroom, and that they are now being held to higher standards and expectations. Express confidence in their collective ability to meet those expectations. While this may or may not be the case, it is helpful to instill self-confidence in the students. They should sense that if they cannot currently accomplish certain things that are expected of them, they will in time be able to accomplish those things. Assure them that if they are attentive and hardworking, you can guarantee that they will learn a lot in your class. And then, most importantly, make it happen!

Individual Critiques

There are a variety of reasons for conducting one-on-one critiques with students as an alternative or complement to group critiques. Individual critiques may be the result of working with a student on an independent study basis, although this would be quite unusual for a foundation-level student and is not a situation I would recommend under normal circumstances. Individual critiques may be something you set up either at the midpoint or the end of the term or semester, providing you with an opportunity to give students a broader or more general evaluation of their work in your course up to that point in time. Individual critiques may be something you arrange with a student who is clearly struggling more than is necessary, a student who you think would benefit from some private and individual attention.

There are also those brief individual critiques that are an integral part of any working class session as you move around the room from student to student and provide them each with guidance, encouragement, assistance, and feedback. This critique is a bit different than other one-on-one critiques, primarily because it takes place in the company of other students even though your interaction is directed specifically toward one student and her work, and is not necessarily intended for the ears and eyes of any other student. You must be sensitive to the fact that anything you say may easily be overheard by anyone else in the room, and your comments should reflect this fact.

When students are working in class you will often find it more beneficial to *show* them something regarding a critique of their drawing technique or process rather than to *tell* them. In fact students often learn a lot simply by watching their teacher observe and respond to visual information. And if you are able to provide some verbal explanations of what you are seeing or thinking or doing as you work on their drawings or designs, the benefits are even greater. But as you may have already discovered, it is often difficult for even the most experienced artist/teacher to talk and draw at the same time, and this is something the students themselves should be discouraged from doing. If you do wish to do an individual demonstration on a student's work as part of a constructive critique, it is wise to extend the courtesy of asking the student's permission to draw on her drawing, or to erase or rework part of her drawing. In most cases students will welcome your assistance, but on occasion you will encounter a student who does not want you to do anything to her drawing. She would prefer that you provide verbal assistance and feedback only. Respect the student's wishes in this situation.

Regardless of the circumstances under which you conduct a one-on-one critique, students are generally happy to be given your individual attention and focus, even if only for a relatively brief amount of time. That is not to say that your individual focus does not also make some students a bit nervous, particularly if they know that they are not doing very well and would like to be doing better in order to make a positive impression on their instructor. For those students who seem unusually nervous when you meet with them to discuss their work and/or their working habits, a few words of acknowledgment and affirmation can help to diffuse their discomfort. Let them know that the intent is to help them, and even though that help may take the form of constructive criticism, it is an important tool for their progress and increased awareness. Acknowledge the fact that when you were a student, you used to feel a bit

anxious or nervous when a teacher was discussing your work. And as always, a little humor can go a long way toward relaxing a student who is feeling tense or ill at ease.

Individual critiques that are conducted in complete privacy (in an office space or an unoccupied classroom, for example) provide both the instructor and the student with an opportunity to address relevant issues in greater depth, and to tailor comments, questions, and concerns more specifically to that student's work. A student may feel more comfortable expressing confusion or uncertainty in private, or may be more willing to ask questions that he fears are "stupid" if other students are not around. An instructor may be able to dig a little deeper in an effort to identify the source of a problem if the forum is not public. An instructor may feel more comfortable with confronting a student more directly about chronic absences or attitude problems or lack of effort or any number of other issues if there is no audience. Some students will find themselves experiencing difficulties that go well beyond the classroom and that are more personal in nature. It will feel much safer for them to consider offering this information if they know it will be held in confidence.

It is much more probable that concerns that reach beyond the quality of the student's work will surface in an individual meeting or critique than in a group critique. When this happens, it is important to recognize that your primary responsibility is in relation to the student's artistic development. When personal issues interfere with a student's ability to function adequately in a particular course, or when personal issues appear to impair a student's artistic development, it is vital that you recognize your limits and remind yourself of where your expertise lies. Acquaint yourself in advance with the resources available on campus to address problems of a more personal nature and direct the student to the appropriate resources for additional help.

Diagnosing Problems in Student Work

Regardless of our efforts to the contrary, it is nearly impossible to critique work in a purely objective fashion. But objectivity in analyzing student work is a worthy goal. Regardless of one's personal aesthetic sensibility, it is vitally important to provide students with a constructive analysis of a particular drawing's strengths and weaknesses while avoiding generic "recipe" or "formula-based" solutions. It is especially important at the foundation or introductory level to focus on the more tangible and fundamental issues of technical, formal, and perceptual considerations, as issues of content and conceptual emphasis are often at the mercy of the students' awareness of more fundamental visual concepts. Bear in mind that there are those aspects/qualities of a drawing that can elude analysis, rooted instead in intuition or personal sensibility. While we cannot specifically identify their presence in a drawing, we know when we encounter them, and efforts to describe them through language may find us marveling at the essential inadequacy of words in these instances.

In those initial experiences of formal art education where observation of form/subject is the point of departure, it is quite possible to identify some recurring problems that the students will encounter in their drawing experience and that you, as the instructor, will encounter in guiding their drawing experience. An awareness of some of the more insistent hurdles and problems will provide a solid framework for critiquing student work and diagnosing problems. As is the case in any situation where

troubleshooting takes place, effective solutions are more readily arrived at when there is a clear identification of the problem. In some instances, a problem will be a problem in relative terms only, as an element of a particular drawing. What may be troublesome in one drawing may be a necessary and working element in another.

In many other instances, a problem or defect in a drawing will be nearly universal (that is, it would be a problem in the context of any drawing). An example of this would be a drawing of the human head, based on observation and the desire for a likeness, in which the eyes are located too high in the overall shape of the head, which in turn alters all of the proportions of the face. This is a perceptual error that would not be relative; it would be considered a problem in any drawing. Some may say that altering proportional relationships of the features of the face can have powerful expressive properties, and this is most certainly true. But the distinction here is grounded in *intention*. One's *intention* to distort for expressive purposes is distinctly different from an *accidental* and inconsistently applied distortion based on perceptual and observational errors.

The kind of verbal feedback that teachers provide students during a critique begins to indicate to the students how their work for a particular assignment will be evaluated and graded. Therefore, it is especially important that a teacher be very conscious of what she says during a critique. Let it be an accurate reflection of your response to the student's work. When work is moving in the right direction and shows a degree of success, it is relatively easy to discuss the strengths of the work, followed by a discussion of what needs improvement and suggestions for making those improvements. When confronted with weak work that is, for whatever reason, glaringly unsuccessful, there is certainly room and reason to temper one's remarks. You need not destroy a delicate ego with overly harsh words of criticism. It is possible to convey a work's shortcomings or failures in a manner that is sensitive, compassionate, and encouraging, bearing in mind that a learning environment should provide a relative degree of safety or security that encourages risk-taking and experimentation. But do not back down. If there are clearly problems with the work, you ultimately do a disservice to the student if you lead them to believe otherwise.

Following are some general drawing problems that you will encounter on a fairly regular basis, regardless of subject matter.

Inaccurate Proportional, Scale, or Shape Relationships

This is perhaps one of the most common weaknesses observed in the work of students in the early stages of their development. Whether in a drawing of the human form, or of a still-life arrangement of forms, an awkward and inaccurate size relationship between parts of a form or between one form and another is apparent. In this instance, there is generally a disregard or lack of understanding for sighting techniques or other measuring techniques used to observe size and shape relationships between parts of a subject or between multiple subjects in a drawing.

In the event that sighting techniques are understood but not applied, there is a tendency to draw what we experientially know about our subject rather than what we actually observe, and these two attitudes are frequently in conflict. For example, we know that a particular chair has a square seat and four legs of equal length. We know

this because the square shape of the seat of the chair has room for and supports us when we are seated on it, and the chair rests firmly on the floor because its legs are all the same length and meet the floor simultaneously. But when observing the chair from an oblique angle, the seat does not appear to be in the shape of a square, and the legs appear to meet the floor or ground plane in different places, implying that the legs are not all equal in length. With this example, it is easy to understand how an emphasis on "knowing" versus observation can contribute to a drawing's demise.

With the human form as subject, proportional problems are common, indicating a lack of regard for relating the scale or size of various parts of the figure. Proportional problems may also indicate a disregard for establishing a unit of measure as the basis for determining the relative scale of all other forms to this unit of measure. In the case of the figure, the unit of measure is most often the head. Again, the tendency to draw what we experientially know about our subject rather than what we actually observe contributes to degrees of visual illiteracy. We know that there is a certain length to the thigh or upper leg, for example, in relation to the length of the lower leg. But when we observe the figure seated in a chair, we see a foreshortened view of the thigh that often does not relate to the lower leg in the way that we would expect. This difference between what is known and what is seen creates a conflict for the uninitiated beginner, and the more familiar "what we know" will override the less familiar "what we see." So we lengthen the thigh in an effort to get it to match what we know about a thigh, and the figure appears to be sliding off the seat of the chair because of the conflict between the position of the body and the adjusted proportions.

In some instances of proportional problems in a student's work, there is an emphasis on length relationships at the expense of width relationships. What may at first appear to be a torso that is much too long, for example, may actually be the result of a torso whose length is accurate in relation to the unit of measure but whose width is too narrow. The converse is also true. What may at first appear to be an arm that is incorrect in length may actually be an arm whose length has been accurately observed but whose width is incorrect, having been assumed or guessed at.

These perceptual short circuits require a more careful study and understanding of the principles of observing size, shape, and scale relationships and the underlying language translation from 3-D (the actual, observed form) to 2-D (the flat plane upon which the form is represented). Sighting and scaling are addressed in chapters one, two, and three.

Multiple Perspective Eye Levels

If a student is familiar with the principles of perspective, then forms that have an observable relationship to perspective (any forms derived from a cubic structure) can be represented with a clear sense of a fixed eye-level line or horizon line and with a clear sense of converging parallel edges meeting at a single point on that horizon line. But even for a student who has no prior understanding of perspective principles and no experience with drawing in perspective, sighting provides a method for accurately observing and recording the angles and lengths of a form's edges and axes. If sighting principles are applied with care and concentration, and if all forms are seen in their spatial relationship to all other forms, a unified sense of spatial placement and location

can be achieved, even in the absence of specific perspective training. Once again, sighting provides a key component for accurate observation.

Foreshortening Inaccuracies

Foreshortening, especially in the extreme, can throw off even the most careful observer. Not only are the axes and the length and width relationships of forms altered (often radically), but the resulting shape of a form seen in a foreshortened view often bears no resemblance to how we typically imagine that form to look. Once again, sighting techniques are tremendously helpful in observing and recording foreshortened forms, whether they are found in the human figure, in a still life, in a study of an interior space, or in some other subject.

Foreshortening is related to the perspective principle of diminution in size. Not only does it alter the appearance of an isolated foreshortened form, but it may also create a radical shift in size or scale relationships between the various parts of a more complex form. This is highly evident in drawing a reclining figure. If the observer is positioned at the figure's feet or head, with the main axis of the body at a pronounced angle to the plane of vision, there will be various degrees of foreshortening observed in the limbs and the torso of the body. But there will also be dramatic differences in the size or scale relationship between near and distant parts, such as the feet and the head. Entire parts of a form may disappear in a strongly foreshortened view. Instances of overlapping increase or are heightened in a foreshortened view. In the event that these visual cues are not observed and recorded with care, the visual impact of foreshortening will not be achieved.

The student of foreshortening must be encouraged to utilize sighting techniques to observe the often unexpected width, height, and size relationships, and should be cautioned against the strong inclination to tilt the sighting stick along the axis of a form, often unconsciously, as opposed to the correct technique of keeping the sighting stick within the two-dimensional plane of vision that represents the picture plane.

Flat and Restricted Line Work

This inadequacy in a drawing is characterized by line work that is uniform in tone, width, and texture, and is generally found along the outermost contours of a form. As such, the line work serves primarily to describe a flat shape rather than a volumetric form. If the line work ventures into the interior of a form, it usually does so reluctantly and lacks the sensitivity to describe a range of undulating surfaces such as may be found in the human form. Rather, that same uniform line within the interior of a form will tend to read more like a scar or a tear than as a description of a changing and shifting surface.

In this instance, a student often has a very narrow idea of what constitutes an edge (the place where form meets negative space is one narrow definition), and views line as capable only of defining this particular kind of edge. For this student, the idea that line can describe volume and space is not a familiar one. If the notion that line can beautifully describe form, volume, and space is accepted by the student, she may still

struggle with knowing when, why, and how to introduce variation into her line work. In addition to an awareness of the systems used to denote hard, medium, and soft drawing materials and their role in developing line variation, the student must become familiar with the ideas governing the use of lighter and darker, thicker and thinner, softer and sharper, and textured and smooth lines to denote edge, form, volume, etc. Line variation is discussed in depth in chapter one.

Details at the Expense of Underlying Forms

Although over-attention to detail can develop in linear drawings, this is an issue that is usually closely related to the student's use or misuse of value or tonal structure. In many cases, a drawing may progress well in the linear state only to begin to fall apart when the student begins to explore value or tone as a description of form, volume, and light source. The problem is rooted in overattention to details and specifics at the expense of the larger, simpler forms and volumes upon which the details are based. Detail attracts our eye, and it can be especially challenging to bypass detail until the "sponsoring" or "host" form is clearly established as a volumetric form.

In the figure, this issue most often develops in relation to areas of greater detail such as the head and face, or the feet and hands. Nostrils are colored in as dark holes before the nose takes on any volume or structure. Eyelashes and irises take precedence over the spherical form of the eyeball and the eyelids. On a grander scale, the eyes, nose, mouth, and ears may all be properly positioned and well defined, through tonal structure, as individual forms. But the facial features may be lacking a sense of cohesiveness because the greater form and volume of the head itself, upon which these features are based, has been ignored or underdeveloped. Hands may show all sorts of lines and creases and knuckles and fingernails, but this information may rest on fingers that lack volume and fullness. Nipples may rest on breasts with no volume.

The same premature scrutiny can be found in the study of inanimate or nonfigurative forms as well. A still-life arrangement of fruits and vegetables may focus on surface texture without acknowledging the spherical form upon which the texture is found. A study of a tree may excessively describe the texture of bark without sufficient emphasis on the columnar volume of the trunk and branches. A drawing of a shoe may obsessively describe laces and eyelets or the pattern found on the sole of the shoe while denying the larger volume of the shoe itself. A drawing of a house seen in two-point perspective may beautifully describe doors and windows and rooflines and columns and brick patterns, while missing the overall tonal shifts from one large plane or side of the house to another, which describe the house as a large cubic structure upon which the details of doors, windows, etc., can be found. As you can see, the list of examples is endless.

The solution to this problem is in repeated emphasis on working from general to specific, and in introducing the student to techniques and exercises that facilitate this approach to observation. Exercises for reinforcing the process of working from general to specific are outlined in chapter one and, in relation to the figure, in chapter two.

Scaling Inaccuracies in Relation to Perspective

In its most fundamental state, problems with scaling are directly related to problems with proportional relationships between individual elements in a composition. If these individual elements do not relate to each other convincingly in terms of size, the integrity of the drawing is compromised. When forms can be observed directly, sighting techniques provide a means for determining accurate size relationships.

In its more specific application, scaling refers to a process based in perspective that determines the accurate size relationships of forms on a fixed ground plane in an illusionistic three-dimensional space. If a student is attempting to invent elements in an illusionistic three-dimensional space without the benefit of direct observation, scaling issues will be evident through size and placement discrepancies. Forms may appear to be too big or too small in relation to other forms, or forms may appear to be unintentionally floating above a ground plane or crashing through a ground plane. Drawing situations where scaling problems may arise include attempts to address multiple forms within an interior space or a room environment, or attempts to address multiple forms in a deep exterior space, such as a landscape or a cityscape. Doorways and furniture may appear too small to accommodate figures or too large; houses and trees and cars may appear too large or too small in relation to each other.

The process of scaling effectively establishes a corridor of convergence that determines the change in apparent size or scale as a given form is moved to different positions within the illusionistic three-dimensional space of a drawing. It also maintains an accurate size relationship between different forms within this same illusionistic three-dimensional space. The process of scaling is addressed in depth in chapter one, and in relation to the figure, in chapter two.

Lack of Volume or Timid Value Structure in Three-Dimensional Forms

As noted, lack of volume can result from excessive emphasis on detail at the expense of the sponsoring or host form. If this is not the cause, lack of volume is often rooted in inadequate tonal structure resulting from fear or timidity about tones becoming too dark. It may also result from a misuse of media based on a lack of awareness of different grades of lead, charcoal, graphite, conte, etc. The student may be unwittingly limiting himself to harder media, which in turn limits the resulting tonal range.

It is important to make a distinction between timid, underdeveloped value structure and high key value structure. High key value structure would be sensitive to the six divisions of light and shadow (highlight, light, shadow, core shadow, reflected light, cast shadow), and would intentionally represent them using tones found on the lighter end of the value scale. An anemic or timid value/tonal structure would not acknowledge the full and rich range of lights and shadows necessary for describing volume effectively.

In the event that a student is misusing media due to a lack of awareness of the systems used to denote hard, medium, and soft drawing materials, the student must be made aware of the system and what it means. Harder tools make a lighter mark and can incise the paper if too much pressure is applied in an attempt to make a mark darker than what the medium is intended for. This is especially true in the

case of drawing pencils. The softer the tool, the darker a mark it makes, the more easily that material will smear and move around, and the less easily or thoroughly it will erase.

In the case of timidity, the student must be encouraged to push tonal ranges further. It can prove helpful to set aside harder drawing materials and encourage the use of medium and soft materials only. It may also facilitate a breakthrough to have the tonal-timid student establish an overall ground or base tone of vine charcoal from which to work both additively (with compressed charcoal pencils and sticks) and subtractively (with erasers). It may also prove helpful as an exercise to present the student with some lit forms whose local tone is dark to begin with, which can relieve some of the anxiety of making shadows on a light form too dark. Repeated encouragement is important. Information on what to look for when identifying value structure can be found in chapter one.

Overly Generalized Drawing

Overly generalized drawings are characterized by a lack of development beyond a certain intermediary point. The drawing is on the right path, but not reaching the destination. Description of volume or form does not address any details of surface or form, and value structure, if applicable, does not develop beyond an initial limited tonal range. The drawing is developed competently up to a certain point, but moving beyond that point either is not pursued or is pursued hesitantly and with negative results. Often the student is afraid of "ruining" a drawing that is working well in the early or intermediate stages because she does not feel confident in developing darker passages that define a full value range (timid value), or because she is overwhelmed by the shift from generalized information to detailed information, or because her attention span is limited and she is unwilling or ill equipped to move beyond general analysis of form to more careful scrutiny. Encouragement to take the plunge is important, with the understanding that practice and experience will make this transition from a moderately developed drawing to a fully developed drawing easier.

If technical issues seem to be more the problem than perceptual issues, make sure it is understood that this is often a good time to make a shift in drawing materials, particularly if the initial drawing was developed using stick media. Detail is more easily addressed using pencil forms of lead or graphite or charcoal or conte, which provide greater control.

Substituting Recipes or Formulas for Careful Observation

This is a common problem in drawing, particularly when the form being drawn is one that has historically been the subject of how-to books or instruction that encourages the use of recipes or formulaic solutions. Careful analysis and observation is replaced with generalizations and stylizations (what we know versus what we see) that result in generic-looking forms lacking unique character and integrity. If this approach to drawing is well established, it can be a difficult habit to break. It is often far more challenging to unlearn something that has become second nature than to learn something about which one has no prior knowledge.

Unintentionally Ambiguous Space

Ambiguous space that is arrived at unintentionally delivers mixed messages to the viewer, becoming space characterized by passages that convey form and volume juxtaposed with passages that read as flat, two-dimensional shapes. There may be a shift in technique or process or media from one part of the drawing to another, from continuous tone modeling to hatching and crosshatching to outlining, for example. A unified language or voice is markedly absent, resulting in a drawing that is visually confusing, weak in presenting the compositional principle of harmony, and lacking in authority. It is a drawing that is hard to believe, difficult to trust. Addressing these shortcomings requires that intention is clarified (what is the drawing intended to speak to), and that attention be given to maintaining a relatively constant language that works toward realizing the intention.

Rigid or Pristine Drawings; Lack of a Sense of Process

A drawing may be well composed and reflect accurate and careful observations of form, but still lack freshness and a sense of the process of drawing. This is often the result of a student's fear of making a mistake, or his fear that a drawing will become too "messy." In an attempt to avoid this, there may be evidence of an overly restrained approach, resulting in a stiff or rigid drawing. The student's lack of enjoyment of the *process* of drawing is evident in the results. Line work may lack fluidity, and every indication of process—if any even exists—may be painstakingly erased and "corrected." Fear and caution become obstacles, and the desire for perfection stands in the way of discovery through process and trial and error. Exercises that emphasize process over product can help to promote enthusiasm for the act of drawing and for visual evidence of the search which is vital to the life of a drawing.

Sometimes this excessive caution is the result of previous drawing experiences, such as technical drafting, which may have emphasized a degree of precision that is frequently inappropriate for a freehand drawing. In this instance it is helpful to discuss with the student the different approaches and their relationship to the desired results and function of a drawing.

Poor Composition

The ways in which a drawing may reflect poor composition are numerous, due to the many factors that must be considered in developing a strong composition. Typical compositional weaknesses in the work of beginning students are often grounded in a disregard for the most basic compositional rules or guidelines. The work may show a lack of visual balance; awkward or overstated divisions in the picture plane; a lack of recurring similarities of line, shape, value, texture, or form necessary for compositional harmony; or a most fundamental disregard for the relationship between image and format.

This disregard is typically not intentional. It results instead from a narrow and singular focus on the individual forms or images that make up a drawing, eclipsing the need to pay attention, from the onset, to the relationship of forms or images to each

other and to the format or picture plane, which becomes their universe by defining the total space in which they exist. Key compositional concerns are discussed in chapter one.

Key Questions for Critiques

At the discretion of the instructor, these points of discussion can be distributed as hard copy for the students to consider as they address various issues.

Regarding Composition

The following questions are helpful during a critique in directing the individual student or a group of students toward thinking about significant compositional concerns. While there is some assumption that student work is dealing with recognizable imagery and/or objects, the questions can also serve to critique work that is rooted in abstraction or is nonobjective. Reference to "objects" in the questions suggests the presence of tangible and recognizable forms. By substituting the word "shapes" or "elements," the emphasis shifts to compositions that utilize the elements of art in an abstract way. Consequently, these questions could effectively address either drawings dealing with a still life in which the objective is to record the information accurately and realistically, or a two-dimensional design project that explores the elements of art and their arrangement in an abstract or nonobjective fashion. The focus of these critique questions is a broad-based analysis of composition.

- What kind of balance has been used in the composition? Has unintentional centralized or symmetrical balance been avoided? Has a more dynamic asymmetrical balance been used instead?
- Does the composition contain activity in different spatial planes? Have foreground, middle ground, and background been addressed?
- Do objects or elements in your composition occupy the foreground, the middle ground, and the background?
- Has attention been given to both positive and negative space? Has the arrangement of objects and/or positive space resulted in some interesting negative spaces?
- Have the objects in your composition been grouped in varied and interesting ways? Are there smaller compositions within the larger composition?
- Has overlapping been used in your composition? If not, why not? What does overlapping indicate?
- Are there objects of varying size and character or are all objects roughly the same size? Are there both regular and irregular shapes or objects represented in your composition?
- Is there a combination of both open and closed shapes used to help integrate positive and negative space, or figure and ground?
- Is the entire composition developed equally, or are there primary and secondary focal points? Are there areas where the visual emphasis is greater and areas where the visual emphasis is lesser?
- Where are the literal or implied divisions in the picture plane located? Are dynamic divisions based on the Golden Section or the Fibonacci Series in evidence

(⅔ to ⅓; ⅗ to ⅖; etc.), or is the picture plane routinely divided into halves and/or quarters?

- Is the overall composition excessively crowded or excessively empty? Does this serve any significant purpose?
- Is there evidence of harmony (recurring similarities of line, shape, texture, value, and/or color)? At the same time, is there evidence of variety of these elements?
- Do the primary elements used in the composition deny the picture plane, or do they serve to reinforce and reflect the picture plane?
- Do directional forces and visual paths of movement direct the viewer's eye throughout the composition? Are there "dead" spaces in the composition?
- Are all forms fully contained by the picture plane, or has some cropping been used? If so, is the cropping occurring in a way that reinforces unequal divisions of forms, or are forms cropped in half?
- Has tonal structure or value structure been used in the composition? If so, is the general direction of the light source clearly identifiable?
- Are the values or tones in the composition well distributed and well balanced?
- Has value been used in both the positive spaces and the negative spaces, or just in the positive spaces?
- If tangible objects are being drawn, have cast shadows been used to help anchor the forms to a ground plane? Do objects appear to be floating?

Regarding Drawing

While there is some assumption that student work in drawing at the foundation level is dealing with recognizable imagery and/or objects, the questions can also serve to critique work that is rooted in abstraction or is nonobjective. Consequently, as was the case with the questions for a critique of composition, these questions could effectively address either drawings dealing with a still life in which the objective is to record the information accurately and realistically, or drawings that explore the elements of art and their arrangement in an abstract or nonobjective fashion. The focus of these critique questions is a broad-based analysis of drawing as defined by traditional drawing media applied to traditional drawing surfaces. If color is introduced through the use of chalk pastels or colored pencils or even oil pastels, then it is necessary to include questions that directly address the use of color in the drawing.

- What is the subject being drawn? Does it involve representation, abstraction, simplification, distortion, or transformation?
- What media are used and on what kind of surface?
- What is the organizational element in the drawing? Is it a curve, a diagonal, a horizontal, a vertical, or a combination?
- What kind of line is used, if any—contour, mechanical, gestural, calligraphic, broken, or implied? Where is line concentrated? Does it create mass? Does it create value? Does it define edges?
- Note the distribution of different types of line in a drawing. Are all the lines the same or do they vary throughout the drawing?
- Is there line variation utilized in the drawing? Does the line variation reinforce volume and weight and directional light source? Is the variation random or does it address specific concerns in relation to the forms or objects it depicts?

- What kinds of shapes predominate? Organic/curvilinear? Geometric/rectilinear? Do the shapes exist all in the positive space, all in the negative space, or in both?
- Are the shapes large, medium, or small, or a combination of all three? Are they the same size? Are there repeated shapes?
- How have shapes been defined? By line? By value? By texture? By a combination of these three?
- Are shapes flat, two-dimensional, and decorative, or are they volumetric, three-dimensional, and plastic?
- Is there value structure or tonality in the drawing? Can you divide value into three groups—lightest light, darkest dark, and middle gray? Can you identify in your value structure the six divisions of light and dark—highlight, light, shadow, core shadow, reflected light, and cast shadow?
- How are your values distributed throughout the drawing? Is value in the positive spaces only? In the negative spaces only? In both? Do the values cross over objects or shapes, or are they contained within the objects or shapes?
- Is value used to indicate a single light source or multiple light sources? Does value define planes? Does it define space? Does it define mass or weight?
- Does the value structure create a mood? Is it high key value, or low key value, or is it a complete value range?
- Is invented, simulated, or actual texture used in the drawing? Is there only one kind of texture used or are there many textures used? Are textures repeated throughout the drawing?
- Have you used more than one medium? If so, does each medium remain separate from the other media, or are they integrated?
- What kind of space is utilized? Is it flat or two-dimensional or decorative space? Is it shallow space? Is it a deep or infinite space? Is atmospheric perspective used to indicate space? Is it an ambiguous space, or a combination of different kinds of space?
- Are spatial indicators used? Is there evidence of diminishing size, variety in positions or base lines, overlapping, sharp and diminishing detail, sharp and diminishing contrast, linear perspective, or converging parallels?
- How is the composition related to the page or drawing format? Is it a small drawing on a large format? Is it a large drawing on a small format? Is there a lot of negative space? Does the image fill the format or is there a lot of extra or unused space around the edges of the format? Do the negative shapes seem to have equal importance to the positive shapes? Are other compositional devices employed?

Regarding Figure Drawing

The following points of discussion are intended as a guideline in thinking about and critiquing drawings of the human figure. It should be noted that some of the issues worth discussing in a critique of figure drawings are addressed in the critique questions concerning composition and drawing. But there are also some aspects of figure drawing that are specific to figure drawing and important to address in a critique that strives for thoroughness and specificity.

- Is the figure represented proportionately? Does the head relate to the torso, the torso to the limbs, the limbs to the extremities (hands and feet) correctly in terms

of size? In other words, do the parts relate to each other in terms of size, and do the parts relate to the whole in terms of size? Is the width of forms considered in relation to the length of forms? Has the tendency to make the hands and feet too small been avoided? Is the process of sighting being employed to help determine accurate proportional relationships? Are the angles and axis lines of the figure accurate? Are the features of the face positioned correctly in relation to the head?

- Are the contours of the figure being addressed thoroughly? Is contour activity being overstated or understated or stylized? Do the contours of the figure accurately represent the presence of anatomical elements and their influence on the appearance of the figure? Is attention being given to interior contours as well as exterior contours? Is the representation of contours taking into account instances of overlapping? Are contour lines reserved for actual edges in the figure or is contour line being used to draw the edges of shadow?

- Is line work uniform in value and width and sharpness, or is there variation and sensitivity in the line? Are changes in value and width and sharpness in response to observed changes in contours, or does the variation in line work appear to be somewhat random? Does the line variation take into consideration the light source, the speed of contours, surface tension, and weight or mass? Does the line work convey a sense of volume in the figure, independently of shading or tonality? Does the quality and character of the line shift in describing the difference between delicate interior contours and firm exterior contours? Is there delicate line work underlying the more established line to convey a sense of process and search, or does the line appear stiff and rigid? Have appropriate medium and surface been used to build line quality and variation?

- Is composition being carefully considered? What is the scale of the figure in relation to the drawing format? Is the figure small on a large format, or large on a smaller format? Is the entire figure represented or are parts of the figure cropped? If there is cropping, is it planned and intentional or the result of poor planning? Does the placement of the figure on the page feel comfortable and balanced, or does it feel crowded to one side or to the top or bottom of the format? Does the scale of the figure on the format activate the negative space areas?

- Has value structure/tonality been addressed in a generalized manner in the initial stages, without premature attention to details? Is value structure distributed uniformly throughout the figure, or have focal points been developed? Does the treatment of value reinforce a clear light source, or does it create confusion regarding the light source? Can you identify the six divisions of light and dark in the drawing of the figure? Are details defined through value at the expense of the larger, simpler planes of value upon which detail is based? Does value cross over edges of the figure or is value contained by edges of the figure? Does tonal structure help to identify anatomical structure? Has the relationship between shapes of shadow and shapes of light been accurately recorded? Are there abrupt value transitions, or gradual value transitions, or both?

Regarding Perspective

The following points of discussion are intended as a guideline in thinking about and critiquing perspective drawings. The way in which perspective is being explored may

vary. While these questions are generally addressing work which focuses purely on perspective and the cubic form as the basic geometric solid from which many other forms are derived, it is also possible to apply many of these questions to work that incorporates elements of perspective without being specifically focused on perspective.

- Is weighted line used effectively in the composition? Is line quality used to define the foreground, middle ground, and deep space? Lines should be darker and thicker in the foreground, growing progressively lighter as they move toward the vanishing point. Is there a gradation from darker to lighter line in the drawing?
- Is value/tonality used in the perspective study? Does the use of value help create a sense of spatial depth? Is the gradation from darker to lighter effective in describing planes and volumes? Is there a sense of consistency in the use of value in relation to light source?
- Has the placement of forms on the picture plane been carefully considered? Is the composition varied and interesting, employing principles of composition such as balance, harmony, and variety?
- Are the cubes drawn in correct proportion on their foreshortened sides? Cubes should look as though they are equal-sided. Do the cubes look more like rectangular solids than like forms that have six equal sides?
- Has the scale determined for the drawing been adhered to? Are the VPL and VPR or the SVPL and SVPR located in the correct position in relation to the station point? Is the eye-level line or horizon line the correct distance from the ground line according to established scale?
- Are the forms below the horizon line sitting firmly on the ground plane or do they appear to float?
- Is overlapping used correctly, insuring that the mass of one form or cube does not trespass into the mass of another? This error occurs when two cubes or forms appear to be occupying the same space. Have cubes or forms derived from cubes been drawn transparently in order to identify if trespassing is occurring?
- Are the sizes of the forms consistent with their position on the picture plane? Forms that are lowest on the page should generally be the largest. Forms that are higher in relation to the horizon line should generally be smaller. This relationship is reversed for forms located above the eye level.
- Is there a gradation from large to small on the picture plane? Is the diminution too extreme or does it need to be more pronounced? Is the progression from large to small smooth and consistent?
- Is the convergence of the forms executed correctly? Do lines and surfaces appear to come together on forms as they recede from the viewer toward vanishing points?
- If the subject is in one-point perspective, are the lines of convergence meeting at the same vanishing point? If the subject is in two-point perspective, are the lines of convergence meeting at the proper vanishing points?
- Are the sides, tops, and bottoms of forms properly foreshortened as their angle to the picture plane increases or decreases? Often cubic forms are not foreshortened enough.
- Has the cone of vision been established? Is the cone of vision too constricted? Is distortion present in any of the cubes or forms near the edges of the picture plane? Has the cone of vision been adhered to?

- If construction lines are to be present in the final presentation, are they appropriately light and delicate or do they interfere with the reading of the drawing?
- Is the presentation of the drawing strong? Is the drawing clear and clean and readable? Are points of intersection and points of convergence precisely drawn? Are all vertical lines drawn parallel to each other and drawn as true verticals? Is the drawing crumpled, creased, or otherwise disheveled?

Grading

There are few things that contribute to conflict between a teacher and a student more than grades. And the problems inherent in grading can be attributed, in part, to both teachers and students. Many teachers are afraid to grade a student fairly and objectively, particularly if that grade falls anywhere below a B-minus, into the dreaded realm of "average." Teachers may fear the complaint of a student, which may turn into an official grade grievance. While most institutions of higher learning have a specific procedure in place for addressing grade grievances, it is rarely a pleasant experience for anyone involved and often leaves someone with bad feelings.

But where does this problem originate? A few possibilities come to mind. Many institutions are collectively guilty of grade inflation. Some teachers give out blanket As or Bs to an entire class, reflecting their unwillingness to invest the time and energy necessary to evaluate the work of each individual student in a manner that is as fair and objective as possible, and effectively rendering the grades meaningless. This can lead to unrealistic expectations on the part of students, who may come to expect As and Bs as routine, contributing to the false notion that simply showing up on a fairly regular basis is sufficient to receive a grade that was originally intended to indicate excellent or very good performance.

For students entering college directly out of high school, there is another issue that may lead to unrealistic expectations. Many students find themselves to be shining stars in their high-school art classes, frequently based upon their ability to copy photographs or other images that already existed in a two-dimensional form. But when they encounter a basic drawing course or a life drawing course in which they are faced with the challenge of translating three-dimensional information into the two-dimensional language of drawing, there will often be a degree of struggle, which is natural when first exploring a new or unfamiliar process. It can be a difficult transition for even the most humble and realistic students. Receiving a B when they are accustomed to receiving As, or receiving a C when they are accustomed to receiving Bs can initially be traumatic. It is tricky territory to negotiate for even the most seasoned teacher who is aware of the need for objective evaluation while also being sensitive to a student's need for encouragement.

In other instances, a student who is a high achiever or an overachiever or a perfectionist may feel that nothing less than an A is acceptable, and this is generally an unrealistic goal, with few exceptions. Still other students may feel pressured externally to perform at a consistently high level, either from parents who are contributing financially to their education or from agencies granting scholarships that are contingent upon maintaining a certain grade-point average. The pressures upon students, whether generated internally or externally, can be tremendous, particularly when they

are unaccustomed to or unprepared for the intensity and workload of the college experience. Add to this the fact that many students attempt to work full- or part-time jobs while attending school full time, and you have a recipe for potential problems.

But in fact most institutions require that we evaluate or measure a student's work against a standard of performance, effectively indicating a student's degree of success, and most institutions utilize the traditional grading system of A, B, C, D, and E or F. The traditional meaning of these grades, which I personally subscribe to with some exceptions, is taken from the Riegle Press, Inc., class record book and reads as follows:

GRADE A: SUPERIOR
1. Scholarship: Strong, exceeding requirements of instructor.
2. Initiative: Contributions exceeding the assignment, showing independent resourcefulness.
3. Attitude: Positive benefit to class.
4. Cooperation: Leading all group activities, constant and spontaneous.
5. Individual Improvement: Marked and growing.

GRADE B: GOOD–ABOVE AVERAGE
1. Scholarship: Accurate and complete, meeting all requirements of instructor.
2. Initiative: Good when stimulated by some desirable achievement.
3. Attitude: Proper and beneficial to group.
4. Cooperation: Good in group work.
5. Individual Improvement: Showing marks of progress and responding to stimulation.

GRADE C: AVERAGE
1. Scholarship: Barely meeting assignments and showing evidence of need of encouragement.
2. Initiative: Uncertain and apparent only at times.
3. Attitude: Generally neutral but not objectionable.
4. Cooperation: Not positive nor very effective and irregular.
5. Individual Improvement: Very ordinary, definite marks lacking.

GRADE D: BELOW AVERAGE, YET PASSING
1. Scholarship: Not meeting all assignments and requirements of instructor.
2. Initiative: Lacking.
3. Attitude: Indifferent.
4. Cooperation: Just fair at times and lacking at other times.
5. Individual Improvement: Not noticeable.

GRADE E OR F: FAILING
Work unsatisfactory and is a failing grade and hence not defined.

Weighing All the Issues

I am very aware that this particular system of grading may be considered most applicable to realms of study that more readily embrace absolutes, such as mathematics,

English grammar, or certain branches of science. Art is a field of study in which there are few, if any, absolutes, and where a student is frequently confronted with exploring and revealing personal feelings, preferences, and opinions that are not an integral part of other more objective realms of study. Because there are subjective aspects involved in the creation of art, and consequently in the evaluation of art, it is often not a simple task to identify which grade best reflects a student's overall performance. If effort is taken into account, the process may be made even more difficult based on the fact that you will encounter instances when a student has worked very hard on a piece (A for effort), and yet the results of that effort do not meet your standards or requirements (C or D for results). How do you reconcile this difference? There is no easy answer or formulaic solution. You must wrestle individually with these kinds of discrepancies in arriving at a grade that seems fair and honest.

Some would argue that a student of the visual arts, with an inherent emphasis on self-expression, should not be held to the same standards as a student of disciplines based in more objective realms. Some would argue that a difficult attitude should not adversely affect the evaluation of a student if his work is adequate, particularly at the postsecondary level. Still others may argue that traditional grading systems are entirely inappropriate with regard to the study of art, and may advocate the use of a pass/fail system of grading, or no grading at all. While I can understand most of these points of view to some extent, I am not in favor of abolishing grading systems, and instead favor a system with much greater nuance than a pass/fail system. Since it seems necessary to maintain some form of measuring performance and progress, I favor as much nuance as is practical. While you may personally prefer some alternative form of evaluation, most institutions ultimately require that you assign a final grade for students in your charge that reflects the system that the institution collectively endorses.

Appendix *A*

Classroom Documents
and Other Teaching Aids

Preparing for the Classroom Experience

It is important to provide your students with certain key information at the onset of any course you are teaching. This generally includes a materials list, a handout defining pertinent information (such as your attendance policy, grading policy, sketchbook or homework requirements, office hours, and a reading list), and a course syllabus. Depending on the specific course and the level of the course, this information varies in content and depth.

Preparing this information in advance helps you to clarify your intentions for the course, and provides the students with reference material. Some colleges and universities require that you keep a copy of these documents on file. In the event that a student has a complaint or a grade grievance is filed, information is available to refer to which can support the instructor's stance regarding key policies, such as attendance requirements, that have influenced the student's grade.

Providing the student with clear information regarding the structure of the class will also help to establish an initial degree of trust and respect for your authority and expertise in the classroom. It is important for the student to have the initial impression that he or she is going to have a valuable experience in your class, an impression that will be supported as the course progresses. Unless you are feeling confident of your enthusiasm, authority, and expertise, you will find it difficult to convey this to the students. Organizing yourself in advance and having a solid idea of what you would like to accomplish for a particular course is an important beginning point. And being able to convey this clearly from the onset will establish confidence in both you and your students. This is not to suggest that rigidity or inflexibility is called for. You should feel free to make adjustments and changes in any way that you deem necessary for the benefit of the class.

Some instructors provide a bare minimum of information, while others go into much greater detail. I personally recommend being as thorough as possible, but the

way in which you present course expectations and requirements is an individual decision and one with which you should be comfortable. Following are some examples of printed materials that I provide students on the first day of classes, and some explanatory remarks. Some information is reserved exclusively for intermediate (or advanced) coursework, while other information is pertinent only to introductory-level coursework.

Providing a Materials List

The following handout outlines a required and suggested (in italics) materials list for an introductory Life Drawing I course. This is typically a freshman- or sophomore-level course (depending upon the curricular structure of a given institution) that may or may not have been preceded by some coursework in basic drawing. The same handout, with some revisions, can be used for a Basic Drawing I or II course or a Life Drawing II course since the materials list is fairly comprehensive. It is, of course, serving only as an example. If presenting a materials list for Basic Drawing I, I would need to include some materials that are specific to the study of mechanical perspective because that is an integral part of the Basic Drawing I course at the institution where I teach. Your materials lists should be tailored to your syllabi and should reflect the kinds of drawing experiences you want your students to have.

Notes Regarding the Materials List
- Provide the name of the course, the course number, the instructor's name, the semester, and the instructor's office location and office hours on the materials list. You may also want to list the required textbook for the course if there is one.
- If you have a specific material or brand name in mind, make this very clear to the students. It is also acceptable to specify a brand name that you do *not* want the students to purchase.
- Particularly at the beginning level, you should not assume that students know what the materials are. If possible, show examples and discuss the characteristics of a particular tool or material. For example, many beginning students do not know the difference between vine charcoal sticks and compressed charcoal sticks.
- Many beginning level students are unfamiliar with the systems used to indicate hardness and softness of drawing pencils, conte, charcoal, etc. Explain to them the meaning of the simple indicators of s, m, and h, and the more elaborate system of numbered progressions through h, hb, and b.
- Discuss the different kinds of charcoal pencils and your preferences for them, if you have one. What are some of the pros and cons of working with charcoal pencils encased in rolled paper versus charcoal pencils encased in wood?
- Try to be specific about what materials are absolutely essential for getting started, and what materials are optional or may not be necessary until later in the course. Most students are on a very tight budget, and this can help them to spread out the cost. Note that I have made this distinction on the materials list provided.
- If possible, place a copy or two of the required text (if there is one) on reserve in the library so that students who are unable to purchase the text immediately may have an alternative to meet their reading assignments.

Foundation Life Dwg I (FN 0221)
Semester: Spring 1998
Instructor: Deborah Rockman, Office 601
Office Hours: Monday, 3:30–6:30

Materials List

- 1 pad of 18" x 24" *multimedia* white drawing paper (look for texture on the surface)
- 1 pad of 18" x 24" newsprint paper (smooth surface is preferable to rough surface)
- 1 sketchbook or journal, 9" x 12" or 11" x 14" (spiral bound or hardbound)
- 1 drawing board, 19" x 25" or larger to accommodate drawing paper (commercial or home-made)
- Large clips for attaching pads or individual sheets of paper to drawing boards
- Portfolio, 19" x 25" or larger
- Vine charcoal sticks; 1 package each of soft and medium (do not buy *hard* vine charcoal)
- Compressed charcoal sticks; minimum 2H (hard), HB (hard), 2B (medium), and 4B (soft)
- Drawing crayons (conte sticks), black or sanguine (reddish-brown); avoid hard drawing crayons
- Charcoal pencils (numerous brands available); 6B, 4B, 2B, HB, 2H, or S, M, H
- Drawing pencils (numerous brands available); 6B, 4B, 2B, HB, 2H, 4H
- Graphite sticks; soft and medium
- Ebony pencil (all are equally soft)
- Kneaded rubber eraser and Pink Pearl eraser
- Tube eraser (Pink Pearl or other type)
- Spray fixative (No. 1303 Krylon Crystal Clear)
- Roll of drafting tape
- ⅛" dowel stick or suitable alternative (thin knitting needle, shish-kebab skewer)
- Viewfinder(s) constructed of rigid material (1-½" x 2", 2-¼" x 3", and 3" x 4" for 18" x 24" drawing format)
- *Conte pencils, carbon pencils, carpenter's pencils*
- *Prismacolor colored pencils*
- *White charcoal pencil*
- *X-acto knife and refill blades*
- *Rubber cement or other paper adhesive*
- *Assortment of black, white, and middle-gray construction paper*
- *Small hand mirror*
- *Odorless solvent (Turpenoid or Permtine)*
- *Black india ink (nonwaterproof)*
- *Small metal or plastic palette with individual sections (plastic egg cartons work well)*
- *Assortment of water jars or cans or plastic containers*
- *Assortment of brushes—flats and rounds, wash and acrylic/oil, a variety of sizes from ½" to 3"*

Some additional materials and individual sheets of drawing paper may be purchased as you need them. Italicized items need not be purchased immediately. You will be informed ahead of time if and when these items are needed for a specific classroom or homework assignment.

Expectations and Requirements

The following handout outlines general expectations and requirements for an introductory Life Drawing I course. This is typically a freshman- or sophomore-level course (depending upon the curricular structure of a particular institution) that may or may not have been preceded by some coursework in basic drawing. A similar format can be used for a Basic Drawing I or II course or a Life Drawing II course with any adjustments necessary to reflect changes in your expectations or requirements.

Notes Regarding Class Procedures

- Encourage students to make an appointment if they have something they would like to discuss or questions they would like to ask while having your undivided attention. Make an effort to let them know that you are indeed accessible, and that you welcome their questions.
- Make sure that you discuss your expectations and requirements with students and elaborate when necessary. Discussion will also help to generate questions the students may have regarding your expectations and requirements, and may help to alleviate some anxieties.
- Beginning-level students or students with whom you have not worked before often benefit from more discussion due to their limited experience. Talk about your attendance policy, talk about the critique format, and talk about your grading policy.
- It is important, of course, to tailor your handouts to the specific course you are teaching and the approach you use in the classroom. There are many possible topics you may wish to address in your handouts that I have not touched on in the examples presented, which are based on one specific curricular structure at one specific institution.

Foundation Life Dwg I (FN 0221)
Semester: Spring 1999
Instructor: Deborah Rockman, Office 601
Office Hours: Monday, 3:30–6:30

Class Procedures and Additional Information

Attendance is crucial and poor attendance and/or consistent tardiness will be reflected in grades regardless of work quality. I will allow three (3) absences for *legitimate reasons,* after which each additional absence will affect and lower your final letter grade. Coming to class fifteen minutes late or more is recorded as an absence. You are responsible for homework assignments given on a day when you are not in attendance. Extenuating circumstances will be considered on an individual basis.

Assignments, including presentations, research or reading of any kind, and work completed for critiques, are due on the designated day. Unless you are absent for legitimate reasons on the day an assignment is due, *absolutely no late work will be accepted* and will result in a failing grade for that particular assignment. If you are absent on the day an assignment is due, bring your completed assignment to class on the day of your return. Once again, extenuating circumstances will be considered on an individual basis. Project solutions exhibiting sufficient effort may be reworked prior to grading based on feedback received during critiques.

Critiques of work will be held to provide students and instructor with feedback. The attention and participation of each class member is expected. Critiques will be specifically geared toward developing critical thinking skills with regard for technical, formal, and conceptual issues. Please keep in mind that a critique of your work is not a critique of you as an individual.

A **sketchbook** will be kept outside of class by each student and should contain drawings, sketches, and relevant notations in relation to the human form. Your journal should show evidence of a *minimum* of two hours of work per week, and work should be dated along with a brief notation of your intentions or concerns for that particular study. In addition to ideas that are self-generated, you should devote time in your journal to reexploring media, techniques, and concepts presented during class, especially when you consider that the more thoroughly an idea is investigated, the more complete your understanding of it will be. Your focus will always be directed toward some aspect of the human figure. Some experimentation with medium and technique is encouraged and applauded. I may at times direct you very specifically as to what I would like you to draw in your sketchbook, in which case I expect you to follow my instructions carefully. Sketchbooks will also be used in class for thumbnail sketches, note-taking during class lectures and presentations, and for assorted other things, so be sure to always have your sketchbook with you during class. You will receive various handouts throughout the semester that I will expect to be accessible to you during class time for reference. Your sketchbook is a good place to keep these handouts. Your sketchbooks will be collected and graded periodically throughout the semester with advance notice of one class session. No sketching or drawing should be done from photographs, magazines, or any two-dimensional sources, with the exception of the work of historical masters. No late sketchbooks will be accepted.

Preparedness is important in order for the classroom experience to be most effective. Please keep all of your materials well stocked. Don't wait until you've run out of paper or drawing materials *during* class before you decide to buy more. If special preparation in terms of materials or research is requested for a particular class session, please come prepared. Consistent lack of preparation will affect the quality of your work and will consequently lower your grade.

Grading Policy: If you meet all assignments with average effort and results and attend class regularly, you will probably receive a "C." If you desire a higher grade, I expect extra effort to be reflected in your work both in class and outside of class as well as in your attitude. I expect each of you to always give your best possible effort, and I will do the same. Your in-class work, represented in your midterm and final portfolios, will account for approximately two-thirds of your grade, with all out-of-class work (including homework and examinations) accounting for the remaining one-third of your grade. In addition to overall progress and improvement, I will be considering attitude, attendance, preparedness, class participation, creative endeavor, and risk-taking in determining your final grade. Please keep in mind that while hard effort is admirable and is taken into account, it does not guarantee successful results and is not the only criteria for determining your grade.

Homework assignments will be graded individually, including your midterm exam/project and your final exam/project. Your midterm and final portfolios will be graded as a *body* of work, with *one* grade assigned for the entire portfolio of in-class drawings.

The following handout outlines general expectations and requirements for an intermediate-level drawing course. You will note some differences between it and the preceding handout for an introductory-level course. This is typically a sophomore- or junior-level course that follows two semesters of required Basic Drawing. The course is most often considered to be a transitional course between the more specifically directed experiences of Basic Drawing I and II and the self-directed experiences of more advanced drawing courses.

Fine Arts Drawing III (FA 0233)

Semester: Spring 1999
Instructor: Deborah Rockman, Office 601
Office Hours: Monday, 3:30–6:30

Class Procedures and Additional Information

Assignments, including presentations, research or reading of any kind, and work completed for critiques, are due on the designated day. Unless you are absent for legitimate reasons on the day an assignment is due, *absolutely no late work will be accepted* and will result in a failing grade for that particular assignment. Extenuating circumstances will be considered on an individual basis. If you are absent on the day an assignment is due, you are expected to bring the completed assignment with you on the day you return to class.

These assignments or "problems" will be broad enough in scope to allow an infinite number of interpretations, thus avoiding the limitations often associated with structured class assignments and allowing a gradual transition from the more rigidly directed experiences of Basic Drawing II to the self-directed experiences of advanced drawing.

The use of photographs is highly discouraged except as reference or for photo collage or Xerox transfer. You are strongly encouraged to use your own photographs whenever possible. Exceptions to this would include an exploration of appropriation, which is the practice of creating a new work by taking a preexisting image from another context—contemporary or historical art, advertising, the media—and combining that appropriated or borrowed image with new ones, or altering it in the re-presentation. Or, a well-known artwork by someone else may be re-presented as the appropriator's own. Examples of artists who have explored appropriation include Jeff Koons, Sherrie Levine, Sigmar Polke, Cindy Sherman, Gerhard Richter, David Salle, and Julian Schnabel.

I expect you to regularly peruse current art and illustration journals and periodicals to maintain some awareness of current events in the world of visual arts—*Artforum, Art in America, Art News, Arts, New Art Examiner, Illustrator's Annual, European Illustration Annual, American Artist,* etc. All periodicals are available in the library. Keep your eyes open for any discussions or articles that you consider relevant to the course in some way. Please photocopy *any* pertinent information and bring it to my attention.

Critiques of work will be held to provide students and instructor with feedback. The attention and participation of each class member is expected. Critiques will be specifically geared toward developing critical thinking skills with regard for technical, formal, and conceptual issues. Please keep in mind that a critique of your work is not a critique of you as a person. When possible, a guest critic will be invited to provide an additional viewpoint.

A **journal/sketchbook** will be kept by each student for the purpose of working out ideas for drawings you wish to pursue in response to each given assignment. This problem-solving process should include thumbnail sketches, Xeroxes, words, thoughts, ideas, and any other information that will assist you in developing a strong drawing technically, formally, and conceptually. For each full-scale, finished drawing that you execute, alternative approaches should be explored in your journal before advancing to the completed, full-size drawing. You are required to review your ideas with me before exploring your final solution to each problem assigned. You are expected to invest a *minimum* of three hours per week outside of class time in your studio, working on your drawings and ideas. Always have your journal with you during class time.

Media: While I am generally quite open to a variety of definitions of "drawing," and support the notion of some mixed media if that is of interest to you, I must remind you that this is a *drawing* course and that drawing should be a primary and integral part of your work. If a boundary, as I define it, begins to be crossed, we will discuss it and I will make any restrictions or limitations clear to you. I applaud and encourage informed experimentation.

Grading Policy: If you work with average effort and results and attend class regularly, you will probably receive a "C." If you desire a higher grade, I expect extra effort reflected in your work both in class and outside of class as well as in your attitude. I expect each of you to always give your best possible effort, and I will do the same. It is clearly expected that you will invest an appropriate amount of time and energy toward your work. There will be a total of four assignments given throughout the semester. I will be grading each individual drawing that you do in response to the assignments, as well as looking at the overall body of work you have completed at midterm and again at the end of the semester. In addition to overall progress and improvement, I will consider attitude, attendance, preparedness, class participation, sketchbook development, creative endeavor, and risk-taking in determining your final grade. Please keep in mind that while hard effort is admirable and is taken into account, it does not guarantee successful results and is not the only criteria for determining a grade.

Determining Course Content

The Syllabus or Course Outline

Providing a syllabus for the course you are teaching is important for a number of reasons. Most significant is the fact that providing an outline for the progression of the course requires you to think ahead, to seriously consider what you think is important to present in any given teaching situation. This is in direct contrast to the ill-advised laissez-faire approach in which the teacher simply makes an effort to stay one step ahead of the students. It also provides the students with some idea of how their experience is going to unfold, and in the event that they miss a class, they will have an indication of what went on in their absence. Of course a syllabus should not be cast in concrete because you will often find that changes are necessary based on a different pace of learning than you had anticipated. Make it clear to yourself and your students that the syllabus is subject to changes and adjustments.

How much detail the syllabus provides is an individual decision. You will note that the examples provided are much more detailed for introductory-level courses where greater structure and more directed experiences are the norm. As students progress toward more advanced coursework and more independent and self-directed experiences, the syllabi are increasingly simplified and general. For syllabi that are broken down week by week, the entries under each week typically represent two separate class meetings, three hours each for a total of six contact hours weekly.

A few different examples of syllabi are provided that reflect coursework at beginning and intermediate levels of drawing and figure drawing, and for a semester-long course in perspective The syllabus format varies slightly from one course to another and from one semester to another. Some syllabi include reading assignments, if required, and specific dates, while others do not. Items that you wish to be emphasized for the student may be italicized, capitalized, underlined, or presented in bold text, assuming you have access to a computer when preparing documents.

It should be noted that syllabi are documents in flux, and should be regularly reviewed and adjusted to reflect changes in course descriptions, changes in course prerequisites, or simply changes in what you, as the instructor, believe to be most important to present in the limited time available. The following syllabi, which are offered as examples, reflect what was considered most important by the instructor at that particular time within the framework of a particular school's curriculum and philosophy. These syllabi are not intended to be an exhaustive list of all studio experiences relevant to a particular course. There is room for substitution, experimentation, and changes in the sequencing of the classroom experiences.

Sequencing of material can be especially challenging. While some drawing experiences are apparent in their relationship to other drawing experiences—which should come first and what should follow—other experiences can be ordered in a variety of ways. If a particular sequence in a given semester seems to have been awkward or less than successful, consider rearranging your syllabus the next time you teach that course.

It is recommended that you include the course title and number, the semester and year, your name, office location, and office hours on each syllabus. Some examples of student work are provided for introductory-level drawing and figure-drawing courses, including work done during class time and work done in response to homework assignments.

Syllabus for Foundation Drawing I, a first-year course

Foundation Drawing I (FN 0131)
Semester: Spring 1999
Instructor: Deborah Rockman, Office 601
Office Hours: Tuesday/Thursday, 11:30–1:00

Course Syllabus

Week One January 9
Discussion of class procedures, materials list, syllabus, etc.
Introductory lecture, slides, and discussion
Introduction to line in drawing: blind outline drawing and blind contour drawing

Week Two January 16

Continuation of line: review of outline and contour drawing

Introduction to modified contour drawing, gesture or rapid contour drawing, and refined contour drawing (modified contour drawing superimposed over a gesture/rapid contour drawing)

- *1st homework assignment given, due in one week*

Introduction to sighting, and the use of a sighting stick: sighting for relative proportions, for angles in relation to verticals and horizontals, and for plumb lines or points of relationship

Establishing a point-of-reference object for maintaining accurate scale relationships; exercises in point-to-point drawing

Week Three January 23

Continued exploration of the three applications of sighting and establishing a point-of-reference object

- *1st homework assignment due; 2nd homework assignment given, due in one week*

Continued exploration of sighting with greater complexity of objects and some foreshortening introduced

Week Four January 30

Introduction to composition and using a viewfinder: positive/negative space relationships and transfer of information from viewfinder to drawing surface

Investigation of thumbnail composition studies

- *2nd homework assignment due; 3rd homework assignment given, due in one week*

Continued investigation of composition: full-page studies focusing on an arrangement of objects

Week Five February 6

Introduction to perspective: one- and two-point perspective with emphasis on cubes, ground plane, no trespassing, and respecting the cone of vision

- *3rd homework assignment due; 4th homework assignment given, due in one week*

Continued investigation of one- and two-point perspective: ellipses, geometric solids, box flaps and inclined planes, cube multiplication, cube division, and scaling methods

Week Six February 13

Continued investigation of one- and two-point perspective

- *4th homework assignment due; 5th homework assignment given, due in one week*

Application of perspective principles to still-life arrangement of boxes: use of sighting or "visual perspective" in conjunction with technical perspective

Week Seven February 20 (Midterm Week)

Introduction to transparent construction in relation to freehand perspective; the reduction of all forms to geometric solids—cubes, spheres, cones, and/or cylinders

- *5th homework assignment due*

Continued investigation of transparent construction in relation to freehand perspective; the reduction of all forms to geometric solids

SPRING BREAK SPRING BREAK SPRING BREAK

Week Eight March 6

Introduction to line sensitivity: exploration of line quality with emphasis on line variation and modulation to describe volume and mass (width of line—thick or thin; value of line—light or dark; texture of line—rough or smooth)

- *6th homework assignment given, due in one week*
- *Midterm portfolios due*
 Continued exploration of line quality and sensitivity with emphasis on line variation and modulation to describe volume and mass
 Week Nine March 13
 Continued investigation of line sensitivity with emphasis on variation in line to describe firm exterior edges vs. delicate interior edges
- *6th homework assignment due; 7th homework assignment given, due in one week*
 Continued investigation of line sensitivity
 Week Ten March 20
 Introduction to cross-contour drawing: line acting independently of edges to enhance volume and dimension; emphasis on surface analysis and incorporation of line variation
- *7th homework assignment due; 8th homework assignment given, due in one week*
 Continuation of cross-contour drawing: application to both regular and irregular forms; incorporation of line variation to further enhance volume
 Week Eleven March 27
 Introduction to value structure: use of a single value (middle tone/middle key value) to identify, define, and separate shapes of light and shapes of shadow in the tradition of sustained gesture drawing
- *8th homework assignment due; 9th homework assignment given, due in one week*
 Introduction to principles of general to specific and house building: out-of-focus slide drawing to illustrate principles
 Week Twelve April 3
 Introduction to full value structure and identification of the six divisions of light and dark—highlight, light, shadow, core shadow, reflected light, cast shadow
 Emphasis on general-to-specific approach and use of a hatching or stroking technique as opposed to continuous tone
- *9th homework assignment due; 10th homework assignment given, due in one week*
 Continued investigation of full value structure: includes concern for awareness of directional light source and combined use of sensitive line and value structure
 Week Thirteen April 10
 Continued investigation of full value structure with comparison of continuous tone to more process-oriented hatching or stroking technique
- *10th homework assignment due; 11th homework assignment given, due in one week*
 Continued investigation of full value structure: emphasis on continuous tone
 Week Fourteen April 17
 Introduction to focal point development with combined use of sensitive line work and full value range in isolated passages of drawing
- *11th homework assignment due (opportunity to rework)*
 Continued investigation of focal point development with combined use of sensitive line work and full value range in isolated passages of drawing
- *Final portfolios due*
 Week Fifteen April 24 (Finals Week)
 No classes held; final portfolios returned

Alternative Syllabus for Foundation Drawing I

Foundation Drawing I (FN 0131)
Semester: Fall 1999
Instructor: Deborah Rockman, Office 601
Office Hours: Monday/Wednesday, 3:30–5:00

Course Syllabus

UNIT ONE (Weeks 1 and 2)
Introduction to Line
- Discussion of class procedures, materials list, syllabus, etc.
- Blind outline drawing, blind contour drawing, modified contour drawing, gesture or rapid contour drawing; discussion of different kinds of line

UNIT TWO (Weeks 3 and 4)
Introduction to Sighting
- Sighting for relative proportions, sighting for angles in relation to verticals and horizontals, sighting for plumb lines or alignments between landmarks
- Significance of establishing a point of reference or unit of measure
- Regular (mechanical) and irregular (natural) forms

UNIT THREE (Weeks 5 and 6)
Introduction to Line Sensitivity
- Methods for developing line variation, contour and cross-contour line with variation, straight-line construction, development of "process" or "adjustment" lines, identifying different types of edges and an appropriate use of dimensional line to describe these edges
- WIDTH of line—thick or thin; VALUE of line—light or dark; TEXTURE of line—rough or smooth; FOCUS of line—soft or sharp

UNIT FOUR (Weeks 7 and 8)
Introduction to Composition and the Use of a Viewfinder
- Positive/negative space relationships, transfer of information from viewfinder to drawing surface, beginning your drawing with a delicate gestural drawing
- Partial page (thumbnail) composition studies in line and limited value, full-page composition studies in line and limited value

UNIT FIVE (Weeks 9 through 13)
Introduction to Technical and Applied Perspective
- Perspective terminology, establishing a perspective environment (scale, eye level, and station point), one- and two-point perspective and their differences, respecting the ground plane, the cone of vision and the "no trespassing" rule (TECHNICAL)
- Introduction to ellipses, geometric solids, inclined planes, cube multiplication, cube division, scaling methods (TECHNICAL)
- Still life of boxes and other cubic structures (APPLIED AND TECHNICAL COMBINED)
- Introduction to transparent construction in relation to freehand perspective; the reduction of all forms to geometric solids (APPLIED)

UNIT SIX (Week 14)
Introduction to Value/Tonal Structure

- The six divisions of light and dark, what to look for in light and shadow, the process of value reduction, working from general to specific
- Demonstration of directional light and its impact on form definition
- Out-of-focus slide drawing to reinforce general-to-specific approach

Basic Drawing I

Reading Assignments, Homework Assignments, and Important Due Dates

Week One August 31

Unit One
- Completed Reading: Chapter 2 (pages 31–62)

Week Two September 7 (Labor Day—No classes on Monday)

Unit One
- Completed Reading: Chapter 1 (pages 3–30)

Week Three September 14

Unit Two
- Completed Reading: Instructor's Handout on Sighting
- HOMEWORK ASSIGNMENT GIVEN ON 9/16, DUE WED 9/23 (Sighting Processes)

Week Four September 21

Unit Two
- Completed Reading: review handout on sighting
- HOMEWORK DUE (W 9/23), CLASS CRITIQUE

Week Five September 28

Unit Three
- Completed Reading: Instructor's Handout on Line Variation
- HOMEWORK ASSIGNMENT GIVEN ON 9/30, DUE WED 10/7 (Line Variation)

Week Six October 5

Unit Three
- Completed Reading: Chapter 5 (pages 137–167)
- HOMEWORK DUE (W 10/7), CLASS CRITIQUE

Week Seven October 12 (**Midterm Week**)

Unit Four
- Completed Reading: Chapter 3 (pages 79–104)
- MIDTERM PORTFOLIO DUE WEDNESDAY, OCTOBER 14

Week Eight October 19

Unit Four
- Completed Reading: Instructor's Handout on Composition
- HOMEWORK ASSIGNMENT GIVEN ON 10/19, DUE MON 11/2 (Composition)

Week Nine October 26

Unit Five
- Completed Reading: Chapter 8 (pages 209–233)

Week Ten November 2

Unit Five
- Completed Reading: Finish Chapter 8; Instructor's Handouts and sections of Perspective Workbook

- HOMEWORK DUE (M 11/2), CLASS CRITIQUE
- HOMEWORK ASSIGNMENT GIVEN ON 11/4, DUE WED 11/11 (Perspective)

 Week Eleven November 9

 Unit Five
- Completed Reading: Instructor's Handouts and sections of Perspective Workbook
- HOMEWORK DUE (W 11/11), CLASS CRITIQUE

 Week Twelve November 16

 Unit Five
- Completed Reading: Instructor's Handouts and sections of Perspective Workbook
- HOMEWORK ASSIGNMENT GIVEN ON 11/16, DUE MON 11/30 (Perspective)

 Week Thirteen November 23 (Thanksgiving—No PM classes)

 Unit Five
- Completed Reading: Instructor's Handouts and sections of Perspective Workbook

 Week Fourteen November 30

 Unit Six
- Completed Reading: Chapter 4 (pages 105–136)
- HOMEWORK DUE (M 11/30), CLASS CRITIQUE
- FINAL PORTFOLIO DUE WEDNESDAY, DECEMBER 2

 Week Fifteen December 7 (**Finals Week**)

 No classes held; final portfolios returned

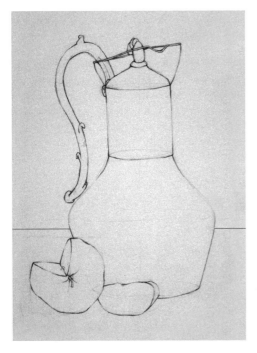

Figure App.—1. Student work. Jennie Barnes. Simple still-life drawing investigating sighting and point of reference (in-class).

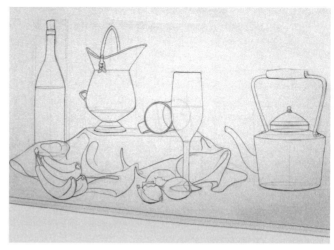

Figure App.–2. Student work. Lea (Momi) Antonio. A more complex still-life drawing investigating sighting and some foreshortening (homework).

Figure App.–3. Student work. Kirk Bierens. Thumbnail composition studies and full-size composition study from thumbnails (homework).

Figure App.–4. Student work. Negative space emphasis (in-class).

Figure App.–5. Student work. Jennie Barnes. Compositional study of regular, irregular, and cubic forms (homework).

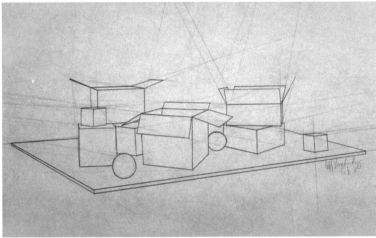

Figure App.–6. Student work. Jeff VandenBerg. Applying sighting and freehand perspective principles to an arrangement of cubes, boxes, and spheres (in-class).

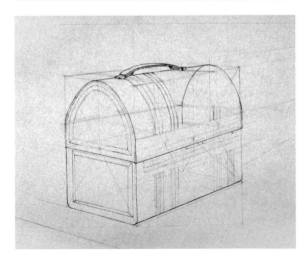

Figure App.–7. Student work. Taver Zoet. Transparent construction drawing of a metal lunchbox (in-class).

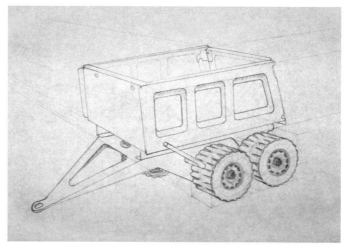

Figure App.—8. Student work. Matt Grindle. Transparent construction drawing of a compound form (in-class).

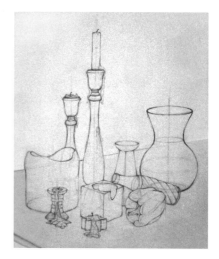

Figure App.—9. Student work. Kirk Bierens. Investigation of composition, symmetry of regular forms, transparent construction, line variation, and placement of table edges as grounding device (homework).

Figure App.—10. Student work (detail). Kirk Bierens. Investigation of composition, line variation for firm and delicate contours, and surface texture (homework).

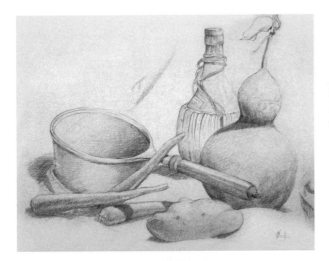

Figure App.—11. Student work. Clarkson Thorp. A general-to-specific approach to building tonal structure (in-class).

Figure App.—12. Student work. Jackie Wanink. Full value study of drapery on toned paper (in-class).

Figure App.—13. Student work. Janie Bobrowski. Focal point development through line variation and limited tonal structure (homework).

Syllabus for Foundation Drawing II, a first-year course

Foundation Drawing II (FN 0132)
Semester: Fall 1998
Instructor: Deborah Rockman, Office 601
Office Hours: Wednesday, 12:30–3:30

Course Syllabus

Week One
Discussion of class procedures, materials list, syllabus, etc.
Reading: Chapters 1 and 10, and pages 157–160
Review of sighting and the function of a viewfinder
Compositional studies with development of thumbnail sketches emphasizing line, simplified value, and positive/negative space development
Reading: Chapter 3 (Learning to See) and Chapter 8 (Composition)
Week Two
No classes Monday—Labor Day holiday
Focus on negative space: relationship between positive/negative space and transposition of light and dark using stick charcoal
• *1st homework assignment given, due Monday of Week 4 (thumbnail studies)*
Week Three
More work with negative space
Focal point development; combined use of sensitive line and full value range in selected passages
Week Four
• *1st homework assignment due: full class critique*
• *2nd homework assignment given, due Wednesday of Week 6 (focal point development)*
Reading: Chapter 6 (Value)
Review of the six divisions of light and dark; subtractive drawing on hand-tinted surfaces
Week Five
More subtractive drawing; experimenting with different base media and different erasers
Reading: All of Chapter 8 (Space) and Chapter 9 (Perspective)
Spatial Development: spatial relationships of the elements of art and how to suggest space and depth on a two-dimensional surface with initial focus on line
Week Six
Continuation of spatial development utilizing both line and value structure
• *2nd homework assignment due: full class critique*
• *3rd homework assignment given, due Monday of Week 9 (spatial development)*
Reading: Chapter 5 (Line)
Week Seven
Introduction to mark-making and layering of marks to build value structure; moving beyond hatching and continuous tone
Continuation of mark-making and layering of marks; exploring different kinds of marks and activating the two-dimensionality of the paper surface

Week Eight (Midterm Week)

Introduction to "field drawing" and eraser work; activating the drawing surface with graphite and eraser

• *Midterm portfolios due*

Reading: Chapter 12 (Still Life) and Chapter 17 (Expressive Drawing)

Eraser drawing: using the eraser as a drawing tool; further activation of the drawing surface

Week Nine

• *3rd homework assignment due: full class critique*

• *4th homework assignment given, due Monday of Week 12 (metamorphosis)*

Option to reinvestigate field drawing or eraser drawing

Reading: Review of Chapter 12 (Reflective Surfaces)

Week Ten

Introduction to reflective/translucent/transparent surfaces: creating the illusion using subtractive drawing or commercially tinted paper

Continued investigation of reflective/translucent/transparent surfaces on black paper with white media

Week Eleven

In-class work session for 4th homework assignment (metamorphosis)

Continued investigation of reflective surfaces on black paper with white media

Week Twelve

• *4th homework assignment due: full class critique*

• *5th homework assignment given, due Monday of Week 15 (autobiographical trompe l'oeil)*

Reading: Review of Chapter 6 and Chapter 7

Control of value structure and review of the six divisions of light and dark: application of black and white drawing media on neutral-toned paper in response to a still life of white objects

Week Thirteen

Continued investigation of black and white media on neutral-toned paper

In-class work session for 5th homework assignment (trompe l'oeil)

Reading: "Drapery" from Nicolaides

Week Fourteen

Control of value structure: illusionistic studies of white drapery with accents of color

Continued investigation of drapery still life

Week Fifteen

• *5th homework assignment due: full class critique*

Final session for work on drapery study

Week Sixteen

No classes held

• *Final portfolios due*

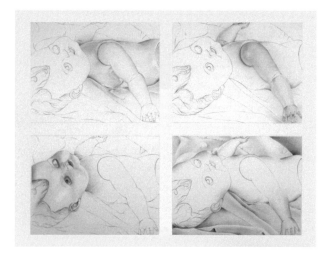

Figure App.—14. Student work. Jill D. Wagner. Repeated composition with shifting continuous tone emphasis (homework).

Figure App.—15. Student work. Maureen Murphy. Investigation of subtractive drawing processes and composition (in-class).

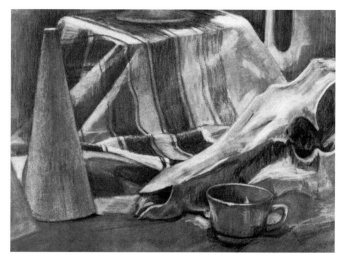

Figure App.—16. Student work. Jacquelin Dyer DeNio. Restrained use of mark-making to establish tonal structure (in-class).

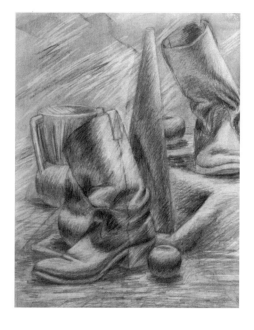

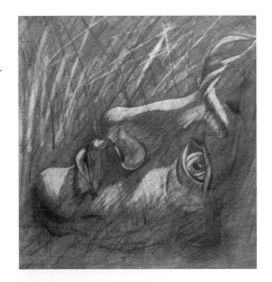

Figure App.—17. Student work. Graphite mark-making is used to establish a base tone for subtractive drawing (in-class).

Figure App.—18. Student work. Daniel Yates. Full tonal development using mark-making combined with eraser work (in-class).

Figure App.—19. Student work. Vickie Marnich Reynolds. Investigation of foreground, middleground, background, and full tonal structure using mark-making and eraser work (in-class).

Figure App.—20. Student work. Julie Sugden. Metamorphosis of an object (homework).

Figure App.—21. Student work. Jacquelin Dyer DeNio. Conceptually related metamorphosis of one form into another (homework).

Figure App.—22. Student work. Vickie Marnich Reynolds. Investigation of reflective surfaces using white media on black paper (in-class).

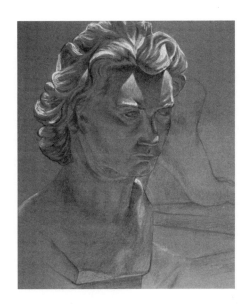

Figure App.—23. Student work. An unfinished study of white still-life objects using black and white drawing media on gray-toned paper (in-class).

Figure App.—24. Student work. Jacquelin Dyer DeNio. A full tonal study of drapery using black and white drawing media on gray-toned paper (in-class).

Figure App.—25. Student work. Jacquelin Dyer DeNio. An autobiographical trompe l'oeil drawing (in-class and homework).

Syllabus for Foundation Life Drawing I, a second-year course

Foundation Life Drawing I (FN 0221)
Semester: Fall 1998
Instructor: Deborah Rockman, Office 601
Office Hours: Thursday, 1:00–4:00

Course Syllabus

Week One (Aug. 28 and Aug. 30)
First day of class—introductory discussion
Reading: Pages 3–19 (Intro. and Chapter 1)
Introductory lecture from "Drawing the Human Form"
Introduction to outline drawing as shape and silhouette drawing as mass
Comparison of outline and contour drawing and introduction to blind contour drawing
Reading: Pages 27–31 on gesture drawing (section of Chapter 2)

Week Two (Sept. 6)
No classes on Monday—Labor Day holiday
Introduction to modified contour drawing (reference to model and own hand)
Introduction to gesture drawing as rapid contour: focus on axis lines and rapid estimation of proportions
Discussion of figure proportions and general comparative differences between male and female proportions
Reading: Pages 46–63 on proportions, perception, and perspective (Chapter 3)
Homework: Two separate drawings of live figure, partially clothed or nude; comparative study of same pose done in *blind* contour drawing and *modified* contour drawing. **(Due Monday, 9/11)**

Week Three (Sept. 11 and 13)
Review of gesture drawing
Lecture on sighting for relative proportions, for angles in relation to verticals and horizontals, and for plumb lines (both vertical and horizontal)
Refined contour drawings and utilization of sighting principles
Homework Due—no critique
Homework: Use a master's drawing as reference; the image should be a nude or nearly nude *full* figure with *clearly defined contours* (no gestural-like drawings and no paintings as reference). Include a high-quality, enlarged Xerox of the original piece, including the name of the artist, birth and death date, nationality, title of piece, size of original, and media of original. Work in *line only,* using what prior knowledge you have concerning line variation, and address all contours or edges, both inner and outer contours. Work with charcoal pencils or graphite pencils on high quality, 18" x 24" white *charcoal* paper; use your page effectively and fully. Using sighting techniques only, reproduce the drawing as accurately (in terms of proportions) as you possibly can, while creating your own line variation.
(Due Wednesday, 9/20)
Continued investigation of sighting principles
Reading: Pages 74–94 on line (Chapter 4)

Week Four (Sept. 18 and 20)

Introduction to line sensitivity: exploration of line quality, emphasis on variation and methods for achieving it; concern for simple composition and proportional relationships

Reading: Review of pages 46–63 and pages 74–94

Homework due—class critique

Reading: Information on skeletal structure from Chapters 6 and 7

Homework: Use a master's drawing of a portrait as reference with clearly defined contours (no gestural-like drawings as reference). Make sure that value or "shading" does not hide or disguise edges. Include a high-quality, enlarged Xerox of the original piece, including the name of the artist, birth and death date, nationality, title of piece, size of original, and media of original. Work in line only, using what knowledge you have concerning line variation, and address all contours or edges, both inner and outer contours. Work with charcoal pencils or graphite pencils on 18" x 24" white *charcoal* paper; use your page effectively and fully. Using sighting techniques only, reproduce the drawing as accurately as possible (in terms of proportions), while creating your own line variation. Make the head life-size. The portrait study can be in profile, three-quarter view, or frontal view, with the head upright, tilted on its axis, or tipped forward or backward. (Due Wednesday, 10/4)

Week Five (Sept. 25 and 27)

Introduction to skeletal structure: lecture and discussion

Elaborate on homework assignment of master's portrait study

Review of skeleton

Drawing of generalized forms of skeleton with emphasis on line sensitivity, overall proportions, and development of structural shapes for skull, rib cage or thorax, and pelvis

Reading: Information on skeletal structure from Chapters 6 and 7

Homework: Continue working on portrait assignment, due Wed., 10/4.

Week Six (Oct. 2 and 4)

Review of skeleton

Introduction to bony landmarks of the body: investigation of influence of skeletal structure on surface appearance

Linear study of full skeleton or sections of skeleton with concern for accurate proportional relationships, application of sighting principles, and line sensitivity

• *Assign midterm portfolio requirements, due Monday, 10/9*

Homework due—class critique

• *Reminder: Midterm exam Monday, Oct. 16*

Reading: Information on skeletal structure from Chapters 6 and 7

Homework: Study for midterm exam on skeletal structure and bony landmarks.

Week Seven (Oct. 9 and 11) Midterm Week

Linear study of full skeleton for entire class session with concern for accurate proportional relationships, application of sighting principles, and line sensitivity

• *Midterm portfolio due today*

Linear study of full skeleton within the fleshed figure with concern for proportion and accurate placement of skeleton, application of sighting principles, line sensitivity, and bony landmarks

Reading: Information on skeletal structure from Chapters 6 and 7

Week Eight (Oct. 16 and 18)

• *Midterm exam on skeletal structure and bony landmarks*

Linear studies of fleshed figure with concern for evidence of skeletal structure and bony landmarks, sighting, proportions, line sensitivity, and use of page

Reading: Pages 34–41 on the compositional sketch (section of Chapter 2) and pages 219–226 on composition (section of Chapter 9)

Week Nine (Oct. 23 and 25)

Sustained gesture drawings as an introduction to general-to-specific principles

Continue work with linear sighting process

• *Assign final project on skeletal structure, due Monday, 11/27*

Lecture on composition and use of the viewfinder with emphasis on placement and positive/negative space development

Thumbnail studies, ¼ page maximum, primarily linear focus with simplified value structure (2–3 values)

Reading: Review of pages 34–41 and pages 219–226

Week Ten (Oct. 30 and Nov. 1)

Continued exploration of composition through thumbnails and full-page studies; primarily linear focus with simplified value structure (2–3 values)

In-class work session for final project on skeletal structure

Reading: Pages 191–211 on portraiture (Chapter 8)

Homework: Work on final project.

Week Eleven (Nov. 6 and 8)

Introduction to portraiture: abbreviated lecture on simple proportional relationships and placement of features in frontal, profile, and three-quarter views

Continued exploration of portraiture, profile, frontal, and three-quarter views (value optional)

Reading: Pages 95–115 on value (Chapter 5)

Homework: Work on final project.

Week Twelve (Nov. 13 and 15)

Discussion of six divisions of light and dark

Discussion of what to look for when identifying shadows and light—shape and proportion, edge activity, variation within large shapes, relativity of value, etc.

Discussion and exploration of general-to-specific approach to drawing

Reading: Review pages 95–115 on value (Chapter 5)

Full value study working from general to specific

Reading: Pages 56–70 on linear perspective (section of Chapter 3)

Homework: Work on final project.

Week Thirteen (Nov. 20 and 22)

Introduction to foreshortening in conjunction with composition, line quality, proportion, and full value structure with application of general-to-specific principles

Review of skeletal structure and bony landmarks

Continued investigation of foreshortening

• *Assign final portfolio requirements, due Monday, 12/4*

Reading: Review of pages 56–70

Homework: Work on final project.

Week Fourteen (Nov. 27 and Nov. 29)

• *Final project on skeletal structure due—full class critique*

Continued investigation of foreshortening

Week Fifteen (Dec. 4 and 6) Finals Week

• *Final portfolios due*

Figure App.—26. Student work. Cheri McClain Beatty. Straight-line construction of figurative contours (in-class).

Figure App.—27. Student work. Douglas Borton. A page of gesture studies drawn in vine charcoal provide the base tone for this head study (homework).

Figure App.—28. Student work (after Hyman Bloom). Kerre Nykamp. Sighting and line variation are used to re-create the figurative proportions from the work of a master (homework).

Figure App.—29. Student work. Judith Sklar. Emphasis on line variation and sensitivity, and compositional scale and placement (in-class).

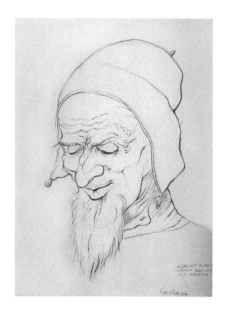

Figure App.—30. Student work (after Albrecht Dürer). Greg Peruski. Sighting and line variation are used to re-create the proportions of the head and face from the work of a master (homework).

Figure App.—31. Student work. Dennis M. O'Rourke II. A study of the full skeleton from direct observation (in-class).

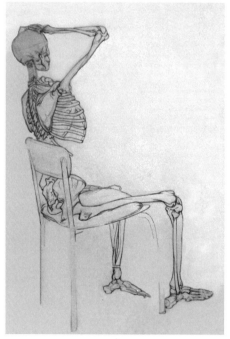

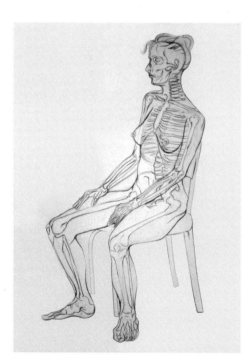

Figure App.—32. Student work. Scott Bower. A study of the full skeleton and its relationship to the fleshed figure from direct observation of skeleton and model (in-class).

Figure App.–33. Student work. Mary Evers. Sustained gesture drawing including reduction of tonal structure to two values (in-class).

Figure App.–34. Student work. Dennis M. O'Rourke II. Thumbnail composition study using line only, based on direct observation through a viewfinder (in-class).

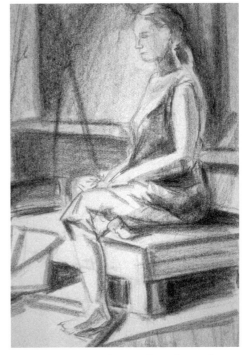

Figure App.–35. Student work. Andrea Helm Hossink. Thumbnail composition study using tonal structure based on direct observation through a viewfinder (in-class).

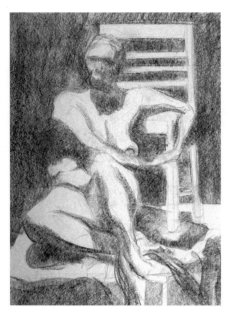

Figure App.–36. Student work.
Tonal simplification emphasizing
negative space areas (in-class).

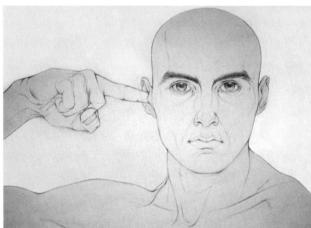

Figure App.–37. Student work.
James Peterson. Linear self-portrait
incorporating a hand and deleting hair to
emphasize the size and shape of the head
(homework).

Figure App.–38. Student work.
Patricia Hendricks. Portrait study
with tonal structure (homework).

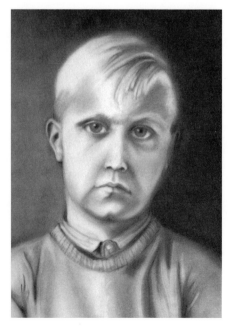

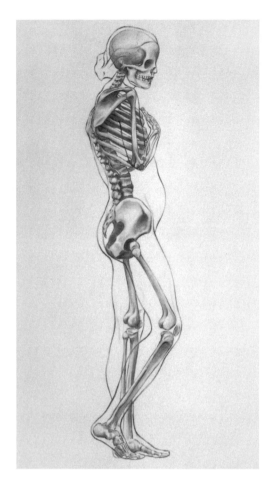

Figure App.–39. Student work (after Degas). John Elsholz. Constructing the full skeletal structure within a master's drawing (in-class and homework).

Figure App.–40. Student work (after Agesander, Athenodorus, and Polydorus of Rhodes). James P. Miller II. This student chose to compare the skeletal structure to the fleshed and muscled form in his construction of the skeleton within a master's work (in-class and homework).

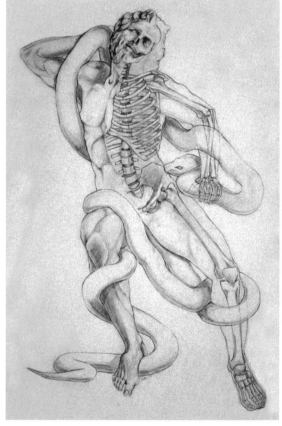

Figure App.—41. Student work. Steve Amor. Full tonal structure using the broad side of a stick of drawing material (in-class).

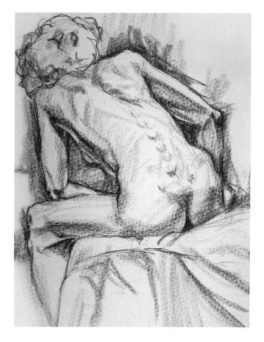

Figure App.—42. Student work. Denise Posegay Lehman. Full tonal structure using subtractive drawing techniques (in-class).

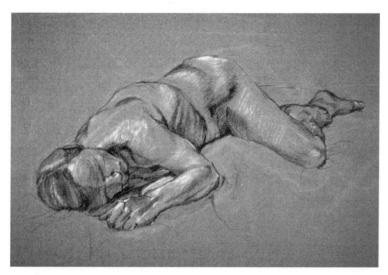

Figure App.—43. Student work. Cindy Bennett. Investigation of foreshortening using black and white drawing media on tinted paper (in-class).

Syllabus for Foundation Life Drawing II, a second-year course

Foundation Life Drawing II (FA 0222)
Semester: Spring 1998
Instructor: Deborah Rockman, Office 601
Office Hours: Monday/Wednesday, 10:00–11:30

Course Syllabus

Week One (January 9)
Introductory discussion and lecture
Review and discussion of gesture drawing
Review of sighting and the function of a viewfinder and their application
Test drawings—concern for line quality, proportion, simple composition, combined use of line and value
Reading: Chapter 3, pages 46–63 (proportions, perception, and perspective)
Homework: 18" x 24" page of hand studies on charcoal paper, minimum of four studies, with concern for proportion, line quality, composition, and complexity of hand positions (include overlapping/foreshortening); due Tuesday, January 23.

Week Two (January 16)
Application of sighting techniques and viewfinder
Review of line variation (line sensitivity/dimensional line)
Investigation of line with one full-figure study and one cropped study
Exploration of hand and foot structure for full class session; schematic breakdowns by more developed studies
Reading: Chapter 4, pages 74–94 (line)

Week Three (January 23)
Homework assignment due—class critique
Reading: Chapter 2, pages 34–41 (the compositional sketch)
Wet or dry sustained gestures as preparation for composition studies with the application of general-to-specific principles
Blocking in simplified areas of light and shadow without linear guidelines—surface vs. edge/contour
Reading: Chapter 9, pages 219–231 (composition)
Homework: 18" x 24" page of foot studies on charcoal paper, minimum 4 studies, with concern for proportion, line quality, composition, complexity of foot positions, choice of medium, and sense of process or search; due Thursday, February 8.

Week Four (January 30)
Composition lecture and application of the viewfinder
Compositional studies: development of descriptive thumbnail sketches utilizing line, simplified value structure, open value, and positive/negative space development on both small and medium format
Partial page and full page composition studies with concern for positive/negative space development
Reading: Chapters 6 and 7, muscle structure

Week Five (February 6)
Introduction to muscle structure of the human figure; lecture from the flayed figure
Reading: Chapters 6 and 7, muscle structure
Homework due—class critique
Reading: Chapter 8, pages 191–212 (portraiture); *Drawing on the Right Side of the Brain* by Betty Edwards, section on portraiture
Week Six (February 13)
Review and further exploration of musculature: application of general-to-specific principles with emphasis on surface activity and musculature through study of proportion and value structure (use of flayed figure or male model)
Homework: 18" x 24" self-portrait with primary emphasis on proportional relationships, likeness, line variation (value is optional), treatment of both exterior and interior edges in a manner that suggests three-dimensionality. Drawing should be executed from life (no photo references) and should *not* include hair, with the exception of facial hair such as eyebrows, beard, or mustache. You will be bald and attention should be paid to the specific shape of the head and to the ears, both often obscured by hair; due Tuesday, February 27.
Abbreviated portraiture lecture with concern for muscle structure and value structure; rapid schematic "portrait" studies based on various head positions of the model
Homework: Continue working on bald self-portrait
Week Seven (February 20) Midterm Week
Review of muscle structure
Continued work with portraiture with concern for muscle structure and value structure; reference to flayed figure and model
• *Assign midterm portfolio requirements, due Tuesday, February 27*
Reading: Chapter 5, pages 95–115 (value structure)
Review of six divisions of light and dark: what to look for when studying value
Review of musculature with continued investigation of general-to-specific principles; attention paid to surface activity through study of proportions and value structure
Reading: Chapters 6 and 7, review of muscle structure
Week Eight (February 27)
Homework due—class critique
• *Midterm portfolios due*
Open session with the model
Review of muscle structure for midterm exam
Homework: Study for exam on muscle structure

SPRING BREAK SPRING BREAK SPRING BREAK

Week Nine (March 12)
• *Midterm exam on muscle structure*
Introduction to subtractive drawing on hand-tinted surfaces: "carving" a drawing
Week Ten (March 19)
Continued work with subtractive drawing
Focal point development with specific focus on the extremities (heads, hands, and feet); areas of greater and lesser interest and development through isolated use of value structure
Homework: 18" x 24" or larger study of a hand interacting with an object or objects of your choice (holding or gripping an object). Work on charcoal paper (18" x 24") or Strathmore

Bristol paper (23" x 29"). Concern for proportion, line quality, composition, tonal structure, visual interest, autobiographical element, choice of media, and sense of process or search; due Tuesday, April 9.

Week Eleven (March 26)

Multiple figure study in media of choice on surface of choice with concern for proportion, line and value, composition, positive/negative space, and sense of process/search

Reading: Chapter 3, pages 55–70 (linear perspective)

Foreshortening and spatial development in relation to the human form: how to suggest space and depth on a two-dimensional surface (space indicators)

Combine with subtractive drawing to develop both positive and negative space

Homework: Continue working on hand and object study

Week Twelve (April 2)

Continuation of foreshortening and spatial development

Can be combined with black and white media on neutral-toned paper to develop both positive and negative space

Reading: Chapter 10, pages 241–268

Introduction to mark-making and layering of marks to build value structure and define/describe form: activating the surface of the drawing

Homework: Continue working on hand and object study

Week Thirteen (April 9)

Homework due–class critique

Introduction to field drawing and eraser drawing: further activation of the drawing surface and expressive handling of materials with emphasis on interpretation vs. mimesis

• *Assign portfolio requirements, due Thursday, April 18*

Week Fourteen (April 16)

Continued investigation of mark-making and layering of marks

Continuation of field drawing and eraser drawing

Open session with the model for final portfolio

• *Final portfolios due*

Week Fifteen (April 23) Finals Week

Final portfolios returned

Figure App.–44. Student work. Gypsy Schindler. A page of hand studies emphasizing composition, proportion, structure, and line variation to describe volume (homework).

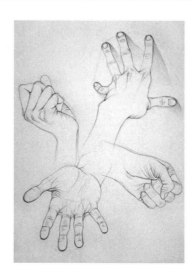

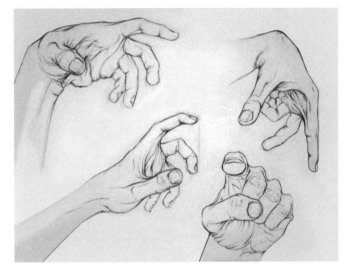

Figure App.–45. Student work. James Peterson. A page of hand studies emphasizing composition, proportion, structure, line variation, and foreshortening (homework).

Figure App.–46. Student work. Glenda Sue Oosterink. A delicately developed drawing emphasizing proportion, composition, and subtractive drawing techniques (in-class).

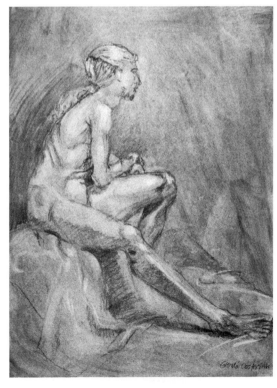

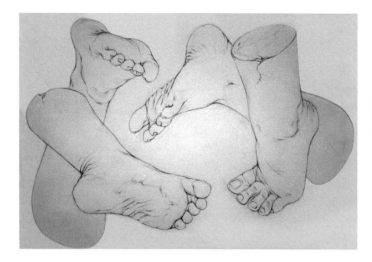

Figure App.–47. Student work.
Jamie Hossink. A page of foot studies
emphasizing composition, proportion,
structure, and line variation
(homework).

Figure App.–48. Student work. Joe Freeberg.
A page of foot studies emphasizing composi-
tion, proportion, structure, and line variation
(homework).

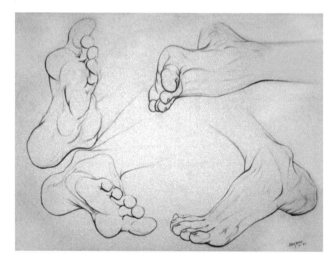

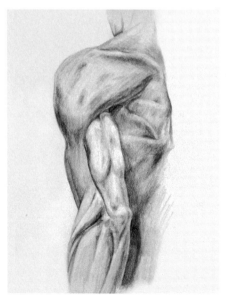

Figure App.–49. Student work. Jamie Hossink.
A study taken from a flayed figure of the
superficial muscles of the shoulder and upper
arm, posterior view (in-class).

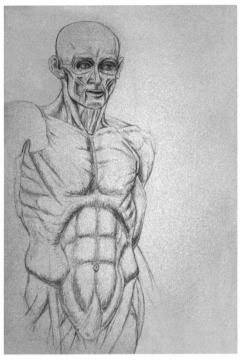

Figure App.—51. Student work. Andrea Helm Hossink. A highly detailed study of the major muscles of the torso, arm, and leg (homework).

Figure App.—50. Student work. Carol Shahbaz. A study taken from a flayed figure of the superficial muscles of the torso and face, anterior view (in-class).

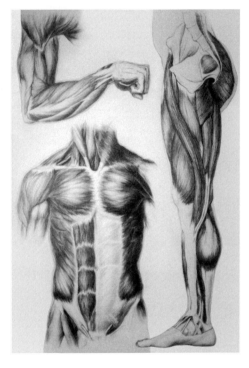

Figure App.—52. Student work. Jamie Hossink. A linear self-portrait incorporating a hand with emphasis on proportion, likeness, composition, line variation, and visual interest (homework).

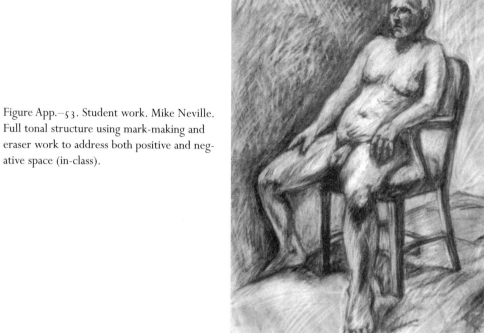

Figure App.–53. Student work. Mike Neville. Full tonal structure using mark-making and eraser work to address both positive and negative space (in-class).

Figure App.–54. Student work. Gypsy Schindler. Autobiographical "self-portrait" of hands with atmospheric perspective (homework).

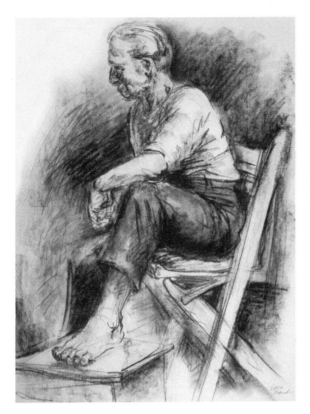

Figure App.–55. Student work.
Rebecca Marsh McCannell.
Mark-making to describe full tonal
structure in both positive and negative
space (in-class).

Figure App.–56. Student work. Ann G. Rusky.
Combining mark-making, subtractive
drawing, and eraser work to create tonal
structure and mood/atmosphere (in-class).

Syllabus for Fine Arts Drawing III, a second- or third-year course

Fine Arts Drawing III (FA 0233)
Semester: Spring 1999
Instructor: Deborah Rockman, Office 601
Office Hours: Tuesday/Thursday 10:00–11:30

Course Syllabus
Week One (January 8)
Introductory discussion
Project 1 assigned; due Monday, January 29
Handouts, slide lecture, and class discussion
Studio time and individual consultations
Week Two (January 15)
Lecture on the Golden Section as a compositional device
Studio time and individual consultations
Week Three (January 22)
Studio time and individual consultations
Week Four (January 29)
Project 1 critiqued
Project 2 assigned; due Wednesday, February 21
Handouts, slide lecture, and class discussion
Studio time and individual consultations
Week Five (February 5)
Lecture on scaling in perspective
Studio time and individual consultations
Week Six (February 12)
Guest speaker
Studio time and individual consultations
Week Seven (February 19) Midterm Week
Studio time and individual consultations
Project 2 critiqued
Week Eight (February 26)
Project 3 assigned; due Wednesday, March 21
Handouts, slide lecture, class discussion
Studio time and individual consultations
Individual Midterm Critiques
Independent studio time

SPRING BREAK SPRING BREAK SPRING BREAK

Week Nine (March 12)
Guest speaker
Studio time and individual consultations
Week Ten (March 19) Advising Week
Studio time and individual consultations
Assign reading from art periodical for class discussion Monday, April 2
Project 3 critiqued

Week Eleven (March 26)
Project 4 assigned; due Monday, April 16
Handouts, slide lecture, class discussion
Studio time and individual consultations
Week Twelve (April 2)
Studio time and individual consultations
Class discussion of reading assignment
Week Thirteen (April 9)
Studio time and individual consultations
Week Fourteen (April 16)
Project 4 critiqued
Individual final critiques
Week Fifteen (April 23) Finals Week
Individual final critiques

Syllabus for Foundation Perspective Drawing, a first-year course

Foundation Perspective (FN 0140)
Semester: Fall 1999
Instructor: Deborah Rockman, Office 601
Office Hours: Tuesday/Thursday 9:30–11:00

Course Syllabus
Week One
Introduction to Principles of Perspective (Perspective Theory)
Reading: Chapter 1: Introduction
Introduction to Perspective Terminology
Reading: Chapter 2: Some Perspective Basics
Homework assigned
Week Two
Sighting Systems: Use of Measuring and Aligning Stick
Sighting for relative proportions, sighting for angles in relation to verticals and horizontals, sighting for vertical, horizontal, and diagonal plumb lines
Getting Started: Basic Concepts
Discussion of standardized scale or format—scale, eye level/horizon line, picture plane, station point, ground plane/ground line, cone of vision, key cube or mother cube, vanishing points (VPL, VPR, CVP and SVP), diagonal measuring line
Reading: Review of Chapter 1 and Chapter 2
Homework assigned
Week Three
Getting Started: Using Tools
Introduction to T-square, compass, protractor, 30°/60° triangle, 45°/45° triangle, eraser shield, mechanical pencil
One-Point Perspective
Constructing cubes and one-point gridded ground plane

Reading: Chapter 3: Edges in Horizontal and Vertical Planes
Homework assigned
Week Four
Two-Point Perspective
Constructing cubes by *estimation* and two-point gridded ground plane
Reading: Review of Chapter 3
Homework assigned
Week Five
Scaling Methods for One- and Two-Point Perspective
Discussion of significance of leading edge or leading plane, maintaining consistent scale, planting cubes firmly on the ground plane, use of diagonal measuring line (DML) and SVPs, and vertical, horizontal, and diagonal scaling
Reading: Handouts on Scaling
Sliding or Multiple Vanishing Points and Cube Rotation
Discuss correcting distortion (base angle of less than 90 degrees) and accounting for instances when not all cubes are positioned parallel to each other
Reading: Handouts on Multiple Vanishing Points
Homework assigned
Week Six
Cube Multiplication
Introduction of "Xing" method to find true center of cube face
Introduction of fencepost method and measuring line method
Cube Division
Xing and +ing face of cube to find true center of cube face and to subdivide cube further
Reading: Chapter 7: Using the Square as a Reference
Homework assigned
Week Seven (Midterm Week)
30°/60° Method for Precise Two-Point Cube Construction
Construction of 30°/60° gridded ground plane based on convergence of cube base diagonals at SVP
Reading: Handouts on 30°/60° Cube Construction
45°/45° Method for Precise Two-Point Cube Construction
Construction of 45°/45° gridded ground plane based on convergence of cube base diagonals at SVP
Reading: Handouts on 45°/45° Cube Construction
Alternative Methods for 45°/45° Cube Construction
45°/45° cube construction based on height of leading edge to facilitate scaling
Homework assigned
Week Eight
Ellipses in One- and Two-Point Perspective
Discussion of relationship of circle to square and location of eight tangent points (Xing cube face to find perspective center and +ing cube face to bisect edges
Construction of interior square based on ⅓ divisions of bisected diagonal
Location of major and minor axes and their independence from corner-to-corner diagonal of cube face

Symmetry of ellipses and the right angle relationship between central axis of cube and major axis of ellipse

Reading: Chapter 5: The Circle and Chapter 6: Circles and Cylinders

Homework assigned

Week Nine

Ellipses in Vertical and Horizontal Elevator Shafts

Discussion of ellipse properties: they open up as they move above or below eye level, they open up as they move away from us in parallel planes, they close up as they move away from us in the same plane

Homework assigned

Week Ten

Geometric Solids and Transparent Construction

Transparent construction of cylinders, cones, vessels, pyramids, prisms, and other geometric solids

Reading: Handouts on Geometric Solids

Homework assigned

Week Eleven

Inclined Planes

Construction of box flaps, stairways, and rooftops

Use of vertical trace lines as extensions of VPs, and location of vertical trace points or auxiliary vanishing points (AVPs)

Reading: Chapter 4: Inclined Planes

Measuring Lines

Use of measuring lines to divide planes into equal or unequal increments

Reading: Appendix A: Mechanical Systems

Homework assigned

Weeks Twelve and Thirteen

Empirical Perspective

Freehand perspective based on sighting and observation and freehand transparent construction of objects derived from basic geometric solids

Freehand drawing of still life of boxes and box flaps designed to explore multiple or sliding vanishing points, inclined planes, cube rotation, etc.

Freehand drawing of two-point interior environment

Reading: Handouts on Freehand Perspective

Homework assigned

Weeks Fourteen and Fifteen

Introduction to Three-Point Perspective

Architectural interiors and exteriors based on imagination and observation

Reading: Chapter 7: Three-Point Perspective

Standardized Scales and Formats for In-Class Drawings:

8 ½" X 11" Format

Scale: ½" = 1', Eye Level: 6', Station Point: 8', Key Cube: 2' high

11" x 14" Format

Scale: ½" = 1', Eye Level: 8', Station Point: 11', Key Cube: 3' high

18" x 24" Format

Scale: 1" = 1', Eye Level: 7', Station Point: 9', Key Cube: 3' high

Preparing a Slide Library

Documenting Two-Dimensional Work with 35mm Slides

If you are going to show slides of student work in your teaching, you must first develop a collection. Experience suggests that in the early stages of teaching, when you have your first adjunct or temporary position, there can be a real sense of urgency in documenting the work of your students for future use and reference. If this is the case, you may find yourself taking slides of far more work than will ever serve your purposes, without careful regard for quality of the work and at considerable cost. I recall a number of occasions when I got back several rolls of slides that I had shot at the end of a semester in an enthusiastic effort to beef up my collection of student work. More often than not, I would sit down and go through the new slides and wonder repeatedly, "Why did I shoot this piece, why did I shoot that piece?"

A good collection of documented student work can serve many useful purposes, including enhancing your chances of finding a desirable full-time teaching position. It is wise to be selective about the work you wish to shoot and to take extra care in doing it right the first time, as it will save you time, energy, disappointment, and money.

If documenting your own work, remember that quality slides can enhance your chances of being accepted into juried group exhibitions or awarded a solo exhibition, inviting closer examination of your work by a gallery you are interested in, or finding that perfect teaching position. For artwork that is too large or bulky to be scanned on a flatbed scanner, quality slides of this same work can be scanned on a 35mm slide scanner, saved on a Zip disk, and used in the development of a web page. These slides can also generate high-quality hard copy in the form of digital printouts. Slides of personal work are often the first (and perhaps only) exposure someone will have to your work, and first impressions are important when competition is strong.

If you are using this information as a guide, determine in advance if you would like to have all original slides for each piece being documented, or if you would prefer to have duplicates made from each original slide. If you wish to have all original slides, considerably more money will be spent up front for slide film and developing, but you will have better quality slides and will save yourself the expense of duplicating slides later. Bracketing is strongly recommended whether shooting all original slides or planning to have duplicates made.

The following information provides some helpful guidelines for documenting two-dimensional work.

Necessary Equipment
- 35mm camera
- Tripod
- Slide film, tungsten or daylight (I recommend tungsten film)
- Cable release
- Black felt or velvet cloth larger than artwork
- Lights (minimum two bulbs, hoods, and clamps)
- Kodak gray card
- Nonreflective tacks (clear pushpins work well)

- Light meter, if not built in to camera
- Optional polarizing filter to eliminate excessive glare
- Optional macro lens or close-up rings, if not an integral part of camera lens, for detail shots

What Not to Do

- Avoid shooting from too far away so that the image is small and distant in the slide frame. Get as close as you can to the work you are photographing without cropping the image in the viewfinder.
- Avoid shooting out-of-focus slides. Focusing carefully and using a tripod and cable release to stabilize your camera will help to prevent this.
- Avoid shooting crooked slides or allowing parallax to occur. Parallax is when part of the image in the slide appears to be farther away than the rest of the image due to a misalignment of the camera with the artwork. Parallax will make a square or rectangular format appear out of square, that is, narrower at one end or narrower at the top or bottom. Make sure that your viewfinder is squared around the image to avoid crooked slides and that the plane of your camera is parallel to the plane of the work to avoid parallax.
- Avoid light leaks or light mixture. Color shifts or gross discoloration can result. Use only the lights that are balanced with the film you have selected, and eliminate all secondary or incidental light sources, including daylight from windows if you are not using daylight film.
- Avoid shooting against a disruptive background, such as a brick wall or a wall that is heavily marked or scarred. A black felt ground is most ideal.
- Avoid using metal tacks or shiny/reflective objects to secure your work if they will show in the slide, as they can cause glare. Instead, use clear pushpins or map tacks or double-sided tape.
- Avoid cropping into the image unless you are shooting a detail shot, which should be fully indicated in the slide labeling. Full composition should be shown.
- Avoid taping your slides unless you plan to make duplicates. This practice is often frowned upon and many competitions will not accept taped slides.
- Avoid glare in your slides by using a polarizing filter or by bouncing your light indirectly onto your work through the use of diffusers and other devices.

Procedure for Shooting Slides

- Set up your felt or velvet on a flat, vertical surface that will accept pushpins or nails or whatever you are using to secure your work.
- Center your artwork horizontally on the felt, at eye level, using nonreflective tacks.
- Set up lights so that the height corresponds to center of the artwork (again, at eye level).
- Lights should be directed toward the center of the piece at a 45-degree angle to the artwork and a 90-degree angle to each other; if artwork is large, more than two lights will be necessary and should be directed at the four quadrants of the artwork. Strive for uniform illumination of the surface.
- Check lights for accurate placement. Lights should be at least 5 or 6 feet away from the work and the surface of work should be fully and uniformly lit with no "hot

spots"; lights can be moved farther back if necessary to light the surface of larger work more effectively. The wattage of your bulbs will in part determine how close or how far away your lights can be positioned without creating any hot spots (too much light) or dead spots (not enough light).

- With lights on (only the required lights), and with your ASA (film speed) properly set, take a full-frame light reading of a gray card positioned where the center of the artwork is. Be sure you do not block your light source in any way or cast shadows on the gray card with your body.
- Your f-stop should now be set at 4, 5.6, 8, or above in order to allow for the best depth of field and to insure sharp focus for both two- and three-dimensional work. If you are shooting only two-dimensional work that is nice and flat, you can work with an f-stop setting below 4 (requiring less light on your subject) while maintaining sharp focus.
- After choosing an f-stop, shutter speed should then be adjusted according to the reading from the gray card to provide a balanced or centered light reading. If a tripod and cable release are used, your shutter speed can be very slow and the slide image will still be in focus. Keep in mind that a slower shutter speed will yield slightly higher contrast in the slide image.
- Keep your f-stop and shutter speed at this setting for the duration of shooting, unless you choose to bracket your exposures for each piece photographed. *Bracketing is highly recommended!*
- To bracket, which provides you with a number of separate exposures for each piece, simply adjust your f-stop up once and down once from the balanced reading and shoot each piece at each of the three different exposures. You can bracket in increments of a half step up and down, a three-quarter step up and down, or one full step up and down. These three separate exposures should be sufficient to insure an exposure that is accurate. The best exposure from the developed slides can then be used to make duplicate slides.
- After determining the correct f-stop and shutter speed, place your camera on the tripod and adjust the position so that your artwork fills the viewfinder sufficiently, is well centered, and does not show parallax. You want the vertical plane of your camera to be parallel to the vertical plane of the artwork.
- Attach your cable release and shoot the desired number of exposures.
- If shooting more than one work of art, it is suggested that you shoot your larger pieces first and work your way down to the smaller pieces. This makes it easier to locate the centered placement of the work on the felt or velvet backdrop each time you introduce a new piece.
- If at any time you move your lights (closer for very small pieces or farther away for large pieces), or if you add lights for larger work, you must take a new light reading from your gray card and adjust your f-stop and shutter speed accordingly since the amount of light illuminating the piece will have changed.

Labeling Your Slides
- Labels may be typed or handwritten, but should always be neat and legible. A number of office supply companies make labels that fit perfectly on a cardboard or plastic slide mount, measuring ½" x 1-¾".

- Labels can also be prepared on a computer using any label-making word-processing software program that provides a template for slide labels. By using a small but legible font and point size, it is possible to get all pertinent information on a single label with four lines of text. Label sheets that match the software template and are compatible with laser or inkjet printers are available from office supply retailers.
- Labels should include the following information, and should be positioned on the nonemulsion side or front of the slide:

 Artist's name
 Title of piece (you can underline the title, put it in quotation marks, or italicize it)
 Medium/media ("mixed media" is sufficient when a variety of media are used)
 Dimensions (height first, followed by width, and then depth, if applicable)
 Date of execution (year is sufficient)

- A red signal dot, available through Avery brand office supplies, should be placed in the lower left-hand corner of the slide. This indicates the correct viewing position of the slide. Sometimes an arrow is used to indicate the top of the slide.
- Information can be arranged in a variety of ways to make best use of the space available. Three different examples for arranging information on one or two labels follow:

 Deborah A. Rockman
 Oxbow 8 11" x 14" 1984
 Acrylic and Oil Pastel

 Alexis B. Branham
 Turn the Other Cheek 1994
 Graphite on Paper 24" x 30"

 Richard Koester 1996
 Heifer (Big) 26" x 34"
 Mixed-Media; Vinyl on Glass

Coordinating Slide Film, Lights, and Light Dishes

To insure proper exposure and color balance, it is vital that you work with film, lights, and light dishes that are suited for each other. This means, for example, that 3200° Kelvin tungsten film must be used with 3200° K (Kelvin) tungsten lights, or film that is balanced for daylight must be used with actual daylight or with 4800° K (Kelvin) blue photo bulbs that duplicate the temperature of daylight. This also means that higher wattage bulbs, such as 500 watts, must be used with a larger dish size to properly distribute the light.

Below are listed some options for coordinating film and lights. The number of slide film options can be overwhelming, particularly if you are not a trained photographer. For additional information on the primary features of different films, contact the company directly. Based on extensive personal experience, I highly recommend using Ektachrome 3200° K tungsten slide film balanced with 3200° K tungsten lights. EPY 64 ASA was specifically developed for photographing works of art. This slide film is

quickly and easily processed as opposed to Kodachrome film (which can take up to a week for processing) and provides good color balance.

Tungsten Film Choices (3200° K tungsten film)

All tungsten film easily available in the United States is made by Kodak, with one exception from Fuji. The films are listed first by letter code, followed by film speed (ASA). Letter codes containing the letter "P" indicate professional film, which assures that color balance will be consistent from one roll or batch of film to another over time. Professional film must be refrigerated at all times until it is exposed, and should be allowed to warm to room temperature before using.

- EPY 64 ASA
- ET and EPT 160 ASA
- EPJ 320 ASA
- RTP 64 ASA (Fuji)

Tungsten Light Choices (3200° K bulbs)

- 300 watts (letter code BAH) for smaller work
- 500 watts (letter code ECT) for larger work
- 3400° K bulbs may be used in place of 3200° K tungsten bulbs if necessary, without a significant shift in color balance:
 - 250 watts (letter code BBA) for smaller work
 - 500 watts (letter code EBV) for larger work

Daylight Film Choices

Daylight films easily available in the United States are made by Kodak, Fuji, and Agfachrome. The films are listed first by letter code, followed by film speed (ASA). Letter codes containing the letter "P" or followed by the author's asterisk indicate professional film, which assures that color balance will be consistent from one roll or batch of film to another over extended periods of time. Professional film must be refrigerated at all times until it is exposed, and should be allowed to warm to room temperature before using.

KODAK FILMS ("E" indicates Ektachrome; "K" indicates Kodachrome)
- E100S* 100 ASA
- E100SW* 100 ASA
- E100VS* 100 ASA
- E200* 200 ASA
- ER and EPR and EPX all 64 ASA
- EN and EPN and EPP and EPZ all 100 ASA
- ED and EPD 200 ASA
- EL and EPL 400 ASA
- EES 800/1600 ASA
- EPH 1600 ASA
- KM and PKM 25 ASA

- KR and PKR 64 ASA
- KL and PKL 200 ASA

FUJI FILMS
- RVP 50 ASA (Velvia)
- RD 100 ASA (Sensia)
- RAP 100 ASA (Astia)
- RDP 100 ASA (Provia)
- RM 200 ASA (Sensia)
- RH 400 ASA (Sensia)
- RHP 400 ASA (Provia)

AGFACHROME FILMS
- RSX* 50 ASA
- CTX 100 ASA
- RSX* 100 ASA
- CTX 200 ASA
- RSX* 200 ASA

Used with Actual Daylight or 4800° K Blue Photo Flood Bulbs
- 250 watts (letter code BCA) for smaller work
- 500 watts (letter code EBW) for larger work

Dish Diameter for Bulbs
- 10" dish for 250–watt or 300–watt bulbs
- 12" dish for 500–watt bulbs

Organizing a Personal Slide Library of Student Work

Once you begin to accumulate a number of slides of student work, it is to your advantage to store and organize them in a way that protects your slides from dust, dirt, and scratches and makes access easy and convenient. In addition to slides of student work, you can also take slides of the work of contemporary and historical masters from high-quality reproductions in books and periodicals using a portable magnetized copy board. A copy board allows you to flatten the page where an image is located and take a slide directly from the printed page. Slides of this nature are useful for supplementing the slide collection of the school where you are teaching. You may find the work of a particular artist whom you consider important to your teaching to be absent or underrepresented, in which case you can document the artist's work from reproductions, which will suffice for general classroom purposes.

In using your slides for teaching, it is best to organize them in a way that reflects your approach to teaching. Consider first placing your slides in categories that reflect a general emphasis, such as figurative work, nonfigurative work, design, perspective, and so on. Depending on what you teach, you may also want to consider an emphasis on media, such as figurative drawing, figurative painting, nonfigurative drawing, or

nonfigurative painting. Within these broader categories, you can identify more specific emphases, such as linear emphasis, tonal emphasis, compositional emphasis, portraiture, hand and foot studies, anatomy, or spatial development. The categories can be as few or many, as general or specific as you desire. The idea is to start somewhere with organizing and categorizing your slides. As your collection develops and you use it more frequently, you will recognize when a change in organization seems necessary to facilitate finding what you want with minimal effort.

Slide storage boxes are an excellent way to store and label your collection. Slide boxes most frequently are single plastic cases, single metal cases, or a grouping of metal drawers, which is more cumbersome and much harder to lug around when necessary than a single drawer of slides. Some provide slots for individual slide storage, while others provide a format for storing groups of slides, which is what I recommend. Cardboard sleeves are provided for labeling and separating the slide groupings. After trying a number of different types and brands of storage cases, I found that the Logan brand metal cases work best for me, and are available at any well-stocked photo supply store.

Appendix *B*

Preparing Students for What Lies Ahead

Career Opportunities in the Visual Arts

Why Choose Fine Arts?

> The pursuit of fine arts is a leap of faith. It requires the courage to embrace the unfamiliar, the willingness to reveal an innermost vision, and the desire to immerse one's self in a journey whose destination is in constant flux. It is an enduring adventure, a way of life.

Students often approach their instructors for help and information when they are considering an educational emphasis or career in the visual arts. More often than not, their questions indicate concern for their ability to make a living when they emerge from the educational experience to face the world outside of academia. They wonder, "Will I be able to support myself?"

Although we all know there are no guarantees, there is often the misconception on the part of the student that the only way to support yourself with a degree in art is through the sale of your work, which may conjure up stereotypical images of the starving artist struggling to make ends meet. Elsewhere in the spectrum is the idea of the artist who waits tables in a restaurant or flips hamburgers for a fast-food establishment to make money, relying on the off-duty hours to pursue one's studio work in a haze of postwork fatigue.

While both of these scenarios play out with varying degrees of frequency, and while they may appeal to some students and their particular temperaments, there are many students who recognize that it is not easy to financially support yourself purely through the sale of your work and who are not interested in a job unrelated to the arts with the hope of squeezing in some studio time between work and sleep.

It is important to alert your students to the myriad possibilities for employment and careers in the arts that focus on a wide range of art-related activities—studio work, administration and management, education, museum work, commercial or nonprofit involvement. The options for a creative application of one's strengths and skills in the

arts are broad. The following information outlines briefly some of the possibilities that can be pursued. Students should be made aware that some of the options require graduate degrees or additional education beyond the BFA degree. Encourage students to research an area they are interested in by referring to the publications on the market that address careers in or related to the visual arts, and by taking advantage of information available on the Internet.

Career Options

Graduate Studies: Studio apprentice, graduate teaching assistant.

Exhibiting Artist: Cash awards, honorariums, and purchase awards.

Artist's Commissions: Private, public, and corporate commissions.

Freelance Work: Illustration, graphics, mural painting, and other related activities.

Commercial/Business Endeavors: Gallery owner, artist's agent, art appraiser, art buyer, set/prop designer, print studio owner.

Teaching/Academic: Elementary, secondary, and postsecondary (college) level, private tutoring, adult and continuing education programs, slide librarian for college and university slide collections.

Arts Administration and Management: Museums, commercial galleries, nonprofit or community-based arts organizations, government-funded arts organizations.

Museum Work: Director, curator, registrar, preparator, slide librarian.

Conservation, Restoration, and Preservation

Contemporary Theory and Criticism (Art Critic): Published writing and/or lectures and speaking engagements.

Grants, Residency, and Fellowship Programs: Visiting artist, visiting lecturer, artists-in-schools residency.

Art Therapy: Art therapist in schools or mental health organizations.

Building a Résumé

As students seek jobs, scholarships, exhibitions, or admission into graduate school, they will eventually be expected to provide a résumé that addresses their work and their training as artists and designers, and this inevitably raises the question of how to organize a résumé that is art-oriented. In addition to approaching instructors for letters of recommendation, students may also ask for your assistance in organizing and fine-tuning their résumés.

A résumé is a document in constant flux, with ongoing additions and deletions that are intended to reflect professional growth and activity, to suit a specific purpose, to bulk up an otherwise sparse résumé, or to shorten a résumé that over time has become too lengthy. Regardless of the specific application or the way in which the information is designed or organized graphically, there are a number of headings that should be considered, many of which are specific to the visual arts and reflect an art-related career. Whether or not various headings are applicable at any given time will be best answered by considering how many entries one can place under a specific heading. It is best not to utilize a heading for which there are less than two significant entries.

It is suggested that you remind students who are seeking your guidance that their résumés will appear very different from a professional résumé, and there is often a significant difference between the résumé of an art student at the undergraduate level and the résumé of an art student at the graduate level. As one progresses in one's career, information that was once considered significant becomes less significant to the point where it should be deleted from a résumé. A solo exhibition in a neighborhood coffee house is appropriate for an undergraduate student to note, but might be inappropriate for a graduate student or a recent MFA grad to include on a résumé.

The following information is intended to serve as a guideline for potential résumé headings and for organizing information under each heading. The most recent information should be listed first, followed by additional information in reverse chronological order. Examples of various résumé entries are included for all but the self-identification headings. Some of the entries are culled from actual résumés and some are fictitious entries, intended to serve as examples of information organization.

Suggested Headings

Name, Address, Phone Number, E-mail Address, Fax Number
This vital information is an integral part of any résumé and provides the reader with a variety of ways to reach you.

Education
Dates, degrees worked on or received, with any specializations noted, institutions attended, and location of the institution (city and state or country is sufficient).

 1981 **Master of Fine Arts,** *Drawing/Printmaking;* University of Cincinnati, Cincinnati, OH

 1977 **Bachelor of Arts,** *Fine Arts;* **Bachelor of Science,** *Secondary Art Education,* University of Washington, Seattle, WA

Professional Experience
Dates, title of position, institution or employer, and a brief list of significant responsibilities if necessary. List only experience that is specific to the field in which you are trained and educated.

 1983– **Professor of Art** (1992–current), **Associate and Assistant Professor of Art** (1983–92), Kendall College of Art and Design, Grand Rapids, MI

 1992–98 **Fine Arts Program Coordinator,** Kendall College of Art and Design, Grand Rapids, MI

 1981 **Visiting Artist,** *Drawing and Life Drawing,* Cincinnati Art Academy, Cincinnati, OH

Arts-Related Work Experience or General Work Experience
Dates, title of position, institution or employer, brief list of responsibilities if not apparent by title of position.

 1979 **Art Instructor,** Adult Education Program, Boston Community Schools, Boston, MA

 1976 **Playground Supervisor,** Parks and Recreation Program, Community Schools, Fenton, MI

Scholarships/Awards/Honors

Dates, name or type of scholarship or award, institution or exhibition through which award was granted, and name of juror (if applicable).

1997 **First Place Award,** National All-Media Juried Exhibition, Touchstone Gallery, Washington, DC
Juror: Virginia Mecklenburg, Senior Curator, National Museum American Art

1992 **Honorable Mention Award,** 34th Annual Mid-Michigan Juried Exhibition, Midland Center for the Arts, Midland, MI
Juror: Alice Huei-zu Yang, Assistant Curator, New Museum of Contemporary Art, New York, NY

1988 **Purchase Award,** Festival of the Arts Juried Exhibition, Grand Rapids Art Museum, Grand Rapids, MI
Juror: Judith Russi Kirshner, Curator, Museum of Contemporary Art, Chicago, IL

1977 **Magna Cum Laude Graduate,** Georgia State University, Atlanta, GA

1972–77 **State of Georgia Academic Scholarship,** Georgia State University, Atlanta, GA

Service/Leadership Positions

Dates, title of position, committee or institution or employer, and brief list of significant responsibilities.

1997– **Fine Arts Faculty Representative,** College Senate, Herron School of Art, Indianapolis, IN
Responsible for representing fine arts department in college senate and reporting back to fine arts department

1993–96 **Personnel Committee,** Kendall College of Art and Design, Grand Rapids, MI
Responsible for peer evaluation

1987–92 **Member of the Board of Directors,** Urban Institute for Contemporary Art, Grand Rapids, MI
Responsible for helping with fundraising and coordinating volunteer efforts

1984 **Chairperson,** MFA Thesis Exhibition Committee, University of Cincinnati, Cincinnati, OH
Responsible for coordinating all activities related to publicity of MFA thesis exhibitions

Residencies/Fellowships/Internships

Dates, name of fellowship or residency, location (sponsoring organization and city/state), and brief list of significant activities or responsibilities.

1997 **The Ragdale Foundation,** One-Month Visual Arts Fellowship, January 1997, Lake Forest, IL
Developed body of work for solo exhibition

1994 **Fulbright Fellowship,** 1994–95 Academic Year, Belgrade Academy of Arts, Belgrade, Yugoslavia
Taught advanced courses in drawing and figure drawing and developed a body of work

1990 **Vermont Studio Colony,** One-Month Visual Arts Fellowship, January 1990, Johnson, VT
Developed body of work for sabbatical leave exhibition

Lectures/Seminars/Workshops

Dates, title or name or theme, location (sponsoring organization or institution and city/state), and facilitator or presenter if you attended. Make sure it is clear whether you were *giving* a workshop or attending a workshop being *given by some-one else.*

1995 **"Issues of Pedagogy and Sexual Identity,"** Panelist/Presenter,
83rd Annual College Art Association Conference, San Antonio, TX

1994 **International Non-Toxic Printmaking Master Workshops,** Attendee, Grande Prairie Regional College, Alberta, Canada

1991 **"The Art of the 'Others': Images of the Body,"** Lecturer for *Symposium on the Nude*, delivered at Grand Rapids Art Museum, Grand Rapids, MI

Publications

These consist of *published* books, articles, essays, reviews, etc., written *by you*. Include the type of publication (book, magazine, professional journal, etc.), name of publication, edition or volume number (if applicable), date of publication, and page numbers (if applicable).

2000 **"The Art of Teaching Art,"** Book published by Oxford University Press, New York, NY

1997 **"Beauty or the Beast: The Role of the Unconscious in Creativity,"** Essay published in *The Kendall Journal,* Kendall College of Art and Design, Grand Rapids, MI

Bibliography

These include *published* articles, essays, reviews, etc., written *about you* or your work. Include the author, title of review or article in quotation marks, name of publication, edition or volume number (if applicable), date of publication, and page numbers (if applicable). Indicate if text or copy is accompanied by a reproduction of your work.

Chiapella, Julia. "Luck of the Draw," *San Jose Tribune,* December 1998, 1(C).

Green, Roger. "Women Battle Restrictions on Creative Expression," *Kalamazoo Gazette,* March 1998, 4(E); *Grand Rapids Press,* January 1998, 6(D); *The Flint Journal,* January 1998; *The Saginaw News,* December 1997, 8(C); reproductions.

Bornstein, Lisa. "The Seduction of Shadow and Light," *South Bend Tribune,* January 1996, 1–2(E); reproduction.

Pincus, Robert L. "Visual Poetics," *Los Angeles Times,* December 1983; reproduction.

Grants/Commissions

Date awarded, name of grant (you may include the amount of the award) or name of individual or organization awarding a commission, brief description of the commission, and location for commissions (city and state or country) if not indicated in name of organization.

1994 **Michigan Council for the Arts Individual Artist Grant,** $8,000

1992 **Baltimore Community Hospital,** Commissioned wall murals for lobby and information area, Baltimore, MD

1989 **Bishop Airport,** Commissioned large-scale oil pastels for lounge area, Flint, MI

Collections
Who purchased your work (an individual or organization), and location (city and state or country).

> **Steelcase, Inc.,** Grand Rapids, MI; **Eastman-Kodak,** Rochester, NY; **Grand Rapids Art Museum,** Grand Rapids, MI; **University of Cincinnati,** Cincinnati, OH; **North Dakota State University,** Fargo, ND; **Warner, Norcross & Judd, Attorneys at Law,** Grand Rapids, MI; **Moorhead State University,** Moorhead, MN; **Bank of America,** Portland, OR

Exhibitions
Date, title of exhibition, type of exhibition (one-person or solo, small group, invitational, or juried) if not indicated by subheadings, location (sponsoring organization or institution and city/state), and juror (if recognized in field).

> 1998 **"Waging a Word War,"** Solo Exhibition, Memorial Union Gallery, University of Wisconsin, Madison, WI
>
> **"Troubling Customs,"** International Group Exhibition, Ontario College of Art and Design Gallery, Toronto, Canada; The Katherine Lane Weems Center, The School of the Museum of Fine Arts, Boston, MA; **Curators:** Erica Rand, Bates College; Sallie McCorkle, Penn State University; Cyndra MacDowall, University of Toronto
>
> 1997 **"Contemporary Drawing,"** Group invitational exhibition, Cabrillo College Gallery, Aptos, CA
>
> **"Phat 50,"** Group invitational suite of prints to commemorate the 50th anniversary of the South Bend Regional Museum of Art, South Bend, IN
>
> **Great Lakes Regional Art Exhibition,** Juried Competition, Midland Center for the Arts, Midland, MI; **Juror:** Tom Hinson, Curator of Contemporary Art, The Cleveland Museum of Art
>
> 1996 **"TextArt,"** Invitational Group Exhibition, LaFontsee Galleries, Grand Rapids, MI; **Curators:** Scott and Linda LaFontsee
>
> **"The Seduction of Shadow & Light,"** One-Person Exhibition, South Bend Art Museum, South Bend, IN
>
> **Regional Juried Exhibition,** ARC Gallery, Chicago, IL; **Juror:** Richard Francis, Chief Curator, Museum of Contemporary Art, Chicago, IL

Gallery Representation
How long you have been represented, name of gallery, and location (city and state or country).

> 1997– **Zolla-Lieberman,** Chicago, IL
> 1995– **Toni Birckhead Gallery,** Cincinnati, OH
> 1994– **LaFontsee Galleries,** Grand Rapids, MI

References
Name, title or position, academic affiliation or place of employment, full address, telephone number, fax number (if available), and email address (if available). You can either list the references or note "References available upon request." You should ask a person's permission before giving out that person's name/address as a reference, and forewarn your reference when to expect a call from a reference-seeker.

Work-Related Travel

Dates, locations, and relevant activity.

> 1994 **Chichen Itza, Mexico,** photographic documentation of Mayan ruins.
>
> 1987 **North Africa (Egypt),** photographic documentation and drawings of Pyramids of Giza, the Sphinx, and other architectural landmarks.

"Selected" is used as a preface to a heading if you wish to edit the information under the heading for the sake of brevity. It indicates that you are mentioning only the most significant information appropriate to the heading rather than all of the information appropriate to the heading.

The order in which you present the headings and accompanying material is in part determined by whom the résumé is intended for. For example, if you are applying for a job, "professional experience/related work experience/work experience" would probably be addressed on the first page. If submitting your résumé to a gallery for the purpose of showing your work, your exhibition record may be considered more important than your work experience. If applying for graduate school, you may wish to determine where your greatest successes have been and prioritize with those in mind. For example, if you have not shown your work prior to graduate school, you would clearly not want to prioritize or even include an exhibition record.

If you need to conserve space or "tighten up" your résumé, experiment with various fonts and their space utilization, and with different arrangements of information that best utilize line and page length while remaining well organized and easily read.

Preparing a Slide Portfolio

Encourage your students to shoot slides of their work. A good collection of representative slides of personal work can serve many useful purposes, and slides are more versatile than photographs because they can be projected. Quality slides can enhance the chances of being accepted into a graduate program of choice, being accepted into juried group exhibitions or awarded a solo exhibition, inviting closer examination of your work by a gallery, or finding a desirable teaching position. For artwork that is too large or bulky to be scanned on a flatbed scanner, quality slides of this same work can be scanned on a 35mm slide scanner, saved on a Zip disk, and used in the development of a web page. These slides can also generate high-quality hard copy in the form of digital printouts. Slides of personal work are often the first (and perhaps only) exposure someone will have to your work, and first impressions are important when competition is strong.

In shooting slides, it is wise to take extra care in getting it right the first time, as it will save time, energy, disappointment, and money. When preparing to shoot slides, determine in advance if you would like to have all original slides for each piece being documented, or if you would prefer to have duplicates made from each original slide. If you wish to have all original slides, considerably more money will be spent up front for slide film and developing, but you will have better quality slides and will save yourself the expense of duplicating slides later. Bracketing is strongly recommended whether shooting all original slides or planning to have duplicates made.

The information provided in Appendix A under the heading "Documenting Two-Dimensional Work with 35mm Slides" provides some helpful guidelines for shooting slides. Presenting this information to students in tandem with a demonstration can help even a student with no photography experience to begin developing a personal slide library.

Writing Letters of Recommendation

Part of the responsibility of teaching includes providing letters of recommendation for a variety of purposes for current students, former students, and colleagues. These letters may be requested for a student's transfer to a different institution, for a student seeking scholarship money or employment, for a student seeking admission into a graduate program, for a colleague seeking promotion or tenure, for a colleague seeking a teaching position at another institution, or for a colleague seeking a general professional recommendation.

You may at times find it necessary to turn down a request for a letter of recommendation if you have serious reservations about a student's qualifications or abilities. In relation to a colleague's request, if you do not feel that you are familiar enough with the person's professional life to be able to honestly provide words of praise, you may wish to decline with a brief explanation. Chances are good, however, that colleagues will not ask you for a letter if they do not feel confident that you can provide them with a supportive letter. On rare occasions you may feel compelled to decline a request due to more serious reservations about a colleague's professional ability or integrity, in which case you must decide how you wish to best handle the situation. If you receive a request with very little notice and a fast-approaching deadline, you may again find yourself needing to decline if you are simply too busy to give the letter the attention it deserves.

Student requests will often come in waves, based on deadlines for scholarship applications or graduate school application deadlines, and if you receive a number of requests all at once, you may need to be selective about how many letters you agree to write. Sometimes student requests are a bit inappropriate, but you must be the ultimate judge of this. For instance, if you had a student for only one course several semesters prior, and are not currently familiar with the student's development, you can suggest to the student that he find another faculty member who is more familiar with his work.

If a student was particularly difficult to work with and you cannot authentically recommend the student, it is appropriate to deny the request and make your reasons clear to the student. I have encountered this situation only a few times in my teaching career with students who were seeking letters of recommendation for graduate school, and it was not a pleasant or easy situation. But it is important to recognize that your professional integrity is involved—if you can't say something nice, don't say anything at all. Once again, if you simply do not have the time to meet a deadline that is fast approaching, explain this to the student and suggest that he or she provide you with more adequate notice in the future.

Whether providing a letter for a colleague or student, it is often very helpful to request a copy of her résumé. This provides you with information about her specific

accomplishments or positions held, and you can make mention of these in your letter. Regardless of the purpose of the letter of recommendation, there are some guidelines that should be followed.

- Always follow proper letter form. Include the date, an inside address (which should be provided by the person requesting the letter), and an appropriate greeting. End the letter with a proper closing such as "Sincerely" or "Respectfully," followed by your name, your academic rank (assistant professor, professor, etc.), and your title if it is considered significant (chairperson, program coordinator, etc.).
- Begin the letter by clearly stating your intent. "This is a letter of recommendation for John Smith for admission into your graduate program in drawing," for example.
- After stating the full name of the person you are recommending, you may throughout the remainder of the letter choose to refer to that person by their first name or by their last name with the appropriate prefix of Mr. or Ms. In either case, be consistent in your reference throughout the body of the letter.
- State your title and position, and provide information regarding how long you have known the student or colleague, and in what capacity.
- Provide information on your assessment of the person's general ability as a student or a colleague, followed by mention of strengths that are specific to that person.
- Make specific mention of any accomplishments that are particularly notable in relation to the recommendation. If, for example, a colleague is seeking a position of leadership at another institution, offer observations of his current leadership as a department chairperson or a committee chair. If a student is seeking employment that requires self-motivation, make mention of the ways in which the student has shown self-motivation in your contact with him or her.
- If specific information is requested in the letter of recommendation (often the case in graduate school recommendations), make sure to address this information thoroughly.
- If a student has the option to request or deny access to the letter, encourage him or her to deny access, as a confidential letter is generally considered to be more meaningful. This is due to the fact that if you know a student is going to read the letter you write, it is tempting to exaggerate your praise to avoid any potential conflict or disappointment on the part of the student.
- If you are providing a letter based on your professional affiliation with an institution, your letter should be sent on letterhead stationery.

Sample Letters
Student Scholarships

Leeanne Grant has asked if I would provide her with a letter of recommendation for an Intertel Scholarship, and it is my pleasure to do so.

Leeanne has been a student of mine a number of times over the last several years at Kendall College of Art and Design, in Drawing I, Drawing II, and currently in Life Drawing II. Her dedication to her education in the arts is evidenced in part by the fact that she has continued to work full time throughout the majority of her experience at KCAD while taking night

classes toward her BFA degree. This semester she made the decision to attend school full time in order to complete her education in a more timely fashion.

Leeanne is not a typical student in that she has already received a bachelor's degree in social work and made the difficult decision in 1988 to leave a secure position in her field to pursue her interest in the applied arts. Having taught for a number of years, I can attest to the fact that she brings to her studies a level of maturity and commitment that is atypical of a younger and less mature student. In her desire to advance herself, she seeks out the most challenging instructors and applies herself totally to what is asked of her.

Leeanne excels in her major area of study as well as in her academic courses, recognizing the value of a liberal arts experience in creating a well-rounded and informed individual. She is a talented designer, as indicated by her transcripts from Kendall and by the assessment of her performance by employers with whom she has worked in areas related to the graphic arts and advertising. She is bright, she learns quickly, and she is an example to her fellow students.

Leeanne is an absolute delight to work with—interested in learning, willing to invest herself above and beyond the call of duty, and receptive to feedback. She is one of those students who makes teaching a pleasure as I observe her growth and development. This woman will excel in her pursuits and is therefore an excellent candidate for your scholarship program. Please accept my highest recommendation for Leeanne Grant as a recipient of an Intertel Scholarship. Thank you.

General Merit of a Student

Elizabeth Williams has asked if I would provide her with a letter of recommendation for a three-week course in printmaking at the Royal College of Art in London during the summer of 1994, and it is my pleasure to do so.

Elizabeth is an excellent student—talented, motivated, mature, involved, and eager to advance herself. Her work ethic and classroom involvement provide inspiration for her fellow students. She is receptive to feedback and constructive criticism and is driven to excel in all coursework.

Elizabeth was one of the top award winners in the 1993 Kendall College of Art and Design student competition, and is very involved in the local artist's community. She is a valued volunteer at the Grand Rapids Art Museum, functioning as a docent and as an assistant in coordinating fund-raising events for the museum.

Please accept my high regard for her both as a student and a person. I have no hesitation in recommending her for your program. Thank you.

Student Transfer to Another Institution

Jon Gregory has asked if I would provide him with a recommendation for admission into your illustration program, and I am happy to do so.

Jon was a student of mine last semester in Life Drawing I, and is currently a student in my Life Drawing II course. These are both non–major specific foundation-level courses.

Jon is an excellent student—interested, committed, actively involved, eager to learn, and with a sound basis in observational drawing skills. With an interest in illustration, he was initially declaring a major in that department here at Kendall College of Art and Design. But with a specific interest in computer animation, he recognized that Kendall is not the best option for the pursuit of his interests, as we do not currently offer courses in computer

animation. With this in mind, he has decided to apply to your institution. I am very confident that you will find him to be an excellent and valued addition to your student body. I can recommend Jon without hesitation.

Admission to Graduate School

Jason Shale has asked if I would provide him with a letter of recommendation for admission into your graduate program in fine arts, and I am happy to do so.

I have worked with Jason a considerable amount since he began his studies at Kendall College of Art and Design several years ago. I had him in my perspective course as a first-semester freshman, and have worked with him every semester for the past two years as he has pursued a concentration in drawing. He is currently working with me in Thesis Drawing as he prepares for his BFA exhibition in the spring.

Jason is a student for whom I felt a lot of concern when he first came to Kendall. It was immediately clear to me that he was a very bright young man with considerable potential, but his ability to focus and concentrate and stay interested in something for any length of time was poor at best. He was undisciplined, although always seemingly eager to learn and expand his base of knowledge. I didn't anticipate his return after the first semester or two.

But Jason stuck it out through the hard times, and I have had the pleasure of observing a transformation in him within the last two years that has revealed a young man who possesses all the commitment, ability, and passion to succeed as an artist. The same young man who would express a different conceptual direction in each new drawing he did is now developing semester-long series of drawings that explore a particular concept in great depth. The same young man who expressed great impatience with any kind of process that took time to develop and refine is now working on exquisite small renderings that require a significant time investment and that provide him with great satisfaction for a job well-done. The same young man who consistently expressed that he just didn't know what he wanted to do is now very specific in expressing his interest in drawing as a pure medium, an end unto itself; his interest in the computer as an additional tool for expanding his drawings into other realms; and his interest in attending graduate school, earning an MFA degree, and making his art.

To be concise, I never would have imagined Jason coming this far five years ago. But it is now apparent that making art is the thing that matters most to him and he will stop at nothing in pursuit of this. He would benefit tremendously from a challenging and rigorous graduate school experience, and he would be an asset to your program. Please give him your serious consideration. Thank you.

Francis Chang has asked if I would provide him with a letter of recommendation for admission to your graduate program, and I am happy to do so.

Francis was a student in my Drawing III course in the spring semester of 1995, and I have also worked closely with him through academic advising and transfer credit evaluation. I am consistently impressed with his artistic commitment, his natural ability, and his sensitivity to pictorial and conceptual issues alike. These attributes are even more impressive considering the fact that Francis must work especially hard to fully grasp more complex concepts because we are communicating in English, which is not his primary language. He must also contend with many issues that are specific to Western society and culture, which is relatively new to him, and he shows remarkable versatility and understanding in this respect.

Francis sets a powerful example for other students with whom he comes in contact through his work ethic, his inquisitive nature, his respect for others, and his dedication to advancing himself technically, formally, and conceptually. He is a tremendous draughtsman, but is not content to rely solely on technical virtuosity in his work, as some students are. He understands the significance of content, and exhaustively researches the topics he wishes to address in his work. Although there is often some struggle in our efforts to communicate verbally on an abstract level, his efforts to understand are tireless. I have had the opportunity to read some research papers he has written in relation to topics he has explored in his visual work, and I found his writing to be well organized and informative. Regardless of the challenges he encounters due to language, Francis's work is consistently some of the best in his studio courses. I only wish all of my students showed the same dedication and enthusiasm.

In summary, I would like to say that I have thoroughly enjoyed working with Francis, and I see in him a tremendous potential that is likely to be realized given his energy, his dedication, and his gift for image-making. I strongly recommend him for your consideration, and am confident that he would be an asset to your graduate program. Thank you.

Promotion of a Colleague

Roy Milkowski has asked me to provide him with a letter of recommendation for promotion from Assistant Professor to Associate Professor, and I am happy to do so.

Having been a colleague of Roy's for fourteen years, and as coordinator of the fine arts program, I am quite familiar with his capacity as a teacher of art. He has impressed me with his high degree of enthusiasm and his obvious concern for the growth and development of his students. He has been actively involved in reviewing and evaluating both foundation and fine art course content, and has made valuable contributions to fine arts as coordinator of the painting program for the past three years. Roy is a team player, supporting the philosophy of the program within the framework of his individual teaching style. His classroom syllabi, handouts, and other supportive materials are thorough and well organized, indicating concern for historical and contemporary issues alike.

Perhaps the best evidence of Roy's performance in the classroom is the work produced by his students. I have consistently seen high-quality work from those in his charge, showing sensitivity for technical, formal, and conceptual issues. His students are encouraged to develop strong skills of observation while investigating an inventive and sensitive use of materials. He is not a hand-holder, but encourages in his students self-discovery.

Roy is a respected member of our full-time faculty, as both a teacher and an artist. After eight years of adjunct teaching at the college, he was hired as a full-time faculty member in 1991. When I am seeking professional assistance, it is invariably Roy who offers his help and follows through on any request made of him. He has volunteered to serve as co-coordinator of the fine arts program during my sabbatical leave, and I am comfortable with his ability to handle a position of this responsibility. As his résumé indicates, he has also served on numerous committees within the college, and takes these responsibilities seriously. He is highly regarded in the local and regional arts community, having received numerous awards and honors in local, regional, and state exhibitions and competitions, and was the recipient of a grant from the Michigan Council for the Arts in 1988.

In Roy you will find that rare and valuable combination of an accomplished and dedicated artist and an enthusiastic and effective teacher. I have much respect for him both

personally and professionally, and can recommend him without hesitation for promotion from Assistant Professor to Associate Professor. Thank you.

Tenure for a Colleague

Danielle Fruenthal has asked if I would provide her with a letter of support for tenure at Aquinas College, and it is my great pleasure to do so. I have known Danielle since she first arrived in Grand Rapids in 1993. In a very short amount of time, she established a community-wide reputation as a compelling new teacher, an innovative and versatile artist of substantial ability, and an authentic and charming individual. My respect for her continues to grow.

In addition to her role as a faculty member at Aquinas, which she sees as both an honor and a great responsibility, Danielle has become involved in the larger art community in a very visible and substantial way. Her numerous exhibitions and installations show evidence of her creative transformation of materials, her sensitivity to unusual combinations of media, and her capacity for appealing to both the intellect and the emotions of the viewer.

I have invited her on a few occasions to come to Kendall College of Art and Design as a guest critic for some of my advanced drawing classes, and her insight and professional demeanor provided a very meaningful experience for my students. When I was asked by Oxford University Press to suggest some professionals in my field who might be interested in reviewing my book proposal for a guide to college-level teaching, I included Danielle as one of my choices. She reviewed my proposal for Oxford, provided some very helpful insights and suggestions (some of which were implemented in the final proposal), and played a supportive role in my receiving a contract for publication with Oxford. Danielle has also become a powerful and significant presence at the Urban Institute for Contemporary Art, providing a multitude of services all on a voluntary basis.

Given my nearly twenty years of full-time teaching at the college level, Danielle stands out as a truly committed teacher and artist, a balancing act that is often difficult to maintain and that eludes many in academia. She has contributed tremendously to the art department at Aquinas, and students speak very highly of her. I can think of no more deserving candidate for tenure, and offer my support with great enthusiasm.

Teaching Position for a Colleague

Ms. Elaine Brouwer has asked if I would provide her with a letter of recommendation for your teaching position in Two-Dimensional Design, and I am happy to do so.

I first came to know Elaine when she began teaching at Kendall College of Art and Design as an adjunct instructor in the fall of 1990. Since that time she has proven herself to be a highly valued colleague whose contributions to the college have consistently been above and beyond what is required of an adjunct faculty member. As her résumé indicates, her professional involvement in the Foundation and Fine Arts Department includes voluntary attendance at departmental meetings, participation in our annual fine arts walkthrough (a tool for program assessment), service on BFA review committees, and service as an invited guest critic in advanced-level painting and drawing courses. Additionally, and most notably, Elaine was responsible for working with our former fine arts coordinator in developing a series of lectures/discussions of great relevance to our advanced fine arts students. These discussions, presented in a seminar format over a period of a year and a half, were tremendously successful and led to the creation of two advanced-level, required seminar courses in the fine arts major that address contemporary art theory and criticism.

Having lived and worked as a professional artist in both Detroit and New York, Elaine has brought a unique perspective to the college. Not only is her professional and educational experience broad and varied, but she is exceptionally well-read and well-informed, contributing a valuable intellectual, historical, and philosophical component to the college and to the department. She is an effective and respected teacher and is sensitive to the different needs and abilities of the students in her charge—from the timid first-semester freshman to the outspoken and confident senior student. Her respect for the "team player" philosophy at Kendall College of Art and Design has made her a strong and vital link in the faculty chain.

Elaine's exhibition record indicates a number of local, regional, and national exhibitions to her credit. She has been especially active since her arrival in Grand Rapids four and a half years ago. Her studio activity attests to her belief that one's experience as an artist is vital to one's effectiveness as a teacher. In addition to her exhibition activity, she lectures in western Michigan on topics of interest to artists, art educators, patrons, and students of the arts.

In summary, I have great respect for Elaine's versatility and strengths as an artist and art educator. She has been an enormous asset to Kendall's Foundation and Fine Arts Department. Although your gain would be our loss, I highly recommend her for your consideration.

Howard Michaels has asked if I would provide him with a letter of recommendation for the position available at Milwaukee Institute of Art and Design, and I am happy to do so.

Howard came to Kendall College of Art and Design as an adjunct faculty member in the Foundation and Fine Arts Department in January of 1993. I distinctly recall my initial enthusiasm after viewing examples of Howard's studio work and student work. Given our frequent use of adjunct faculty, and the frequency with which we are often disappointed in their teaching skills, we are always on the lookout for dependable, committed, and skilled additions to our adjunct roster. After hiring Howard, we discovered our enthusiasm was well founded.

Howard shows a great capacity to elicit high-quality student work from both the uninitiated first-semester freshmen and the more advanced-level students. He commands the respect of students and colleagues alike, and has consistently displayed a willingness to perform above and beyond the call of duty. Although not required to attend faculty meetings and other activities outside the classroom, Howard has been very active within the department and is always willing to be involved in the students' development. He has volunteered his time for sophomore-level portfolio reviews, has served on BFA candidate review committees and BFA thesis exhibition committees, and has been, by invitation, a guest critic in a number of advanced painting and drawing courses.

In terms of theory and criticism, Howard has contributed a strong intellectual component to the department. He is well-read and capable of effectively communicating the most basic concepts as well as more complex concepts to the students, depending upon the level of the course he is teaching. The students have responded very favorably to him. His own studio work has set a strong example for the students in terms of formalist qualities, including the orchestration of composition, color, surface, texture, and their relationship to content and meaning. His current work with architectural forms as a point of departure is most striking. His paintings are beautifully executed, eloquent, and poetic. He is truly successful in his desire "to represent the experience through the form, the painting, and not to offer merely a picture of the experience."

I hold Howard in high regard as an artist, a teacher, and a person, and I am confident that the slide documentation of both his work and the work of his students will support my respect for him professionally. He is a person of strength, commitment, and integrity, and I recommend him for your serious consideration without hesitation.

Artist-in-Residence Program

This is a letter of strong recommendation and support for Ms. Lisa Robinson in her application for an artist-in-residence position.

I first met Lisa in January of 1990 when we were both professional artists-in-residence at the Vermont Studio Colony in Johnson, Vermont. Throughout the course of our one-month residency, I came to have great respect for Lisa as a person and as an artist.

In a setting where a number of artists from different disciplines are living and working together, it is important to find that balance between supportive professional interaction and respect for the privacy of others. I quickly recognized Lisa's sensitivity toward her fellow residents, and her dedication to maximizing her studio time and exploring the unique possibilities colony life had to offer. Lisa provided valuable insights into the work of others (when it was requested) and personally pursued a strong body of work in both painting and drawing.

As I came to know her better on a personal level, I saw talent, strength, compassion, dedication, and a wonderful sense of humor. I hope to one day share the artist's colony experience with her again. During my twelve-month sabbatical in 1989–90, I met many people throughout my residencies at various colonies in the East and the Midwest. Some were ill-suited for the experience, many adequately made use of the experience, and a few excelled and flourished—among them, Lisa. I can recommend her without hesitation. She will be an asset to your program.

Graduate School Checklist

The following is an outline of procedures, requirements, suggestions, and pitfalls related to applying to graduate school in the visual arts. It is intended to be used as a basis for discussion between faculty and students and as a catalyst for generating questions. It is extremely helpful to include in the discussion, if possible, students who are currently in an MFA program or who have recently graduated from an MFA program. The majority of this information was prepared by Jay Constantine, Professor of Art at Kendall College of Art and Design, who has generously agreed to contribute it to *The Art of Teaching Art*.

MFA Programs in the Visual Arts

- A directory of the same name is available through the College Art Association in New York City, and includes substantial information regarding some of the specifics of individual programs throughout the United States. It is most likely also available in your school or local library.
- If you are using the Internet for research into graduate programs, the web is only helpful in accessing the *U.S. News & World Report*'s Top 100 Fine Art Graduate Programs. Currently there are no indexes that organize art programs by geography or major. Therefore, further exploration requires the web address of the school you

are interested in. Many sites offer virtual campus tours (with photos and captions of buildings), descriptions of departments and program requirements, and biographical information about the faculty. Some web sites include images of faculty and student artwork. If you are a digital media major, the addresses or links to faculty and student sites will be of special interest.

- Start the process of looking for a school a year in advance—no less than six months in advance.
- Make a list of schools you are interested in, noting the name, mailing address, e-mail address, web site address, phone and/or fax number and, most importantly, the application deadline.
- Pin this list on the wall of your studio or living space, along with a calendar, so that it glares at you while you eat, work, and sleep. Remember those deadlines!
- Mail, fax, or e-mail brief form letters requesting the following materials from each college or university you are interested in: a school catalogue, an application form for admission, and application forms for a variety of financial aid (fellowships, assistantships, tuition waivers, scholarships, etc.).

If you are a bad letter-writer or a procrastinator, send an e-mail or call the school long distance and request the above materials. Most information will be sent to you free of charge. Catalogues can take a long time to reach their destination. Send for them as early as possible—like now.

What to Look for in an MFA Program

- Look for what concentrations are offered—painting, drawing, sculpture, printmaking, photography, digital media, etc. Make sure the school has a department in your desired area of concentration. The MFA Directory has a chart at the beginning with programs available at each individual institution.
- Admission requirements differ from school to school. Make sure you read the information carefully, and be on the lookout for special requirements.
- Fellowships, assistantships, and tuition waivers are the most important factors for those students who need financial help. Find out if these are offered in the first or second year. You should take immediate note of any school offering fellowships, assistantships, or tuition waivers to first-year students.
- Be realistic! Look at the price of tuition and ask yourself if you can afford it. Some schools only offer assistantships in the second year, if at all. You may have to bear part or all of the cost on your own. Even if you receive a tuition waiver, you will have to pay your living expenses while in graduate school.

What to Do Once You Have Received the Catalogues

- Take note of examples of student and faculty work reproduced in the catalogue.
- Examine the course of study and note the academic requirements, such as art history. Don't choose a school that neglects academics.
- Examine the size and diversity of the art faculty. Take note of their credentials and gallery affiliations.

- Make sure they are an accredited institution. Look for NASAD (National Association of Schools of Art and Design) accreditation in particular.
- See what their visiting artist program is like, and who some of the most recent visiting artists are.
- See how many credits are necessary to get the MFA (some schools ask students to get an MA first, which could take longer and cost more).
- Keep in mind that the catalogue is essentially an advertisement for the school. Take the subjective information with a grain of salt.

Financial Assistance: Some Definitions

Fellowship: The proverbial "free ride," most fellowships consists of paid tuition and a stipend to cover living expenses. This type of award is more commonly given to second-year students who have proven their talent and discipline.

Teaching Assistantship: This involves a stipend and/or a tuition waiver in exchange for a three- to six- credit-hour teaching load. The teaching assistantship will be your first real teaching experience at the college level.

Graduate Assistantship: A straight graduate assistantship is usually free tuition and a stipend for congenial grunt work as a lab assistant.

Scholarship: Tuition waivers are sometimes called scholarships. At times it is a sum of money that only partially alleviates the burden of tuition costs. You pay your own living expenses.

Tuition Waiver: Your tuition is paid, but you pay your own living expenses.

Gathering Materials for Application

You will need to do the following things:

- Contact the financial aid office of each school. At universities, you will be dealing with this department separately. Don't assume that the art department will take care of things for you.
- Fill out the application forms. Some ask for résumés and some have a form for this information.
- A statement of intent is usually required and is very important. (More information about this follows.)
- Request transcripts from any and all colleges attended. There is a nominal fee.
- Request faculty recommendations, and give faculty as much advance notice as possible.
- Be prepared for an interview. (More information about this follows.)
- Find out about the GRE test in your area—where and when is it offered, and if it is available in both traditional and electronic form. Traditionally, the GRE is offered twice a year, once in the fall and once in the winter. Recently, however, the GRE began to be offered electronically, with testing opportunities available monthly. Since test scores may take a few months to process and mail, allow adequate lead time in order to meet application deadlines for January, February, and March. Not all schools require the GRE.
- Pay your application fee. They won't process a thing without it.

Documentation of Your Work: Slides and Slide Information Sheet

Complete information on how to shoot slides of two-dimensional work is provided in Appendix A under the heading "Documenting Two-Dimensional Work with 35mm Slides."

- Arrange your slides in the slide sheet to create the most consistent and beneficial view of your work. Put your best work first in the slide sheet. Try to create visual transitions for works that don't quite fit smoothly in your portfolio. Avoid non-sequiturs.
- You must have a cohesive body of work with an emphasis in the concentration to which you are applying. Remember, when the committee looks at your work you will basically have about five minutes to make your impression. Your work must have a strong voice.
- Apply for what you are best at. You can always change your concentration later.
- Your slides are everything! Try to steer away from work that looks assignment-oriented. They are interested in your conceptual concerns as well as your formal and technical skills. You will be applying with people who probably have just as much facility as you do.
- Label slides properly and include a slide list with title, dimensions (height listed first), and media.
- Always get instructor advice about your portfolio before you send it off.
- Some schools are now accepting application portfolios on CD-ROM, particularly if the applicant is interested in a digital-based discipline. If you are interested in applying on CD, find out what the specific requirements are.
- It is wise not to send multimedia portfolios. For example, ceramics, fibers, prints, drawings, and paintings should not be in the same portfolio. Be focused.
- It is best to put your materials in a folder or binder before placing them in a manila envelope. Include a self-addressed, stamped envelope for the return of your slides. It is important to put a piece of cardboard in the folder to keep slides from getting bent in the mail. Have the post office stamp your original and return envelope with "Do Not Bend."

Expenses

Expect to spend at least $800 for the entire process.

- Application fees: $25 to $50 per application
- Envelopes (manila and business size)
- Slide-viewing sheets
- Slide originals, slide duplicates, and related photo costs (a significant expense)
- Stamps for postage and return postage
- Carousel (some institutions ask for your slides in a universal carousel)
- Preparation of required documents (résumé, cover letters, letter of intent, artist's statement, etc.)
- Transcripts

The Interview, Artist's Statement, and Letter of Intent

Much of the same information can be used for an interview (if one takes place), your artist's statement, and your letter of intent. The main difference between the statement of intent and the artist's statement is that the statement of intent is specifically geared toward your goals for graduate school, while the artist's statement is a broader reflection on your work in general.

The following is a list of the most essential issues you need to consider in writing an artist's statement or letter of intent, and in preparing for an interview with a representative of the program or institution you are interested in. Some information may be more important than other information for your particular situation.

- An opening statement (monologue) about yourself and some of the experiences that inspired you to become an artist.
- Discuss with confidence the goals you hope to achieve in graduate school as well as the goals you wish to achieve in your work.
- Give an overview of your work and your basic philosophical orientation.
- Summarize the important ideas or attitudes underlying your art, and discuss the source of your ideas.
- Discuss books or articles that have significantly influenced your thinking.
- Discuss artists or traditions that have significantly inspired your work.
- What is it about these artists or traditions that is historically significant and personally significant?
- Describe your work and the formal/technical elements that you utilize (e.g., paint handling, media manipulation, composition, scale, etc.)
- Discuss significant or recurrent images, ideas, or motifs that are present in your work.
- Discuss how your work relates to or reflects your philosophy.
- Use résumé-quality paper for your artist's statement and your letter of intent.

If each of these issues was addressed thoroughly, your statement and letter of intent would be far too lengthy. Identify those points that seem most important to you and focus on them in your writing. Be clear, concise, and informative. If you are interviewed, many of the same questions will probably come up, and this will be your opportunity to elaborate on any idea or concern that was touched upon in your letter or statement.

Preparing for an Interview

Some institutions will interview their top candidates. The interview may be conducted by faculty members, the director of the graduate program, or may include current graduate students as part of a panel of interviewers. You should be as prepared as possible for your interview, with the following suggestions in mind:

- Anticipate the interviewer's questions. Make a list and study it.
- Be prepared to answer all kinds of questions about your work and philosophy, both sympathetic and unsympathetic. Know the pros and cons, the strengths and weaknesses, of your work.
- Have your artistic philosophy clear in your own mind. Know it and be able to talk about it.

- Be prepared to talk at length about individual works, as you may be asked to give a slide presentation.
- Be prepared with your own questions. Be ready to ask the interviewers questions about their program.
- Be prepared for the unexpected.
- Remember that you must do more than answer questions. Don't be merely reactive. It is important to be confident and volunteer information. Don't hesitate to take a leadership role in your interview.

After Receiving Notification of Acceptance or Rejection

If you were interviewed as part of the application process, you may have already had an opportunity to address some of the issues listed below during a campus visit. If you have been accepted without an interview, you should plan to visit the top two or three colleges or universities of your choice. If possible, arrange meetings in advance with the people you would most like to talk to, and be prepared with questions or concerns you want to discuss. You should address the following issues during your visit:

- The size of the art department, the building, and its facilities.
- Studio space. Do first-year students have access to studio space?
- The visiting artist program. Ask for a schedule for the current term. VAs from past years are usually listed in the catalogue.
- The size and quality of the institution's art gallery. Ask for a schedule of past and present exhibitions.
- Intellectual and cultural climate of the city. Are there galleries, art museums, art centers, etc.?
- Proximity to major cultural centers or large cities.
- Try to schedule your visit during a faculty show or a college-wide student exhibition.
- Prepare ahead of time a list of all questions you would like to ask students, faculty, support staff, director of graduate studies, and anyone else you may come into contact with.
- Talk to the director of graduate studies if possible, and ask a lot of questions. Find out which way the graduate program leans—abstraction, representation, new genre, conceptual, figurative, etc.
- Plan to meet the teacher(s) in your area of concentration and try to attend a critique (it is wise to arrange this in advance of your visit). This is most important. You will be studying with these people for at least two years. Do they have brains worth picking?
- What do the students think of the program? What do you think of the student work?
- Ask about the structure of the program in terms of faculty and student interaction. Some grad programs have been referred to as "art boot camp" because of frequent meetings and critiques and significant structure. Other grad programs are minimally structured, requiring far fewer meetings between faculty and students, and the students may not even know each other.

- Find out if there are allotments for different disciplines or concentrations. There is sometimes a set number of graduates enrolled in each department or discipline. Some accept more students than others.
- Don't be afraid to take notes as you are talking to people. A lot of information will be coming your way and note-taking will help you to remember who said what and where.

Things to Consider in Choosing a Program
- The reputation of the program or institution. Reputations linger, while faculty and actual department quality can fluctuate. Your best approach is to ask current or recent graduates for updated commentary on the program you are interested in. Get more than one opinion.
- How much financial help they can give you in the form of fellowships, tuition waivers, assistantships, etc.
- The quality of the faculty.
- The location of the institution.
- Your personal impressions.
- What kinds of experiences the program can offer you in contrast to the under-graduate program you are currently in. Your graduate program should provide new experiences rather than serving as a continuation of the familiar.

Bibliography

Barcsay, Jeno. *Anatomy for the Artist.* New York: Gallery Books-W.H. Smith, 1975.

Bartschi, Willy A. *Linear Perspective.* New York: Van Nostrand Reinhold, 1981.

Berry, William A. *Drawing the Human Form: Methods, Sources and Concepts.* New York: Van Nostrand Reinhold, 1977.

Betti, Claudia, and Teel Sale. *Drawing: A Contemporary Approach.* 2nd ed. New York: Holt, Rinehart and Winston, 1986.

Chaet, Bernard. *The Art of Drawing.* New York: Holt, Rinehart and Winston, 1978.

D'Amelio, Joseph. *Perspective Drawing Handbook.* New York: Tudor Publishing, 1964.

Doblin, Jay. *Perspective: A New System for Designers.* New York: Whitney Publications, 1966,

Edwards, Betty. *Drawing on the Right Side of the Brain.* Los Angeles: J.P. Tarcher, 1979.

Goldstein, Nathan. *The Art of Responsive Drawing.* 2nd ed. Englewood Cliffs, NJ: Prentice-Hall, 1977.

Goldstein, Nathan. *Figure Drawing: The Structure, Anatomy and Expressive Design of the Human Form.* 2nd ed. Englewood Cliffs, NJ: Prentice-Hall, 1981.

Mendelowitz, Daniel M. *Drawing.* New York: Holt, Rinehart and Winston, 1967.

Mendelowitz, Daniel M., and Duane A. Wakeham. *A Guide to Drawing.* 4th ed. New York: Holt, Rinehart and Winston, 1988.

Osborne, Harold, ed. *The Oxford Companion to Art.* Oxford: Clarendon Press-Oxford University Press, 1970.

Raynes, John. *Human Anatomy for the Artist.* New York: Crescent Books-Crown, 1979.

Sheppard, Joseph. *Anatomy: A Complete Guide for Artists.* New York: Watson-Guptill, 1975.

Supplemental Reading

The books listed below are recommended for general reading, and for additional infor-
mation about technical, formal, and conceptual issues as they relate to drawing, figure
drawing, artistic anatomy, perspective, and design principles. This list does not include
books listed above in the bibliography.

Supplemental Reading for Drawing

Calle, Paul. *The Pencil.* Cincinnati: North Light-Writer's Digest Books, 1974.

Chaet, Bernard. *An Artist's Notebook: Techniques and Materials.* New York: Holt, Rinehart
and Winston, 1979.

Enstice, Wayne, and Melody Peters. *Drawing: Space, Form, Expression.* Englewood Cliffs,
NJ: Prentice-Hall, 1990.

Kaupelis, Robert. *Experimental Drawing.* New York: Watson-Guptill, 1980.

Kaupelis, Robert. *Learning to Draw: A Creative Approach to Drawing.* New York: Watson-
Guptill, 1983.

Rawson, Philip. *The Art of Drawing: an Instructional Guide.* Englewood Cliffs, NJ:
Prentice-Hall, 1984.

Smagula, Howard J. *Creative Drawing.* Wm. C. Brown Communications, 1993.

Supplemental Reading for Figure Drawing

Brodatz, Phil. *The Human Form in Action and Repose.* New York: Reinhold Publishing,
1966.

Brown, Clint, and Cheryl McLean. *Drawing from Life.* New York: Holt, Rinehart and
Winston, 1992.

Gordon, Louise. *How to Draw the Human Figure: An Anatomical Approach.* New York:
Penguin Books, 1987.

Hale, Robert Beverly. *Drawing Lessons from the Great Masters.* New York: Watson-
Guptill, 1977.

Supplemental Reading for Artistic Anatomy

Farris, John Edmond. *Art Student's Anatomy.* 2nd ed. New York: Dover, 1961.

Goldfinger, Eliot. *Human Anatomy for Artists: The Elements of Form.* New York: Oxford
University Press, 1997.

Kramer, Jack. *Human Anatomy and Figure Drawing: The Integration of Structure and Form.*
New York: Van Nostrand Reinhold, 1972.

Oliver, Charles. *Anatomy and Perspective.* New York: Viking, 1972.

Peck, Stephen. *Atlas of Human Anatomy for the Artist.* New York: Oxford University
Press, 1982.

Schider, Fritz. *An Atlas of Anatomy for Artists.* 3rd ed. New York: Dover, 1957.

Supplemental Reading for Perspective

Auvil, Kenneth W. *Perspective Drawing.* Mountain View, CA: Mayfield Publishing, 1990.

Coulin, Claudius. *Step-By-Step Perspective Drawing for Architects, Draftsmen, and Designers.*
New York: Van Nostrand Reinhold, 1982.

Gerds, Donald A. *Perspective: The Grid System.* Santa Monica, CA: DAG Design, 1989.

James, Jane H. *Perspective Drawing: A Point of View.* Englewood Cliffs, NJ: Prentice Hall, 1988.

Montague, John. *Basic Perspective Drawing: A Visual Approach.* New York: Van Nostrand Reinhold, 1985.

White, Gwen. *Perspective: A Guide for Artists, Architects and Designers.* New York: Watson-Guptill, 1974.

Supplemental Reading for Design Principles

Bouleau, Charles. *The Painter's Secret Geometry.* New York: Hacker Art Books, 1980.

Cheatham, Frank R., Jane Hart Cheatham, and Sheryl A. Haler. *Design Concepts and Applications.* Englewood Cliffs, NJ: Prentice-Hall, 1983.

Cook, T.A. *The Curves of Life.* New York: H. Holt, 1914.

Doczi, Gyorgy. *The Power of Limits: Proportional Harmonies in Nature, Art and Architecture.* Boston: Shambhala, 1985.

Ghyka, Matila. *A Practical Handbook of Geometrical Composition and Design.* London: A. Tiranti, 1964.

Hambridge, J. *Dynamic Symmetry.* New Haven: Yale University Press, 1920.

Kappraff, J. *Connections: The Geometric Bridge Between Art and Science.* New York: McGraw-Hill, 1991.

Lund, F.M. *Ad Quadratum.* London: B.T. Batsford, 1921.

Myers, Jack Fredrick. *The Language of Visual Art: Perception as a Basis for Design.* New York: Holt, Rinehart and Winston, 1989.

Ocvirk, Otto G., Robert E. Stinson, Philip R. Wigg, Robert O. Bone, and David L. Cayton. *Art Fundamentals: Theory and Practice.* 8th ed. New York: McGraw-Hill, 1998.

Artist Index

*I*ndex

* Note: Page numbers set in *italics* indicate illustrations

abstract compositions, *25*
academics as career option, 296
accreditation of MFA programs, 311
adductor muscles, *142*, 144
age, facial features and, 123
Agfachrome films, 293
agitated lines, 62, *63*
alignment
 diagonal, 21, 31, *31, 32*
 horizontal, 19–21, *20, 21,* 31, 97–98
 vertical, 19–21, *20, 21,* 31, 97–98
altered lines, 60, *62*
alternative viewpoints, *32,* 130–132, *132*
ambiguous space, 234
anatomical lines, 57
anatomy. *See also* muscles; skeleton
 anatomical details, 57
 anatomical terminology, 145
 artistic *vs.* medical, 133–135
 as element of figure drawing,
 135–137
 relative proportions of human form,
 102
 works illustrating, *133, 134–136,*
 138–139, 141–142, 271, 274, 280–281

angles, sighting techniques to establish,
 17–18
angry lines, 62, *63*
angular lines, 59, *60, 61*
animal skulls, 87
application for graduate school,
 302–303, 309, 311–312
appropriation of artwork, 248
arms
 bones of, *139,* 140
 muscles of, *136, 142,* 143
 relative proportions of, 102
art criticism as career option, 296
art supplies, cost of, 244
articulation, points of, 15, 31, 107, *107*
artist-in-residence, letters of recommen-
 dation for, 309
The Artist's Mother (Woman Sewing), 1883
 (Seurat), *40*
artist's statement, 313
arts administration as career option, 296
assessing work. *See* critiques
assignments. *See* homework assignments
assistantships, 310, 311
asymmetry of ears, *126*